Photography: The New Basics
Principles, Techniques and Practice

Graham Diprose and Jeff Robins

with 547 illustrations, 485 in colour

Thames & Hudson

First published in the United Kingdom in 2012 by Thames & Hudson Ltd,
181A High Holborn, London WC1V 7QX

British Library Cataloguing-in-Publication Data
A catalogue record for this book is available from the British Library

ISBN 978-0-500-28978-5

Designed by Adam Hay Studio

Printed and bound in China by Toppan Leefung

To find out about all our publications, please visit
www.thamesandhudson.com
There you can subscribe to our e-newsletter, browse or download
our current catalogue, and buy any titles that are in print.

Contents

0.1 The Brazilian photographer Luana Gomes lived for ten days with the Berber people of Morocco, gaining their confidence to take a series of intimate pictures, including this *Portrait of Abdou*.

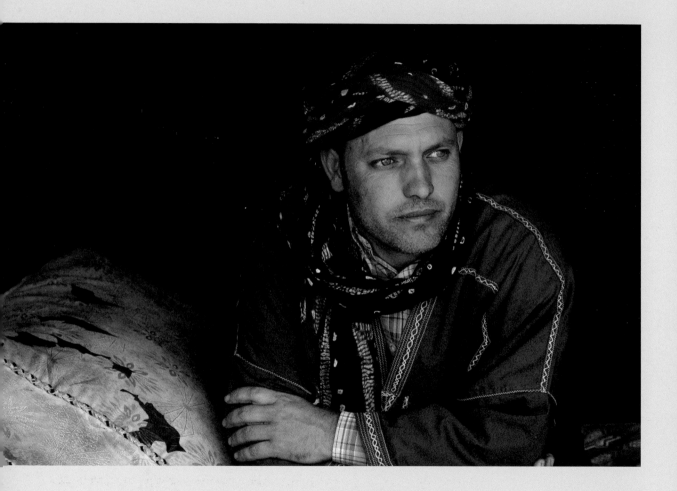

Introduction

Wherever in the world you are reading this, one thing is certain: photography is not the same as it was five years ago, and is almost unrecognizable when compared to image-making in the last century. Photographers in the twenty-first century, especially those looking to develop a successful career, need a very different set of skills. Apart from blurring the traditional photographic markets, changes in technology have transformed mobile phones into cameras; iPods® into handheld cinemas; and home computers and iPads® into powerful communication tools. All these changes mean that photographic imaging is now more exciting – and challenging – than ever before.

The Skills You Will Learn in This Book

This book will help you to develop the range of skills you will need to approach photographic imaging in a complete and professional fashion. Although you will obviously need cutting-edge digital photography and computing skills, new technology cannot always provide the answers, which means that today's photographers also need to be aware of traditional craft-based techniques.

Technical skills alone will not make you a good photographer, however. Photography has influenced – and been influenced by – art history in general, and continues to do so, and to understand contemporary photography from both an aesthetic and a technical standpoint you must be willing to tap into both recent and older histories: to explore the work of great individual photographers and artists, as well as their discoveries and ideas. Whatever your particular interests, you should familiarize yourself with as wide a range of genres and subjects as possible. It is also important that you understand how the cultural and socio-political background has affected what photographers past and present – including you – choose to capture with their camera.

Fortunately, photography's history has provided a rich collection of photographic images – many of which are now easily accessible online – so twenty-first-century students of the medium have every opportunity to study the visual and technical skills employed by iconic photographers. This can help you to develop a strong, personal visual style, taking elements from one source and blending them with another, while adding your own vision, of course.

0.2 The Russian photographer Nadya Elpis came to London to study photography, producing a portfolio including this *Rush Hour in Krakow* that won her a scholarship to study in Paris, where she now works.

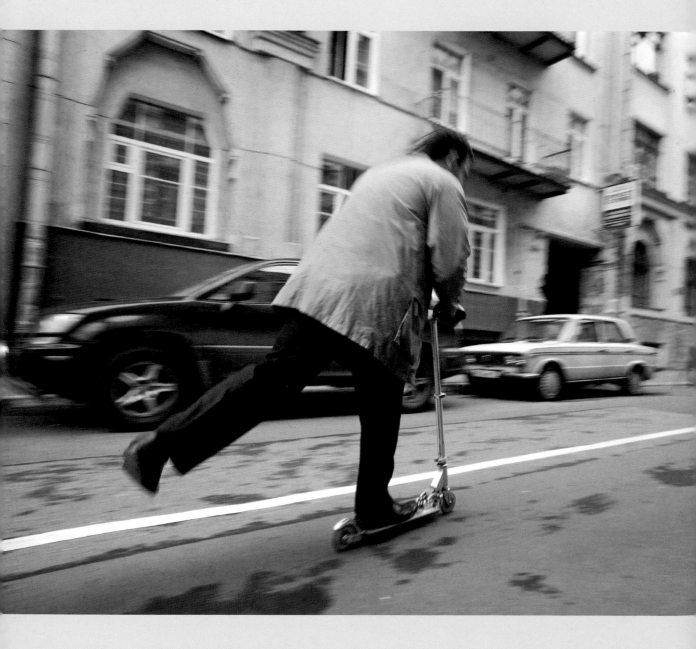

You may wish to specialize in a particular genre – fashion, portraiture or commercial studio work, for example – but if you are seeking to turn photography into a career, it is increasingly important that you should be able to cope with a broader range of assignments when requested to do so.

Whether you aspire to making a living from commercial photography, establish a reputation as a fine artist, or simply wish to get the most from your hobby, you need to think about how others will get to know about you and your work. There are a number of photo-sharing websites, such as Flickr, that will help you show your images to others; creating a personal website, too, has never been easier.

If you want to transform your photography into a career, however, that may not be enough: to succeed today, you need to add many more skills, such as networking, costing and a basic knowledge of any taxes you will need to pay. Unless money is no object, you should immediately look for suppliers who can give you the best deals on the equipment and services that you need, and decide what to charge if someone wants to buy some of your pictures. If you start to make any regular income from your photography, it is a good idea to check out tax laws in your country as soon as possible: some governments support 'start-up businesses', while others will be after a cut of your money right from the start.

This may sound like a lot to learn. One way in is by assisting an established photographer, which can really help when you are starting out. The hours may be long, and the wages minimal (if you are paid at all), but this is a great way to become familiar with many of the professional practices and skills that you will need to advance your own career.

Whatever your dream, take a look at everything that you have going for you: the languages you speak, the places you have visited, your other hobbies and skills, personal contacts, and people who your parents and tutors know. Any or all of these may help you to take better pictures and present them to a wider audience. Photography today is a truly global medium, and the ability to work across different countries, languages and cultures will become ever more important. With this in mind, try to look at the work of young photographers from around the world and not just those in your own college class or home town. As well as learning from their ideas, do not forget that these brilliant young Russian, Chinese, Indian or Brazilian photographers (who will often speak English as well as most UK and US natives) harbour exactly the same ambitions in photography as you do. They should provide you with the incentive to work hard and learn as much about contemporary photography as you can. They are, after all, your 'competition'.

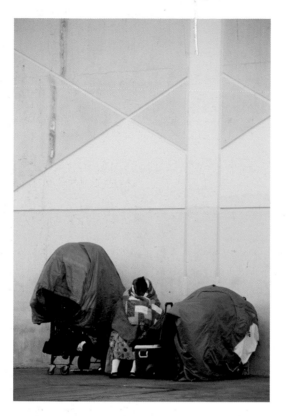

0.3 This homeless woman in Los Angeles was captured as part of a project about the recent state of the US economy by Weronika Krawczyk, a young Polish photojournalist.

How This Book Will Help You

To ensure that you have a deep understanding of both the traditional and the digital skills that you will need to practise photography at the highest level, this book has been designed so that each chapter builds on the one preceding it, with chapter-specific exercises designed to help put the theory into practice. As a result, certain topics are referred to on a number of occasions, each time in greater depth in order to reinforce and expand the concept under discussion.

There is no assumption that you will be working with the latest high-end photographic equipment, so you can work your way through the exercises using an inexpensive digital or film camera as you develop your creative skills and practise new techniques. Whether you are working on these ideas in the classroom or by yourself, each will help you develop new skills and a portfolio of creative images and ideas: but try to avoid working in complete isolation. On a formal photography or art course this could mean discussing your results with your friends, peers and tutors, who will be interested to see your work on the exercises and able to offer useful feedback. Such websites as Flickr, Tumblr and Facebook are also valuable outlets: not only will they enable you to show your work to a wider audience, but also – and more importantly – they will enable you to gain feedback about your work. The main thing is that you are prepared to share your images and accept (constructive) criticism. In this way, and by following up the suggestions in this book about researching the great themes and genres of photography, you will develop a more conceptual approach to the medium and to your own style of image-making.

GETTING THE MOST FROM YOUR DIGITAL CAMERA

In this chapter you will learn:

- Important things to consider when buying your first digital camera
- The basic camera settings and why you should use them
- New skills and ideas for composing better pictures

1.0 (previous page) Planning a good low angle and choosing the exact moment to hit the shutter button helped Bella Falk to take this superb action picture on her Casio compact camera, proving that you do not need to buy lots of expensive kit when you are getting started in photography.

1.1 The circular snapshot produced by early Kodak cameras (*c.* 1890) allowed the capture of everyday events without needing the skills or costs of a professional. The identities of the woman and her photographer are unknown.

Taking Pictures

When George Eastman launched a low-cost roll-film camera in 1888, it meant that ordinary people could begin to document their lives (**1.1**), and some of the mystery that professional photographers had relied on for their trade disappeared for ever. Sixty years later, little had changed, and in the 1940s Kodak Brownie cameras were still widely used to shoot black-and-white roll film that came in a range of different sizes (**1.2**). Often the local chemist or photographer would process and print the films in a darkroom at the back of the shop. By the 1970s, photography enthusiasts were far more likely to own a 35 mm film camera, shooting on colour negative film that was sent away to a specialist laboratory to develop, with small prints made from each and every frame.

Today, however, film is used less often – especially in the consumer market – and many aspiring photographers will have taken their first images on a mobile phone, perhaps uploading them to a computer before sharing them with friends via e-mail, or reaching a much wider audience through a website or blog. Very few images are likely to be printed – certainly not every picture – and in the digital age, the financial cost of pressing the shutter and taking an image is no longer a significant part of the decision in capturing a moment.

While this has made photography far more accessible to a wider range of people, it has also had a negative impact on the medium: the immediacy and low cost of digital capture have reduced the need to think about the act of taking a picture, and this means that you are more likely to end up with poor images. On the positive side, anyone wishing to improve their photography can now have plenty of practice, with instant review allowing them to correct any mistakes. Experimentation no longer carries the same financial burden that was once involved in film processing.

1.2 By 1902, more than 150,000 Kodak Brownie cameras had been sold in many countries around the world. Slogans included 'Can be operated by any boy or girl', and children could join the 'Brownie Club' and win prizes in its photography competitions.

15

Compact

1.3 Today's compact digital cameras have advanced enormously in just a few years, and they can now take great pictures (and high-definition video).

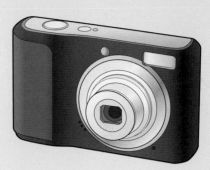

Fixed Lens

1.4 Fixed-lens digital cameras often have excellent optical zooms (see p. 21) and are particularly useful in such dusty environments as safaris, cities or colleges, as dust cannot get onto the sensor. Many can shoot Raw files (see Chapter 4) and have full manual controls.

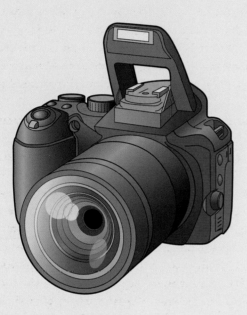

Single-Lens Reflex (SLR)

1.5 A digital SLR camera will allow you to take great pictures in almost any genre and environment. The vast range of manufacturers, specifications, lenses and complex menu options can be daunting to the photographer.

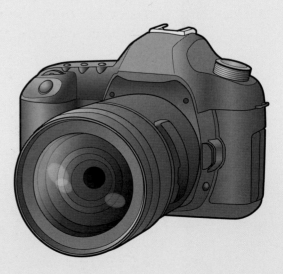

Choosing a Digital Camera

So you have taken some good shots with your mobile phone and want to upgrade to your first digital camera. But with so many on the market, what factors should you consider?

Budget usually has to come first. While it makes sense to avoid buying a cheap camera that you will want to upgrade in a year – perhaps less – you may also want to buy a 'photo-quality' **ink-jet** printer, and a tripod, flash and camera bag. Unless you have unlimited funds, these extras all need to be included in your budget, so be prepared to make compromises if you have to.

Size is also a consideration: do you want a compact camera that will slip discreetly into a pocket or handbag (**1.3**), or something larger, such as a **single-lens reflex** camera (SLR), that requires a kit bag of its own (**1.4, 1.5**)? SLRs can be heavy, especially when you take additional lenses into account, which can be an issue if you are travelling or hiking long distances – whereas weight is unlikely to be a problem if you prefer to work in a studio environment. So think about the subjects that you enjoy shooting and whether you would prefer to carry a large camera or a smaller one: it could be that you do not need the biggest and heaviest SLR.

Once you have decided which type of camera you prefer, try to read as many reviews as possible to gain an overall perspective on which make and model may suit your needs. It is worth short-listing a few different cameras and then trying them out in a shop to find the one that feels right in your hand. We will take a look at SLRs in more detail in Chapter 4, but here are some key considerations if you are looking for a smaller, compact camera model.

The first thing to note is that some compact cameras have a delay between the moment when you press the shutter and the camera taking the picture, while the camera focuses and gets the exposure right for you. Although this occurs less often in today's cameras, it still exists with some (very) cheap models and can be frustrating when you find you consistently miss an expression on someone's face or are attempting an action shot where timing is everything. You may find that some cameras also feel unbalanced, perhaps with awkward controls or difficult menus, so bear this in mind when you come to buying: it may be cheaper to buy over the Internet, but getting 'hands on' with your potential purchase can more readily highlight any problems that could be a constant source of frustration in the longer term.

Megapixels

The light-sensitive **sensor** in any digital camera (whether it is a compact or an SLR) will be made up of **pixels**: tiny 'dots' that receive the light and convert it into an electronic image. Put simply, the greater the number of pixels, the higher the **resolution** of the photograph, which allows you to make bigger enlargements or crop an image to improve composition without noticeably reducing the overall image quality. Even the most inexpensive cameras are likely to have an imaging sensor of 10 million pixels (10 **megapixels** [MP]); more moderately priced cameras will include a sensor of 12 megapixels or higher. If you print an image uncropped, a 10MP camera should make a high-quality, A4-sized print, while an 18MP sensor can produce A3-sized enlargements at its highest resolution setting, without a noticeable loss in quality.

Viewfinders and LCD Screens

While SLR cameras rely on an 'eye-level' viewfinder for composing photographs, the vast majority of compact cameras use a large **liquid crystal display** (**LCD**) screen instead, which can show both the image you are about to take, and the resulting picture. The size of the screen allows more information about the camera settings to be displayed (so you know precisely what the camera is doing), while larger screens give a much clearer impression of the images you have already taken.

Note, however, the use of the word 'impression': although LCD screens are useful for assessing a composition, they are not without problems. In very bright lighting conditions they can become tricky to view (**1.6**), regardless of whether you are composing a photograph or reviewing one, and the appearance of the LCD screen will change depending on the **ambient light**. In dimly lit conditions, for example, the on-screen image will look far brighter, making it difficult to judge whether an exposure is correct or not.

1.6 Viewing a compact camera screen on a beach or snowy day can make it very difficult to judge if the exposure is correct. Try to find some shade, or turn your camera away from the sun, to check your images.

Sensors (1.7)

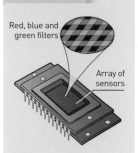

Red, blue and green filters

Array of sensors

Digital cameras use chips covered in thousands of tiny light sensors to capture the image.

Resolution

The number of pixels on a camera sensor determines the size of the final image. Below is a list of the sensor sizes found in a range of digital cameras, along with the maximum print size these would deliver at the 'standard' photographic print resolution of 300 pixels per inch (**ppi**) – note that the differences may not be as pronounced as you would at first think.

Megapixels	Typical Image Size	Print size at 300ppi
6	**2816 × 2112** pixels	**9.39 × 7.04** in. / **23.85 × 17.88** cm
10	**3872 × 2593** pixels	**12.91 × 8.64** in. / **32.79 × 21.95** cm
12	**4272 × 2848** pixels	**14.24 × 9.49** in. / **36.17 × 24.10** cm
14	**4608 × 3072** pixels	**15.36 × 10.24** in. / **39.01 × 26.01** cm
15	**4752 × 3168** pixels	**15.84 × 10.56** in. / **40.23 × 26.82** cm
16	**4928 × 3264** pixels	**16.43 × 10.88** in. / **41.73 × 27.64** cm
18	**5184 × 3456** pixels	**17.28 × 11.52** in. / **43.89 × 29.26** cm
21	**5616 × 3744** pixels	**18.72 × 12.48** in. / **47.55 × 31.70** cm
25	**6048 × 4032** pixels	**20.16 × 13.44** in. / **51.21 × 34.14** cm

Automatic Settings vs Manual Control

Most new photographers begin by switching their camera to Automatic, so that the camera sets everything itself: auto-exposure, **auto-focus** and auto everything else. In most instances this will produce a correctly exposed and focused photograph, and with some compact cameras you may be able to use only automatic exposure and focus. While this is convenient for 'snapshots', when all of the decision-making is left to the camera, any notion of creativity on the part of the photographer is removed from the equation: the *camera*, not *you*, is making the picture.

Therefore, you should consider only compact cameras that offer a greater range of manual controls, such as **Aperture Priority** or Manual exposure modes, and the ability to adjust and fine-tune as many of the in-camera processing options as possible. Slightly more expensive cameras may also offer you **Raw** (uncompressed) files as well as **JPEGs**, the option to record images in the **Adobe® RGB colour space**, and a host of other features. Although you might not use these immediately, you will find that having the option to control the camera manually can produce more striking results as your confidence and skills grow.

Batteries

Battery technology was once the Achilles heel of digital photography, as power-hungry cameras drained batteries with alarming speed, but recent advances in technology have delivered significant improvements in both mobile phones and digital cameras, allowing batteries to become smaller, with a longer life before they need to be recharged. There are numerous technologies used in digital camera batteries, but the most common in mid-range to high-end compacts are lithium-ion (Li-ion) rechargeable batteries. These are light, relatively cheap and do not suffer from the 'memory effect' if you charge them before they are drained fully (see box). If you plan to do a lot of travelling in remote areas without electricity, recharging your batteries can be a problem. Batteries need charging regularly, even if a camera has not been used for a while. They do not retain all their charge if unused, so always charge them up before going on a shoot. Other compacts (usually lower-cost models) rely on two or four AA-sized batteries for power. This makes the camera heavier and more bulky (because of the larger battery compartment), and digital cameras can discharge regular alkaline batteries very quickly. At the same time, though, AA batteries are available for sale almost anywhere in the world, so getting replacement cells is not necessarily a problem. You can carry spare sets, but there is a price, both financial and in terms of weight.

An alternative to alkaline technology is lithium-ion or nickel-metal hydride (NiMH) batteries, both widely available in the necessary AA size. These last significantly longer than their alkaline equivalent (Li-ion even more so), but this is reflected by a higher purchase price to start with. As well as single-use batteries, which need to be disposed of once they are drained, you could consider rechargeable AA-sized nickel-metal hydride or lithium-ion cells. These can be a good substitute for standard batteries if you are going to be near a mains power supply, but extended shooting in remote areas may prove problematic.

Memory Effect

Some older (nickel-cadmium/NiCd) rechargeable batteries suffer from what is known as a memory effect. Unless the battery is fully discharged, it 'remembers' the level of charge it had before recharging began, and when it subsequently reaches this level again (during use), it can stop working – effectively reducing the apparent capacity of the battery to the point that it is rendered useless. This is not the case with lithium-ion and nickel-metal hydride batteries.

Mains Leads

Although a mains lead and transformer are not always supplied with a camera (especially compact models), they can be useful if you are often working in a studio, as they avoid your having to wait for batteries to recharge, or interrupt a shoot to change over to a charged set. It is also safer to use a mains lead if you are downloading files directly from the camera or cleaning the sensor.

Digital Zoom vs Optical Zoom

Some compact digital cameras boast fantastic **digital zoom** features that allow you to take pictures of a smaller part of your subject. **Optical zoom lenses** also allow you to shoot telephoto (closer up) or wide-angle photographs (**1.8**), but these lenses tend to be larger and more bulky, and the range of **focal lengths** covered by the lens is often lower than a digital zoom. While this may sound as though a digital zoom is the better option, the key difference is in the way that they work: an optical zoom is based on the physical properties of the lens, while a digital zoom is not. Instead, a digital zoom simply crops the picture to give the impression that you are getting closer to the subject. This discards lots of the pixels in the image, which reduces the resolution and gives a lower-quality result (**1.9**). Digital zoom is therefore best avoided in any camera, particularly if you have any sort of manipulation software on your computer that allows you to crop or enlarge parts of your pictures at a later stage.

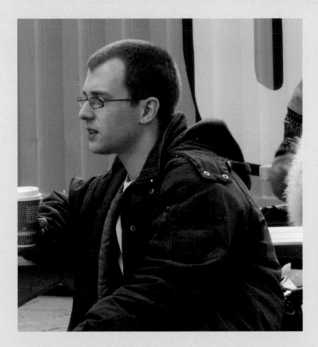

1.8 An optical zoom uses a good-quality lens to allow you to go in closer on a subject, and the image is captured using the whole digital chip.

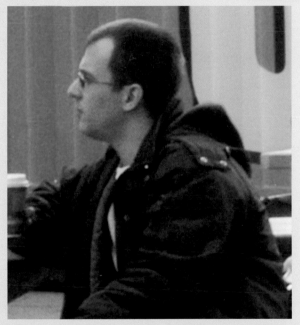

1.9 In this comparative picture, a digital zoom was used. It simply crops into part of the image on the camera chip, at the image storage stage, thus throwing away pixels and reducing the image quality.

Flash

Even the smallest compact cameras – and some mobile phones – have a built-in flash. Some pop up automatically in low-light conditions, while others can be activated through the camera's menu. Most are only strong enough to work up to 2–3 m away, though, and will not light a whole room, let alone a much larger space. Given the size of the camera, the flash and lens also have to be close together, which creates a further problem. When you are photographing a person looking into the camera, the flash will light the back of their eyes, and because the lens is in line with the flash, the camera records the **reflected light**, creating **red-eye**, which can ruin a picture (**1.10**).

Some cameras have an option to help combat this by firing a weaker burst of flash just before the main picture is taken. The pupil in the subject's eye contracts when the first flash fires, allowing less light into (and out of) the eye, so that the amount of red-eye is reduced (**1.11**). Some cameras and image-manipulation software can also detect red-eye in a picture and remove it.

1.10 Red-eye is the unfortunate effect of having the flash too close to the axis of the lens, particularly on smaller cameras, so that the back of the subject's eyeball is illuminated, giving him or her a 'demon' look.

1.11 In this picture, the red-eye effect is reduced. Some cameras can be set to do this automatically in capture, while many photographers prefer to use image-manipulation software on a computer to make the correction.

22

Memory Cards

The **memory cards** used to store your pictures in the camera come in a variety of shapes, sizes, speeds and capacities. Most manufacturers no longer include a memory card with their cameras, so one of the first things you need to do is to purchase one before you get started.

The most common memory card formats for compact cameras are SD (secure digital) and CompactFlash. The SD card is available as standard SD, SDHC (high capacity) and SDXC (extended capacity). It is important to note that not all SD-compatible cameras will accept SDHC or SDXC cards, so check before buying one. Other memory card formats that are used are MemoryStick (in some Sony cameras) and xD picture cards (primarily in Olympus cameras), although xD is now considered obsolete.

Regardless of the card that your camera takes, you need to budget for as much storage as you can afford, especially if the camera you are buying also shoots **high-definition (HD) video**: shooting movies will eat up storage space quickly. Current capacities range from 1 **Gigabyte** (Gb) up to 64Gb, with the cost rising as the amount of storage space increases.

The other consideration is the memory card's 'speed'. This refers to the rate at which it can transfer data, both onto and off the card, which includes reading images for reviewing them in-camera. A fast card can move data at 90 megabits per second (mbps) or more, but will be more expensive than a slower card with the same storage capacity. Note that it is not only the card that controls data movement speeds, but also a combination of the memory card and the data bus in the computer in your camera: buying the fastest, most expensive memory card could be a waste of money if your camera cannot work that quickly.

Multiple Memory Cards

Although it costs a little more, some photographers buy two or three smaller cards, rather than one larger capacity card (for example, two 4Gb memory cards instead of an 8Gb one). The reasoning behind this is simple: if one of the cards is lost or damaged, or the data becomes corrupted, the photographer can still keep shooting with the other card.

Downloading Images

You can download images from most cameras by plugging them directly into a computer via a USB lead, but the transfer time can be quite slow if you work in this way (even with a fast memory card). The majority of photographers take the memory card out of the camera and use a card reader for much faster transfer times.

Formatting Memory Cards

Always use the camera menu to format your memory card and remove your downloaded images, rather than doing this on your computer. Reformatting in your computer can mean that your camera might not recognize your card. If you encounter this problem, data-recovery software may help. This is often available online from your memory card manufacturer's website.

Getting Started

Before you start taking pictures, it is worth spending some time studying and setting up the menus (**1.12**). Once you have charged the batteries and turned the camera on, you are likely to find two sets of menus. One menu will work only in shooting mode (often indicated by a little red camera symbol), and the other menu in playback mode (usually identified by a small, green, right-facing arrow). Playback mode is mainly used to review your pictures and delete the ones that you do not like.

Image Resolution and Quality

Most digital cameras shoot JPEG files (at least as their main option), with the resolution and quality of the images determined in-camera using Image Size and Quality (or similar) options in the menu. The image size is given as **pixel dimensions**, megapixels (3MP, 6MP or 12MP, for example), or simply 'Large, Medium and Small', and refers to the physical number of pixels used to make the image: the more pixels used, the bigger the image.

Quality usually offers a choice of 'Fine, Normal or Low' (or similar). This refers to the amount of **compression** applied to the JPEG file. JPEG files use a **lossy compression** system, which means a certain amount of information is discarded when the file is recorded; by setting the quality, you control how much.

If you choose a Low quality setting, for example, the JPEG files will be more heavily compressed, which will allow you to fit more pictures onto the memory card at the expense of reduced quality. Conversely, a High or Fine setting will apply minimal compression to maintain the highest quality. We shall look at this in greater detail in Chapter 4.

1.12 While some compact cameras have very simple controls that will suit a photographer who is happy to 'point and shoot', many are designed with a full range of manual controls and settings.

Raw Files

In addition to JPEG files, some high-end compact cameras (and all SLRs) allow you to record Raw files. This is a much better, but more complex, option, and one that is covered in greater detail in Chapter 4.

In-Camera Colour Effects

As well as allowing you to set the **white balance** to get technically 'correct' images, some cameras offer you a choice of creative colour effects, such as black-and-white and sepia (brown) toning. If you do not have access to image-editing software, these are worth trying, but editing programs offer much better ways of achieving these effects on the computer, with a greater level of control.

White Balance

The human eye and brain are adept at compensating for different colours of light: when you step indoors from daylight to a tungsten-lit room, you do not notice a change in colour. But if you stand outdoors at dusk and walk back into a lighted room, interior lights look noticeably warmer, or more orange. This is because daylight and **incandescent** (tungsten) lighting – as well as all other light sources – have a distinct **colour temperature**. Some are warmer (more orange) and others cooler (more blue). We shall look at this in greater detail in Chapter 4.

While your eyes (and brain) adjust readily to these changes, your digital camera cannot: it needs to be told what 'temperature' the light is so that the colours appear neutral. This is more commonly referred to as the **white balance**. On most cameras there is a range of white balance settings, including Automatic, pre-set values for Sun, Cloud, Shade, Incandescent, **Fluorescent** and Flash, and a Custom or Manual option (**1.13**).

1.14 (above) Using the 'wrong' white balance setting on purpose, Julija Svetlova set her camera to Tungsten Light to throw an eerie blue cast into the shadow areas of her model's skin tones and the background landscape.

1.13 (right) The White Balance menu offers accurate colour control in different lighting conditions. The Auto setting works well, except with flash. Custom white balance is particularly useful in mixed lighting, where the Auto setting can become confused.

1.15 Christian Sinibaldi took this picture of migrants by the fire, lit by tungsten car headlights. He white-balanced to Daylight to give these warm colours but had to imagine the effect, since his brain would have corrected out whatever colours his eyes could see.

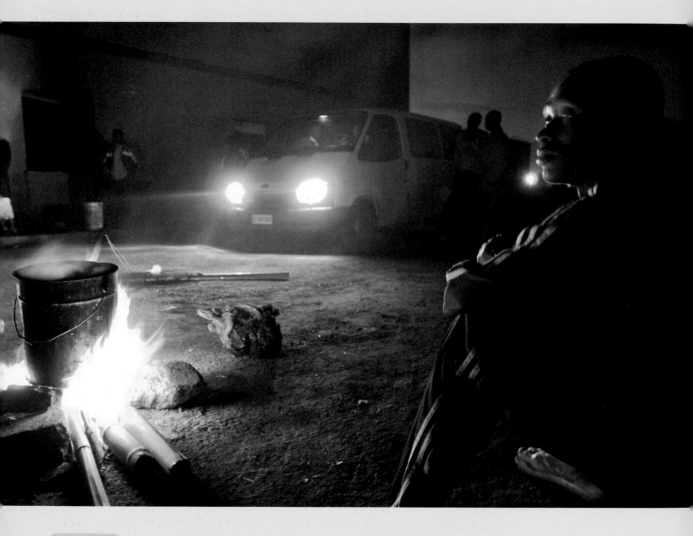

Sharpness

Some cameras have a Sharpness option that digitally sharpens your JPEG images before they are saved to your memory card. This should be turned off in the camera menu. It may sound like a good idea to make a picture look sharper, but in-camera sharpening can add strange haloes around edges, making it impossible to enlarge the image successfully. There are far better sharpening techniques available in editing software.

Although the Auto setting can be used to set the colours correctly in most straightforward lighting situations, the pre-set options are often more accurate: try setting the white balance to Sunny when shooting outdoors on a sunny day, Cloudy in overcast or rainy conditions, Incandescent when you are shooting indoors using domestic tungsten lighting or old-style photoflood lights, and so on.

With energy-saving light bulbs or fluorescent light tubes, white balance becomes more difficult, as these types of lighting give an unpleasant yellow/green colour. You can see this effect when shooting under fluorescent light with daylight slide film or the Sunshine white balance setting on your digital camera. A bigger problem is that almost every make of tube gives a slight variation in colour. Because of this, some cameras will have two or more Fluorescent options, allowing you to see which one works best for the particular lighting conditions you find yourself in. Alternatively, there may be a Custom white balance option that can help you deal with these (and other) awkward light sources: the camera manual should explain precisely how this is done, as the actual process differs between cameras.

There is no rule stating that you have to use the 'right' white balance, and deliberately using the wrong white balance setting can sometimes lead to interesting, creative and fun results (**1.14, 1.15**). The Incandescent setting, for example, is designed to correct the overly orange, warm light source from tungsten lamps by increasing the amount of blue in the image. If you use this setting in daylight, it produces a very cold result that could be ideal for a 'gothic' fashion shoot, for example. Alternatively, the Cloudy setting adds more orange to counter the cool blue light created in overcast conditions. At sunset – when the light is already warm – setting the white balance to Cloudy will enhance this even further.

This is a great opportunity to play while you learn, particularly with finding subjects where the wrong white balance setting looks great. You could also try holding coloured gel filters or even a slightly crumpled cellophane sweet wrapper in front of the camera lens, applying different white balance settings to see what happens. Make notes of what you do so that you can re-create the effect in future images.

ISO

ISO stands for International Organization for Standardization and is recognized worldwide as the measurement of the sensitivity of film (or a digital sensor) to light. It took over from the previous standard, ASA (American Standards Association), in the 1960s, and uses the same numbering system, so ISO 100 is effectively the same as 100 ASA. ISO numbers work on a very easy scale: if your camera is set to ISO 100 and you change the setting to ISO 200, it effectively makes it twice as sensitive to light, while changing from ISO 100 to ISO 50 would make it half as sensitive to light.

Your camera may not have the full range of ISO numbers described here, but the principle is the same: ISO 25 to ISO 100 is considered low sensitivity; ISO 200 to ISO 400 is generally regarded as medium sensitivity; and ISO 800 and above is high sensitivity.

As well as referring to the recording medium's sensitivity to light, the different ISO ratings have an impact on the image characteristics, especially if referring to film. With film, an ultra-slow (low-sensitivity) emulsion of ISO 25 or ISO 50 will exhibit fine grain and high contrast, reducing the range of tones between black and white and resulting in colour films that produce bright, heavily saturated colours. With digital photography, when an image is taken at a high ISO sensitivity setting, the camera simply amplifies weak electronic signals

from the sensor, resulting in random coloured pixels (known as **noise**) appearing across the image (**1.16**).

ISO 100 is often the lowest ISO setting found on a digital camera, and it is the range from ISO 100 to ISO 400 that covers most general photography. In fair weather, or 'good' light, this ISO range combines noise-free digital images (or a reasonably fine-grain film) with good-to-average contrast. This is entirely dependent on the camera, though: some low-end compact models perform less well at ISO 400 than others.

Above ISO 400, the sensitivity can be considered high, or 'fast'. The result is increased sensitivity to light, meaning that exposures can be made in low-light conditions without having to rely on slow **shutter speeds** and a tripod. The increased sensitivity does have its drawbacks, though, with noise becoming more visible. The most recent digital cameras have improved noise-reduction algorithms to help minimize its effect, and a result of this has been an increase in the highest ISO settings available. Whereas ISO 800 or ISO 1600 was once the maximum sensitivity setting, it is now common to see ISO 3200, ISO 6400 or even ISO 12800 listed.

In film, the equivalent effect to noise is 'grain'. Although this is a product of physical particles of silver or dye in the emulsion, rather than signal amplification, the end result is similar: pictures appear lower in contrast, with a textured pattern across the image that is most noticeable in the darker areas. There are some ISO 1600 and ISO 3200 films (primarily black and white) for working in very low light where the use of flash would not be allowed, or is simply undesirable, but the same rule applies here as it does to digital capture: the higher the ISO, the greater the level of grain and the less detail will be recorded.

While digital noise is often seen as undesirable, the same is not true with film grain, which has an 'organic' look that many photographers actively seek to exploit. Fashion photographers, for example, sometimes use grainy films intentionally, to make their images more exciting, while digital photographers may add a 'grain effect' in their image-editing software for a similar reason.

ISO and Contrast

While you may instinctively set a fast ISO on a dull, cloudy day, this will only serve to lower the contrast further, and could produce a very 'flat'-looking picture. Setting a lower ISO will produce an image with more contrast.

Brightly Coloured Subjects

A low ISO setting (or film speed) is ideal for photographing brightly coloured subjects, as it will enhance the colour, but it can result in a loss of detail in the highlight and shadow areas in high-contrast scenes. A faster ISO setting (or film) can reduce the contrast slightly, allowing far more shadow and highlight detail to be recorded. Again, using ISO to control contrast or grain is a good area for experimentation.

Avoiding Loss of Detail

Some books suggest that, when taking pictures of photographs and artwork with a film camera, you should use the slowest film possible (such as ISO 25–50) to avoid grainy pictures and any loss of detail. The increased contrast can be a worse problem, leading to loss of shadow and highlight detail. Using ISO 100 or ISO 200 film is a much better compromise. Copying artwork with a digital camera is less of a problem as contrast can be manipulated in an image-editing program, but settings in the region of ISO 100–200 still work best.

1.16 Grain sometimes looks very attractive when shooting black-and-white film at 800 or 1600 ISO, although there is an obvious loss of detail and contrast. Digital noise at these speeds hardly ever gives a good-looking result.

Focus

Many mid-range to high-end compact digital cameras have an option that allows you to switch between automatic and manual focus. While auto-focus (AF) works well most of the time, if you decide to move your subject away from the centre of the frame (where the AF often functions), you may find the camera focuses on the background, while the subject you are picturing is not sharp. Some cameras solve the problem with an AF-lock button that lets you lock the focus while you recompose the shot, or will hold focus as long as you keep your finger halfway down on the shutter, again allowing for recomposition. Others offer a choice of focus points or zones that can be activated manually to accommodate off-centre subjects, while manual focus will allow you to take control if focusing is critical and you are photographing something suitable (**1.17**): manual focus can be good for portraits and still life, but is very rarely suited to sports and action photography.

Camera Care

Fitting a glass UV filter over the front element of a lens is a very good way to prevent damage from dust and grit. Try to avoid sandy beaches, and in dry, dusty conditions, keep your camera in a sealed polythene bag when not in use. Dust and grit should be blown off the lens or removed carefully with a fine, damp brush, rather than by rubbing with a cloth. If you are out on location – particularly with a digital camera – avoid changing lenses in a dusty environment, as any particles that settle on the camera's sensor (or work their way into the film-transport mechanism) can cause damage and mean you need to do lots of retouching to your pictures. Some digital cameras have sensor-cleaning systems built in to help with this, but if yours does not, sensor cleaning is best left to a professional camera repairer.

On all SLR cameras, you should avoid cleaning the mirror. If any dust is apparent when you look through the viewfinder, it is normally on the focusing screen located at the bottom of the pentaprism (the prism that transmits the image seen by the focusing screen to the viewfinder). This dust can be carefully swept off with a brush, with the camera's lens removed, but care should be taken not to touch the sensitive mirror and, if you are in any doubt, it is again best left to a professional repairer.

In terms of general camera care, the inside of all cameras should be kept clean; this is especially important with film cameras, where dust and dirt can cause scratches to appear on your negatives and transparencies. The shutter on a digital camera is electronic, but on film cameras it is mechanical, and can become sticky through lack of use. It is good to get into the routine of checking for this every so often, by setting the shutter speed to 1 sec. and firing the shutter, saying 'one-thousand-and-one' as you do so. The shutter should close just as you finish saying 'one-thousand-and-one': the shutter is sticking if the camera seems to take much longer. To remedy this, fire the camera shutter repeatedly for 15 minutes with the shutter speed set to ½ sec., and then repeat the process for a further 15 minutes using a 1-sec. shutter speed. With luck the problem will clear, but if it does not, you will need to get it checked out by a professional repairer.

Humidity can be a problem both for the electronics in digital cameras and for film, where the exposed but undeveloped latent film image can lose speed, contrast and accurate colour. Using polythene bags to keep your kit dry in high humidity is a very sensible precaution, as there are also cases of fungus attacking lens glass and small insects infesting lenses and eating the grease in the focusing ring. Extreme cold can also cause problems: battery life is drastically reduced, mechanical shutters can freeze at around −5°C and the gelatine in film can become brittle and crack below about −20°C. There is also a problem with condensation when moving between warm and cold environments.

1.17 By using manual focus, a very wide-angle lens and a very small lens aperture, Christian Sinibaldi was able to capture this dramatic and creatively cropped image.

Visual Issues

Whether you are using the most expensive digital SLR or an inexpensive compact camera, how you arrange the elements you are photographing in the frame – the 'composition' – can have a significant impact on the success, or otherwise, of the image. There are a few helpful rules when it comes to composition, and while they can be broken, it does help to have an understanding of them to start with: there is a significant difference between breaking the rules intentionally for creative effect, and simply not knowing them in the first place.

Putting a person in the centre of a picture, for example, gives little idea of where the portrait is being taken, and this gives it a 'snapshot' quality. Similarly, in landscape or cityscape photographs, horizon lines that go through the centre of the frame can look clumsy and unsophisticated, effectively cutting the picture in half. In both of these examples, the photographs would look much better if you employed a formula that painters have used for hundreds of years called the Golden Section. It works well for other subjects, too.

To employ the Golden Section (also known as the Rule of Thirds) imagine that your viewfinder or LCD screen has a 'noughts and crosses' grid on it, with lines drawn one-third and two-thirds of the way both across and down your picture. The vertical lines (or one of them) can be a very good place to position a person in a landscape or townscape background, so that we see not only the person, but also the location and context where he or she is being photographed (**1.18**). Landscapes can work well if the horizon is placed on one of the horizontal thirds lines, either so that the image is two-thirds land and one-third sky or, if the cloud formation is fantastic, the other way round so that the sky dominates.

The corners of a photograph can be a very good place to put a line in the composition that recedes into the distance, such as the kerb of a road or a canal bank (**1.19**). In the same way that we read a book from the top left, we read most photographs from the top-left corner, except in portraits in which a face or eyes look at us. To produce a strong and visually successful composition, it is important to understand how a viewer's eyes explore the image. Of course, if you were brought up to read books from a different corner, you may find different pictures interesting. Thanks to the Internet, we all see many more pictures taken by people from different cultures, and it is interesting to consider this when you think about what you want to photograph or why you think an image is 'good' or 'bad'.

Your choice of viewpoint is equally important. Most of us start taking photographs from eye level, but much more interesting perspectives can be achieved by shooting a 'worm's-eye'

1.18 Using the Golden Section or Rule of Thirds when posing these lawyers in their office, Robert Griffin was able to create a very pleasing composition, which is often much more difficult with more than one sitter.

1.19 Nadya Elpis carefully composed this strong image so that your eye travels into the depth of the picture down the phone wires (top left) and exits from the edge of the road exactly lined up in the bottom right-hand corner.

1.20 (overleaf) By using a high angle to remove all unwanted background clutter, Bella Falk totally isolates the child, bringing an additional sense of pathos into the picture. Black and white often works best in situations like this.

view, from a low angle, or from a dramatically increased height, looking down on the world (**1.20**). You might also get a more interesting composition by holding the camera at an angle of 45° or by going in as close as you can focus to make your subject appear more abstract. In all of these instances, it is a good idea to avoid busy backgrounds and objects that clutter a picture and distract the viewer from the subject. These can visually confuse what you are trying to communicate.

Look carefully at what you choose to include in a photograph and what you selectively crop in the viewfinder or on the rear LCD screen. You can use different elements in a single picture to tell a wonderful narrative, or shoot a series of images that are presented in sequence to tell a much more complex story. The key to successful results is to plan the story you intend to tell with your pictures and keep in mind how they might be viewed.

Compose In-Camera

You will get the best image quality if you compose your pictures carefully in-camera. This negates (or reduces) the need to crop later, which will lose pixels and possibly limit the usable size of the photograph. With some subjects, however, grabbing that vital 'decisive moment' is the most important criterion, even if you need to crop the image to a greater or lesser degree later on. It is also a good idea intentionally to leave a small amount of space around still-life or portrait shots, as the final shape of a picture may be different from the shape of your camera's digital or film image.

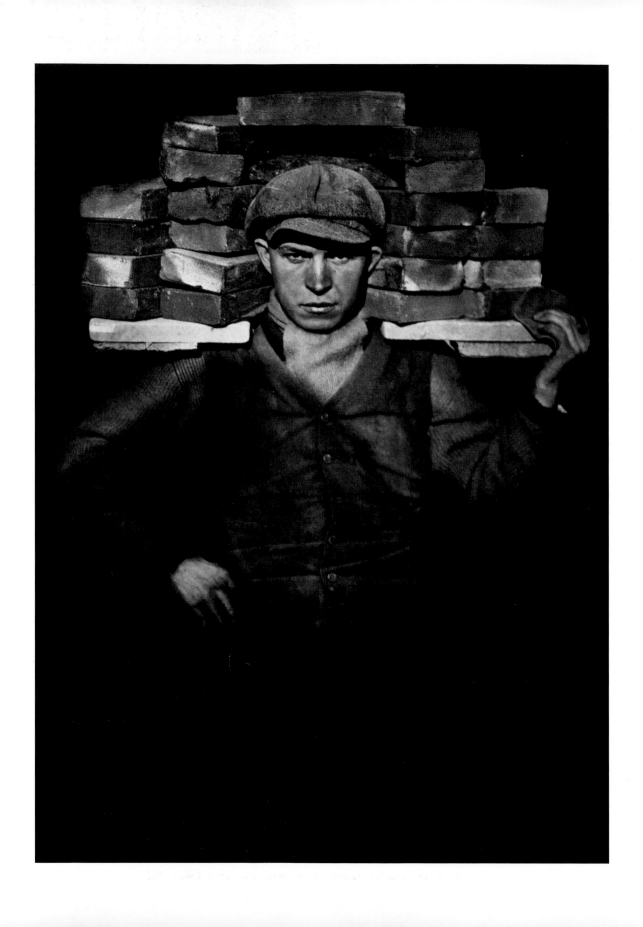

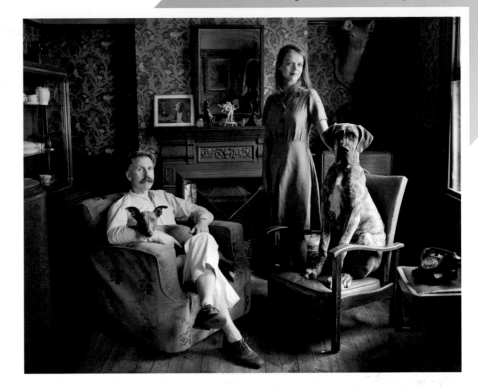

1.21 (opposite) August Sander's picture of 1928, *The Bricklayer*, achieves a much stronger documentary message by having the figure stop to look directly at the camera, rather than posing him in a different, less direct and powerful way.

1.22 (above right) Many contemporary photographers also pose their subjects looking directly to camera. Martin Usborne showed his picture *Tiger, Rag, Johnny and Emma* at an exhibition at the National Portrait Gallery, London, in 2009–10.

Breaking the Rules: August Sander and Diane Arbus

Even with an inexpensive compact camera set to Auto, you can start to explore the rules of composition and look at how you can intentionally break some of them. You would not be the first to do so.

August Sander was a German photographer whose most important project was about 'Man in the Twentieth Century'. This involved photographing German workers from many trades and social backgrounds, mainly during the 1920s and 1930s. Sander's subjects usually stand in the middle of the photograph, often looking directly at the camera, posed with some tools of their trade. But these are not thoughtless tourist snapshots: they are carefully composed portraits where the content and context become enhanced by this more unusual composition, giving even the most humble labourer or builder a remarkable dignity (**1.21**).

Here also are subjects that work best in black and white – not because colour film was in its infancy, but rather because the portraits become stronger without the distraction of colour. Monochrome allows the subject's individuality to come through and forces more involvement and interpretation from the viewer.

In the 1960s, in the United States, Diane Arbus used a similar technique to Sander's for her portraits of such subjects as midgets, transvestites and asylum inmates. Again, most look directly at the camera, many in an almost confrontational way.

There are numerous websites where you can research the work of these two photographers and find others – perhaps not so well known – who can also inspire you. Looking at the work of past masters of photography is a vital part of the development of your individual style, and incorporating elements of other people's work into your photographs can help you build your own, unique portfolio (**1.22**).

Exercise 1
SELECTIVE STORIES

Resources

Even if you do not yet have access to a camera, you can work through this exercise, for which you will need a selection of old magazines and newspapers; scissors or a scalpel; glue or tape; two sheets of A3-sized card (black or grey); a pencil or marker pen; and access to a photocopier. Throughout this book, you will need a sketchbook or workbook in which you can collect all your development work. It is good to be self-critical and to record how, as an idea develops, it goes right or wrong; how you could have done things differently; and, most importantly, some of the technical details of your experiments.

The Task and Extended Research

Whenever you take a photograph, you make a decision about what you include in the picture and what you leave out. This can affect the whole meaning of a photograph. They may say that the camera never lies, but it can certainly be very selective about the story it tells.

This is an exercise in cropping. Choosing four photographic images from magazines or newspapers, aim to discover and create new stories for each image, simply by re-cropping them and selecting different parts of the original pictures. It might be that a new crop changes the meaning of the picture entirely – perhaps by covering up a figure or object – or it may reveal a number of different areas that went unnoticed before (**1.23–1.26**).

Feedback

The most serious advertisement, or a very familiar image, can be totally transformed by clever or witty cropping. Perhaps a few of your friends could try this exercise too, as a competition. Keep your card L-shapes to use on your own photographs: many professional photographers use this simple tool for looking at, and cropping, their work. Show your tutors this exercise and your results. It is a good way to learn about composition.

Getting Started

On one of the sheets of black or grey card, draw two L-shapes with arms 4 cm wide and as long as possible. Cut these out with scissors or with a scalpel. Use your two L-shapes to explore the images you have chosen, moving them around on top of each other as you create a flexible frame or window. You can use your L-shapes to change the size or shape of the part of the picture that you reveal, effectively treating them as a viewfinder that selects and crops different sections of the images. Shapes can be long, thin panoramas, or the size of a postage stamp. When you find a crop that you like, draw around the inside of the frame, onto the image, to remind yourself of the most interesting crops. If you decide to change a crop that does not work, analyse why it is not successful and make a note of this before re-cropping the picture. It is important that you make notes and sketches to record this process, or even take digital images that document your exploration. You could also use a photocopier to play with scale and distortion. Be experimental and playful in your investigations. Cut out and paste the best crops into your workbook, adding notes about the original and how you have changed the content and context through cropping and editing.

1.23–1.26 Look at how many different stories you can make from selectively cropping this single image of steps and passers-by, taken by Nadya Elpis. Perhaps you can find others that we have missed.

Exercise 2
LIGHTING LIFE

Resources

You will need a digital camera (a compact camera will suffice).

The Task and Extended Research

This exercise is all about experimenting with colour, both technically and creatively, to explore the way that certain colours, combined with the right image, can help create a mood or convey a human emotion. As some of the exercise is dependent on the weather, you should be prepared to work on it across a week or two to complete both parts.

Part 1

Choosing either the Golden Section or the style of August Sander, take a series of portraits of a friend. You should not use flash, so make sure that your flash is deactivated, or, if it works automatically, cover it with your finger or black tape. Take your images under the following lighting conditions, adjusting the white balance setting as described. Make notes of which settings you use and the effect that they have.

- **Outdoors on a sunny day.**
 Take one shot with the white balance set to Auto and a second, similar, image using one of the pre-set white balance options.
- **Outdoors on an overcast or rainy day.**
 Again, use Auto white balance for your first shot, and one of the pre-set options for your second.
- **Indoors, with the subject standing by a window lit from one side. Room lights off.**
 Use the Sunny white balance pre-set for your first photograph and the Cloudy pre-set for your second.
- **Indoors, with the subject standing by a window lit from one side. This time, switch the lights in the room on.**
 Take one shot using the Cloudy pre-set and another using the Incandescent white balance setting.
- **Subject sitting at a desk, lit by a tungsten desk-lamp or similar light source.**
 Produce two photographs, using the Incandescent and Sunny white balance settings.
- **Subject sitting at a desk, lit by two or three candles (please consider any fire risk!).**
 Use the Sunny and Incandescent white balance pre-sets to produce two portraits. Note that as candles are not very bright, you may need to rest your camera on the back of a chair or use a tripod to hold it steady during the (long) exposure.

1.27 Julija Svetlova used a colour gel over her camera flash
to take this double-exposed image of a statue in a park in St
Petersburg. Anything in range of the flash changes colour, but
the background – unreached by the flash – remains unaffected.

Part 2

Using the knowledge gained from Part 1, experiment with deliberately setting the wrong white balance, using gels/cellophane sweet wrappers over the lens, or inventing your own way of changing the colour in an image (**1.27**). Collaborating with your model, shoot as many pictures as you like, with the aim of producing at least two portraits that convey each of the following emotions (so twelve images in total):

Anger	Contentment	Strength
Calm	Fear	Caring

Choose the best pair of images representing each emotion and make small prints that you can put into your workbook with an explanation or caption describing the role that your model was playing and the technique that you used.

Getting Started

This exercise needs the help of a patient friend. You will also need to have a 'script' for each shot that you are going to take, and a storyboard, and to have planned all the settings, filters and so on. In Part 2, you could also consider the model's clothing or make-up.

One of the hardest things is to concentrate on all of the technical issues and camera settings while keeping your model entertained. You will also find that putting a camera up to your eye is like talking to someone with your hand in front of your face – it can make conversation much more difficult.

Many of the best portrait and fashion photographers talk to their models continually throughout a shoot, to keep them relaxed and to stop them getting bored. If you own a tripod, try setting the camera up so that it is aimed at your model and then sit beside it while you shoot (rather than looking through the viewfinder or at the rear LCD screen) so that you can maintain eye contact with your sitter.

Feedback

Your model will be a good person to give you feedback, not only about your portrait ideas and lighting, but also about whether the sessions were boring and whether it was a good idea to volunteer. With permission from your model, it should be fun to send the pictures to your friends; ask them for their feedback as well.

Exercise 3
ANOTHER POINT OF VIEW

Resources

You will need a digital camera (a compact camera will suffice), or a 35 mm camera and daylight-balanced slide film.

The Task and Extended Research

This exercise is all about looking at a familiar environment in a new and exciting way. First you will explore your neighbourhood or, if you prefer, choose somewhere new. Identify about 100 m of a street that will be your 'subject' for this project. Choose carefully and think creatively, as you have to stick to the rules and not go to lots of different places.

Working within this confined area, you need to take six pictures from a 'worm's-eye' view (**1.28**), six pictures as if you are a giant looking down on the world, six pictures as if you are a three-year-old child (not only in the camera height but also in the wonderment of rediscovering the commonplace, **1.29**) and, finally, six pictures that might be taken by somebody who is drunk and who cannot hold the camera steady, straight or still. Be careful to choose an area where you feel secure about using and being seen using your camera, or take a friend.

Choose your best two (or three) images from each set to print out and put them into your workbook with an explanation or caption about the role that you were playing and what you feel you have achieved.

1.28 A 'mouse-eye' view of a well-quarded gallery in the Hermitage Museum, St Petersburg. Julija Svetlova shot this interesting and humorous image, showing that it can really pay to shoot from a different point of view.

43

1.29 By shooting upwards from a low angle, Bettina Strenske captures a strong light shining through the yellow umbrellas, so that they stand out against the drab grey city background.

Getting Started

When you first start this exercise you will probably feel very self-conscious as you crawl around on the floor or hang over balconies with people looking at you, but concentrate on finding exciting angles and thinking about some of the compositional points discussed in this chapter and you will forget about anyone else around you quite quickly.

Some of your pictures can be quite close up and some may become quite abstract, but think about continuity between your images, especially as they are intended to be seen as a set. Do not be afraid to experiment, even if the images do not always work out – the result will be much better than a series of boring and 'safe' pictures.

Feedback

This is a great project to do with even the simplest of cameras and shows that any everyday environment can be a place to experiment and create interesting pictures. As with the previous exercises, ask for feedback from friends (particularly those who also know the area) or challenge them to guess where you took the shots.

USING MANUAL
CAMERA SETTINGS

In this chapter you will learn:

- How to use manual lens aperture and shutter speed settings on a camera
- How to use these controls to manipulate the exposure creatively
- The effect of lens aperture and shutter speed combinations

Using a Camera in Manual Mode

2.0 (previous page) If an inexpensive compact camera has a Manual setting, many possibilities are opened up for you. Graham Diprose changed the white balance from Auto to Cloudy Day, making the camera add yet more warm orange colour bias into this attractive shot of a sunset off the Greek island of Santorini.

2.1 (opposite) Even when you are using very expensive cameras, the exposure meter can be fooled by a very light or dark subject (left side). A Manual setting can make image control much easier in post-production and help you to keep more detail (right side).

In order to become a creative photographer, you need to master your camera's Manual mode so that all the settings become instinctive. This means that you need to learn not only how to programme the little computer in the camera, with all its complicated options, but also how to programme the most wonderful computer on the planet – the one located behind your eyes. Just like a brilliant jazz pianist who never looks at the keyboard, you need to reach a point where the technical aspects of the camera have become second nature, so that you can concentrate on the content, style and composition of your images. Therefore, it is vital to understand this chapter fully before moving on to develop your creative skills.

Exposure

The exposure for a photograph depends on a number of factors, each of which can determine whether the end result is too light, too dark or just what you want (**2.1**). Key issues to bear in mind are:

1. The brightness of the **ambient light**. For example, whether you are outdoors or indoors, or if it is a sunny day or raining and overcast.
2. How sensitive the **sensor** or film is to light. This is controlled by the **ISO**, as discussed in Chapter 1.
3. How much light you let into the camera. This is controlled by the lens aperture, which works in the same way as the pupil in your eye.
4. How long the sensor or film is exposed to the light. This is controlled by the shutter speed and usually measured in fractions of a second.

The lens aperture and **shutter speed** – together with the ISO setting – allow you to control light, with the aperture and shutter speed forming the basis of a formula that defines exposure:

$$\text{Exposure} = \text{Intensity} \times \text{Time}$$

This means that when you take a picture, the exposure is equal to *how much light you shine on the sensor or film* (intensity – controlled by the lens aperture), multiplied by *the length of time you shine the light on the sensor or film* (time – controlled by the shutter speed). So exposure is a simple enough concept.

Exposure Equation

The exposure equation is called the **Reciprocity Law**. In science, laws are proven to work when they are considered universal and invariable facts of the physical world. The Reciprocity Law does not always work, however: in very low lighting with long exposures, or extreme brightness with very short shutter speeds of thousandths of a second (as used in scientific photography), it fails. For now, we will deal with the 'normal' conditions where this law still applies.

Lens Aperture

The earliest photographers did not need any sort of aperture over (or in) the lens to control the intensity of the light: exposure times ran into many minutes, as their film was very 'slow' and insensitive to light, so lens aperture was simply not an issue. As photography developed, various discoveries, such as the wet-plate collodion process (and the later dry-plate collodion process), began to reduce exposure times from minutes to seconds, which meant that photographers were faced with a new problem: too much light exposing their image.

The solution to this was to create an aperture – a hole smaller than the actual diameter of the lens – to control the amount of light entering the camera in exactly the same way that the iris in your eye controls the amount of light entering it. The maths that describes a lens aperture and its effect is slightly complicated, because when the diameter of a lens aperture doubles, the area of the aperture increases by four times, letting four times as much light pass through it. Therefore, doubling the aperture quadruples the exposure.

Early photographers placed a fixed aperture in a sheet of metal in front of the lens, but this caused problems with image sharpness, adding to the issues that they already faced. They also discovered that controlling the aperture was not the sole answer, because there was one further factor that influenced how much light entered the camera: the lens itself. As a 100 mm **focal length** lens lets in half as much light as a 50 mm lens, early photographers realized that they needed a larger aperture for a 100 mm lens and a smaller aperture for a 50 mm lens, to achieve the same effect overall. This was very complicated and required a lot of maths to get it right, so to avoid these difficult calculations, photographers devised a universal system called 'relative aperture', or **f-stops** (named for the fact that reducing the aperture size increases the **depth of field**) – see box below.

2.2 (opposite) Dancer Martina Langmann and her partner were a tricky technical challenge. Graham Diprose needed to hold deep shadows and bright highlight detail in this promotional shot for a south London dance festival.

F-Stop Formula

$$\text{Relative aperture (f-stop)} = \frac{\text{The focal length of the lens}}{\text{The actual size of the aperture}}$$

This could work with inches or centimetres, provided that you use one unit throughout. For example:

$$\frac{80 \text{ mm focal length lens}}{10 \text{ mm actual aperture size}} = f/8 \text{ Relative aperture}$$

Applying the same formula, a 40 mm focal length lens with an aperture of 5 mm would also be $f/8$, as would a 200 mm lens with a 25 mm aperture. As a result of this development, lenses could be made with adjustable irises to change the aperture in a lens, and the lens manufacturers could put a series of calibrated markings on the barrel of the lens for that specific focal length. This meant that photographers no longer needed to do any complex mathematics to get the relative aperture right (**2.2**).

In practice, the relative aperture formula generates a series of random-looking numbers for most cameras, with the traditional range of apertures being:

$$f/1.4 \quad f/2 \quad f/2.8 \quad f/4 \quad f/5.6 \quad f/8 \quad f/11 \quad f/16 \quad f/22$$

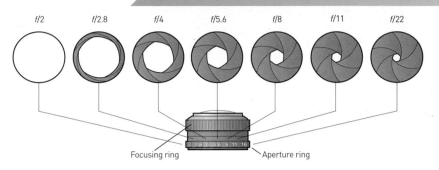

f/2 f/2.8 f/4 f/5.6 f/8 f/11 f/22

Focusing ring Aperture ring

2.3 (opposite) In this street scene shot in Lagos, Portugal, Bettina Strenske shut the lens down to a small aperture to get a large depth of field, but needed to avoid too long a shutter speed that would risk camera shake, or getting image noise from using a higher ISO.

2.4 (above) A typical lens, showing f-stop numbers and distances in feet and metres on the focusing ring. The tiny numbers and lines in between help you to judge how much of the picture will be in focus at a particular lens aperture.

Not all cameras use the same range of aperture (or f-stop) numbers, though: some lenses can go below $f/1.4$ or above $f/22$. There is also confusion generated by the way in which this formula works: rather counter-intuitively, the smallest number (say, $f/1.4$) will be a large aperture opening, while the largest number on a lens (such as $f/22$, for example) will be the smallest hole (**2.4**).

These numbers are not actually random. They are, in fact, a mathematical sequence based on the square root of 2 (which is approximately 1.4). If you multiply $f/2$ by 1.4 you get $f/2.8$, multiplying $f/2.8$ by 1.4 gives $f/3.96$ (which is close enough to $f/4$), and so on. You can try the rest for yourself with a calculator, although it should be noted that the numbers are occasionally not exact and are rounded up to the next whole number.

As you go from one aperture setting to the next, you will either halve or double the amount of light entering the camera. If you change the aperture to a lower f-stop number (from $f/4$ to $f/2.8$, for example), you double the amount of light entering the camera, which is commonly referred to as increasing it by one 'stop'. Conversely, going up to the next, higher f-stop ($f/4$ to $f/5.6$, for example) will close the lens aperture by one stop, halving the amount of light entering the camera (**2.3**). So, if the aperture is set to $f/8$ and the sun comes out (making the scene one stop brighter), you could 'stop down' to $f/11$ to compensate.

Such phrases as 'stop', 'shut down' and 'stop down' are an important part of the photographer's language, as is a thorough understanding of what the aperture is and how it works. With practice, once you understand f-stop numbers, you are halfway to being able to use your camera's manual settings to make exciting and creative pictures.

Modern Aperture Settings

Digital cameras often have apertures in between the traditional settings, so that between $f/8$ and $f/11$, for example, you may find apertures of $f/9$ and $f/10$. Photographers working with older cameras may use the term 'stop down to between $f/8$ and $f/11$' to mean a setting between the two aperture values, or some might say '$f/8$ and a half'. If you are assisting a photographer you need to make sure that you understand exactly the phrase that he or she uses.

Alternative Numbering

In 1881, the Royal Photographic Society suggested using a set of more intuitive aperture numbers that followed the sequence 1, 2, 3, 4 and so on. This did not catch on, and despite Kodak attempting to revive the system in the early 1950s, very few cameras that used this alternative method have survived.

Shutter Speed

If exposure equals the intensity of light (controlled by the f-stop) multiplied by time, then you need to consider how the shutter speed, as well as the aperture, affects your image. Just as changing the aperture will halve or double the amount of light entering the camera, so the shutter speed has the same halving/doubling effect, depending on the length of the exposure. On an average sunny day, with the camera set to ISO 100 (or using ISO 100 film), you might choose to use exposure settings of $f/8$ at $\frac{1}{60}$ sec., but any of the settings below would, in effect, give you the same actual exposure.

F-stop:	$f/1.4$	$f/2$	$f/2.8$	$f/4$	$f/5.6$	**$f/8$**	$f/11$	$f/16$	$f/22$
Shutter speed:	$\frac{1}{2000}$	$\frac{1}{1000}$	$\frac{1}{500}$	$\frac{1}{250}$	$\frac{1}{125}$	**$\frac{1}{60}$**	$\frac{1}{30}$	$\frac{1}{15}$	$\frac{1}{8}$

Starting from $f/8$ at $\frac{1}{60}$ sec., if you close the aperture down by 1 stop (to $f/11$), you halve the amount of light entering the camera, but, if you change the shutter speed to $\frac{1}{30}$ sec., you double the exposure time. Half the amount of light, for double the time, means that the overall exposure remains the same. So any of the settings on the table above will give the same exposure – from a large aperture of $f/1.4$ with a very short shutter speed of $\frac{1}{2000}$ sec., through to a small aperture of $f/22$ with a much longer shutter speed of $\frac{1}{8}$ sec.

So does it matter which combination you use? The answer is a very big 'yes', as there are a number of factors that need to be considered when choosing the most appropriate combination of f-stop and shutter speed with which to make your image (**2.5, 2.6**). You could set up a camera in a busy street, shooting at $f/1.4$ at $\frac{1}{2000}$ sec., for example. All the people walking past, as well as cars and buses, will be clearly visible, as the fast shutter speed will freeze their movement. If you then set the camera to $f/11$ at $\frac{1}{30}$ sec., the overall exposure will remain the same (so the image will not be any lighter or darker), and people walking slowly by may still be frozen, but with the longer exposure time, moving cars may begin to blur.

2.5 A very fast shutter speed, such as $\frac{1}{1000}$ sec., will freeze any rapid motion, such as the sea crashing over this breakwater, giving us a view that no human eye would ever be capable of capturing.

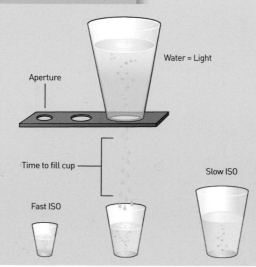

Aperture and Shutter Speed

Water = Light

Aperture

Time to fill cup

Fast ISO

Slow ISO

2.6 In this analogy, a full cup represents the correct exposure and the water represents light. If the cup is small it does not need much water before it is full up, just like using a fast ISO. Filling a cup through a larger hole needs less time than when using a smaller hole. This is how the aperture and shutter speed relationship works with light.

Camera Shake

With slow shutter speeds, it is important to use a tripod. Otherwise, such a speed as $\frac{1}{8}$ sec. (or even perhaps $\frac{1}{30}$ sec.) will result in camera shake (**2.7**). Camera shake is not the same as 'out of focus': with camera shake, nothing in the picture appears sharp and everything is equally blurred, whereas if a picture is out of focus, some parts of it can still appear sharp.

The general rule for avoiding camera shake is to use a shutter speed no lower than the reciprocal of the focal length: that is, using a 50 mm lens you should avoid camera shake by shooting at a shutter speed of $\frac{1}{50}$ sec., or faster, while you would need to set a shutter speed of $\frac{1}{120}$ sec. or faster to avoid camera shake with a 120 mm focal length, and so on. This is especially worth remembering when you are using a **zoom lens** and manual shutter speeds, as it is easy to forget to use a shorter exposure if you zoom in on your subject.

2.7 At a slow shutter speed of $\frac{1}{4}$ sec., you will get camera movement unless you use a tripod. With a little experimentation and an appropriate subject, however, camera movement can be used to very creative effect.

2.8 Alefiya Akbarally used a shutter speed of around $\frac{1}{60}$ sec., which froze most of this image of Sicilian potter Marco Monforte's studio, apart from his rapidly moving hands while he was shaping the clay on his wheel.

If the exposure is changed again – to $f/22$ at $\frac{1}{8}$ sec. – even people will start to blur, while cars may disappear altogether if they are moving fast enough. Although you will have kept the overall exposure the same for each shot, you will produce three quite different results.

Of course, there is no rule as to which version of your street image is 'right', and you do not have to keep your camera fixed to a tripod. You could try taking the camera off the tripod and **panning** it as your subject, such as a fast-moving car, passes by. Try setting your camera to $\frac{1}{15}$ sec. or $\frac{1}{8}$ sec., shooting as the car passes you, and then following it with the camera. This will give a smooth panning shot where the subject (in this example, a car) appears relatively sharp in the picture, but the background becomes blurred or streaked (**2.9**). It may not matter if your subject is not totally sharp, as this can add to the feeling of motion. Other subjects also work well when you use a long exposure. Shooting fairground lights at night, for example, with an exposure of 1 sec. or more, while waving the camera around at random, can give amazing, abstract results. Do not expect every shot to be a winner, though.

In-Camera Image Stabilization

A relatively new, but quite expensive, innovation that helps avoid camera shake is **image stabilization**. Into the lens are built sensors that detect motion and then move an optical element in the lens to compensate for it, keeping the image in the same place on the imaging sensor. In theory, this allows for sharper pictures when using slower shutter speeds. Be aware, however, that this may be impossible to check on the small **LCD** camera screen and lead to disappointment when you view an image on a larger computer screen later.

Tripods and Beanbags

Tripods are among the most creative tools in photography. They are also one of the heaviest, and advertise that you may be carrying an expensive camera out on the street, or somewhere where people may not want you to take photographs. Moreover, they can be an expensive option. Cheap, flimsy ones, however, are useless when it comes to providing adequate support. A very low-tech alternative is a beanbag, which can be made easily at home. Simply stitch two 12 cm (5 in.) squares of fabric together and fill with dried lentils, barley or rice. The bag should not be filled up so that it is solid – leave it slightly soft so that you can push it into different shapes with your fingers. Out in the street or indoors, you can place your beanbag on a flat surface, push your camera onto it until it nestles into the material, and then use slow shutter speeds to take great pictures. Best of all, the cost of the raw materials is not much more than a loaf of bread, and you can use any colour or patterned fabric to create a 'custom' camera support. Even if you own a tripod, a beanbag is easier to carry around on some occasions.

2.9 By panning a camera to follow the moving subject, shooting from side on and choosing the right slow shutter speed (about $\frac{1}{15}$ sec. in this case), Anya Campbell was able to take this great shot of a horse and trap.

Lens Aperture and Depth of Field

2.10 The closer in we go to a subject, the smaller the depth of field. By also using a wide-open lens aperture, such as *f*/2.0, and very carefully focusing on a particular area, we can create much more exciting images.

When you choose a combination of lens aperture and shutter speed you may have in mind the need to avoid camera shake, but there is another important factor to take into consideration: the depth of field. Although you focus your lens at a specific distance, there is a proportion of the picture – both in front of and behind the 'plane of focus' – that will also appear acceptably sharp. The actual amount that appears sharp is the depth of field, which extends one-third in front of the plane of focus and two-thirds behind, and is strongly affected by the aperture setting that you use (**2.10**).

It is important to realize that a camera always takes a very different picture from that seen by the human eye (**2.12**). If three people stand in a line, at the same distance from a camera, all three will be in focus, as they are all the same distance from the lens. But when you use your eyes to look at the same three people, focusing on the person in the centre, you will see a very different image: those at either side will appear much less in focus. The reason for this is that the human eye focuses very accurately over a small angle of view of about 3°, so the camera takes a different picture from what you actually see.

If you take a photograph of the three people standing side by side, they may all be in focus, but the gaps between them may not make for a good composition. If you move the camera to an angle of about 45° to the line of people, the composition improves, but you will find that it is now impossible to get all three in focus at the widest lens aperture – the depth of field is too shallow.

Circles of Confusion

Whenever we focus accurately on an object or person, everything nearer or further away will be out of focus to a lesser or greater degree (even if it appears 'sharp'). The further away in either direction from your plane of focus, the more blurred the image (**2.11**). This is caused by something known as a 'circle of confusion'. Put simply, a circle of confusion is a point that no longer appears as a point in an image, but as a blurred circle.

You can see this for yourself by cutting a circle measuring 1 cm in diameter from a piece of black paper and placing it 2 m in front of your camera. If you select a 50 mm focal length and focus manually on the circle, you will see a sharp dot that appears 'in focus'. If you move the paper so that it is only 1 m away and do not refocus the lens, however, the dot will appear unsharp. Many tiny, blurred circles make the edge of the dot look out of focus; these blurred circles are the **circles of confusion**.

2.11 When a subject is exactly in focus, the lens aperture matters little, but with any object nearer or further away, a large lens aperture will create much bigger blur circles. The smaller the aperture, the smaller the out-of-focus blur circles and the greater the depth of the picture that is apparently in focus.

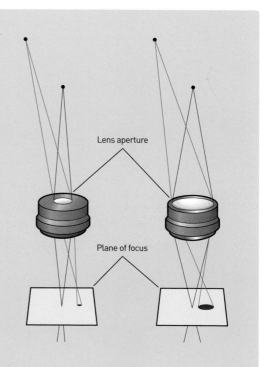

Lens aperture

Plane of focus

2.12 Here we have simulated the view that the human eye actually sees, with only a small central area in focus. Part of photography's overall appeal is that it creates a very different image from that seen by the human eye.

2.13 (above) In any cookery book from twenty years ago, the entire food shot had to be in focus to be 'correct'. Today photographers invariably take a shot with only minimal depth of focus, as our taste in food photography has changed. Photo by Jeff Robins.

2.14 (left) To produce high-quality still-life images, a photographer may use large-format film or a high-resolution digital SLR camera. A large studio flash that allows a smaller lens aperture to be used can offer a very sharp overall image. Photo by Jeff Robins.

But if you simply shut the lens aperture down from, say, $f/2.8$ to $f/11$ (changing the shutter speed accordingly), without changing the point of focus, all three people will come more into focus. This is because as you close down the lens aperture, the circles of confusion (see p. 56) in the areas of the image that are not in focus become much smaller. The images of these circles on the sensor or film also become much smaller, improving the appearance of sharpness in the image, and increasing the depth of field. Understanding this immediately gives you choices: to emphasize just one person or subject using a wide aperture (such as $f/2.8$), or to stop the lens down to a smaller aperture ($f/11$ or $f/16$, for example) to produce an image where much more of the scene appears in focus.

The closer an object is to the camera, the shallower the depth of field, and the smaller the aperture required to get more of the picture sharp. Many commercial still-life photographers use powerful studio flashes that allow them to set an aperture of $f/32$ or smaller to get their subjects all sharply in focus (**2.14**).

Styles of image-making are always changing, so there is no such thing as the 'right' depth of field. In food photography, for example, many images are now taken using a wide aperture setting so that only part of a plate of food is in focus, which makes a more interesting and appetizing picture – at least for the time being (**2.13**). Therefore, one of the advantages of using manual settings is being able to control how much of the picture is in focus and what the viewer will look at – allowing you to communicate your message more clearly.

When you look through the viewfinder, no matter what f-stop you may have set, all **SLR** cameras open the lens to its widest aperture so that you can see more easily to compose your image. This also gives you the least depth of field, enabling you to make sure that the vital parts of the picture are sharp. At a wide-open aperture, a busy background will appear out of focus in the viewfinder – possibly with attractive abstract blurring – making, for example, the subject of a portrait stand out. This is when things can go easily wrong, though, because if the photograph is taken at a smaller aperture setting, the background will be in sharper focus (**2.15**): unless you are shooting with the aperture at its widest setting, you will not get a photograph that matches what you see through the viewfinder.

Hyperfocal Distance

The **hyperfocal distance** is the closest distance at which a lens can be focused, while keeping objects at infinity acceptably sharp. It is therefore the focus distance that gives the maximum depth of field at a given aperture. When you focus on a point nearer to the camera than the hyperfocal distance, depth of field decreases, and the same happens if you focus beyond the hyperfocal distance.

2.15 Through the viewfinder, Huw Diprose saw his friend with the background out of focus, but as he shot, the camera, set on Auto, shut the aperture down, bringing all the unwanted background clutter into focus.

When working outdoors, most portrait photographers prefer to use such apertures as $f/5.6$ or $f/8$, because this makes sure that the subject is sharp, but the aperture is not small enough to bring a distant background in focus. Of course, some photographers will produce a stunning image where both the subject and background are sharply in focus at $f/22$, or with a wider aperture setting so that the depth of field is minimal and only the subject's eyes are in focus, while the tip of their nose is unsharp. Both techniques are worth experimenting with (**2.16, 2.17**).

2.16 (opposite) Steve Franck created this dramatic image by using a wide-angle lens at a very small aperture to get both the girl and the plane in focus. Luckily, with plenty of light, he was able to work with an average shutter speed.

2.17 (right) By using his camera on 'Manual', A. J. Heath could shoot this picture at a wide-open aperture, throwing the background out of focus. In the bright sunlight, he had to use a slow ISO and very fast shutter speed.

Depth-of-Field Preview

Many cameras help you to preview the effect of the aperture setting by providing a depth-of-field preview button. This will shut the lens down to the aperture that you have set when you press it and, although the viewfinder image goes darker, this allows you to see how much of the picture will be in focus. If your camera has a depth-of-field preview feature, learn how to use it.

Depth of Focus/Depth of Field

There is often confusion between the terms 'depth of focus' and 'depth of field', with many photographers using them as interchangeable terms. While it is true that both are concerned with how much of the picture is acceptably in focus, and both will increase as the lens aperture is shut down, the two terms do not mean the same thing.

Depth of field is outside the camera: it is the distance either side of the focus point that still looks acceptably sharp.

Depth of focus occurs inside the camera: it is an ideal distance between the lens and the sensor (or film) that will give you perfect focus on an object (known as the image plane).

2.18 In this picture the exposure meter is overcompensating for the very bright sky so that all the detail in the buildings is lost.

Auto Settings

If you just want to take some pictures for your workbook, perhaps as visual research for a project, then using your camera's Automatic and Programme settings can sometimes make sense: a precise exposure might not be necessary. Yet while the Auto setting is useful, it is hardly a creative tool, and your brain is a much better judge than your camera when it comes to determining the settings that will give you a great picture.

Getting the Exposure Right

You need to take into account how your subject is lit, as well as controlling how much light you allow to enter your camera. There are several issues to think about here, and the automatic settings on your camera will often not provide the right answer.

Automatic or Programme camera modes are designed to assume that any subject you are photographing will average out at a standard grey tone if all the tones in the scene are mixed together. This is equivalent to a grey card that reflects 18% of the light that falls on it.

The camera's exposure meter will set the lens aperture and shutter speed accordingly, based on the theory that tones darker and lighter than 18% grey will be correctly exposed. For subjects with a wide range of tones, photographed under average lighting conditions, this works and the result is generally satisfactory. But for many of the most difficult and exciting lighting conditions, this can fail to give you the most effective result, or indeed the 'correct' exposure (**2.18**).

Many professionals can instinctively guess a correct exposure to within a stop, often because they have become used to using a camera without a built-in meter. How do they do that? Well, it is not as difficult as it may seem. If they are used to working at a certain ISO and shutter speed, they can remember what the exposure was the last time they shot on a sunny or cloudy day, consider if the subject is the same (or lighter or darker), and at least be confident enough to shoot a test photograph.

As a first step towards learning how to judge exposure without relying on a light meter, the following aperture settings are well worth learning and remembering.

Bright sunny day: snow or beach scene	*f*/22
Bright sunny day: normal average subject	*f*/16
Hazy sun with soft-edged shadows	*f*/11
Cloudy, but bright sky with white cloud cover	*f*/8
Cloudy with heavier grey sky	*f*/5.6
Cloudy: very dull, heavy cloud, about to rain	*f*/4
As above but in a dark street or woodland	*f*/2.8

Of course, this table only tells you what aperture to set, and does not take into account the shutter speed and ISO. There is a simple formula to help you here: choose the ISO setting you want to use and convert this into a fraction to determine the correct shutter speed. So, if you are using ISO 100, all the apertures in the table are true at $\frac{1}{100}$ sec.; if you are using ISO 400, the shutter speed should be $\frac{1}{400}$ sec.; and so on. If your camera does not have the precise shutter speed, set the one nearest to it ($\frac{1}{125}$ sec. for ISO 100 or $\frac{1}{500}$ sec. for ISO 400, for example).

2.19 A large dark area like the river may look correctly exposed, but this is at the expense of the remainder of the picture, which looks overexposed and washed out. Any large dark area in an image can cause this.

This is a perfectly workable solution, but suppose that you want to use a smaller aperture for a greater depth of field, or a faster shutter speed to freeze movement – what then? For example, if you are using ISO 100 on a 'Hazy Sun' day, the above formula suggests you need to use an aperture of $f/11$ at $\frac{1}{100}$ sec. But this is not the only option. Remember that there are many combinations of aperture and shutter speed that will give you the same exposure, so you can choose the one that will give you the result you want to achieve. In this example, any of the following would provide you with the same exposure:

F-stop:	$f/5.6$	$f/8$	$f/11$	$f/16$	$f/22$
Shutter speed:	$\frac{1}{400}$	$\frac{1}{200}$	$\frac{1}{100}$	$\frac{1}{50}$	$\frac{1}{25}$

Knowing this, you could choose to shoot at $f/5.6$ with a shutter speed of $\frac{1}{400}$ sec. to freeze movement, or set the aperture to $f/22$ at $\frac{1}{25}$ sec. to increase the depth of field. This is more useful, but there are still some situations in which it will not give you the result you want. For example, it does not take into account the brightness of your subject. If you were shooting pictures of someone with dark skin, outdoors on a cloudy/bright day (normally $f/5.6$), then a better exposure would be $f/4$ to get more detail in his or her face. Conversely, if the subject is very pale, you might stop the lens down, either by half a stop, or by a full stop. Even photographers using an exposure meter rather than the table above might take their reading by pointing the camera at their subject and then adjust the exposure: it is all about thinking 'what are the most important elements in this picture?' and adjusting the exposure to record the most detail in your subject.

Adjusting the exposure becomes more important when you realize that it is possible to fool an exposure meter, no matter how sophisticated it is (**2.19, 2.20**). If you stand someone wearing dark clothes in front of a whitewashed wall, to take a full-length portrait, the camera's light meter will give you one result. If you then move your subject so that he or she is against a dark wall, the exposure reading will change, even if the lighting conditions remain the same. The reason for this goes back to the way in which a camera is calibrated: to assume that any subject you are photographing will average out at a standard grey tone. In this example, the subject and the lighting have not changed, but the background has, and it is this that is having an effect on the exposure reading.

So how do you prevent this from happening? One option would be to stand very close and take an exposure reading from your subject's face, setting the camera to Manual or using exposure lock so that the exposure settings remain the same after you recompose the picture to full length. Alternatively, you could forget about your subject altogether and hold a grey card about 25 cm (10 in.) in front of the camera – between the camera and the subject – and take an exposure reading from that. This would prevent the lightness or darkness of the wall from giving you an erroneous reading, but it still would not take account of the subject's light or dark skin tone or clothing. So, whatever the meter tells you, you still need to use your brain to get the exposure right, although most cameras have features that can help you judge this correctly, the most common being centre-weighted and spot-metering options.

As its name suggests, **centre-weighted metering** weights the exposure so that the reading is biased towards the centre of the image. In the example given above, this will help prevent the light or dark wall from changing the exposure, and also take the subject's skin tone and

2.20 The exposure meter is taking too much account of the bright background, leaving our subject in darkness. You could avoid this by using a fill-in flash or pointing a spot meter at the subject, to read only on his face or body.

light or dark clothes into account. If your subject is not standing in the middle of the picture, move your camera so that he or she is, and then set the exposure manually before recomposing the image (**2.21**).

Many cameras also have a **spot meter**, or you can buy one as a separate unit. Spot meters take a reading using a very narrow angle of view: on a full-length portrait they might read only a 15° angle (just reading the face) or, with a 5° or 7° angle, meter only from a cheek or forehead, so that you do not need to walk right up to your subject. A spot meter can give you a very accurate exposure reading, but you must be careful to look for an area in your subject that is similar in tone to the 18% mid-grey, as pointing it at an overly light or dark area will result in an under- or over-exposed result. If you are using an in-camera spot meter then you will need to use the exposure lock (or set the aperture and shutter speed manually) if your subject is not in the centre of the picture.

2.21 This image shows the effect of the meter reading the centre of the picture rather than giving a correct exposure on the intended subject.

Spot Meters

Spot meters can be very useful for landscape pictures when you want to avoid a large amount of sky fooling other metering patterns, and also for photographs that include water, as reflected highlights can also lead the meter into giving an exposure that is too dark. When you have used a spot-meter setting, get into the habit of setting the system back to its 'all over' multi-zone metering pattern (often called Matrix, Evaluative or similar) to avoid mistakes on your next shoot with a normal subject.

Pavements and grass make good target areas if you are looking for a mid-tone area to take a spot-meter reading from; the sky, water and shiny objects should be avoided.

Exposure Options (2.22)

Matrix metering can average ten or more segments from different parts of the picture, but can be fooled if a number, outside of the subject, are particularly dark or light.

Matrix

Centre-weighting is a good option if your subject is in the middle of the picture, but it can give an odd result if you are composing using the Golden Section (see p. 32) or placing the subject near the picture edge.

Centre

Spot meters need thoughtful use as a very narrow point is being read. They can be useful for metering a mid-grey building on the opposite side of a river, or to record accurate tones of very light or dark skin, but choose carefully which tiny area you wish to read and think of the implications for the rest of your image.

Spot

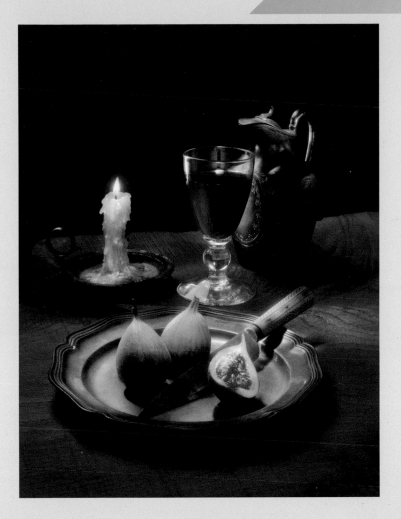

2.23 Dark images create very rich colours, similar to the Old Master paintings of a bygone age. When taking this large-format image, Jeff Robins would have 'bracketed' a number of sheets of film – that is, taken several versions of a shot at different exposure levels, and selected the best result.

2.24 Graham Diprose shot this high-key image using an early 6MP Leaf digital back on a Hasselblad. By keeping the Raw file and using very recent conversion software, he was able to recover much of the highlight detail.

Another method of taking an exposure meter reading is to measure **incident light**, or how much light is falling onto a subject, rather than the amount of light being reflected off it. This requires a handheld light meter, and a white plastic dome is usually placed over the exposure cells. The meter is then pointed towards the light source, rather than at your subject. For the best results you need to hold the meter a few centimetres in front of a sitter's face for a portrait, or under the same (predominant) lighting conditions for a landscape. While the meter accurately reads the amount of light falling on a subject, it takes no account of how much light that subject reflects, so it does not matter if the subject is wearing white or black, or is dark- or fair-skinned – the exposure reading will be the same. There are still factors for the photographer to consider, though. While an incident meter reading might give you $f/8$ at $\frac{1}{125}$ sec. using ISO 100 for a person standing in daylight, if the subject is dark-skinned and wearing a dark suit, you might decide to increase the exposure by 1 stop (or more) to record a greater amount of detail in the darker tones – perhaps setting $f/5.6$ at $\frac{1}{125}$ sec., or adjusting the shutter speed so that you take your shot at $f/8$ and $\frac{1}{60}$ sec.

An exposure meter cannot, of course, act creatively. A good photographer will think about the most interesting exposure to yield an exciting image. Creative use of exposure can also help with a design or layout. By making a picture a stop lighter, it may be possible for a designer to run black type directly over the image on a magazine page so that it reads better. But if legibility of type is not a consideration, a moody picture 1 stop darker might be much stronger, as the mysterious subject appears to come out of the shadows. In each of these ways, exposure estimation becomes very creative, but it does require plenty of practice until it becomes instinctive. If you are concentrating fully on getting the exposure correct, you will not be putting as much thought into the image content or composition, or the contrast or lighting that make a great picture.

Shutter Priority and Aperture Priority

While using Manual mode offers complete control over your camera, when you need to work quickly, try the **Aperture Priority** (A) and **Shutter Priority** (S) settings found on many mid-range and high-end cameras. In Aperture Priority, you choose the aperture and the camera selects what it thinks is the appropriate shutter speed. If you are taking portraits on a sunny day, for example, you could set the camera to Aperture Priority and select $f/5.6$ so that the busy background goes out of focus – the camera will take care of the shutter speed. Alternatively, if you were handholding a 200 mm telephoto lens, you could use Shutter Priority to set a shutter speed of $\frac{1}{250}$ sec. to avoid any risk of camera shake, and leave the camera to decide on the aperture setting. You could also set the camera to work at $\frac{1}{15}$ sec. to take panning shots, or stop the lens down to $f/22$ to maximize the depth of field. The opportunities are limited only by the amount of light available and your own creativity.

Exposure Compensation

As the overall exposure is set automatically in both Aperture Priority and Shutter Priority, many cameras have an exposure-compensation function that allows you to adjust the exposure. This is often set in $\frac{1}{3}$- or $\frac{1}{2}$-stop increments, so that you can override the camera's exposure estimation for a lighter or darker result.

Exercise 1
SELECTIVE FOCUS

Resources

You can do this exercise using any digital or 35 mm film camera that has a Manual mode. If your camera does not have full manual control, try using Aperture Priority or Shutter Priority instead. Remember to keep notes and experiments in your sketchbook or workbook for future reference.

2.25 In this amusing picture of a pigeon in New York City, Pamela Ossola covers many aspects of this exercise: a very close-up subject, a large depth of focus, a view from a high place and solving tricky exposure problems.

The Task and Extended Research

This exercise is intended to help you take control of your camera and image-making. You will not be able to rely on any Auto or Programme modes, so you must think carefully about your selected shutter speed and aperture to fulfil the brief. You should also consider all of the composition and cropping points raised in the previous chapter.

Choose an interesting location, such as a busy street, park, riverside or the seaside, and then choose a section that is no more than 100 m long, within which you will take all of your pictures. If you are shooting on film, decide also if you wish to shoot in black and white or colour, and whether to use negative or transparency film.

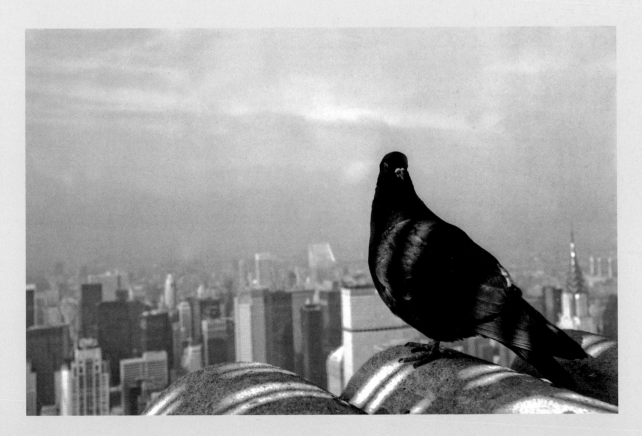

Choosing Colour Film

Shooting in colour is easier in many ways – as you see the world in colour – so if you are shooting on black-and-white film, consider what makes a successful and strong picture when the colour that you see in the viewfinder is not recorded. If you want to shoot black and white, but do not have the resources for processing and printing, use a colour process (C41) monochrome film such as Ilford XP2 or Kodak T-Max C41, both of which can be developed and printed by any high-street processor.

Getting Started

You can choose your own subjects, involve people or avoid them, choose somewhere busy or quiet; but try to avoid heavily overcast days or very bright sunlight as these may affect the exposure too severely. Shoot the following, keeping careful notes of the camera settings that you used:

- Six images showing a large depth of field (2.25)

- Six images showing a shallow depth of field

- Six images of moving subjects, with the camera held still (resting on a table or a wall, or on a tripod)

- Six images of subjects that are as close up as you can focus at (making abstract images)

- Six images panning with subjects (such as cars, buses or people) as they pass the camera

- Six images experimenting as you wish: high and low camera angles, with the camera held at an angle, deliberate over- or underexposure, and so on

Print up the best two or three images from each set and include them in your workbook, along with notes about your camera settings, what you were aiming to achieve and what actually happened.

Feedback

The most familiar and everyday scene can often become exciting or abstract, proving that the camera takes images that the human eye can never see. A few of your friends could join in this exercise as a competition, all shooting in the same area on the same day.

If you are on a photography course, show your tutors and friends this exercise and your results. It is a good way to learn about aperture, shutter speed and ISO, and their combined effects. The choices that you have to make will help you to take exciting images that can never be achieved using the camera's Auto settings.

Exercise 2
FACE-TO-FACE ENCOUNTERS

Resources

You can do this exercise using any digital or 35 mm film camera that offers full manual control, or you can use Aperture Priority or Shutter Priority. As before, remember to keep notes and experiments in your sketchbook or workbook for future reference.

2.26 After she got over her initial fear of talking to strangers, Bella Falk made this great set of street portraits, taking just a couple of hours. They worked so well as a series that she decided to present them together.

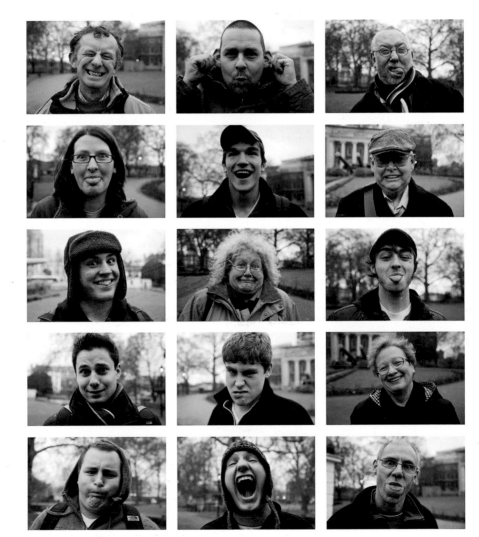

The Task and Extended Research

This exercise is about building your confidence to approach complete strangers in an attempt to get them to help you with your image-making. This may seem like a daunting task, but once you get started, you will be surprised how easy it is to do. A word of caution, though – be careful and consider your own safety during this exercise, and take note of any local advice if you are working in an area you are not familiar with.

You are required to take thirty-six head-and-shoulders portraits of complete strangers walking along your chosen location or street (**2.26**). The rules are simple: no candid shots; no running up to people, shooting and running away; and no long lenses. A standard focal length is best for this.

This means you will need to develop a 'chat line' to get people to help you: something along the lines of 'my photography tutor has set me this impossible project' will usually gain sympathy and encourage people to pose for you. Some will say no and some you may decide not to ask, but with a bit of luck, what you should find towards the end of the session is that very few people get past you without your getting a picture of them.

Getting Started

You could choose the same location as the previous exercise – a busy street, park, riverside or the seaside – and again select a section that is no more than 100 m long in which to take all your pictures. Obviously, you will need to find somewhere where there are plenty of people.

Before you begin, think about the aperture you will use and the depth of field, and how best to avoid potentially distracting backgrounds. Decide also what you are going to say when you first approach people.

The best output for this exercise is a contact sheet made either in a darkroom or using your image-editing program. If you have a digital camera, include the file numbers with each shot to prove that you have not edited your final contact sheet from a far greater number of 'bad' shots (film will have the frame numbers on the side). Either way you should have a number of strong street portraits (and some that are not quite so pleasing) to put into your workbook along with technical details.

Feedback

Make a few notes about how you felt about doing this project: keep your pictures in the order in which they were shot, and note how your confidence grew between the first few frames and the last.

If you are on a photography course, show your fellow students and tutors the results and ask for their feedback. As well as learning about f-stops, you should also learn to shoot fast and to get strangers to help you. Many students feel far more confident once they have done this exercise. You will also have had to think about talking to people instead of just worrying about camera settings, and you may have had to make adjustments to the exposure if some subjects are dark-skinned or wearing dark clothes. Finally, the project will also show you that sometimes a series of pictures can convey a stronger message than a single shot.

WORKING WITH FILM
AND DARKROOMS

In this chapter you will learn:

- Why it is important to understand traditional technology in a digital age

- How to use a manual film camera to make exciting images

- Black-and-white darkroom techniques to make good prints from your negatives

Why Learn to Use a Film Camera in Manual Mode?

3.0 (previous page) Film is an exceptionally creative medium. Julija Svetlova double-exposed these images onto Agfa slide film and then cross-processed it in colour negative chemicals. The dancers were shot in London and the sand dunes were added later in the Canary Islands.

3.1 Nikon's FM2 35 mm SLR camera was made from 1982 to 2001. It remains a favourite back-up camera for many professionals because it is fully mechanical, so the shutter will still work even if the battery goes flat.

Although most digital **SLR** cameras have a Manual mode, many digital compacts do not. An inexpensive way of learning to use all the basic settings that allow real creativity – particularly concerning exposure and **depth of field** – can be to buy or borrow a simple, manual 35 mm SLR camera (**3.1**). These older cameras force you to think about **shutter speed**, aperture and **ISO** in the same way as all the great photographers of the past, and in a way that no fully automatic camera ever can, which is why many colleges still include film cameras in their photographic curriculum.

If you are working with colour film, and in particular colour slide film, you have to be very accurate with your exposure estimation. Colour negative films have a wider **exposure latitude**, which allows some over- or underexposure without major loss of detail in a picture, but all film-based photography requires a disciplined approach. There is also the fact that every time you press the shutter-release button, it costs you money. This can help you focus on your ideas and compositions, rather than taking endless photographs in the hope that one works out. In a way, having image-manipulation software to help rescue badly exposed digital images can make modern photographers more careless and less thoughtful about their image-making.

Some schools and colleges still teach black-and-white photography before moving on to shooting in colour, and reducing an image to monochrome tones is one of the purest and most exciting parts of photographic image-making. The skills that you have learned in the earlier chapters will allow you to make more informed creative decisions when you experiment with black-and-white photography, with composition, light and form becoming as important as the subject. Many photographers believe that learning to reduce images in this way – to the pure form of black and white – and then applying their skills to colour photography, whether film or digital, can greatly enhance their image-making (**3.2, 3.3**).

3.2 When re-creating this wartime scene in his studio, Jeff Robins shot on 5 × 4 in. colour transparency film to capture the atmosphere of the battle.

3.3 Scanning the image to produce a digital version and converting it into monochrome creates a very different look and, in this instance, a more pleasing result.

3.4 Julija Svetlova uses a line she has drawn in her camera to align her film when she loads it, so the film can be loaded twice to produce perfect double exposures. In this shot, the window is in St Petersburg, and the big wheel is in Windsor.

Lomo Photography

The increasing popularity of digital photography has led to film developing something of a cult following among some image-makers. This is most obviously seen with plastic 'Lomo' cameras that fans carry around with them all the time, posting images on websites and blogging comments. This can lead to very exciting and experimental photography, with some Lomo photographers going as far as shooting a roll of film in one city, rewinding it and then posting it to a friend who re-exposes the film (using a Lomo, naturally!) with their own photographs of another city or subject (**3.4**). This can lead to the most amazing 'happy accidents' and to juxtapositions of subjects that could never be planned.

The Advantages of Film

Film cameras are far less susceptible to the extremes of temperature and humidity that can adversely affect the battery and electronics in digital equipment. This makes them the ideal tool for extreme conditions. A film camera with a titanium shutter can continue to function at temperatures as low as −20°C, for example – long after a digital camera's batteries will have ceased to function. Film cameras are equally capable of coping with extremes of humidity, and although such conditions can reduce the speed and contrast of film (and alter its colour balance), this is a small price to pay compared to the damage that a warm, damp environment can inflict on the electronics in digital cameras and computers.

There are also advantages to using film cameras when it comes to shooting in less developed parts of the world. As discussed in Chapter 1, a digital camera relies on battery power, which means that an electricity supply is mandatory for cameras that use proprietary rechargeable cells, while AA-sized batteries may not be sourced readily in remote areas. A fully mechanical film camera, however, requires no battery power: so as long as you have an adequate supply of film, you can continue photographing.

It is also worth bearing in mind that while the majority of Western film manufacturers (and processors) have moved exclusively into digital imaging, many have sold the machines that make the film into such countries as China, India and other Asian regions. This means that you can buy film easily and cheaply in these countries, with the laboratories that process the film usually offering **scanning** services that will allow you to make conventional or digital prints at little extra cost – the best of both worlds.

Cooling Film

If you are taking film to a hot, humid climate, try to keep it cool or refrigerated until about an hour before you are ready to shoot, and cool it again after taking your pictures. A sealed plastic container is very useful for keeping out moisture in a fridge or coolbox.

Common Film Sizes

35 mm Film

35 mm film has perforations down both sides and began as a motion-picture film format in the 1890s. It first became popular in still photography with the launch of the Leica camera in 1925, and is still widely used around the world, making it relatively inexpensive. If the film is carefully scanned, or used in a good enlarger, very acceptable prints up to about A3 or 12 × 16 in. in size are possible. Popular negative films are available in 12, 24 and 36 exposure lengths, although most professional films come only in 36-exposure cassettes. Some 35 mm film stock can also be bought in much longer lengths, in a can, which can then be loaded by hand into film cassettes. This can offer a considerable saving if you shoot a lot of film.

120 Film

Also called 'roll film' because the film – which is 6 cm wide – is attached to a roll of paper that is used to pull it through the camera. In the first part of the twentieth century, 120 film was one of a large number of different roll film sizes and widths, most of which have since been discontinued. In the 1940s, Rollei produced cameras using this film size and, in the 1950s and 1960s, 120 was adopted by Victor Hasselblad for a new range of medium-format professional cameras. Other companies also produced cameras using this format, and it is still a popular choice in medium-format photography.

3.5 (below left) Hasselblad cameras were the workhorses for many late twentieth-century photographers, and the superb lenses can make them a good second-hand purchase if you opt for a film-and-scanning workflow.

3.6 (below right) Mamiya 645 cameras shoot sixteen frames measuring 6 × 4.5 cm on 120 film. The film backs are interchangeable, which allows for rapid fashion or sports shooting, or the option to switch quickly between colour and black and white.

3.7 (bottom left) Mamiya 645 cameras can shoot in Manual or Programme modes, and are equally at home in a studio and on location. They are particularly sharp when used with prime macro lenses for head-and-shoulders portrait or beauty shots.

3.8 (bottom right) Modern 645 cameras have internal contacts that allow them to connect with digital backs, such as this Leaf Aptus 17. This gives the added option of using both high-quality film and digital capture on the same shoot.

3.9 The 120 film format is very adaptable and this Fuji camera can record nine 6 × 8 cm frames for high-quality images. The camera features such movements as rising and drop-front and lens tilt, to improve focus or correct distortions in the image.

Part of its success is that it is a very adaptable format, with various specialist cameras (**3.9**) using the 6 cm-wide film to produce very different image sizes: 6 × 4.5 cm (16 frames), 6 × 6 cm (12 frames), 6 × 7 cm (10 frames), 6 × 8 cm (9 frames), 6 × 12 cm (6 frames) and 6 × 17 cm (4 frames) are all image sizes that have been produced using the standard 120 film format.

Some manufacturers also make a double-length '220' film that fits on a conventional 120 film spool by dispensing with the backing paper. This normally needs an adaptation to the film pressure plate in the camera, though, and the lack of a backing paper also means that it is easier for the film to get scratched in-camera.

3.10 Whenever you look down on a cube-shaped box from above, the top, because it is closer to you, will appear larger than the bottom. Using a drop-front camera movement on a 5 × 4 in. large-format camera will allow you to avoid this distortion.

Large-Format Sheet Film

5 × 4 in. and 10 × 8 in. sheet film are loaded into large-format plate cameras to produce a very high-quality image. This is because the physically larger film requires less enlargement than any other format to get to any given print size. One of the main advantages of sheet film (other than its size) is that most plate cameras allow the lens and film plane to be moved left or right, or up and down. These movements allow perspective distortion to be corrected (or exaggerated) in-camera (**3.10**), as well as allowing greater control over the depth of field, either increasing it, or reducing it so that a much smaller area of the picture is in focus.

> **Sheet Film**
>
> Sheet film has notches in one corner to help you load the film in complete darkness with the emulsion facing in the right direction. If the notch is in the top right-hand corner (or bottom left), the emulsion side is facing you.
>
> Each brand, type and speed of sheet film has its own, uniquely shaped notches. If you are working with more than one type of film – perhaps colour and black and white, or colour negative and colour transparency – it is a very good idea to learn to identify their notches so that you can tell precisely what film you have in your hand, even when you are in total darkness.

Black-and-White Film

Early photographers were faced with the problem that their black-and-white film emulsions were sensitive only to ultraviolet and blue wavelengths of light. This made the recording of skin tones in portraits and foliage in landscapes difficult, as the emulsion recorded both of these as a very dark tone. In an attempt to remedy this, a German chemist named Hermann Vogel formulated a black-and-white emulsion in 1873 that he described as 'orthochromatic', meaning 'fine colour'. Vogel's emulsion was sensitive not only to ultraviolet and blue light, but also to the green wavelengths of the visible spectrum, which lightened the green tones in landscape images. It still, however, left skin tones dark, although the reduced red-sensitivity meant that the emulsion could be used with a red safelight so that the photographer could see the film (or printing paper) without exposing it.

In 1906, panchromatic film was invented. Meaning 'all colour', panchromatic film had the advantage that it could record all the wavelengths in the visible spectrum, including red, which meant that it was capable of producing more natural-looking, tonally accurate black-and-white images. Almost all the black-and-white films in common use today are panchromatic, although orthochromatic films remained popular well into the 1950s because of the convenience of being able to use a red safelight to process them by inspection.

Black-and-white (and colour) films consist of light-sensitive silver halide crystals in a layer of gelatine, a combination that is commonly known as 'emulsion' (**3.11**). In photography, a silver halide is a combination of the metal silver and a halogen: silver bromide, silver chloride or silver iodide, which are part of a 'family' of chemicals that have similar properties. Today, photography uses silver bromide in almost every chemical process, although silver chloride was popular in the 1920s and 1930s for its lower sensitivity to light and its ability to produce a warmer-toned photographic print. Silver chloride has been revived recently in a number of specialist photographic papers, often in combination with silver bromide. Silver iodide is also sometimes added to certain photographic emulsions.

Most modern films consist of a number of thin layers of light-sensitive emulsion (to improve the range of contrast and increase film speed), coated onto a clear acetate base. An image is focused onto the film by the camera lens and, when exposed, a minute change happens at atomic level to the silver halide crystals in the emulsion. During processing, a developing agent identifies these exposed crystals in the film and breaks them down into small clumps or grains of black silver that will form an overall negative image. The unexposed and undeveloped silver halide crystals are later dissolved away into the fixer, making the film safe to view in daylight. The valuable silver can then be recovered and reused to make new film and paper. This is economically and environmentally friendly, since less silver will be mined or transported as a result.

3.11 A surface hard layer of gelatine helps to avoid damage to the film during handling, while another layer on the back helps to prevent it from curling. The back layer also carries dyes that absorb light and prevent 'ghost' images.

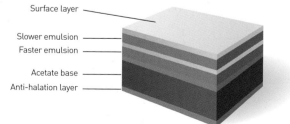

Surface layer

Slower emulsion

Faster emulsion

Acetate base

Anti-halation layer

3.12 Today's film and digital cameras have no difficulty capturing a still life consisting of red tomatoes and green lettuce leaves on a white plate, but this would have been a major problem for the pioneering photographers.

3.14 Orthochromatic black-and-white emulsions extended the sensitivity to green wavelengths of light, so with this still life, the lettuce would appear correct, but the red tomatoes would still appear black.

3.13 The first black-and-white films were sensitive only to ultraviolet and blue wavelengths of light, so, in this example, neither the green leaves nor the red tomatoes would expose the negative, and both would appear almost black on the final print.

3.15 Panchromatic film was invented in 1906, but even during the 1940s and 1950s, many photographers preferred to use orthochromatic emulsions as they could use a safelight to process their film. The advantage of panchromatic film is clear, though: all the colours in this still life have been recorded correctly in black and white.

Regression

The latent image formed during exposure is made up of tiny changes at atomic and electron level in the silver halide crystal and can be lost over time (a process called regression), particularly in hot or humid conditions. To avoid regression, store your film in a dry, cool place and process it at the earliest opportunity. Regression affects colour film more severely than black-and-white film, making images appear under-exposed, low in contrast and often with an incorrect colour balance.

Two manufacturers (Ilford and Kodak) have also introduced black-and-white films that are developed using the colour negative (C41) process. Here, the black silver negative image is replaced by colour dyes in the emulsion, so that all the silver in the film can be recovered and used again. This is even more environmentally friendly, as any silver that is washed down waste pipes is almost impossible to extract at water-treatment plants. Current examples of these films include Ilford XP2 Super and Kodak BW400CN, although how long these will continue to be available is uncertain.

Infrared

As well as conventional black-and-white films, there are specialist films that can produce effects that are hard to achieve with a digital camera. One of these is black-and-white **infrared** (IR) film, which can photograph light that is beyond the visible spectrum. This is difficult to achieve with a digital SLR because the **sensor** is faced with an IR-blocking filter that is designed to absorb infrared light, which means that the camera cannot 'see' it. Although it is possible to have this filter removed by a specialist camera technician (and some people do), the digital camera will be able to shoot only infrared images in the future, and the process is irreversible.

Using black-and-white infrared film is not the most straightforward of processes (**3.16**), and there are a number of vital considerations. First, you must load and unload the camera in total darkness, and use only a metal camera body: a plastic camera body with a tiny plastic window that allows you to view the film cassette inside will fog your film.

To maximize the infrared effect, a filter is also required. A Wratten 25 (red) filter gives a reasonably clear image, while still allowing you to see through the viewfinder, although a Wratten 87 or 89 filter will give a stronger infrared effect. This is because such filters cut out more of the visible spectrum of light, so that only the infrared wavelengths pass through. The downside to this is that both are opaque to the human eye, so the image is not visible in the viewfinder.

For infrared photography, you also need to adjust the focus point. This is because infrared light has a much shorter wavelength and bends less than the longer wavelengths of 'white' or visible light, and therefore focuses at a slightly different point. Older film cameras often have a red dot on the lens that is about 2 mm to the left of the main focusing line, specifically for infrared photography. To use this, you focus the camera without the IR filter fitted, note the distance indicated on the top of the lens barrel and then move this round so that it aligns with the red dot. This will give you the correct focus for IR light, and you can then fit your IR filter and take your photograph.

Infrared-Blocking Filters

All digital sensors are sensitive to infrared light, so you can experiment with putting a Wratten 87 or 89 filter over the lens. Some cameras will work better than others, and some will not work at all. It is quite possible that cheaper cameras will give better results than more expensive ones, simply because lower-priced cameras are likely to have a less effective IR-blocking filter over the sensor. Desaturating the results in your image-editing software, so that they appear in black and white, may give a similar effect to specialist black-and-white films, but this is not guaranteed.

3.16 Ilford and Rollei both make specialist infrared film. The living leaves of trees and grass reflect a lot of infrared light so, with the right filter, they expose IR film much more than normal film, turning the leaves white.

Using a Manual 35 mm Film Camera

Most manual 35 mm cameras follow a similar design, regardless of the make or model: there will be a lens with a movable ring of **f-stop** numbers to control the aperture; a focusing ring with distances marked in both feet and metres; either a fixed focal-length (or prime) lens or a **zoom lens**; and a dial for shutter speeds, usually on the top of the camera body, but sometimes around the lens bayonet fitting. There will also be a dial for setting the ISO of the film if the camera has a built-in exposure meter, as well as a wind-on lever to advance the film, and a rewind knob to return the film into its light-tight cassette after exposure. This often doubles up as the method of opening the camera back by pulling the knob upwards, away from the camera body.

Whenever you unload a film you should always check first that it has definitely been rewound fully into its light-tight cassette. The easiest way to ascertain this is to turn the rewind knob gently in the direction of the arrow on the camera. If you feel any resistance then the film may not be safely back into its cassette, or the camera may already be loaded. This is vital if you share a camera with others who may have important shots on the film: if you open a camera and the film is exposed, it will 'fog', ruining all the exposures on it.

Loading a 35 mm Camera

When the camera back is open, remove any dust or grit with a blower brush or good-quality, damp, modeller's brush. Never touch the shutter blinds, as they are very delicate, easy to damage and expensive to repair, regardless of whether they are made of thin metal or cloth.

With the rewind lever pulled up, the film cassette is placed in the camera with the black, ridged spool pointing downwards. In the top of the cassette spool is a groove that will lock it in place when you push down the rewind knob. Pull the tongue of the film out carefully until it reaches the far side of the camera. Now, turn over the last 5 mm of the film tongue to make it easier to slot into the take-up spindle.

With the back of the camera still open, set the shutter speed to $\frac{1}{60}$ sec. and fire the shutter, before carefully winding on the film. The perforations on either side should be fully engaged on the sprockets either side of the shutter blinds. Fire and wind a second time to check that the film is advancing correctly, and then close the camera back. You are now ready to shoot (**3.17**).

Unloading a 35 mm Camera

You will know when you reach the end of your film, as the wind-on lever will 'lock up'. As soon as this happens, avoid forcing the lever any further or you may pull the film out of its cassette, making it impossible to rewind. To rewind the film back into its cassette, the sprocket 'teeth' that engage with the film perforations must first be disengaged. With most cameras this is achieved by pressing a small button on the bottom of the camera body, although some cameras have a lever on the front of the body that turns instead.

Hold this button (or lever) in, and the rewind knob can then be turned slowly in the direction of the arrow until the film is safely back into the light-tight cassette. It is good practice to rewind your film as soon as it is fully exposed, so that if the back of the camera is opened by accident, the pictures will not all become fogged (**3.18**).

Record-Keeping

When you are shooting a series of films, each cassette or roll should be marked or numbered to help identify them later so you can decide on the best ones to test first when processing. It is also a good idea to keep a brief log of the subjects of the pictures on each roll.

Airport X-Rays

Modern airport X-ray machines will not fog 100–200 ISO films and are unlikely to damage the latent image if the exposed films are scanned on a return journey. If you are travelling through a number of airports on a longer itinerary, it is best to process your films while on location, or request a 'hand search' of your film at airport checkpoints. This is recommended for all films faster than 400 ISO, although bear in mind that the request for a hand search can be declined.

3.17 In these pictures we have placed the camera against a plain background to give you a good view. You may find it better to sit down, with the camera face-down on your lap, holding it between your knees.

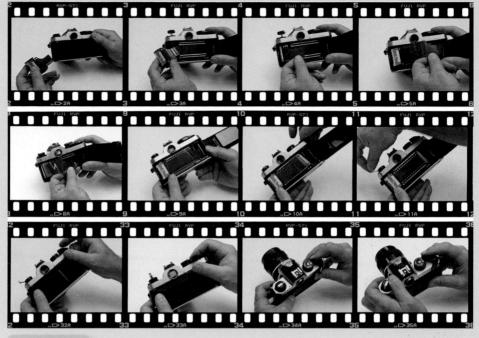

Loading Film

To make sure the film travels through the camera, close the back of the camera and turn the rewind knob a couple of times until you feel a slight resistance. Then fire and wind the camera twice more, watching the rewind knob: it should rotate as the film winds out. Note that the frame counter advances with the wind-on lever whether film is travelling through the camera or not, so do not assume that your film is loaded correctly just because the frame counter is moving.

3.18 If you are worried about trying to leave the film tongue out when unloading your film and opening the camera back, wait until the rewind turns freely and then unload in subdued light, placing it in a light-tight container.

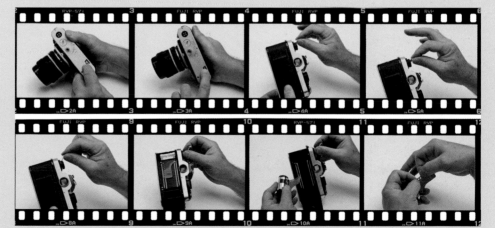

Removing Film

Hold the camera body to your ear while you are rewinding it and listen for a 'click' as the film tongue disengages from the take-up spool. You can remove your film safely at this point. By not winding the film tongue right back into the cassette, you can prevent light from passing through the velvet light trap and fogging your first couple of frames. Tearing (or cutting) the end of the film tongue off will act as a reminder that the film is exposed, reducing the chance of your reloading the same film by accident.

Black-and-White Film Processing

Practising Loading

It is best to practise loading spirals using old or unwanted film until you are successful every time. Start by loading your dummy film in the light, with your eyes open, then with your eyes closed, and finally in the darkroom, with all lights turned off. Handle the film by its edges to avoid touching the emulsion side – perspiration on your fingers can leave fingerprints that will appear on your processed images.

Some photographers prefer to develop their own black-and-white films, either because they consider this to be part of the process of the creation of their images, or because they prefer the consistency they get from a particular combination of film and developer, or development technique.

To process a black-and-white 35 mm film, you first need to remove it from its metal cassette in total darkness: metal levers (similar to beer-bottle openers) can be purchased to simplify this operation. Next, and still in total darkness, the film is loaded onto a metal or plastic spiral; ensure that it is located in the correct grooves so that none of the film is touching the next ring in the spiral.

If you are loading 120 roll film, you need to separate the film from its backing paper before you load it onto a spiral. Loading can be tricky because the acetate base tends to be thinner than 35 mm film and is easier to bend or kink. As silver halides are sensitive to pressure, as well as light, a kink can easily lead to a crescent-shaped mark on the processed film that can ruin an image.

Developer

For a small number of films (up to eight 35 mm films or five 120/220 films) you can use a metal or plastic developing tank, although larger quantities will need to be processed in a 'deep tank' of chemicals with loaded spirals held in a basket that carries them through the various stages of the process simultaneously. If you are using a deep tank, check the manufacturer's recommendations, as development times may need to be extended.

Regardless of the type of developing tank you are using, the first chemical in the process is the developer. This turns the invisible 'latent image' into a visible 'negative' image. It is negative because the more light that shines onto a film, the darker that part of the black silver image becomes after development.

The development of any film is affected by:
- Formulation of chemicals and their age and condition (Solution)
- Dilution with water (Dilution)
- Length of processing (Time)
- Temperature of the process (Temperature)
- How much you stir or shake the film in the chemicals (Agitation)

3.19 You can achieve a more 'gritty' contrast by increasing the development time during film processing; by using a harder grade of paper in darkroom printing; or by scanning and manipulating the image digitally. This portrait is by Palmer + Pawel.

Developer solutions can be formulated to give increased or decreased contrast, to work faster or slower and to produce a coarser or finer grain. Apart from the developing agent that actually identifies the exposed areas of the film and reduces those silver halides to black silver, there is also an alkali accelerator that speeds up the process. All modern developing agents work far better in an alkaline, rather than acidic, solution.

In addition, there are also preservative chemicals that remove oxygen that would otherwise slow down the development process. Oxygen can get into a developer either from the water used to mix the chemical, or from the air surrounding a dish or container. Developer solutions also include a chemical called a restrainer that prevents 'chemical fogging'. This is the process whereby unexposed areas of the film will begin to develop,

regardless – and the longer the development process, the more prone it will be to unwanted chemical fogging.

The more development that a film receives (usually by increasing the time), the higher the contrast in the negatives (**3.19**): unexposed areas remain undeveloped, but exposed areas go blacker, increasing the image contrast. This can, however, result in loss of detail in the brightest (highlight) areas of the subject, which can become a flat black area on a negative.

There is a wide range of developers; some are 'one-shot', and are poured away after use, while others can be used several times, returning the developer to a bottle after use, with a note to increase the processing time when it is next used. In the case of deep tanks, developers can be replenished by a special formula that puts back the chemicals used in processing, rather than replacing the entire solution. These are similar to the original formulation, but do not contain any bromide restrainer, as the bromide released during processing returns to the developer.

When shooting subjects in very flat lighting, underexpose your film by 1 stop and then increase the development time by the equivalent amount (normally 20–30%). This will give you approximately the same overall image density, but it will increase contrast, improving the negative quality for scanning or printing. In high-contrast lighting, the opposite applies: overexpose your film by one stop and then under-develop the film by reducing the development time by 25%. This will reduce contrast. Some photographers will always change the development time to allow for the variable contrast and lighting of their subject.

When development has finished, the parts of the film that were exposed in the camera will have changed from a milky-coloured silver halide into black metallic silver. Unexposed areas of the film are not affected by the developer and remain milky in colour and sensitive to the light. Therefore, before you can take your negatives out of the tank and view them in the light, you must remove the chemicals in the unexposed areas and 'fix' the film.

Stop Bath and Fixer

Since all developers are alkaline, you can stop their action immediately through the use of a very dilute acid, or 'stop bath', which is generally acetic acid. A stop bath helps prevent the alkaline developer carrying over into the expensive acidic fixer, which helps to prolong its effectiveness.

After the stop bath, the film is placed in a fixer, which dissolves away all the unexposed and undeveloped silver halides, without having any effect on the black silver negative image. The silver dissolved into the fixer can be recovered, and its sale will help to reduce laboratory costs and avoid environmental contamination.

Water Type

Tap water can be slightly acidic or alkaline, which can speed up or slow down development. In extreme situations you may need to compensate for this acidity or alkalinity by modifying the developing times recommended by the manufacturer. Alternatively, some photographers use bottled water, opting for a single brand to guarantee consistency.

Pushing and Pulling Film

The ISO rating given for any black-and-white film is a recommendation, rather than an absolute. Black-and-white film can be 'pushed' (given a higher ISO rating) and 'pulled' (given a lower ISO rating) deliberately, simply by changing the ISO setting on your camera and adjusting the processing time to compensate. This can be useful if you find that the film stock you have is too slow for low-light conditions, or if you accidentally set the wrong ISO. It can also be used creatively – pushing a film will increase the grain, for example.

3.20 Choose a clean, dust-free environment to cut up and sleeve your negatives, and avoid wearing woollen jumpers, or similar: the fibres can become statically charged and stick to the film.

The rule for a fixer is that the film needs 'twice the clearing time'. This is the time it takes for film to lose its milky look. If in doubt, read the manufacturer's instructions and add a little extra time, rather than calculating the clearing time by trial and error. Modern films, particularly higher-speed films, have more layers of emulsion and therefore need longer fixing.

Finishing

By this stage, you have successfully processed your film to produce negatives, but some important steps remain. First, all traces of the acid fixer must be washed out of the film, or its archival life will be reduced, by stains or fading of the image. Some photographers use an expensive 'hypo eliminator', or clearing agent, to speed up this part of the process. The water you use to wash your film should ideally be filtered, and at a temperature no higher than 24°C. Your films should be washed for between 30 minutes and 1 hour. It is important not to leave your film washing for too long: a film left washing overnight may survive, but the emulsion will be soft and prone to damage.

After washing, the film is immersed in a dilute detergent 'wetting agent' that helps to ensure that no watermarks are left on the film's surface as it dries. Film can be air-dried naturally, or hung up in a dust-free hot-air cabinet at a temperature of up to 60°C. Long 35 mm films should be weighted at the bottom to prevent them curling or sticking to the film next to them in the dryer, although a slight curl after drying is normal. Once dry, your negatives should be cut into strips (35 mm into strips of 6 frames and 120 into strips of 3 or 4 frames) and stored in paper or archival polythene sleeves. Some system of identifying the negatives will be useful as your archive of images grows. Try to design a system that will involve the least amount of handling of your precious negatives. Always try to sleeve your negatives the same way up and in numerical order, as this will help you to locate an image later. Cutting negatives over a light-box or sheet of white card can help you see the edge of each frame more clearly, and wearing inexpensive white cotton gloves is a good idea, particularly in humid conditions (**3.20**).

Black-and-White Printing

Now that you have processed your negatives, you are ready to enlarge your image. A photographic enlarger is basically a slide projector that points downwards (**3.21**). At the top is a light source, usually a tungsten or **incandescent** light, sometimes with a fan to cool it. Below the light source are glass condensers (**3.22**) that focus the wide beam of light onto the negative, or possibly a soft-box where the light is shone into a white box that is used to illuminate the negative with an even, diffuse light. Below the condensers or soft-box is the negative carrier. This is usually removable to allow you to locate the negative correctly and avoid damaging it. The negative should always be placed 'shiny side up' in the carrier so that your image is printed the right way round (**3.23–3.26**). It is important to note that the lens will invert the image, so you need to place the negative in the carrier upside-down (with the sky nearest to you for a landscape image, for example), so that it appears the right way up on the easel in front of you. This is not as critical with portrait-format images, as these will appear sideways on the baseboard.

After you have loaded your negative and replaced the negative carrier, you can turn on the enlarger light and focus the image onto the enlarger baseboard or an easel, using the enlarger's focusing knob. The baseboard (or easel) acts as a screen and helps to locate the paper in the correct position and hold it flat. The enlarger lens must be the correct **focal length** for the negative size, and for each film format the lens size is the same as the 'standard' lens that you would use when taking photographs: use a 50 mm lens for 35 mm film, an 80 mm lens for 6 × 6 cm film, and a 150 mm lens for 5 × 4 in. film, for example.

Condensers

If you are using a condenser enlarger, you must make sure that the correct condensers are used for the size of the negative you are printing. If the condensers are too small, the image will be cut off, or there will be darkening at the corners of the projected image, while using condensers that are too large will mean the light is weak and uneven.

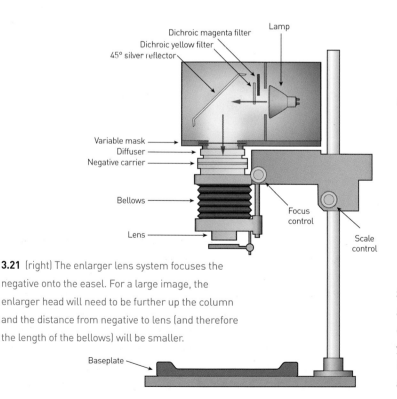

3.21 (right) The enlarger lens system focuses the negative onto the easel. For a large image, the enlarger head will need to be further up the column and the distance from negative to lens (and therefore the length of the bellows) will be smaller.

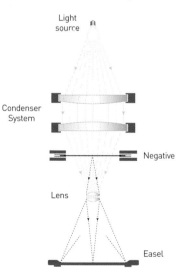

3.22 (above) Providing it is set up correctly, a condenser system will ensure bright and even illumination of your negatives. Often you can also adjust the distance from the lamp to the condenser in the enlarger, to avoid hotspots or light fall-off at the corners.

3.23–3.26 Always handle a negative by its edges, or the perforations, and avoid touching the image area on the emulsion side, particularly if you have damp fingers. To line the negative up perfectly, final adjustments can sometimes be made once the negative carrier is in place.

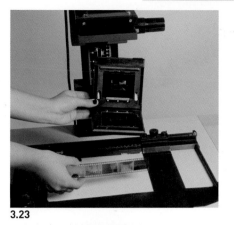

3.23

3.24

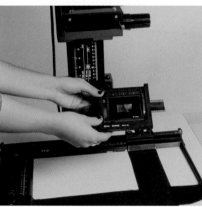

3.25

3.26

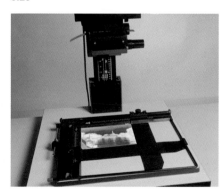

White Light

It is much easier to load a negative in white light than under the darkroom safelight. Always ensure the enlarger is turned off before removing the negative carrier to avoid fogging your light-sensitive printing paper (or the paper of other users, if you are sharing a darkroom).

3.27 (left) Darkroom printing is a very creative process, where cropping, using corners dynamically and lightening or darkening particular parts of the image can improve your photographs.

Open the enlarger lens aperture to its widest setting so that you have the brightest image on the baseboard: this will enable you to see it more clearly, and therefore to compose and crop more accurately (**3.27**). Focus is also at its most critical when the lens is at its widest aperture setting. While 'focus finder' aids are available, many photographers prefer to focus 'by eye', adjusting the focus until the grain in the projected image is at its sharpest.

When the image is first focused on the baseboard or easel, it is almost certain to be the wrong size. If it is too small, you need to move the enlarger head further up the column; if it is too big, you need to move the head down the column. Whenever you resize the image on the baseboard, you will need to open up the lens aperture and refocus the image (**3.28–3.30**).

3.28 Even if you are used to working in centimetres, the maths for setting up a baseboard (or easel) is much simpler in inches. For 10 × 8 in. paper, setting an easel to $7\frac{1}{2} \times 9\frac{1}{2}$ in. will give an attractive $\frac{1}{4}$ in. (3 mm) border all the way round.

3.29 The Inverse Square Law (see box below) concerns not only photographers working with darkroom enlargers, but also those in a photographic studio, where doubling the distance between a light and its subject will mean that only a quarter of the light reaches it – not, as you might expect, half as much.

Inverse Square Law (3.30)

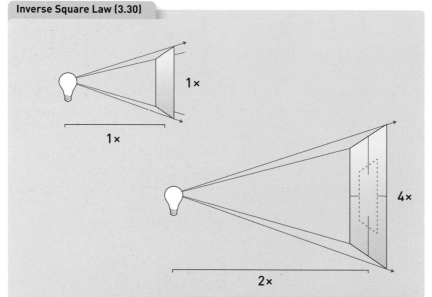

Whenever you move the enlarger head away from the baseboard the picture will become dimmer, because the same amount of light now illuminates a larger area. Conversely, if you move the enlarger head closer to the baseboard, the light is concentrated on a smaller area, so the image becomes brighter. This means that the correct exposure time will change whenever you alter the size of an image or want to crop into part of a negative. This effect is explained by the Inverse Square Law, which states that doubling the distance between a light source and the subject results in only one-quarter of the original light shining on it.

Enlarging-Lens Clicks

It is often difficult to see the lens aperture in the darkroom, even on some modern lenses that are illuminated. Enlarging-lens apertures usually have very positive clicks for each aperture and it can be easier to make a note that you have shut the lens down 3 'clicks', for example, rather than trying to determine the precise f-stop you want to use. Note that some lenses work in ½-stop clicks, so you need to determine if 6 clicks changes the aperture by 3 or 6 stops.

Controlling Contrast and Multi-Grade Papers

Many professional photographers – whether working traditionally or digitally – would say that image contrast is at least as important as exposure, no matter whether you are working in black and white or in colour. In black-and-white photography, high contrast can be either a creative tool or a serious problem, depending on whether it results in a loss of detail in the highlight or shadow areas.

To a certain extent, contrast can be controlled during the black-and-white film processing stage (**3.31**). For example, you could use a slightly longer development time to compensate for having photographed on a flat, overcast day – but it is difficult to gauge

Black-and-White Printing-Paper Contrast Grades	
Grade 0	**Very flat and low contrast** Only used when trying to get the highest amount of detail from a very contrasty negative. Will always give a weak, 'muddy' black.
Grade 1	**Low contrast** Useful if you are making a print that you intend to copy onto another negative or scan.
Grade 2	**Average contrast** Many photographers find this looks flat and prefer to treat Grade 3 as average contrast.
Grade 3	**High contrast** Will give a bright black-and-white print with good blacks, but may need some local image manipulation (dodging and burning – see p. 99) to control detail in the highlights or shadows, or both. Works well with lower-contrast ISO 400 films to give a good tonal range.
Grade 4	**Very high contrast** Images start to lose detail in all areas except the mid-tones unless you are starting with a low-contrast or underexposed negative. With practice, this can give some exciting results.
Grade 5	**Graphic contrast** Tones in the image are reduced close to either black or white, with no mid-tone areas. This can be useful for graphic designers, or to give a photograph a totally different look and feel from what can be achieved with a more conventional print made on Grade 2 or 3 paper.

3.31 The contrast of a print can be changed in the darkroom for dramatic effect, or to hold more shadow or highlight detail. Many students find this useful when learning digital manipulation. Photo by Kit Fordham.

3.32, 3.33 Cool-tone papers give a grey-blue image (above), while warm-tone chlorobromide papers are good for creating brownish prints without toning (top). Jeff Robins experimented with both when making a print of this re-creation of a First World War trench scene.

precisely how much longer the development time needs to be, and you will not know if you have got it right until your film is fixed. There is, however, a way in which contrast can be more accurately controlled, and that is when you make a print in the darkroom. You need as many subtle options as possible to control the contrast of a printed image, and this is achieved by using different contrast grades of photographic printing paper.

It is still possible to buy graded photographic paper that has one of the five individual grades, but most photographers now use multi-grade paper, which allows you to change the effective grade of the paper by filtering the enlarger's light source. Shining a yellow light on the paper produces grades 0 and 1; red gives grades 2 and 3; and a stronger magenta filter gives grades 4 and 5. Specialist multi-grade enlargers have filters built into the head that allow the colour of the light to be changed, or you can use filters below the lens. Individual filters can be made in half-grades – offering a wider range of contrast options compared to fixed-grade papers – but a multi-grade enlarger offers greater control still: the filtration is 'dialled in' by turning a wheel, making it possible to adjust the contrast in much smaller increments, so that prints can be made at grade $2\frac{3}{4}$, for example. Also, as you are changing the colour of the light source, there is no chance that marks or scratches on a filter beneath the lens could degrade the image quality.

Fibre-Based and Resin-Coated Papers

Fibre-based printing papers are also known as 'baryta' papers because of a chemical whitener, barium sulphate, used in their manufacture. Although very popular (they have existed since Victorian times), they place a number of demands on printers that some might describe as disadvantageous: they need to be processed by hand in dishes; washed for a long time to remove fully all the chemicals that soak into the paper's base; and given careful drying, often using a special flat-bed or drum dryer to prevent the paper from curling. Fibre-based prints are also best mounted using a hot press and dry mounting tissue, which means that producing a single print can take at least $1\frac{1}{2}$ hours, perhaps even longer.

Prints on resin-coated papers are far quicker to produce, as the paper was designed for use in both black-and-white and colour print-processing machines. The emulsion is coated onto a thin layer of polyethylene, which also covers the back of the paper, preventing chemicals from soaking into the paper during processing. As a result, processing can occur at temperatures up to 38°C and development times are much shorter. Many automated print-processors also have built-in dryers that enable prints to be processed, 'dry-to-dry', in around 2 minutes. While resin-coated prints are far easier to produce, fibre-based printing papers are preferred by many fine art photographers and museums. This is because, providing they are processed and washed correctly, they are more stable, and so have a longer archival life.

Alternative Papers

Both fibre-based and resin-coated papers come in a wide range of finishes and sizes, but some manufacturers also offer papers that give a warm (slightly brown) toned image or one that exhibits cooler (blue-grey) tones (**3.32, 3.33**). As you become more experienced at printing, you may wish to experiment with these papers, as well as more specialist print developers and post-printing toners. A paper containing a greater amount of silver chloride will give a very warm image, for example, but this can be made richer still through the use of certain developers.

Filter Grades

Most multi-grade filters – whether dial-in or beneath the lens – are designed so that the density (and therefore the exposure time) remains the same from grades 0 to 4. A grade 5 filter, however, is a much stronger magenta colour, and the additional density means that the exposure time will be longer.

Paper Choice

Resin-coated printing paper can be processed in dishes in the same way as fibre-based papers, if you want to use specialist chemicals or view your prints as they develop, but fibre-based papers can never be used in print-processing machines.

Black-and-White Print Exposure

Whenever you shine light on photographic paper it will turn black, and this is the essence of the negative–positive system: clear areas of your negative will allow more light to pass through, so corresponding areas of the print will be dark, while darker areas of the negative will reduce the amount of light hitting the paper, creating lighter tones in your print.

When you are ready to print, the lens will need to be stopped down from the wide aperture setting that you used to focus and compose the image. This is to give a sharper print and to extend the exposure time. Start by closing the aperture down to *f*/8 or *f*/11, and set the contrast grade to 2.5, either by dialling in the required amount of filtration or by using the correct filter under the lens.

Now cut a test strip. The aim of a test strip is to determine the exposure and contrast for your final print, so do not be afraid to make a number of tests: it is far cheaper to make three or four (or more) test strips than it is to waste whole sheets of paper. If you are using 10 × 8 in. paper, try cutting it into four strips, each measuring approximately 8 × 2½ in. Place one strip on the baseboard, diagonally across your image, trying to include the subject (like a face) and a little background. Store the remaining test strips somewhere where they will not be exposed accidentally (in your paper box is a good place).

The next step is to expose your test strip by making a series of exposures (**3.34–3.37**), covering the paper as you go so that your first exposure covers the entire test strip, the second test exposure covers all but a thin section of the paper, the third covers a smaller part of the paper, and so on. Always cover the sheet to make the longest sections possible: only in this way do you get an idea of the best exposure over as wide a range of the image as possible.

Most photographers start by making 5-sec. exposures, with the f-stop staying the same throughout, giving them a series of test exposures as follows:

Test Exposure	Exposure Time	Combined Exposure Time
1	5 seconds	5 seconds
2	5 seconds	10 seconds
3	5 seconds	15 seconds
4	5 seconds	20 seconds
5	5 seconds	25 seconds

Test Strips

If you are using resin-coated paper and running it through an automated processing machine, cut your test strips with scissors or a rotary trimmer. Do not tear the paper as the ragged edges can cause the processor to jam or break down.

This may get you close to finding the 'correct' exposure for your print, but it is important to remember the **Reciprocity Law** (see p. 47) at this stage: an increase in exposure from 5 seconds to 10 seconds is equivalent to 1 stop, but an increase from 10 seconds to 15 seconds is only a ½ stop, and so on. Therefore, if you use the exposures in the table above, the exposure of the test strip does not increase by the same amount each time and the difference between the final strips (20 seconds and 25 seconds) may hardly be discernible at all.

3.34–3.37 Whatever technique you choose to make your test strip, if you are unsure which area received what exposure time, or if you have moved the paper and produced an odd-looking double exposure effect, it is best to repeat it all over again.

3.38 To lighten an area of a print you can use your hand or a piece of card on a wire, moving it around to avoid any sharp outlines or edges. A timer that counts down the exposure is very useful as it will give you a cue to start dodging (see p. 99).

3.39 You can make shapes with your hand to burn in and darken a selective area of the print, or cut a hole in a sheet of card for greater precision. Look at the image cast on the top of the card to see which part of the image is being affected.

3.40 If you make careful notes of your print exposures, with details of any dodging and burning in, it should be possible for you to make a number of matching prints. This is best done in a single session, as matching a print at a later date is never as easy.

For this reason, it is easier to manage the exposures of your test strip by working in 1-stop increments like this:

Test Exposure	Exposure Time	Combined Exposure Time
1	5 seconds	5 seconds
2	5 seconds	10 seconds
3	10 seconds	20 seconds
4	20 seconds	40 seconds

This is achieved easily by leaving the enlarger's timer set to 5 seconds, but hitting the button twice (for 10 seconds), then four times (for 20 seconds), and so on. This also makes it much easier to judge an exposure between any two sections on the test strip.

After processing your test strip, you need to view it in white light, rather than under a safelight. The first thing to consider is the contrast. If the print looks muddy and flat (low contrast), increase the contrast to grade 3 or $3\frac{1}{2}$, but if you are losing highlight or shadow detail, reduce it to grade 2. Then assess the exposure. You may already see that one section of the test strip looks right, or you may have two sections beside each other that are slightly too light and slightly too dark respectively. In either case, make another test strip using your new contrast grade, limiting the overall exposure so that it covers a smaller range: if you know for certain that 5 seconds is too short, and 40 seconds is too long, there is no reason to include these exposures in your second test strip. Once you have determined the exposure and contrast that you are happy with, it is simply a case of using these to make your final print.

Dodging and Burning

Although you may find that a single exposure is all you need to create a great print, this is not always the case, and more often than not, you might decide that certain areas of the image need to be darker than the base exposure and other areas need to be lighter. In this case you need to use 'dodging and burning' (**3.38–3.40**). Dodging involves covering up part of the print for a proportion of the exposure, to hold back the exposure and prevent it from going too dark. You can use your hand or a piece of card, holding it a little way above the easel and moving it about during the exposure to avoid sharp edges. Attaching a piece of card to a thin, stiff wire to create a **flag** will allow you to dodge the central part of an image. 'Burning in' part of a print gives it additional exposure to make it darker, and is often done by cutting a hole in a piece of card so that the extra exposure falls only on part of the image. This hole can be any shape to get the desired effect and your test strip will help you to judge how long the burning in (or dodging) time should be.

Quite often you will need to make a number of prints in order to get a good result – especially if combining both dodging and burning – so don't give up if your prints do not work out first time or every time. As you gain confidence and develop your skills you can also try changing the contrast grade for dodging and burning in, which can help you to get more detail into one area of a picture and more contrast for dramatic effect into another.

Planning Dodging and Burning

To plan complex dodging and burning, it is a good idea to make a 'straight' print first, using a single exposure. Draw around the areas that need a longer exposure and the areas to be held back with a thick black marker (so it can be seen under a safelight); your original test strip can help you decide the longer or shorter exposure times needed.

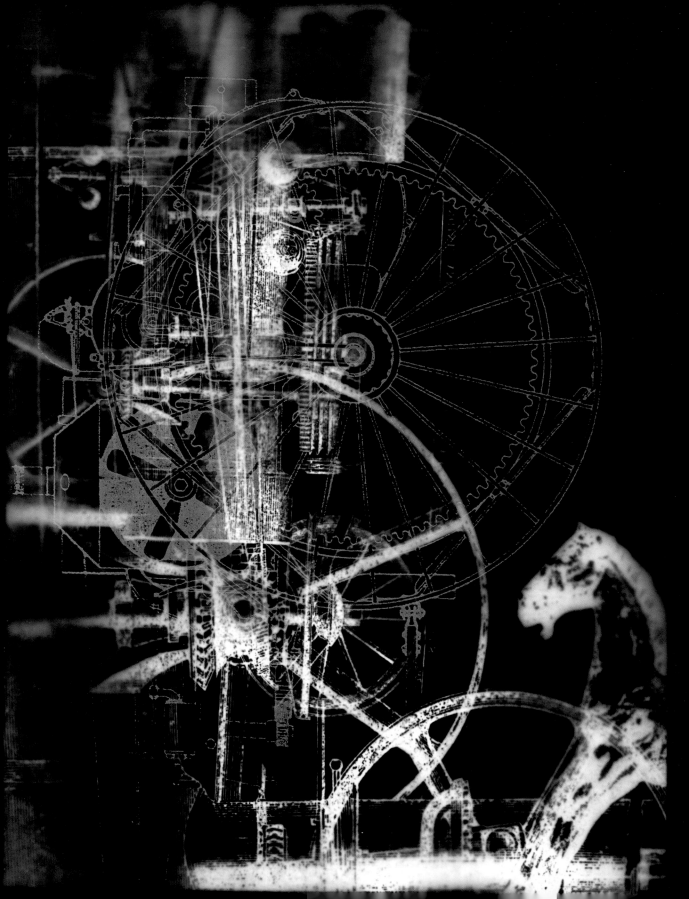

Photograms

3.41 (opposite) Pamela
Ossola used large sheets
of film to mix negatives in
the enlarger with images
on, or just above, the
baseboard easel.

3.42 (above) When
reviewing the test strip for
your photogram, you are
looking for an exposure
time that gives a strong
black, and either excellent
detail in a translucent
object, or a clear, sharp
edge with an opaque object.

While most of the prints that you make will be from negatives, there is no reason why they have to be. A photogram is an image made by placing an object directly onto photo-sensitive paper and exposing it to light, normally using the enlarger as a light source. With a little creative forethought, photograms can be a simple and exciting method of image-making, as well as a good introduction to using an enlarger. All you need is photographic paper, interesting translucent or transparent objects (or solid objects with good outline shapes) and a piece of card around the same size as your photographic paper.

Making sure that all your light-sensitive paper is safely stored away, turn on the enlarger light, open up the lens to its widest (brightest) aperture setting and – without a negative in the enlarger – set the enlarger height and focus to illuminate an area with focused edges that is slightly larger than your photographic paper. Now turn off the enlarger light, close the lens down by 3 stops, set the multi-grade filter to grade 3 (or fit a grade 3 filter below the lens) and place a strip of photographic paper on the baseboard or easel, under the area that will be illuminated, so that you can make a test strip.

Place your objects on top of the paper and make a test strip just as you would for a negative, covering the paper a section at a time as you make your exposures. Process your test strip and then look at it in daylight to determine the contrast and exposure.

When you get a good result on your test strip (**3.42**), arrange your objects on a larger sheet of paper to make your final print. Experiment with overlapping objects and using different objects in combination, or creating a narrative by using a series of shorter exposures and moving your objects to create varying shades of black, grey and white in the final image.

Taking Photograms Further

Once you have mastered the basic photogram skills, think of objects that might give exciting textures or images. Try holding some objects away from the paper so that the edges of the objects go in and out of focus. You can try combining objects on the baseboard with images on large sheets of film or acetate; and even combining objects on the baseboard with negatives in the enlarger (**3.41**).

Colour

Visible light forms a very small part of all the different wavelengths of energy that exist in the universe (**3.43**). The shortest wavelengths of energy include cosmic and gamma rays – invisible both to the human eye and to film – through to X-rays and ultraviolet light, which cannot be seen by the human eye, but can be recorded by most films. Below visible light are longer wavelengths including infrared, then heat, radar and radio waves.

The receptors in our eyes can process only a tiny section of the entire spectrum of light, turning these signals into messages to our brain that enable us to 'see' in colour. Although there is a wide range of colours in the visible spectrum (violet, indigo, blue, green, yellow, orange and red), our eyes have sensors that are stimulated by only the red, green and blue wavelengths, so they 'make up' all the other colours using proportions of these.

Each of our eyes contains some 120 million rod-shaped cells that create a black-and-white image and work best in low light, plus around 7 million cone cells that can see the red, green and blue wavelengths of light. These cone cells send messages to our brain, which translates them into an enormous number of colours: equal amounts of blue and green produce the turquoise colour, cyan; equal amounts of blue and red produce magenta; and equal amounts of red and green produce yellow. When there is an equal amount of all three wavelengths, we see white or neutral grey. Because we can produce any other colour by combining varying amounts of red, green and blue, these are called **additive colours**, and are commonly abbreviated to **RGB**. They are also known as **primary colours**. It is important to understand that in physics and photography, yellow is not a primary colour, as it is in painting.

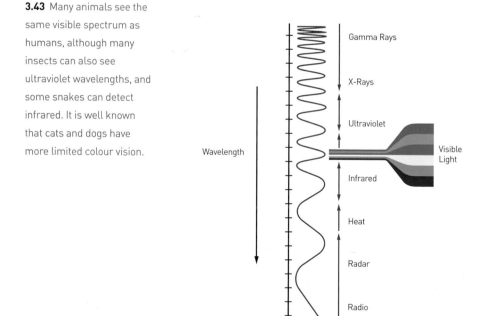

3.43 Many animals see the same visible spectrum as humans, although many insects can also see ultraviolet wavelengths, and some snakes can detect infrared. It is well known that cats and dogs have more limited colour vision.

RGB

It can be hard to believe that when red, green and blue are seen together they work additively to produce white, but you can test this for yourself quite easily. Take a magnifying glass up to a television or computer screen and find a white area. Through the magnifier you will see that the picture is made up of individual red, green and blue dots, rather than just being the white that your brain perceives when the screen is viewed from a distance.

3.44 Such scientists as Isaac Newton (1704), Johann Wolfgang von Goethe (1810) and James Clerk Maxwell (c. 1855) identified the correct relationship between the RGB primary colours and their opposites (or negatives), CMY, as well as those colours that fall in between.

Colour print using subtractive dyes on white paper

The relationships between red, green and blue are useful to understand, and the diagram above (**3.44**) shows that cyan is the opposite (sometimes called the 'negative') of red; magenta is the opposite of green; and yellow is the opposite of blue. These colour opposites are important when it comes to understanding how colour film works.

CMYK

All film and digital cameras (and television and computer displays) operate on the same RGB additive principle as our eyes, but printed output uses a different combination of colours: cyan, magenta and yellow. Yellow ink laid over magenta ink gives red, for example, while equal quantities of cyan, magenta and yellow laid over one another will produce a good black. At least, that is the theory. In practice, the inks are not 'pure', so mixing them equally tends to result in a dark, dirty brown, rather than black. To avoid this, an extra black ink (also known as a 'key') is added to the mix, which is why, when we talk about digital imaging output, we refer to **CMYK**, not RGB.

Colour Negative Films

Colour negative films consist of layers of black-and-white emulsion that are each sensitive to only one band of wavelengths of light: red, green and blue respectively (**3.45**). Since all silver halides are sensitive to blue and UV light, a chemical 'yellow filter' layer is included above the green- and red-sensitive layers to ensure that these record only green or red light. Although only these three layers are needed to produce all other colours (in much the same way as our eyes and brain operate), many modern colour films are multi-coated and will have, for example, two green layers: one that is more sensitive, to improve film speed, and another that is less sensitive, to increase contrast.

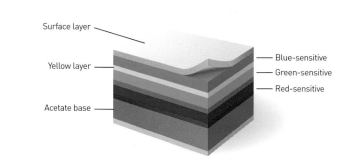

Surface layer

Yellow layer

Acetate base

Blue-sensitive
Green-sensitive
Red-sensitive

3.45 The green- and red-sensitive layers in a colour film can 'see' blue light, but it is filtered out. These layers are often multi-layered to improve film speed and contrast, although negative films have lower contrast than transparencies, giving them better shadow and highlight detail and a wider exposure latitude.

Colour negative films also include colour-making agents called dye-couplers, which are added to each of the colour layers. They remain colourless until they are used in the colour-development process, and therefore do not affect the recording of the picture. Colourless yellow dye-couplers are added to the blue-sensitive layer; magenta dye-couplers to the green layer; and cyan dye-couplers to the red layer. These colours are the opposite (or negative) of the layer itself.

The reason for all these layers and dye-couplers is simple: when you take a photograph of a subject, you want pure red light to affect only the red layer of the film, a yellow-coloured object to expose the red and green layers equally, an orange object to expose the red layer about twice as much as the green layer, and so on. In this way, all the colours in your subject are captured as accurately as possible.

Colour Negative Film Processing

When a colour negative film is processed, the colour developer works like a black-and-white developer to make a negative black silver image. In these areas, the exhausted colour developer combines with the colourless dye-couplers already in the emulsion to form brightly coloured dye: a yellow dye image will form in the blue-sensitive layer, a magenta image in the green layer and a cyan image in the red layer. In other words, a colour negative – in terms of both colour and tone – is formed.

In unexposed, undeveloped areas of the film, no reaction takes place, so no black silver negative or dye image is formed. The black silver and remaining silver halides are removed, usually by a combined bleach/fixer stage in the process, leaving only a yellow, magenta and cyan dye-negative image in the correct places in the layers in the emulsion.

To get this process right, the combination of the processing time and temperature is critical (**3.46**; the temperature must be 38°C, $\pm\frac{1}{4}$°C). If either the time or temperature is wrong then the result can be uncorrectable colour casts, with images displaying green shadow areas and magenta highlights, for example. For this reason, adjusting the standard process for colour negative film is not recommended, so increasing the development time to 'push' a film's ISO, or decreasing the time to 'pull' it, are not advisable.

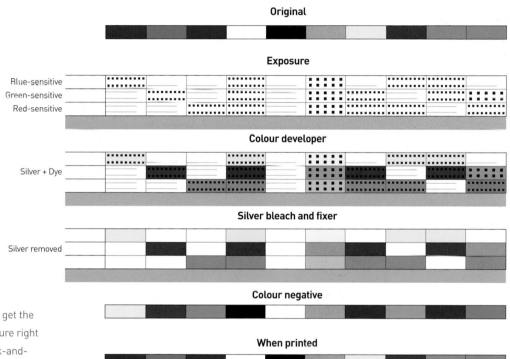

3.46 It is critical to get the time and temperature right for the initial (black-and-white) developer, as it will ultimately dictate how much dye image is made during the later colour developer stage. This makes it very difficult to process a colour transparency film accurately in a small hand tank.

There is a problem with making colour dyes in development, though: they tend not to be very pure or accurate, which can affect the final colour of any print or scan. To prevent this, an orange mask is added to the colour negative emulsion (**3.47**). As the negative is an interim stage in the process, rather than something that will be displayed in its own right, this mask is filtered out as part of the overall correct filtration when making a silver-based 'C-type' print, or by software settings when scanning the colour negative.

For many years, this orange mask caused problems with scanning colour negatives as each make of film – and even different films from the same manufacturer – had an orange mask with a slightly different colour. This gave poor results with generic scanning software, but modern software has improved this (**3.48**), with professional scanners (and many home scanners) now allowing you to compensate for a specific orange mask by entering the name of the film used before it is scanned.

3.47 (below right) The orange mask will give a colour negative more accurate colours than a colour transparency for reproduction ('repro') processes, and some fashion photographers still prefer colour negative film to digital capture.

3.48 (bottom) The problems that used to exist with scanning colour negatives have largely been resolved. Some photographers are making use of the scanning workflow to capture bright and vibrant colours, as with Tom Alexander's photograph of this lavender field.

Orange Mask

The magenta dye in the green-sensitive layer of a colour negative film absorbs some blue light, as well as green, so yellow is added to the magenta dye-coupler to compensate, making it physically yellow in colour. Because of this, the layer will form a magenta dye in exposed and processed areas of the negative, or a yellow mask in unexposed and unprocessed areas.

Similarly, the cyan dye absorbs a certain amount of green light, so magenta is added to the cyan dye-coupler, making it physically magenta in colour. In unexposed and unprocessed areas of this part of the film, we therefore see a magenta mask in the cyan dye layer, or cyan dye where the film has been exposed and developed. It is this combination of yellow and magenta masks in the unexposed and unprocessed areas of the film that makes it appear orange.

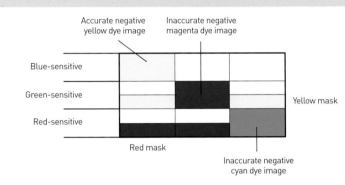

Accurate negative yellow dye image — Inaccurate negative magenta dye image

Blue-sensitive

Green-sensitive — Yellow mask

Red-sensitive

Red mask — Inaccurate negative cyan dye image

Colour Transparency Film

Colour transparency film (also referred to as 'slide film') produces a direct positive image that can be viewed immediately after processing, making it easier to scan and access from an archive than colour negatives. These films require a much more accurate exposure than colour negative film, as they are higher in contrast, which can result in a loss of shadow and highlight detail unless care is taken. Since this film is the final stage of output after processing, the colour also has to be correct at the time of capture, either by using colour filters over the lens, or by matching the film type to the colour temperature of the light source: colour transparency film is available in both daylight-balanced and tungsten-balanced versions.

Colour Casts

Different lighting conditions have their own colour temperature, which can introduce colour casts on colour transparency film. Daylight films are balanced for normal sunlight, but clouds absorb red wavelengths of light, so the light is bluer as the clouds get thicker, leading to a cool colour cast on transparency film. A straw-coloured 81A filter can be used in hazy sunlight to counter this, with a stronger warm-up filter (81C or 81D) helping when you are shooting under heavy cloud.

At sunrise and sunset, the colours become even more extreme, and daylight can have a colour temperature of around 3200K – the same as tungsten lighting. This explains why sunset pictures often look much better than reality: you are effectively using daylight-balanced film under warm, tungsten-coloured lighting conditions. If you need to get a correctly balanced colour image at sunset, then tungsten-balanced film would be a better choice.

The structure of a colour transparency film is very similar to that of a colour negative film, with a blue-sensitive layer at the top, a yellow filter layer beneath that, and then green- and red-sensitive layers of emulsion. Again, most films are multi-layered to improve their speed and contrast characteristics. There is one significant difference, though: colour transparency film cannot use a coloured mask to correct for deficiencies in the dye formed during processing, so it cannot record all colours as accurately as colour negative film. Unless the final output is a colour print, this is normally offset by the problems found in scanning an orange-masked colour negative, so it is of minimal concern.

3.49 Up-rating an ISO 400 colour transparency film to ISO 800 (by increasing the first developer time by about 30%) still gives an acceptable result, but up-rating a colour negative film will usually result in colour-balance problems.

Colour Transparency Processing

Although the basic principles of processing colour transparency film and colour negatives are similar, the end result is very different: a positive image, compared to a negative one. Therefore, the E-6 process used to develop transparency film starts with two additional stages. First, a black-and-white developer is used to make a black silver negative from the exposed areas of the film. Next, the unexposed and undeveloped areas of the film are chemically fogged so that they can be colour-developed, this time to form a black silver positive image and positive dye image. The black metallic silver is then removed using a bleach/fixer to leave a triple-layered positive colour image comprised of yellow, magenta and cyan dyes.

As with processing colour negative film, the entire transparency development process takes place at a temperature of 38°C and needs accurate timings and agitation. The first (black-and-white) development needs to be especially accurate, as the greater the black silver negative image formed at this stage, the less positive dye image will be formed. This provides the opportunity, however, to up-rate or 'push' the film (by up to 3 stops) or down-rate or 'pull' the film (by 1–2 stops), changing the image density (lightness or darkness) without vast shifts in colour balance (**3.49**): colour dyes are not being made at this first stage. You might wish to do this to correct a mistake in exposure, or effectively to increase the ISO of a film when working in low light conditions. The image will become grainier and the contrast increased, but often, if photographing a concert for example, this can be quite acceptable.

Exercise 1
BACK TO BLACK AND WHITE

Resources

You can do this exercise using any 35 mm film camera loaded with black-and-white film. If you have only a digital camera, change your colour images to black and white on your computer after downloading them. Remember to keep notes on your experiments in a workbook for future reference.

The Task and Extended Research

Millions of superb black-and white photographs have been produced since photography's invention (**3.50**); start by finding twenty that you really like. With each, note the photographer's name and country of origin, when the photograph was taken and a brief explanation of why you like it. The next stage is to take ten photographs that are successful because they are in black and white. Although you see colour images in the viewfinder, you will have to imagine how they will look in black and white, and what will make them successful. Maybe they rely on a strong composition, contrasty tones, patterns and shapes, or on a mood that can best be achieved in black and white. Your research on your favourite black-and-white images will help here.

3.50 Sebastião Salgado is one of the masters of black-and-white photography. The choice not to shoot in colour means the content and raw emotion of his pictures is distilled, as in this image taken in the Korem Refugee Camp in Ethiopia, 1984.

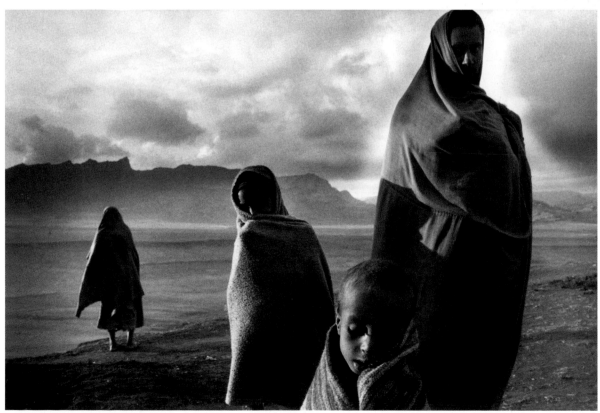

3.51 A co-operative black-and-white cat brought Nadya Elpis good luck for this picture, but she used excellent camera and composition techniques to make it a stronger image than if she had shot in colour.

3.52 Although Henry Fox Talbot used photograms in *The Pencil of Nature* (1844–46), Man Ray's 'Rayograms' of the 1920s and 1930s brought the technique to the fore, initially as part of the Surrealist movement. This image is from 1923.

Exercise 2

FUNKY PHOTOGRAMS

Resources

This exercise is best carried out in a darkroom environment, but there is a variant for those who do not have access to these facilities. You will need some photographic paper, but you do not need to choose the most expensive option – 25 sheets of the cheapest 10 × 8 in. paper that you can find will suffice.

The Task and Extended Research

You can experiment with making photograms in the darkroom as described in this chapter, using a dim red light or covering a low-wattage bulb in red acetate (ensuring it cannot melt or catch fire). You can work at night in a conventional room, preferably a bathroom or kitchen with running water.

A number of famous artists and photographers – including Pablo Picasso, Man Ray (**3.52**) and Alexander Rodchenko – have used photograms, so it is worth researching these and looking for examples of book jackets and CD covers that have been made using this technique.

Getting Started

Lay your objects out on the printing paper and expose them using an enlarger in the darkroom or a desktop angle-poise or similar reading light. You can use a small dish of developer and fixer to process your results. Alternatively, a 10- to 30-minute exposure to daylight will make the exposed paper go dark without the need for a developer. Some interesting colours may appear in the paper image depending on the type that you use, but you will still need to fix the image, which may possibly change the background colour.

You can colour your photogram base using blue, green or red cold-water fabric dyes; cold tea or coffee (fibre-based paper works best); or with more conventional photographic toners. Dying the base one colour and toning the image another may be interesting.

You may also choose to explore a hybrid workflow, by scanning the photogram and then colouring it digitally in the computer (**3.53**). If you have more advanced image-editing skills, you might like to try layering different coloured images on top of each other and experimenting with differing degrees of transparency.

Feedback

You can revisit this exercise over and over again as you gain new skills and ideas. It is surprising how often artists and designers use this simple technique to develop exciting images for both gallery and commercial output.

If you are on a school or college photography course, show this exercise to your tutors, along with your results and notes.

3.53 After making a few simple photograms of a Christmas decoration, Graham Diprose scanned the prints into Adobe Photoshop, colourized them, and overlaid them using layers to create this image.

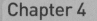

Chapter 4

THE BASICS OF DIGITAL CAPTURE

In this chapter you will learn how to:

• Select and operate a more advanced digital camera with interchangeable lenses

• Choose the best camera settings for your style of photography

• Understand the complex menu selections and set your camera up for best results

Choosing a Digital SLR Camera

4.0 (previous page) Palmer + Pawel arranged to shoot a group of martial artists in their changing room after their fights. Everything was shot in one exposure with no image manipulation, other than a quick clean-up and colour correction after. The skill was in using all the right camera settings.

4.1 (opposite) This typical high-quality stock picture was set up and shot speculatively, so Jeff Robins had to pay for the child model, make the parcel and give up his own studio time. A couple of years later it sold for a good fee.

Many of the criteria outlined in Chapter 1 continue to apply when you start to look for a camera that is suited to the higher resolution and specifications required by professional photographers. First you need to consider your budget: cameras with a better build quality and more advanced **auto-focus** system will be more expensive, as will those with a full-frame **sensor** that offers greater sensitivity and lower **noise**. If you are going to need A3 or larger prints for portfolio and exhibition purposes, a camera with a resolution of 11 megapixels or higher will be required.

Weight and size will also be important factors, depending on when, where and how you are likely to take your pictures. If most of your images will be taken in carefully controlled conditions, in a studio or on location, where a tripod is vital, then this may not be a major consideration, but carrying huge and weighty cameras and lenses over long distances might not be desirable.

For most photographers looking to create professional results, a digital **SLR** model will be the camera of choice. A single-lens reflex camera – whether it uses a digital sensor or film – is one where the image is viewed 'through the lens', using a prism and a mirror (which is moved out of the way when a photograph is taken) to direct the image from the lens to the viewfinder.

Optimum Resolution

Image-manipulation programs cannot enlarge a tiny image from a 4-**megapixel** camera up to a big print size any more than a section of a 35 mm film negative can be blown up to 40 × 50 cm without considerable loss of quality. Detail cannot be put back in if it is not there in the first place and, for the best quality, the size of the captured digital image should not be altered much, if at all. If your budget allows, a camera with a **resolution** of 16 megapixels, or more, is better for producing A3-sized prints than an 11-megapixel one.

Stock Libraries

Be careful if you hope to sell your pictures to stock libraries (**4.1**) or produce work to a professional standard, as many clients require high-resolution files. They will not accept images that have been enlarged digitally on your computer, so you need to ensure that your camera is capable of delivering the files they need from the outset.

An alternative to a digital SLR camera is one of the increasingly common hybrid cameras that combine the larger sensor sizes found in a digital SLR with interchangeable lenses and a comparable set of shooting controls. Where they differ is in their viewing system: most rely on an electronic viewfinder or the rear **LCD** screen for composing images, rather than the optical system that defines an SLR. As a result, these cameras are smaller and lighter than their SLR counterparts, but retain many of the advantages of a digital SLR and are capable of producing high-quality images.

For photographers with a more limited budget, or those travelling to countries or locations where dust and sand are likely to be a serious problem, some manufacturers also produce fixed-lens cameras (**4.2**) that have the same menu features as a digital SLR and, in some cases, a comparable size of sensor. They normally have a good zoom range from wide-angle to telephoto, but are often lighter and have the added advantage that dust cannot get onto the sensor. The disadvantage is that the lens cannot be changed.

Key Features

The range of features offered by a digital SLR varies widely, but there are a number of key features to look out for:

- Manual, **Aperture Priority** and **Shutter Priority** shooting modes
- A wide range of **ISO** settings, ideally with low noise at high speeds
- The ability to record **Raw** and **JPEG** files, both individually and simultaneously
- A choice of **Adobe® RGB** and **sRGB** colour spaces (see p. 136 and Chapter 7, p. 210)
- The type and maximum size of memory card that the camera can accept
- Number, type, size and weight of batteries needed
- Speed of activation. How long does the camera take to 'boot up'?
- External flash socket, or a 'hot-shoe' (see p. 138) on top to connect one to
- Speed of the auto-focus. Is there an unacceptable delay?
- A system for removing dust from the sensor electronically
- A good range of zoom, fixed and macro lenses to choose from
- Viewfinder correction, if you wear glasses
- Mirror lock-up facility for reducing vibration when shooting
- **Depth-of-field** preview

Buffer Size

If you plan to shoot a large number of high-resolution pictures in quick succession, you need to consider the camera's **buffer** size. The buffer is where image data is held temporarily before being transferred to the memory card, and the size of the buffer determines how many images can be shot in a row: once the buffer is full, the camera will stop while the image data is processed and recorded to the memory card, allowing you to continue shooting only once some of the data is cleared. Some digital SLR cameras have larger buffers than others, making them useful for sports photography or photojournalism, where rapid bursts of shots are often required.

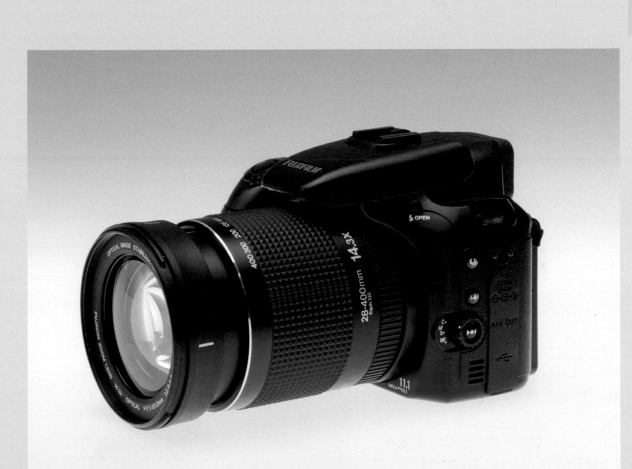

4.2 A fixed-lens digital camera with a good optical zoom that is capable of shooting Raw files can be an excellent and inexpensive back-up camera, or a good starting point for those on a limited budget.

Tethering Your Camera

Some digital SLR and medium-format digital cameras can be linked, or 'tethered', to a computer by either a USB or a Firewire cable. All the functions of the camera and lens can then be set and controlled – completely or partially – from the computer, including using the keyboard or mouse to trigger the shutter.

Tethering a camera can be a useful way to check a shooting set-up at the beginning of a session, as you can view your image at a large size on the computer monitor to determine precisely that the focus and exposure are correct. This is much harder to do accurately using the small LCD screen on the back of the camera. Tethering is not just limited to photography in the studio, either, as a laptop can be taken on location.

Lenses and Lens Coverage

The early digital SLR camera bodies were based on existing SLR film cameras that had a full-frame image size of 24 × 36 mm. The size of the imaging medium (digital or film) determines the angle of view of the lens being used and, as the sensors fitted to most of these digital camera bodies were smaller than the full 35 mm film frame, this narrowed the field of view – if lenses designed for film were used on these digital cameras, their focal length was lengthened relative to the image size. The standard lens for a 35 mm film camera (or full-frame digital SLR), for example, is 50 mm, but when used on a digital camera with a smaller sensor size it behaves like a longer, more telephoto lens.

The effect that a small sensor had on the focal length of existing film-camera lenses was not the only problem, though, as image quality could also be compromised when a lens designed to record a photograph on film was used on a digital camera. In an attempt to remedy this, many modern lenses are produced specifically for cameras with a smaller sensor size, creating a smaller imaging circle that better matches the dimensions of the imaging chip.

Alongside these, an increasing number of full-frame 'digital lenses' are also being designed, with improvements made in three key areas that are critical to high-quality digital photography: the first is the reduction of internal reflections within the structure of the lens; the second is that the type of glass used can optimize the light passing through the lens, giving fewer optical problems; the third is the coating on the lens – modern multi-coated lenses reduce surface flare and edge effects. As a result of these improvements, 'designed for digital' lenses are more efficient in all areas than the lenses designed for use with film cameras (**4.3**).

Image cut-off with longer sensor

Good cover for a small digital sensor

Circular coverage of a lens

4.3 Some specialist lens manufacturers make very high-quality, but less expensive, lenses to fit the bodies of many good digital SLRs. If you are buying on the Internet, you need to be very careful to choose the correct lens for your chip size.

Correcting Chromatic Aberration

Even the very best lenses can suffer from chromatic aberration (see below) to some extent, and digital imaging sensors can accentuate the problem. To counter this, some manufacturers have produced software that recognizes a lens from the image metadata and corrects distortion and chromatic aberration based on the specific **profile** of that lens.

4.4 (top left), **4.5** (above left) Pincushion and barrel distortion are most apparent when you have a straight line close to the edge of your picture. These pictures have been simulated in Adobe Photoshop for clarity.

4.6 (above right) Chromatic aberration can occur even with expensive lenses. Often a colour fringe appears around objects, or at the edges, particularly between very light and dark areas in the photograph.

Multi-Element Lenses and Aberrations

Lenses were used in telescopes and other scientific instruments long before photography was invented, but the most relevant application was in the camera obscura – a light-tight box with a lens that was used by artists to focus an image on translucent paper or canvas. This image could be traced and painted in as necessary to give accurate detail and perspective.

The lenses were not simple pieces of glass, though; they would often have two or more lens 'elements', made from different materials and cemented together so that they bent the light by different amounts. The reason for this was to try to correct the various aberrations and distortions caused by focusing or bending the light, such as straight lines appearing to bend outwards towards the edge of the frame (barrel distortion), or inwards towards the middle of the picture (pincushion distortion) (**4.4, 4.5**). Most good-quality photographic lenses are made to avoid these distortion problems.

A further reason for multi-element lens designs is to prevent **chromatic aberration** (**4.6**). The red, green and blue wavelengths of light that allow us to perceive different colours do not focus at the same point, so lens elements are used to bend each wavelength so that they are all brought together to focus on the camera's sensor. If they are not, a colour fringe can be seen around the edge of an object on the film or sensor, and it is this fringe that is referred to as a chromatic aberration.

The Sharpest Picture

Most digital SLR lenses will be at their sharpest when they are opened up from their smallest aperture setting by two stops (usually $f/8$–$f/11$). They may give more depth of field at $f/22$ or $f/32$, but the tiny lens aperture causes diffraction that leads to a slight loss of sharpness (**4.7–4.10**).

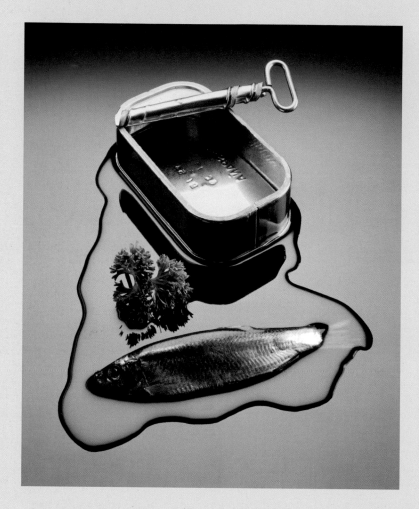

4.7 (above) Diffraction will make your image look slightly unsharp all over, rather than out of focus at a particular point, and it is particularly noticeable with big enlargements (**4.8**, top right). Before trading a good lens in, try opening up the lens aperture a couple of stops and testing again, as this may produce sharper images (**4.9**, centre right).

4.10 (right) Many photographers believe that the smaller the aperture, the sharper the image will be, but this is not true: at the very smallest aperture settings, diffraction can introduce a slight softness. Digital SLRs with small sensors are particularly prone to this problem.

Light rays pass through cleanly

Some light rays bent when passed through smaller hole

Focal Length and Sensor Size

The camera's sensor size needs to be considered when choosing a lens. The following is a guide to focal lengths (and their equivalents) for Full-Frame, APS-C and Four Thirds size sensors.

Full-Frame 36 × 24 mm	APS-C 23.6 × 15.7 mm	Four Thirds 17.3 × 13 mm		
14 mm	10 mm	7 mm	Fish-eye	Extreme wide angle, possibly creating a circular picture. Care needs to be taken to avoid your feet and hair featuring in your image
20 mm	14 mm	10 mm	Very wide-angle	Likelihood of edge or corner distortion, but amazing depth of field giving very exciting images of both close-up and distant subjects
35 mm	25 mm	14 mm	Wide-angle	Less distortion, with good depth of field and a wider angle of view than the human eye. Often used in reportage and photojournalism where the photographer wishes to create a sense of involvement in an event
50 mm	35 mm	25 mm	Standard	A lens with the same angle of view as the human eye. Often underrated as a creative tool
85 mm	60 mm	40 mm	Slight telephoto	Very useful for portraiture as it reduces facial distortion and allows a comfortable distance between the photographer and his or her subject
105 mm	74 mm	50 mm	Telephoto	Useful for candid street shots, still-life pictures where distortion must be reduced and some sports photography
200 mm+	140 mm+	100 mm+	Long telephoto	Must only be used on a tripod, often attached directly to the lens itself; used mainly for sports and wildlife photography

Zoom Lenses

It is only in recent years that the quality of zoom lenses has risen to a level that is acceptable to the professional market. A zoom lens has glass elements within the lens that can be moved backwards or forwards to alter its focal length. Zoom lenses tend to be designed to cover a particular range of focal lengths, and fall into three broad categories: wide-angle zooms covering focal lengths of approximately 12 to 24 mm; standard zooms from 28 to 80 mm; and long or telephoto zooms covering focal-length ranges in the region of 120 to 300 mm.

A fourth category – 'superzooms' – is also becoming more commonly available, covering an exceptionally wide range of focal lengths, such as 18 to 270 mm. For professional use, however, these are not recommended. This is because numerous compromises have to be made in the design of a lens that incorporates such an extreme range of focal lengths, and such design challenges invariably lead to a reduction in overall image quality.

While **zoom lenses** are a convenient solution that allows a range of focal lengths to be carried in a single lens, they are not without their drawbacks. A telephoto zoom is likely to be bulkier and heavier than a **prime lens** with the equivalent **focal length** and maximum

aperture, which means that slight camera movement is more likely. It will be exaggerated by the focal length, unless you remember to shoot with fast **shutter speeds**. Wide-angle and telephoto zooms can also cause increased problems with edge distortion, introducing more noticeable barrel and pincushion distortion respectively.

Prime Lenses

Prime (or fixed focal length) lenses can be cheaper and far lighter than zoom lenses and deliver the maximum optical quality for that one focal length. It is far easier to optimize a lens for a single focal length than it is to make it perform superbly across a range of lengths. For this reason, some professionals still prefer to work with two or three prime lenses, rather than a single zoom lens.

In addition to the benefit of optimum image quality, the maximum aperture on a prime lens is generally wider than a zoom lens covering that focal length, making a prime lens more usable in poor light conditions. A fast prime lens with a wide maximum aperture, such as an 85 mm $f/1.2$, can be fantastic for theatre or concert photography, where flash cannot be used. Such a lens can cost an enormous amount of money, though, and is often much heavier than a zoom due to the size of the lens elements needed to achieve the widest aperture setting. Of course, if you are using prime lenses, these will need to be changed more often – to switch from wide-angle to telephoto, for example – which increases the risk of dust entering the camera body and depositing itself on the sensor.

Test the Lens

It is wise to test any zoom lens that you are intending to purchase, as not all lenses perform equally well across the full range of the zoom.

Lens Hoods

The size and shape of the lens hood need to be considered carefully when zooming out to a wide-angle focal-length setting, as the hood might cut off some of your image. The lens hood made specifically for a particular zoom lens will have been made with the widest focal length taken into account, so this will not be a problem, but at the same time, the hood will be less effective at longer focal-length settings.

Protecting the Lens Coating

Lenses are expensive and the surface coating on the front element can be damaged easily. An ultraviolet (UV) or skylight filter fitted permanently to the front of the lens will protect it and is much cheaper to replace if it gets damaged. These filters have no effect on the exposure, but can improve the colour quality of images, as they reduce the amount of ultraviolet light entering the lens.

Macro Lenses

Macro lenses (**4.11**) are designed specifically for high-quality close-up work up to 'same size' (SS). They are often available in 50 mm, 70 mm and 105 mm fixed focal lengths and deliver a flat field of focus and little or no distortion of the image towards the edges. Many zoom lenses are said to have a 'macro' capability, but in general these allow only closer focusing, rather than true same-size images: a reproduction ratio of 1:1 (same size) is the definition of macro. You should note also that macro lenses are designed for close-up work, and therefore optimized for close focusing; quality can deteriorate slightly when they are used to focus on more distant subjects.

4.11 A good macro lens can open up a whole new world of images. Graham Diprose worked with the designer Peter Cannings and glass-blower Peter Layton to take abstract close-ups of glass vases, bowls and plates.

Lens-Based Image Stabilization

Some of the latest lenses from a number of manufacturers offer **image stabilization**, which helps to reduce camera shake. It does this by using floating optical elements within the lens that compensate for movement introduced by the photographer. The system uses sensors to counter any jerky movements, with the manufacturers claiming that handheld shots may be possible at shutter speeds up to four stops slower than is usually recommended.

In most instances, stabilization identifies both vertical and horizontal movement and tries to correct for both. If you are using your camera to follow a subject in motion, however, you can usually set a mode that disables the horizontal stabilization so that it does not attempt to cancel out your deliberate movement.

4.12 While image stabilization is often useful, Tom Jenkins used a lens without this feature to capture this shot, panning the camera while using a slow shutter speed of about $^1/_{15}$ sec.

4.13 Nadya Elpis used a slow shutter speed for this image, but rested her camera on a nearby support to capture this veteran, a few blocks from Red Square in Moscow.

Advanced Settings

Exposure

The exposure meter in your camera can function in one of three ways to help you determine the exposure for any given subject (**4.14**). These are selected using an option in the menu or by pressing a dedicated button on the body of the camera.

Multi-Zone Metering: Multi-zone, or multi-area, metering is a catch-all term used to describe a metering mode that divides the subject into a matrix of metering zones that are evaluated individually and then averaged, giving a good result for many subjects. Nikon calls this metering mode 'matrix metering' while Canon uses the term 'evaluative metering'.

Centre-Weighted Average Metering: Centre-weighted metering also averages the exposure of the entire image area, but it gives extra weight to the centre of the frame, on the assumption that this is where the main subject or point of interest is positioned. This metering mode is ideal for portraits, when your subject is near the middle of the picture, and is the most common setting that photographers choose for normal image-making.

Spot Metering: When you set your camera to its spot-metering mode, the meter reads the exposure from only the very centre of the frame (or, on some cameras, at the selected auto-focus point). Only a tiny area of the whole frame is read, and the exposure required for the rest of the frame is ignored. This type of exposure reading is useful for backlit subjects, macro photography, night-sky shots or pictures that include light reflecting from rivers, sea, snow or sky, as the exposure reading will not be influenced by surrounding areas. Care must be taken to meter from a mid-tone area, however.

4.14 In-camera matrix, centre-weighted and spot-metering patterns all read refracted light, but in a studio it can be better to place a white 'invercone' over a handheld light meter and measure, or balance, the incident light falling onto the subject instead.

Incident

Refracted

Spot

Reading Incident Light

All in-built camera exposure meters such as those just described read **reflected light**. They can be fooled into giving the wrong exposure when used in certain lighting conditions, such as side- or backlit subjects.

This problem can be avoided by using a meter that reads the **incident light**, which is the light actually falling onto the subject. Many professionals use separate handheld meters with an invercone attachment, a small white dome of diffusing translucent material. To take an incident meter reading you hold the meter right up to the subject, pointing the invercone away from him or her and towards the camera.

If the light source is directly behind the subject, the meter would be best directed to a point midway between the light source and the camera.

Because the invercone is a **diffuser**, it gives an average of the light falling on the subject, which assumes an 18% grey. It therefore takes no account of very light or dark subject matter, but is very useful for balancing different lights illuminating your subject.

Exposure Compensation, Bracketing and Exposure Lock

Although choosing an appropriate metering mode will help you to determine your exposure, any exposure-metering system can only provide you with an estimate of a good exposure, and can be fooled even if used correctly, let alone if mis-set in error – for example, you may photograph a black bird flying in a very light sky where the bird is rather small and towards the edge of the image. An exposure-metering system would produce an image with a correctly exposed sky but an underexposed bird, lacking in detail. In such situations, where the system is unable to take account of very light and dark subjects, the best and most creative exposure will come from the photographer choosing his or her own settings through experience and experimentation. To help you with this, your camera is likely to feature one or more exposure-adjustment tools that can be called upon when needed.

Exposure compensation is applied using a +/– button and a control wheel on the camera, and allows you to adjust the exposure suggested by the camera to make the resulting image lighter or darker. This can be used either for personal interpretation of a scene, or to compensate for a meter reading that has already produced a slightly over- or underexposed result. Applying positive (+) compensation increases (lightens) the exposure, while negative (–) compensation decreases (darkens) it; both are usually available in precise, half- or third-stop increments.

Exposure compensation is based on changing either the aperture or the shutter speed, depending on the shooting mode you are in, which could cause problems with camera shake or **depth of field**. You can check which of the settings your camera will adjust when its exposure compensation setting is used by taking a couple of sample shots at the suggested exposure and with –2 stops of compensation applied, and then checking what has changed by looking at the **metadata** in playback mode.

Exposure bracketing is useful if you are shooting **JPEG** files as it will record a number of different exposures in very quick succession, allowing you later to choose the one you prefer. By using the bracketing function it is possible to choose the number of images captured and also the exposure increment between them, again applied in half or third stops. Turn this mode off when you have finished, or you will affect all subsequent images being captured.

Automatic exposure lock, or **AEL**, works best when you are using centre-weighted or spot metering, and is especially useful when you have a subject that differs wildly from its surroundings in terms of its brightness. Exposure lock is used by placing the part of the image that requires the optimum exposure in the centre of the frame and then half-pressing the shutter release and/or AEL button. This 'locks' the exposure, keeping the same aperture and shutter speed settings when you recompose your image to take the picture. Check your camera's user manual for details, as it is quite common for the AEL button also to lock the focus, unless you override this in the camera menu.

Shutter-Release Controls

The camera's shutter can be controlled to give a number of effects, depending on your subject, so choosing the right setting is important.

Single Frame

S

This is the normal shooting mode: the camera captures just one frame when the shutter is released.

4.15 Some photographers prefer to use single-frame shooting to try to capture an event in a single shot, rather than relying on continuous mode.

Continuous Release

CL

In its continuous shooting mode, your camera will capture consecutive images for as long as the shutter release button is held down. The only limit to the number of frames you can record in succession is the camera's buffer: once the volume of image data fills the buffer, you will have to wait while images are recorded to your memory card before another burst of images can be shot. If you switch back to single-frame shooting, you will be able to record more images as soon as one image has cleared the buffer.

4.16 Continuous mode shoots a rapid series of pictures. Because of the volume of image data recorded, shooting may be limited by the camera's buffer, which will have to be partially emptied before another burst of images can be shot.

Shutter-Release Controls

Self-Timer

Your camera's self-timer introduces a delay between the shutter being released and the image being captured, nominally so that you can get into the shot. The delay is often adjustable – 2 or 10 seconds are the most common options – and as well as being useful when you want to be in your own image, the self-timer can also be used as a form of 'remote release' when your camera is mounted on a tripod, allowing you to trigger the shutter without the risk of introducing camera shake.

CH

4.17 Your camera's self-timer sets an adjustable delay, which is useful if you want to make self-portraits. A tripod, beanbag or flat surface is useful for lining up and supporting the camera while you move in front of the lens.

Multiple Exposure

Some digital SLR models offer a multiple-exposure feature that allows you to combine multiple images in-camera, rather than relying on your image-manipulation software. This requires a considerable amount of experimentation to adjust the exposure of the images so that they balance each other.

Lv

4.18 If your camera features a double-exposure feature, you can combine images in-camera, rather than using your manipulation software.

Other Controls

MUP

4.19 Mirror-up is an underused feature, but one that is highly recommended when shooting at shutter speeds below $\frac{1}{60}$ sec., even if the camera is on a sturdy tripod. Flipping the mirror up before the shot is taken will avoid any overall loss of sharpness caused by vibration of the sensor or camera itself.

4.20 Many digital compact cameras – and an increasing number of digital SLRs – allow you to use the rear LCD screen as a viewfinder, by providing a live video feed of the scene to be captured.

Other Camera Controls

Most digital SLRs feature a main navigation control, on the rear of the camera body, in the form of either a four-way rocker button or a rotational wheel. This will change its function when different shooting and playback modes are selected, and is often lockable to prevent accidental change. On some cameras, pressing a dedicated button will bring up a specific menu, such as **white balance**, **ISO**, metering mode or similar, and then the rocker is used to make the selection, while on other cameras, the settings and adjustments are made using a control wheel located near the shutter-release button (**4.21**).

The camera's rear LCD screen (**4.22**) is the main interface between the photographer and the camera settings, and the majority of digital compact cameras allow you to use this screen as a viewfinder as well, by providing a moving image of the scene to be captured. An increasing number of digital SLR cameras support similar live previews, often called **live view**. This is essential for recording HD video, but can also be particularly useful when it is hard to see through your camera's viewfinder – when you are holding it at a particularly high or low angle, for example. A recent development in digital SLR design is the use of a fixed mirror that allows part of the image to pass through it (to the sensor or rear LCD), while also reflecting the image being photographed through the optical viewfinder. This allows continuous viewing and auto-focus and, as the mirror is fixed, there is less vibration (reducing the risk of blurred images) and potential for higher shooting speeds.

In most cases, while your camera is in playback mode it is possible to overlay your images with some, or all, of the image information known as **EXIF** or 'metadata'. This is information that is recorded alongside the image file, and includes such data as the aperture, shutter speed, ISO and white balance, allowing you to check the settings used for a particular shot.

LCD Screen

The rear LCD screen allows you to review your images immediately after capture, but only a few hundred thousand pixels in the screen are used to represent the millions of **pixels** in the photograph. Most cameras do have a useful magnifier that enables you to check focus and highlight and shadow detail, though.

Reset Button

Your camera is likely to have a reset button, accessible via a set-up menu, that will restore its default settings if you get confused about which settings you have adjusted. Some cameras offer two reset levels: one that will reset some of the custom settings, and a second that will perform a full reset, returning to the manufacturer's defaults. Check the camera's manual for specific details.

Viewfinder

Main control dial

Various selectors

Rotary rocker control

Viewing screen

4.21 The position of buttons and controls varies not only from one manufacturer to another, but also sometimes between camera models. If possible, it is well worth taking the time to get some hands-on experience with a camera before you buy it.

4.22 LCD displays on the top of a digital SLR offer different amounts of information, depending on the camera mode that you are using. Manual normally offers the most information, but it is a good idea to familiarize yourself with what everything means.

Getting Colour Right

In Chapter 1, we looked at white balance, and the same settings covered there will be found on any good digital SLR. But to use these accurately – or experimentally – you need to understand **colour temperature**, which is measured in units called **degrees Kelvin**.

The table on p. 132 tells us that even with the white balance on your camera set to **Incandescent** (3200K), candles will appear warm or red in a photograph, as they have a lower colour temperature of 2500K. You will also notice that daylight is not a fixed colour either; as the sun rises higher in the sky it turns bluer, and this also happens when the weather becomes more overcast. This helps to explain why sunset pictures can look more orange than they appear in real life: although you may be using a Daylight white balance setting (5500K), the sunset is much warmer, at 3200K, which is the same colour as a tungsten light.

Fluorescent lights are missing from the table, as are energy-saving bulbs, because there are numerous versions of these lights, producing a wide range of colour temperatures. Consequently many digital cameras include up to three alternative settings for use with fluorescent lighting.

The mercury vapour lights often used in sports halls can also be problematic, as their colour temperature changes dramatically as they warm up, and can also be affected by the age of the lamp. Other problems can occur when two or more light sources with differing colour temperatures appear in a scene that you want to photograph, such as a table lamp mixing with daylight coming through a window. In these difficult lighting situations, a custom white balance is often the solution, and most high-end cameras will have this feature.

Filters for Colour Slide Film

While the colour of a digital image can be corrected after capture, if you are using colour slide film it is important to recognize these subtle changes as the sun rises or it clouds over, and use a range of orange (81 series) or blue (85 series) filters.

Fluorescent Lighting

Photographers using colour film dread shooting under fluorescent lights, as their colour temperature is so variable. If you are shooting digitally, try to get the white balance as accurate as possible in-camera and refine the colour later, using your image-editing software.

Mixed Lighting

Many photographers do not bother to learn the more complex custom white balance procedure, but it can be very useful, particularly when there are mixed lighting sources.

Approximate Colour Temperatures

Different light sources have different colour temperatures. Our eyes and brain adjust to these readily, so we rarely notice a difference, but your camera's sensor needs a white balance system to compensate.

		White candle	2500K	Very red indeed
		40W household bulb	2800K	
		100W household bulb	3000K	
		Studio photoflood 150W	3100K	
Light Bulb	**White Balance: Tungsten** (also called Incandescent)	Tungsten Halogen Studio Redhead	3200K	
		Tungsten colour slide films	3200K	
		Slide projector bulb	3200K	
		Daylight at sunrise or sunset	3200K	
		Daylight an hour after sunrise (in UK in summer)	3800K	
		Daylight two hours after sunrise	4250K	
		Daylight noon in winter in UK (assuming no clouds)	4750K	
		Daylight three hours either side of sunrise or sunset in UK	5000K	
Sunny	**White Balance: Sunny** A generic 'sunny' setting, as the colour temperature still varies between winter and summer and your proximity to the equator.	Daylight summer 10am to 5pm	5500K	
		Daylight films	5500K	
		Strobe or other large studio flash	5500K	
		Bowens Esprit-type units	5800K	
		Hazy sun, soft shadows	6000K	
Flash	**White Balance: Flash** Normally balanced for the on-camera flash. Some larger studio flashes may suit a Sunny or Custom setting.	Smaller flash units	6000K	
		Digital standard for daylight	6500K	
		Cloudy but bright day	7500K	
Cloudy	**White Balance: Cloudy** Hazy sun will remain quite warm, while heavy thunderclouds give a much cooler (bluer) light, so the results can vary.	Cloudy, dull, overcast	8000K	
		Cloudy and rainy	9000K	
Shade	**White Balance: Shade** When you are shooting in the shade on a bright sunny day, the bright-blue dome of the sky, which gives a cool, blue light, will light your subject.	Bright sunlight but in the shade	12000K	Very blue indeed

Filters Used in Digital Capture

When the only option was to shoot on film, getting the colour right in-camera was crucial, especially if you were shooting colour transparency film. Digital imaging has changed this and your photographs can easily be colour-corrected using image-editing software. As a result, there are now very few filters that you need to consider using at the capture stage.

The first filter that you might want to use is a **neutral-density (ND) filter**. These are available in two types: plain ND, and graduated ND. Plain ND filters are greyish in colour and simply reduce the amount of light entering the camera, without affecting the colour. They come in a variety of strengths, reducing the exposure by 1 stop, 2 stops and so on, and can be used in very bright conditions when you want to work with a wide aperture setting that would otherwise result in an overexposed image, or wish to force the camera to use a slower shutter speed to capture movement.

Graduated ND filters are half clear and half coated, so the neutral-density coating only sits across a portion of the scene, rather than the entire frame. Such filters are most commonly used in slot-in filter systems to balance the exposure in a scene, especially for landscape photographs where the sky is significantly brighter than the land. Again, graduated ND filters are available in a variety of strengths and, because they are used in a slot-in filter system, they can be combined to increase their effect.

The final filter that may prove useful for digital photography is a polarizing filter. You can control reflections in water or shop windows (**4.23**), for example, by rotating the filter on the front of the camera until reflections are reduced or disappear entirely (**4.24**). As this effect is achieved at the time of capture, by filtering the light, it is impossible to re-create in image-editing software. A polarizing filter is at its most effective when the filter is at an angle of 45° to the sun and, outdoors, this can also give an intensely deep blue sky, as well as controlling reflections.

Fashion Shots

Polarizing filters are not just useful for outdoor photography: they can also be used in fashion and beauty photography to reduce reflections on shiny skin. Care needs to be taken, though, as over application of the polarizing effect can make skin take on a 'plastic' appearance.

4.23, 4.24 A polarizing filter allows only wavelengths of light vibrating in a particular direction to pass through it. Often, reflections from glass or water are already polarized in one direction, so by rotating the filter to a certain angle it is possible to reduce this effect.

4.25 It is always risky to use a high level of JPEG compression in-camera, as you may find that if you take a successful picture, you will not be able to enlarge it for your portfolio without a considerable loss of image quality.

Image Resolution

As with smaller, compact cameras, you can change the resolution of the images you capture with your digital SLR, although, having spent your money on a good camera, there is generally very little point. Most cameras offer a choice of three image-resolution settings (**4.25**) that can be applied to JPEG images:

Large (L)

Uses the maximum number of pixels to give the best quality, finest detail and full pixel dimensions of the sensor.

Medium (M)

Reduces the file size, making pictures faster to save, but loses quality and detail. May restrict the amount by which an image can be enlarged.

Small (S)

Used primarily for images that will only be seen on screen or on a web page. Files are very small, so the camera shoots and records them very quickly, but it can be impossible to make prints much larger than a few centimetres/inches in size.

Pixel Dimensions

The **pixel dimensions** of a digital photograph are based on the number of **photodiodes** on the imaging sensor that makes up the capture chip, both horizontally and vertically. If this were 4368 × 2912, for example, that would also tell you the proportions of the captured image.

Recording at Low Resolution

Recording images at a small or medium resolution can be risky: if you take a great photograph in this resolution, you may never be able to print it out at a high enough quality for your portfolio. Commercial clients have also been known to commission images specifically for a website, but then decide that they wish to use them in a brochure or magazine as well, leading to reshoots or disputes if the original images were photographed at a low resolution.

Compression Settings

A digital SLR will offer a choice of Raw and JPEG file formats, but if you choose to shoot JPEGs, further options become available. JPEG files are compressed using what is known as **lossy compression**. This means that the data making up the image is compressed by a process of averaging and, when reopened, will not be exactly the same as when captured. The higher the **compression**, the smaller the file size, but the more image detail will be discarded. This is covered in more detail in Chapter 7.

Small compact cameras only work by compressing files as JPEGs so that they can fit lots of images onto a **memory card**, and many of these cameras will only offer this format. More advanced digital SLRs, however, will offer a choice of compression levels that can be set to suit your usage: low or minimum compression gives large file sizes and maximum image quality; high or maximum compression produces much smaller file sizes with greater degradation; and medium compression yields results that are between the two.

If you choose to shoot in JPEG, convert the file to a 'lossless' file format, such as **TIFF**, as soon as possible after downloading to your computer. If you leave your file as a JPEG and open it and resave it a few times, it will degrade more and more until the damage shows in the image as artefacts (flaws): the compression is cumulative with each resave. There will be no effect if the image is opened and then closed without saving, however, which is how this format is used in web design. Two close-ups of **4.26** are shown: **4.27** (below right) is an uncompressed TIFF, while **4.28** (bottom right) is a JPEG that has been resaved several times.

4.26–4.28 Beware of software that encourages you to make changes to files and then resave them: each time you save a JPEG as a JPEG, a little more image quality is lost for ever.

File Formats

The usefulness of JPEG files is restricted not only by the degrading caused by compression, but also by their limited **dynamic range**, which is the range of tones from black shadows to white highlights. Most digital SLRs, however, also offer Raw-file capture, which can dramatically improve the dynamic range. It is the ability to shoot Raw files that makes a digital SLR camera a serious professional tool. With a Raw file, the data from the sensor is unprocessed, producing a larger file than a JPEG, and one that contains more information. As a result, a Raw file is capable of capturing a dynamic range of up to 11 **f-stops**, similar to the human eye, which is more than any colour film. By comparison, a JPEG can capture only around 7 f-stops, making it far more likely that you will lose shadow or highlight detail from your image. In addition to their increased dynamic range, all Raw files are produced with a higher **bit depth**; that is, they offer a huge increase in the colour detail that is recorded. A JPEG always has an 8-bit colour depth, but most digital SLRs produce Raw files with a 12- or 14-bit colour depth. This gives far more control over the exposure, tone and colour quality of the image when the Raw file is processed in your computer.

Many cameras can be set to produce a JPEG and a Raw file at the same time. With this setting it is still possible to use different degrees of compression for the JPEG image (perhaps to allow you to view your pictures more quickly using the smaller files), with the option to process the best Raw files to TIFFs for optimum quality. Remember that this setting will take up more room on your memory card, reducing the number of images the card can hold.

Colour Space

The human eye can see as wide a range of colour tones as any good digital camera that is recording Raw files, but getting the colours to appear 'correct' in a digital image is not just a question of setting the right white balance. Colour spaces were introduced to remove inconsistencies in colour calibration between such devices as computer monitors, scanners and printers, and, of course, digital cameras. Before colour spaces were introduced, the whole process was dependent on the quality of the device being used and the range of colour and tone that it could 'see'. This could vary wildly and inconsistent results were likely – a printer may see colours differently from a digital camera, for example.

Most digital SLRs offer a choice of two colour spaces (**4.29**): sRGB and Adobe RGB. On a digital SLR, sRGB is often the default setting, and it is the only option on most compact cameras. This is a smaller space than Adobe RGB – that is, it allows a smaller range of colours, which can lead to a loss of tone and colour in an image. Adobe RGB is the largest colour space used by digital SLR cameras in JPEG mode (when processing Raw, the colour space can be assigned when the file is converted) and it was designed to emulate the range of tones and colours produced by conventional colour films. As a result, it is the standard colour space used for images that will be going into print production, for example for reproduction in a book or magazine.

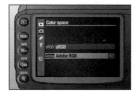

4.29 Menus vary from camera to camera and some will not have this option, but this is the selection to look out for, so that you can choose sRGB or Adobe RGB colour spaces.

Setting Camera Sharpness

Every digital image is made up of tiny pixels the square shape of which has the effect of softening edge detail, making an image look slightly out of focus overall. The digital images from your camera can be improved by sharpening to compensate for this. The complex mathematical algorithms involved in sharpening mean that it is better carried out using a large computer and an image-manipulation program, such as Adobe® Photoshop®, rather than the small processor in the camera: in-camera sharpening can produce quite clumsy-looking results by comparison (**4.30, 4.31**).

As is the case with many in-camera options, the sharpening setting only affects JPEG files, not Raw files, and once applied by the camera it cannot be undone and may limit what can be done to the image later on. Because of this, it is best to switch your camera's sharpening setting to 'off' or 'low', regardless of the file format.

4.30, 4.31 It sounds tempting to sharpen your images in-camera to get a better picture, but this can easily lead to an unprintable or unsaleable image. Sharpening should always be done on your computer, where you can undo the effect if it is too strong.

Shooting with Flash

Most digital SLRs, with the exception of very high-end cameras, have a built-in flash unit that flips up from the top of the viewfinder prism. As with compact cameras, this means that it is very close to the axis of the lens, so portraits may suffer from **red-eye**, especially when the subject is looking directly into the camera. All digital SLR cameras with a built-in flash offer a red-eye reduction mode, however.

Using a light source that is so close to the lens can also result in a bland, flat light, often with a cold blue or white feel that is unattractive for skin tones. Backgrounds also tend to come out very dark and lack detail if the flash is used as the sole light source, simply because the power of these small flash units is low, and they are incapable of reaching far beyond a subject that is more than 2–3 m away. A slow-sync mode may help counter this by combining the brief burst of flash with a longer shutter speed that records more of the **ambient light**, and this can often give more interesting results.

Recognizing the limitations of built-in flash units, camera manufacturers also produce dedicated external flashes that fit the hot-shoe (a mounting point for external flashes, located on top of the camera). The lighting from these will be more powerful than the built-in flash, but many of the in-camera flash problems remain if they are used to light the subject directly. For this reason, the best external flashes allow you to alter the direction of the head, so you can bounce the light off a ceiling or wall to soften it and make it less direct (**4.32**).

To control these external flashes, as well as the built-in unit, digital SLR cameras use **through-the-lens (TTL)** flash metering. This matches the output of the flash to the aperture and ISO settings on the camera, as well as the focus distance, before firing the flash to take the picture. This all takes a fraction of a second, and is barely noticeable. If the resulting exposure is not quite what you were looking for, then most cameras feature flash-exposure compensation, which works in a similar way to standard exposure compensation: use positive (+) compensation to boost the flash output, or negative (−) compensation to reduce it. Used in conjunction with exposure compensation, this can provide you with full control over how your image looks and how the ambient and flash lighting are balanced.

In addition to a hot-shoe flash connection, some digital SLR cameras have a built-in sync socket that allows external studio-type flashes to be connected. Digital SLRs without a sync socket can be fitted with a hot-shoe adapter that slips into the top of the camera and provides a socket that will allow you to connect a flash sync lead.

In both cases, the sync socket simply triggers the flash, nothing more. As there is no TTL control, the camera is normally set to Manual mode, but it is important to ensure that the shutter speed is set correctly. The electronic shutter on a digital SLR will often allow you to shoot at all shutter speeds with dedicated flash units, but if you are working with a studio flash, or a non-dedicated unit, you will need to make sure that the shutter speed is set at, or below, the camera's sync speed. This is usually $1/250$ to $1/125$ sec. and is the fastest shutter speed that can be correctly used to produce a photograph taken with flash. If you exceed this speed, it is likely that part of the image will be 'cut off' and unexposed.

Batteries

A built-in flash relies on the camera's battery for power, and will considerably reduce the number of shots you can take before the battery needs to be recharged. If you need to photograph an awards ceremony, wedding or similar location-based event, never use the in-camera flash unless you have a large supply of fully charged batteries or can run the camera from a mains supply.

Compatibility

Not all external flash units – even those from the same manufacturer as the camera – will be compatible with all camera models, so check before spending your money. Also, if you are buying a flash from a third-party manufacturer, check that it offers full compatibility with your specific camera model: some may not allow all their features to be used on certain cameras.

Triggering Flash Units

Some studio flash units use a high trigger voltage, which can damage the camera's electronic circuits if the flash is connected directly via a sync socket or hot-shoe adapter. If you are in any doubt, use a radio or **infrared** trigger to fire the flash unit. Alternatively, some studio flashes have 'slave' cells, meaning that they can be triggered by detecting the firing of your camera's built-in flash.

4.32 The range of flash units available for your digital camera can be confusing. One that is ideal for a simple close-up shot may be hopeless at lighting a larger group of people or covering the same angle of view as a wide-angle lens.

Focus

A digital SLR will allow you to switch between auto-focus (AF) and manual focus (MF), by using either a switch on the camera lens or a button or switch on the camera body. For most of the photographs you take, auto-focus will produce the result you are looking for, although you may well find that manual focus is preferable in certain situations.

Most cameras offer a choice of three focus modes; some offer more, but this core trio is more than enough to cover most eventualities.

4.33 Auto-focus zones can often be selected by using the rocker switch (multi-selector) on the back of the camera.

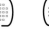

Manual (MF)

Auto-focus is deactivated and the photographer adjusts the focus of the lens manually, using the viewfinder as a guide. Manual focus is useful when the AF system is struggling to get a focus lock (in low-contrast situations, for example) and can help to avoid a delay between pressing the shutter release and taking the image as the AF system 'locks on'. Focusing manually is also useful when you are working with a wide aperture setting and want a very specific part of the image to appear sharply focused.

For critical focusing in manual focus mode, zoom in on your subject so that it fills the viewfinder, check the focus, then zoom out to your planned composition. If using manual focus on a studio tripod, where neither the camera nor the subject will move, the 'magnifier' in playback mode is useful to check a test shot for accurate focusing before shooting.

Single AF (AF-S)

The camera will focus when the shutter-release button is pressed halfway down. If the subject moves, the focus will not change unless the shutter release button is released and half-pressed again. Single AF is the mode used most regularly for slow-moving and static subjects.

Continuous AF (AF-C)

Also called AI-Servo on some cameras. Continuous AF will constantly adjust focus when it detects a moving subject. It is very useful for sports and wildlife photography, as it can help to keep a rapidly moving subject in focus, but it can reduce battery life as the AF system is constantly active.

Consistent Settings

Be careful not to set the lens to auto-focus and the camera to manual focus: always check that the camera and lens settings match.

The majority of AF systems use a number of auto-focus zones, or points, that are spread across the frame. The number of areas can range from five to fifty-one and, depending on your camera, these can be selected automatically by the camera, or you can pick a point manually, which allows you to choose a specific part of the image to focus on, without changing your composition (**4.33**). You will be able to see which AF point has been selected through the viewfinder, where the points are superimposed over the image.

Regardless of whether the focus point is selected by you or your camera, all AF systems need a reasonably high level of light to function properly, and most will use an AF-assist lamp in the camera body when the light levels are insufficient. This can help in poor conditions, but the effective range of the lamp is limited, and it can also be quite intrusive as it blasts light at your intended subject.

Exercise 1
MOVING TARGETS

Resources

This project is designed for digital SLR cameras, but any camera with Aperture Priority and Shutter Priority, or Manual mode, can be used.

You will also need your workbook to make notes and add examples of the images that you take.

The Task and Extended Research

This exercise is an opportunity to experiment with images involving movement. Carefully plan your choice of subject and background. If someone wearing something white moves in front of a dark background, you get a streaky 'painting with light' effect (**4.34**). If someone wears dark clothes and moves in front of a light background, they will become transparent and ghostly and may disappear altogether (**4.35**).

The shutter speed, and the speed at which you move the camera or your subject moves during the exposure, can alter the image enormously. Try the same action with longer exposure times and someone moving slowly, as well as with shorter shutter speeds and more rapid movement.

4.34 With a white subject against a black background, and a 1-sec. exposure, try posing your subject and telling them to walk backwards out of the picture when they hear the camera shutter open.

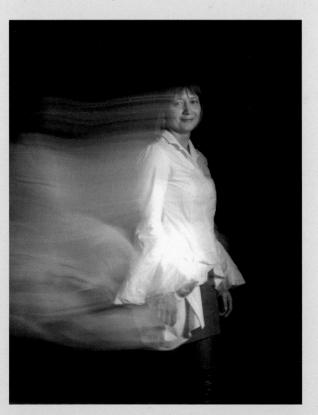

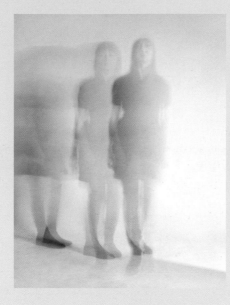

4.35 If a dark subject moves against a light background during your exposure, all that will be recorded is a very pale and ghostly image, particularly if the exposure time is long.

Base Your Exploration on These Ideas

Abstract	Five photographs where the camera moves, but the subject is stationary.
Panning	Five photographs where the camera is moved to follow a moving subject. It is useful to start moving the camera before you shoot and follow the subject shortly after the shutter has closed for a smooth pan.
Dynamic	Five shots where the camera is fixed (resting on a wall, tripod or beanbag, for example), but the subject – or part of the subject – is moving.
Zooming	Five shots with an interesting subject in the centre of the image, where you zoom your lens during a long exposure.
Experimental	Five shots that use any of the above ideas, but taken at night.

Getting Started

You could choose the same location as previous exercises, such as a busy street, park, riverside or the seaside, or go somewhere new. You can look for potential images or get friends to help you by acting as moving subjects. Use Shutter Priority to control the length of your exposure, or switch to Manual, perhaps to make your images lighter or darker than the camera would choose. The brief is to end up with five good images from each of the above ideas, but it is a good idea to shoot more so that you have plenty to choose from.

Feedback

One of the advantages of shooting this exercise on a digital camera is the instant feedback on all your experiments. Sometimes a picture where a small part of the subject is pin-sharp works well, so use the magnifier in playback to check your images as you go. Keep notes of everything you do, so that when you lay the photographs out in your workbook you can see which shutter speed and aperture combinations work best.

If you are on a school or college photography course, show your tutors this exercise and consider presenting the results as a series of images or as a screen-based slide show.

Exercise 2

TELL ME A STORY

Resources

A digital SLR with Aperture Priority and Shutter Priority (or Manual mode) is recommended for its creative controls and immediate feedback, but you can use any type of camera. Use your workbook to make notes and add examples of your images.

The Task and Extended Research

Many magazines that are aimed at the teenage market employ photo-stories as a form of narrative. With their comic-book-style speech bubbles and low-budget approach to models, locations and props, many of these stories lack style or quality; in a way, they are not very different from the storyboards used by the movie industry to plan a scene.

Your task is to create your own photo-story. First draw a storyboard that develops your scenario and narrative, then set up and shoot the images. Present your photographs in a storyboard style, either with speech-bubble dialogue or text underneath each frame, or in a 'silent movie' style. You can do this project by yourself or collaborate with a friend or two if you prefer, but try to choose roles that suit everyone's talents.

Your narrative sequence must consist of at least eight, but no more than fifteen, frames, and should be based on one of these three scenarios:

- 'That is the dumbest idea I ever heard!'
- 'You want it by when?!'
- 'Whatever you do ... don't press the red button!'

Before you begin, investigate the work of photographers who employ narrative and sequence, such as Cindy Sherman (**4.36**), Duane Michals (**4.37**) and Sophie Calle.

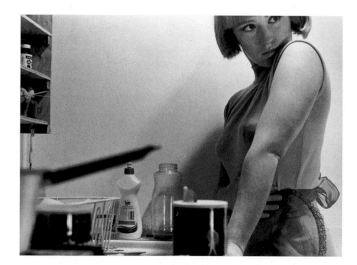

4.36 Although she turns the camera on herself, Cindy Sherman's eclectic photographs are hardly self-portraits, but more a means of commenting on such issues as the role of women and of the artist in the contemporary world.

4.37 Duane Michals often uses photo-sequences to change our perceptions or emotions as each new image is viewed. As he said, 'Photography has to transcend description ... it can never pretend to give you answers. That would be insulting.'

Getting Started

Planning is vital in this exercise, both in writing the outline for your story and in deciding what images you want or need to illustrate it. Use the drawing stage to plan camera angles and lighting for mood and effect, and make a list of all the actors, clothes and props that you will need to shoot your story. You may also need to get permission to use your chosen location.

The drawn storyboard can be as good or as bad as your drawing skills, so it does not matter if you use stick figures or produce beautifully shaded, three-dimensional images: the board is just to help you turn the story into a visual language and plan everything for the day of your shoot.

Remember also that you do not have to shoot the pictures in the order in which they will be presented – TV shows and movies are often shot out of sequence, and you can do the same, though you need to be careful to maintain continuity between shots, especially if you are shooting on location in variable weather conditions.

Feedback

If you are using a digital camera, it will allow you to analyse your photographs instantly, so you may want to try a number of slightly different camera angles or expressions on your models' faces for each frame and edit them down later. You may also want to experiment with lighting, to create a particular mood or effect.

When it comes to presenting your images, use your image-editing program to create a printed contact sheet of your final sequence, or consider combining the images as a digital slide show before showing them to your friends or tutors.

Chapter 5

REVIEWING AND DOWNLOADING DIGITAL IMAGES

In this chapter you will learn how to:

- Play back and evaluate your images in-camera
- Understand the basic computer technology needed for digital imaging
- Download your pictures safely onto a computer hard drive
- Archive your images

5.0 (previous page) To make her model look like a computer circuit board glowing in the dark, graphic designer Kristin Katzer conceived the idea of using the green luminous paint normally found on clocks and watches. Graham Diprose had to work out how to take the photograph.

5.1 Tamara Craiu grabbed this shot of two young tourists stopping in a busy street to share and enjoy their pictures. The ability to review digital photographs immediately – and decide on your favourites – has changed the way that we use photography.

Digital Playback

One of the advantages of digital imaging over film is that it allows you to review your images instantly and decide immediately if they are successful, both visually and technically (**5.1**). With many cameras you can zoom in on an image to check the focus or a facial expression, for example, or to determine whether a creative effect has worked out. This instant access is not without its disadvantages, however, and if you are shooting street photography or taking portraits of friends, you might find that the subject's ability to assess the quality of your work begins to interfere with the shooting process.

Playback Mode

The camera's playback mode is usually activated by a dedicated control, most often a button with a small green arrow. Pressing this will open the last image that you recorded so that it is displayed on the camera's rear **LCD** screen. Images can often be viewed either singly or as a 'contact sheet' with multiple thumbnail images on screen at once.

If you are in single-frame playback mode, you can scroll through your images using the left and right directions on the four-way rocker or rotary switch on the camera back; while in thumbnail viewing mode, the switch can be used in all directions until the required image is found (**5.2**). Pressing the central select button when an image is highlighted will bring it up to full frame. In full-frame mode you can zoom into the picture using dedicated playback zoom controls on the camera to check the focus and detail, and most cameras offer a scroll mode once you have zoomed in, so that you can view different parts of the image.

Use of the LCD Screen

Excessive use of the rear LCD screen in playback mode can run your camera battery down quickly, as the screen is very power hungry.

5.2 The rocker switch performs different functions according to the camera model, particularly in playback mode. Make sure that you understand all the features available on this important control.

Four-directional button to select menus, choose focus area or review images

Select highlighted item

Lock switch

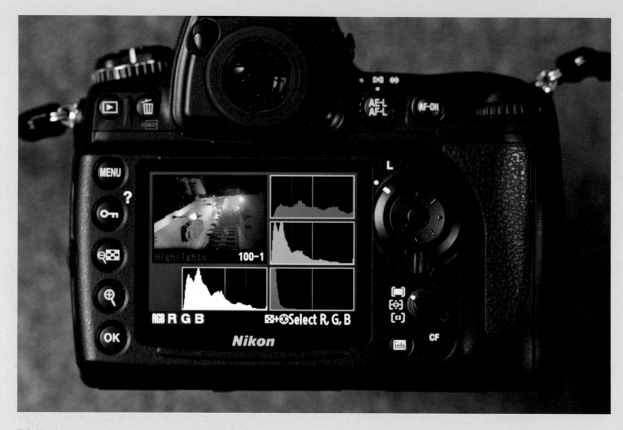

5.3 The in-camera histogram is the best way to check if you have made a good exposure without any clipping (loss of highlight or shadow detail – see opposite). Note that it represents the dynamic range of a JPEG capture, not a Raw image.

Playback mode also provides you with the option to erase unwanted frames, either individually or all at once. Frames that you want to keep can be 'locked' on many camera systems to save them from accidental deletion, although you should be aware that this will not protect them if you format the **memory card**.

The brightness of the LCD screen can be adjusted manually via the menu on many cameras, while some models adjust the screen's brightness automatically when subjected to different levels of **ambient light**. Because of this, it is not a good idea to judge the correct exposure of an image based on its on-screen appearance alone: an image viewed under bright sunlight will look much darker than one that is viewed in low-light conditions. Instead, exposures should be judged by calling up the camera's **histogram** (**5.3**). This is a bar chart that displays the number of **pixels** in the image that have any one of 255 tones between black and white. Reading this can give you a precise guide to the exposure.

The left side of the histogram represents the darker tones in an image, with black at the far left, lighter tones to the right, and pure white at the far right-hand edge. If the majority of the bars are shifted to the left, for example, then the histogram is telling you there are a lot of dark tones in your picture, perhaps meaning it has been slightly underexposed. Conversely, if the histogram is shifted over to the right, there are a lot of lighter tones in the picture, possibly suggesting overexposure. Of course, if the image is very high-key (pale and delicate) or low-key (dark and sombre), a histogram that shows the majority of pixels at one end or the other may still be showing the correct exposure. In both cases, if the bars stack up against the end of the histogram, you have lost detail in this area, indicating blown (pure white) highlights or blocked-up (pure black) shadows that contain no detail.

To aid you in identifying lost highlight or shadow detail, many cameras can be set to provide an on-screen exposure warning when you review your shots, which will make any areas that are **clipped** in the image flash with a bright colour. If this happens, check your histogram and make adjustments to the exposure until the warning no longer appears and the clipped detail is brought back into the image.

Holding Detail with High-Contrast Subjects

If you are photographing a contrasty subject with a high **dynamic range**, you may find that you lose both highlight and shadow detail. In this instance, it is best to reduce your exposure to hold detail in the highlights and let the shadows go black. This will usually give a more acceptable-looking image than one with little or no highlight detail. For the best results, try to keep the data in the histogram as close as possible to the highlight (right) end without clipping.

Camera File Formats

In Chapter 4 we looked at choosing the best image size, image quality and file format when setting up a camera for image capture; but when you are working with **Raw** files, there are additional options to consider. Raw files are larger than JPEGs, but far smaller than the equivalent 16-**bit TIFF**. Consequently, one disadvantage is that the larger file sizes may simultaneously slow down the camera and computer, and fill your hard drives with both the Raw original and the converted TIFF file. Another issue is that almost every new camera model (even from the same manufacturer) introduces an updated Raw format. These are not compatible and need specific software to process the data properly, which can lead to many different Raw-file formats and potentially mismatched processing software. This can put some photographers off shooting Raw, but there is a way around it: convert your Raw files to the Adobe® Digital Negative format, or **DNG**. This is a universal Raw-file format, and the software needed to convert your files is available as a free download (**5.4–5.6**).

Once you have downloaded your images – JPEG or Raw – it is a good idea to convert them into TIFF files. This is a completely lossless file format that can be opened by a wide variety of programs and across platforms with few, if any, problems. As such, it is the industry standard for digital images and should be thought of as your 'archive' image.

5.4 (below) The Adobe DNG converter allows Raw files stored in one folder to be selected, renamed (if required) and saved to an alternative target folder. You have the option to embed the original Raw file within the conversion.

5.5 (above) The DNG Preferences window.

5.6 (right) The DNG Conversion Status window.

5.7 Adrienne Hoetzeneder takes advantage of one of her college's calibrated Eizo monitors to review her most recent work and choose the best pictures to print for her portfolio.

Recording JPEGs and Raw Files Simultaneously

If the option is available, the ability to record a JPEG and Raw file simultaneously can speed up viewing and image selection, but still leave you with the highest-quality digital file to work up for final output (**5.7**). This option, however, will use up more storage space.

5.8 A laptop is very useful when you are working on location, as it allows you to download your work in progress for better viewing. Laptops are not ideal for final image adjustments, however, as colour calibration can be difficult and unreliable.

5.9 (above) A desktop tower is ideal for use in a studio where computing power and speed – as well as large storage capacity – are likely to be needed.

5.10 (right) The better the monitor, the better the range of colours and contrast displayed. It is important to calibrate your monitor, especially when processing Raw files.

Processor Speeds

You cannot compare processing speeds directly, as it is not an exact science. A 2GHz Apple® Mac® might be able to process information faster than a 2.3GHz Windows PC, for example, simply because of the efficiency of the processor and the operating system. Both would be fast, and very suitable for digital imaging, but anyone who claims that 'mine is faster than yours' based purely on the quoted processor speed may be in for a surprise. Some computers also contain a dual microprocessor, or a pair of them (known as a quad processor). Having two processors speeds up the movement of data (two brains are better than one), while four are faster still, and this can mean that a computer with a higher number of slower processors can outperform a computer using a single, high-speed processor.

5.11 An Apple iPad can be used to display a portfolio or images that have just been shot, but it cannot currently be calibrated.

Computers for Digital Photography

There is now virtually no difference in the way that image-editing software works between Windows and Mac computers, and many people who become interested in photography will own or have access to a computer already. This might be a new desktop PC or laptop (**5.8–5.10**), or something a few years old with a much more modest specification.

In all instances, it is important to make sure that your computer is up to the task of working with digital photographs. While most word-processing files are well under 100K (**kilobytes**) in size, an A3-sized image will be closer to 50Mb (**megabytes**) and requires a much higher-specification computer to avoid such problems as crashing or very long processing times.

This often means that when you are planning to upgrade to a higher-**resolution** camera you will need to consider whether your present computer has a specification that is capable of dealing with the larger file sizes. Increasing the amount of memory (**RAM**) can improve performance and allow larger files to be handled, but if the processor (**CPU**) speed is slow, you may not see much value for your money.

Choosing a Hard Drive

An old hard drive or a cheap new one can be a very dangerous place to store your precious photographs – and a false economy. Consider how and where you will back up your files from the start.

Computer Terminology

There is plenty of jargon used when people talk about computers, but the three main technologies to understand are the CPU, RAM and hard drives:

CPU: The Central Processing Unit (CPU) is a computer's 'brain'. It receives and carries out all of the instructions required to run a program or perform a specific task. Its speed is measured in **gigahertz** (GHz).

RAM: Random Access Memory (RAM) is a solid-state chip or group of chips that contains the computer's memory. Data is 'randomly accessible' at any time and in any order. It is not a permanent storage space, and anything stored in the RAM will be lost when the computer is shut down.

Hard Drive: A hard drive is essentially similar to RAM, but it is used to store the data that the computer uses and the results of any calculations made. This can be images, programs, operating systems or even overflow data from the RAM if it gets too full. A hard drive does not lose data when the computer's power is turned off.

Saving TIFFs on a Mac

If you are saving TIFF files on an Apple Macintosh, always set the **byte** order to 'IBM PC' and the image **compression** to 'none' if the file might need to be read by a Windows PC. Most high-street photo labs use a Windows-based system that cannot read a Mac byte order file, or one that has had **LZW compression** (see p. 217) applied.

Macintosh or Windows?

If you are looking to buy a new computer, you immediately face a number of decisions: should it be a Windows PC or Apple Macintosh, a desktop or laptop model? There was a time when most high-end graphics software and digital colour management worked better on an Apple Macintosh, but this is no longer the case. There is still some hardware and software that is made to work on only one platform, but that is becoming rarer.

Most photographers, designers, journalists and those who work in the graphics and media industries are Apple Macintosh users, but this is largely because they started out when Apple Macs were the superior option. You are also far more likely to find Apple Macintosh computers in art colleges than you are to see Windows-based computers, and you may even find teaching and technical staff who do not know how to use a Windows PC. If you own an iPod, iPad or iPhone®, you will also find that these are easier to interface with an Apple Macintosh for uploads or downloads (**5.11**).

If you are starting from scratch, Apple Macintosh's operating system can be easier to learn; but if you have been introduced to a Windows PC already, there is no reason why you should change. What is more important is that you understand that the Windows and Mac operating systems are fundamentally different, and that this can create problems of compatibility. As a rule, Apple computers can read any file saved on a Windows PC or Mac, but many Windows computers will not read or recognize files that have been saved in the Apple Macintosh format.

Apple computers always appear to be slightly more expensive than Windows PCs, but this is because they may be built using graphics cards and other components that are designed to provide good performance with such processor-intensive tasks as image-editing, rather than to appeal from the point of view of price. While a basic Windows PC may be a lot cheaper, it may not be as good at handling graphics. Some companies will build you a bespoke Windows PC from components, however, and this can be a good way of achieving the high performance demanded by photographic images, although it may also bring the cost up to that of an Apple Mac.

Desktop or Laptop?

Choosing which **operating system** (Windows or Mac OS) your computer will run is only the start of your computing decision, as you also need to decide whether to go for a desktop model or a laptop.

Desktops are not made to be portable, so if you are likely to be away from home often – whether travelling or going away to college – a laptop is much easier to take with you and is also easier to use in a studio environment when you want to shoot with your camera tethered to a computer (**5.12**). Laptops can also be used in locations that offer free or inexpensive **Wi-Fi** Internet access, or when staying with friends, but the downside is that you will often get a lower specification for your money than you would if you opted for a desktop computer. Unless you buy a really high-level laptop, it is likely to have a shorter useful life, and upgrading or adding components can also be a problem, so it is advisable to specify a machine that is above your current needs to allow for newer, more demanding software or larger image files.

A desktop is far easier to upgrade, which means that you can add extra memory or a new hard drive to expand its capabilities, often without having to take it to a computer specialist.

5.12 When Graham Diprose and Jeff Robins were shooting their project '... In the Footsteps of Henry Taunt' along the River Thames in 1999, Sony UK loaned them one of the very first PC laptops that could be tethered using Firewire.

5.13 Calibrating a laptop screen is certainly worth while, but in the home, office or studio, a better option is to plug the laptop into a higher-quality monitor and calibrate the larger screen.

Mirroring

Many laptops can be connected or 'mirrored' to a separate, larger and higher-quality monitor to avoid the problems with their built-in displays. The supplementary monitor can then be colour-calibrated for consistent results when you return to your home or workplace.

A desktop computer also requires a separate monitor, and while this is an additional expense, it does provide a much more accurate view of your images, giving you a larger work area for your image editing. Having a separate monitor also gives you the option of upgrading later to a bigger display, without having to change your whole computer.

Laptop Summary

- A laptop screen leaves a lot to be desired when working with images, as the brightness of the image can change dramatically if you alter your viewing position.
- Laptop monitors can be calibrated, but not as accurately as a desktop unit (**5.13**).
- Many laptops have automatic ambient light controls, which can seriously affect the way you judge the brightness of your images.
- The only control you have over the screen will be the brightness setting.

Desktop Summary

- Desktops need a mains power supply, with a UPS (uninterrupted power supply) highly recommended to protect the computer, peripherals and data in the event of a sudden power cut.
- The monitor is separate, so you can buy the best you can afford. Good viewing angles keep the image brightness consistent.
- Desktop computers – and their necessary peripherals – take up much more space than a laptop and use more energy and create more heat.
- It is far easier to add or upgrade components, meaning that a desktop computer has a potentially longer operating life.

Minimum Computer Requirements

To handle digital image files that are suitable for print sizes of around A3 (297 × 420 mm) or are of a high enough quality to be sold as stock or commissioned work, you will need a computer that is capable of dealing efficiently with file sizes in the region of 50+Mb. The following should be considered the minimum system requirements:

- A 2GHz processor (CPU)
- 2Gb of RAM
- A 500Gb hard drive (internal) and a second internal or external portable drive
- A graphics card with at least 256Mb of memory
- DVD reader and writer (will also read and write CDs)
- A number of connection ports, preferably USB2, plus Firewire
- Space for expansion: the ability to increase the RAM, change the hard drive and (possibly) the option to add additional connection ports
- Wi-Fi-enabled
- Long battery life, if choosing a laptop

Adjusting Monitor Settings

A separate monitor can offer a much higher level of colour-calibration control through on-screen displays (OSDs) that adjust colour, contrast and brightness to improve accuracy. A low-cost 'computer and monitor' package is not always ideal for image manipulation: the computer may be high-specification, but often the display is not.

Adapters

You may need an adapter to connect your monitor to your computer. There are three standard types in use: DVI, VGA and ADC. A dealer can advise which one is right for your set-up; be careful if purchasing online. There are also several types of connection to data projectors, and again, choosing the correct leads is vital.

External Drives

There are differences between a desktop external drive and a portable external drive. The portable drive will have built-in shock-absorption systems and is generally powered by the computer, while the desktop unit will be less robust and require its own power supply.

Monitors

Choosing a monitor is often considered secondary to getting the 'right' computer, but it is very important, as it is your interface with your images. Monitors vary greatly in cost and specification, although as bulky cathode ray tube (CRT) monitors are no longer widely available, a good-quality flat screen is preferable.

The monitor is driven by a graphics card, which converts data into the screen display. Both the monitor and card have an influence on the quality of the viewed image. You need to ensure that the graphics card supplied with the computer is up to the job of handling high-quality digital images. The simplest advice is to buy the best monitor that you can afford, and consider using monitor-calibration hardware to keep the image consistent.

When choosing a desktop monitor you must first consider the size of the screen (this should be at least 43 cm/17 in. diagonally) and its physical shape – many are now in a 16:9 widescreen format, rather than the traditional, squarer 4:3 format. For very fine retouching a larger monitor is preferable, perhaps upwards of 22 in. As a rule, cheaper monitors are likely to have a narrower viewing angle in the region of 60° rather than 100°, and fewer on-screen controls, which can make calibration slightly harder.

Many professionals prefer to use not one, but two monitors, where one displays the image and the second is used for the image-editing tools and palettes, as well as providing access to other files and software (**5.14**). Sometimes this will require two graphics cards and a high-end computer, especially if both of the monitors are going to be calibrated.

Graphics Cards

Some of the best graphics cards are designed for handling processor-intensive tasks, such as real-time movie-editing and video-gaming, and can be very expensive. Cards of this quality are not needed for still photography, however.

Hard Drive

All computers come with an internal hard drive or hard disc, and a capacity of 500Gb or more is now common. Most modern desktop computers have additional 'slots' inside the case that allow an additional drive, or drives, to be installed, or you can attach external hard drives to your computer, using a USB or Firewire interface. Both types of hard drive have their advantages, whether it is the low cost and neatness of a hard drive that you install inside your computer, or the convenience of a portable drive that you can unplug and carry around with you.

With their large capacity, hard drives may be worth partitioning. This is a process where you split the disc into smaller segments – partitions – that are each treated as an individual hard drive, with one partition for your software applications, another for images, a third for your music and so on. Partitioning can be used to segregate the operating system and general software from data created by the user. This allows faster access to temporary files created when software is loaded, and thus speeds up operating times. Furthermore, it enables Microsoft operating systems to be run from a dedicated partition of a Mac hard drive. If the disc were to become corrupted, the damage would probably be within a single partition, making recovery more feasible.

5.14 This dual-monitor set-up gives a double-sized desktop area, which is great for working on a file without the distraction of having all the tools on the same screen, as well as for reviewing images.

External Hard Drive Capacity

For extra storage, or to back up the files on your laptop or desktop computer, consider a portable external hard drive with a capacity of at least 500Gb that is connected via USB2 or Firewire 800. It is a good idea to keep this at a separate location from your computer, in case of such disasters as fire or flood.

5.15 When Anya Campbell was commissioned to go on location to photograph deer-stalking in the remote Scottish Highlands, it was vital that she carefully backed up each day's work, to avoid losing any of her pictures. Reproduced courtesy of *Ritz* magazine.

Scratch Disc

You can improve the performance of Adobe Photoshop and some other software by using a scratch disc. This is free space on a hard drive that the program uses when the main RAM memory temporarily runs out of space, with data stored briefly to disc. There are no real guidelines as to the ideal size of a scratch disc, but the more RAM you have in your computer, the less often a scratch disc will be needed, and the less space it will need.

A word of warning: partitioning of a hard drive should be attempted only on an empty drive, as the creation of partitions will erase any data saved on that drive.

Suggested partitions for a 500Gb hard drive:

60Gb	=	Operating System and Programs
20Gb	=	Text Documents
350Gb	=	Image Storage
40Gb	=	Music
30Gb	=	Scratch Disc (virtual RAM in Adobe Photoshop)

Regardless of whether you opt for an internal or external hard drive, or decide to partition it or not, what all hard drives have in common is their fallibility: they have many moving parts that can break or fail from age and wear. When this happens, you are likely to lose access to all the data on that drive. It may be possible to recover the data by employing a specialist company, but this can be very expensive and is certainly not guaranteed, so backing up your files becomes even more important. You should also accept that it is not a matter of 'if' a drive will fail, but 'when' (**5.15**).

Optical Media Drives

Optical media include CD, DVD and **Blu-Ray**; DVD drives that can read and write data to both CDs and DVDs are now the standard on most computers. With the software set up correctly, there will be no issues moving images between Mac and Windows computers, although care must be taken in choosing which media you record your image files onto. Rewritable CDs (**CD-RWs**) have a notoriously short life, often lasting less than a year before the data on them is unreadable, although 'write-once' CDs (**CD-Rs**) can extend this to around ten years, with Gold CD-Rs increasing this further.

DVDs are also a considerable risk over time, although this is not necessarily due to their archival properties but simply because they can hold over six times the amount of data a CD can, so there is more to lose if a disc becomes unplayable. Regular backups should, however, prevent this from happening, and record-once **DVD-R** discs have become a popular and low-cost option for many photographers.

USB Flash Drives

USB **flash drives** are a more archival solution than recordable CDs and DVDs, even though they are normally used only for short-term storage and the transporting of files. Their core technology is based on solid-state memory chips that are similar to the memory card used in a digital camera, which makes them more robust than a hard drive with moving parts or an optical disc that can easily be scratched. It is important that you always ensure they are correctly unmounted from the computer to avoid data loss, and never remove them while indicator lights are flashing and data is being transferred.

Hard Drive Capacity

Two hard drives containing 500Gb each are safer than a single 1-**Terabyte** (Tb) drive, even if this is not the cheaper option. The reason is simple: if one drive fails, you can use the other one.

Burning to Disc

Most CD- and DVD-burning software will offer a 'multi-session' recording option that will allow you to add files to a write-once disc at a later date. Some computers will only see the last session that has been burned to the disc, though, so it is best to avoid this if at all possible. With the low cost of blank CD-Rs and DVD-Rs, writing a single 'closed' session is the safest option.

5.16 (main picture) A graphics tablet is ideal for fine retouching work. Many tablets include buttons that reduce the use of the keyboard. Others allow you to 'draw' straight onto the monitor.

5.17 (below left) A good flatbed scanner will work with flat artwork and film using transmitted light. Many are good enough for medium-format images, but not for 35 mm film.

5.18 (below centre) Although they are quite expensive, high-quality, dedicated film scanners have largely replaced the drum scanners that were commonplace several years ago. They have a very delicate mechanism and need careful handling.

5.19 (below right) If you do not enjoy public speaking and are asked to present or discuss your work, a few hours' preparation using PowerPoint, or such new software as Prezi, can give you more confidence to deliver a professional talk.

5.20 Retouching skin on beauty shots without the final result looking artificial is particularly tricky. Davinia Young developed a technique using Adobe Photoshop's History Brush to achieve this image.

Graphics Tablets

While a mouse is adequate for performing basic image-manipulation tasks, it is not really accurate enough for more advanced image editing, so for detailed retouching a graphics tablet with a pressure-sensitive stylus is highly recommended (**5.16**). An A5-sized tablet will be suitable for most work, although professional retouchers will use larger tablets, or even monitors that can be drawn onto directly for really fine work and such difficult subjects as skin and faces in beauty shots (**5.20**).

Scanners

Flatbed scanners are continually improving in quality and many will allow you to scan both prints and film. Some reasonably priced models are capable of producing acceptable quality files from large- and medium-format film stock (**5.17**), but if you know that you will primarily be **scanning** film, a dedicated film scanner is often a better solution.

Film scanners (**5.18**) can be multi-format – accepting large-format, medium-format and 35 mm film – or dedicated to 35 mm film. The cheapest dedicated 35 mm scanners are often worse than a good flatbed with a film adapter at the same price, so choose carefully. As a high-quality scan can take several minutes, the ability to 'batch scan' multiple frames while you do something else is a bonus. Some film scanners also have the ability to scan across the surface of the film using **infrared** light to detect dust or scratches that are then removed without the need for time-consuming retouching. Most of these will work with any colour film, but it is worth noting that this system will not work on silver-based black-and-white film as the infrared light sees the processed silver grains as dust and tries to remove them.

Digital Projectors

Digital projectors are a great way of displaying and sharing your images with a group, especially for getting feedback on your work and ideas (**5.19**). They are also useful for showing your work in an exhibition space.

Downloading Your Images

One of the most important rules of digital imaging is to back up your files so that you have the images in more than one place, such as on your computer's hard drive as well as on a CD, DVD or memory stick. Your images are at their most vulnerable while they are still in the camera, where they only exist on the memory card and can be accidentally deleted. For this reason, professional photographers often transfer their images to a battery-driven storage device with a small screen as they shoot, or download them to a laptop, even if the storage card is not yet full.

Software-Driven Downloads

Care needs to be taken when you are downloading your images to make certain that they are safely stored on your computer's hard drive. Most manufacturers will supply their own software to help with downloading and storing your images, and will recommend using a cable from your camera to the computer. This type of connection is far from ideal, though, in terms both of the safety of your images and the speed of transfer. The software can also work against you, because, while it can make downloading easier, it is likely that all of your images will be stored in a vast library, which can make it difficult to find them later. As a result, many professional photographers prefer a more manual approach to downloading and organizing their images, using a system that allows them greater control.

Direct Downloads

If you use a cable to connect your camera to a computer, you will find an icon for it in My Computer (Windows) or on the Desktop screen (Mac). You can treat this as you would any other external storage device, simply dragging and dropping your image files to a new folder on your computer's hard drive to copy them from your camera. Once your images have been copied, you can erase them from the memory card so that you can use it again, but do not erase any data using the computer software – this should always be done in-camera, using the 'Format' option from the relevant menu.

Downloading your images directly from your camera is not the quickest process, with most cameras using a Universal Serial Bus (USB) connection from camera to computer.

5.21 Shooting with your camera tethered to a computer allows you to download your images to the computer while you shoot, and to review your pictures on a large monitor, checking for colour and focus.

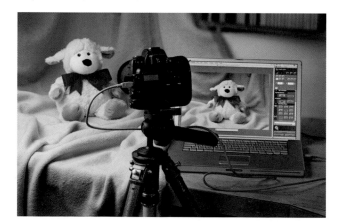

164

Some high-end, larger-format digital cameras use Firewire for tethering the camera to a computer (**5.21**), or for the direct downloading of images, which is slightly faster, but still not as quick as transferring your images using a card reader. Not all cameras need to be physically attached to a computer by a cable, and some offer wireless connectivity via **Bluetooth** or the more recent 'Eye-Fi' technology found in some memory cards. Bluetooth uses a globally unlicensed short-range radio frequency to connect devices, but with data-transfer rates of around 2.6mbps it is of little use for high-resolution digital image files.

Eye-Fi, on the other hand, relies on technology built into the memory card, rather than the camera, to transfer data. It uses the same Wi-Fi technology as domestic wireless Internet connections and connects to a designated computer automatically when it is within range, transferring the data wirelessly and without prompting. The advantage of this system is that it can be used not only to transfer files after you have finished shooting, but also to transfer them while you are shooting, backing up your images to a laptop whenever a shot is taken and recorded on the memory card, for example.

Using a Card Reader

Although transferring images directly from your camera is possible, it is not the fastest option, and most photographers will use a card reader to copy images from a memory card to their computer. There are many different types of memory card, and a universal card reader will accommodate most of them. Such a reader is not much more expensive than a single-format device and is therefore the best option, especially if you have a compact camera that uses a different memory card to your digital **SLR**, or think you might upgrade your camera – perhaps to a different make – at some point in the future.

As with a direct 'from camera' transfer, when you put a memory card into a card reader that is connected to your computer, an icon will appear in 'My Computer' or on your desktop, and the files are copied as with a direct download, using either software or the manual approach outlined above. If the download process takes a long time, this is probably because of the transfer speed of the memory card, rather than your computer.

File Naming

Regardless of your preferred method of transferring files from your camera to the computer, the file names that the camera gives to images will be far from descriptive, often comprising nothing more than a frame number and file type – DSCF0736.JPG or DSC_0015.NEF, for example. It is possible that your camera will reset its file-numbering system to 0001 when the memory card is reformatted, which can lead to different images on your hard drive having exactly the same file name. Obviously, this has the potential for causing mistakes when files are copied, and can lead to the accidental overwriting of seemingly duplicated images, so it is a good idea to set the camera to 'continuous numbering' to avoid confusion.

In addition, get into the habit of renaming your images at the earliest opportunity – either when opening a JPEG in your editing software to view it and save it as a TIFF file, or as your images are imported into your computer from a memory card. Dedicated image-transfer software often has a renaming option that allows you to rename images, set the location of saved files, convert file types – sometimes saving each to a different location – and add copyright information.

Double Backups

Once your files are downloaded onto your computer's hard drive, they are still not safe. If you put the memory card back into the camera and format it, your images will only exist in one place. It is good practice to back up your images onto an external hard drive, CD or DVD to ensure that at least two copies of your files exist at all times. Some software that facilitates the transfer of images can place a copy elsewhere as the files are imported.

Resaving JPEGs

Remember that resaving a JPEG as a JPEG – even at the lowest compression setting – will entail the loss of quality and detail in your image, so convert your JPEGs into TIFFs at the earliest opportunity.

Naming Conventions

Give your naming convention some thought: when you have thousands of images and need to retrieve one quickly, you will definitely want to have a system in place.

Archiving Your Images

It is important to plan as soon as possible how you will archive your images, as it can be very difficult indeed to find a single image when you have many thousands of photographs. Photographers use many different naming conventions, choosing an option that best suits their particular workflow. Some use the date, others use place names, and subject matter might be another method of identification.

When planning your archive, start by thinking about folder structures, and then file naming. If you take a lot of portrait or fashion images you might start by creating a folder using the model's name – Susan, for example – but while this might work now, in five years' time you may have photographed fifty Susans, making the folder name meaningless. Similarly, using the date to identify files may seem like a good idea, but if you do not keep written records of where and when you took your pictures, how will you be able to remember when a particular shoot took place?

Both of these failings can be overcome by adding a 'keyword' to the **metadata** stored with the image. This can be accessed using the search facility in all high-end image-management software, and many photographers will set up a separate database using specialist software.

File Structure

Both Apple Macintosh and Windows PCs use a similar 'family tree' structure for storing and retrieving files, so if you are already familiar with one operating system, you should be able to use the other fairly easily. The default structure on each system works like this:

PC Filename Structure

C:\Documents and Settings\Username\My Documents\My Pictures

C:	The computer's main hard drive (usually internal)
Documents and Settings	The main folder on that drive
Username	The name you call yourself on your computer
My Documents	A folder on your hard drive
My Pictures	A sub-folder within the My Documents folder

Mac Filename Structure

The full address of a file is

Main hard drive\Users\Your username\Pictures

Main hard drive	The name of the hard drive
Users	The Users folder, where all users' work is kept
Your username	The name you call yourself on your computer
Pictures	A sub-folder where your images are stored

5.22 When you know you have taken a great shot that cannot be repeated easily, you need to download it and back it up to a number of places as soon as possible. A. J. Heath shot this picture in Afghanistan, and reshooting was not an option.

Unmounting Your Storage Card

After downloading, you should ensure that you follow the correct removal procedure for your camera, or you may damage the storage card and lose its contents. On a PC this is normally the Remove Hardware icon in the bottom right-hand corner, or selecting Eject on the correct drive icon. On a Mac you can throw the icon into the bin or select Eject using the right click on the mouse.

USB Connections

If you mix high-speed USB2 or USB3 connections with older USB devices, your data transfer will default to the lowest speed.

Mac File Structure

5.23 The Mac file structure displayed as icons.

5.24 The Mac file structure displayed as a list.

5.25 The Mac file structure displayed in columns.

5.26 The Mac file structure displayed in a more interactive 'cover flow' mode.

PC File Structure

5.27 The Windows PC file structure displayed as a filmstrip.

5.28 The Windows PC file structure displayed as tiles.

5.29 The Windows PC file structure displayed as thumbnails.

5.30 The Windows PC file structure displayed as a list and as details. Windows offers more viewing options, such as icons, and you can also switch folders on or off by accessing the buttons just under the main menu bar.

Exercise
DESIGN YOUR OWN ARCHIVE

The Task and Extended Research

Most photographers leave it far too late to start a well-designed archive of their work, which often means they have to spend weeks or even months sorting through thousands of photographs. You can avoid this by designing your own image-archiving system from the start (**5.31**).

Although there are some software packages that can help with your archiving, everyone has their own preferences and individual systems. Your task is to design a filing system and 'family tree' or hierarchy that works for you, whether you have 20 images or 20,000. You may wish to research some of the commercial image-archiving programs to get some ideas; many of these can be downloaded for a brief trial period.

5.31 In a lifetime you are likely to take thousands of photographs. Some of them you will never need again, but others might suddenly be needed many years from now, so your archiving system is important. Jeff Robins has maintained an archive for many years and was able to locate this image of a set built in his studio, from c. 1980.

5.32 Adobe Bridge is installed with Adobe Photoshop and loads Raw files into Photoshop Camera Raw, making it a good choice for photographers already using Adobe products.

Getting Started

Planning is vital in this exercise and you need to think about how you would be able to find one specific image among thousands stored on your hard drive(s). Would it be by subject, date or place, or by using a combination of all three, or would it be based on something else altogether? Do you want to store Raw files and processed images in the same place, and do you want to have small JPEG images that you can send to people as an e-mail attachment? If so, where will you find these and how will you name them? If you have the skills to design a simple database to help find and cross-reference your images, how will this work? What fields would you include to help locate an image and, when it is found, would the result need to be pictorial or just show a file name and location? Consider such programs as Apple's iPhoto® and Aperture®, or Adobe® Bridge®, Photoshop® Elements and Photoshop.com, which is ideal for using on a mobile phone (**5.32–5.33**).

A good place to start is with your twenty to thirty images, a pencil and your workbook. Look at how you want folders to work within other folders as you drill down to find a specific picture. When you have a system drawn out on paper, make the folders on your computer, rename your files and archive them using your new system.

5.33 Adobe's Bridge and Lightroom produce very similar results, as they use many of the same algorithms.

Feedback

This is an exercise that you can test for yourself. Does your system work and can you find your files easily? If you add twenty more, can the system still cope? What about adding another twenty? The true test of this exercise and its success will be if you are still using the same system in six months' time, or have had to develop an alternative filing method.

THE PIXEL STORY

In this chapter you will learn how:

• Digital cameras capture and synthesize colour images

• To change image and document size and resolution

• To choose between Raw and JPEG capture depending on the nature of your subject

6.0 (previous page) An interest in interior design and architectural photography led to more experimental work when Pamela Ossola decided to play with mirroring some of her images in Adobe Photoshop to turn them into a series of large fine art prints, which were exhibited in a gallery in Munich.

6.1 The surface of an orange absorbs all the blue wavelengths of light and some of the green. It reflects all the red light, and the yellow component of the green wavelengths. To our eyes, this will appear orange.

6.2 The relationship of the primary (RGB) colours and the secondary (CMY) colours can be demonstrated by representing each as a triangle and superimposing them. It also demonstrates some of the other colours that can be made by mixing them, with cyan and blue, for example, making azure.

Capturing Colour

Visible light is a small range of wavelengths of electromagnetic energy that affect cells at the back of our eyes, which in turn send messages to our brain that are converted to give us sight. Our eyes are sensitive to wavelengths of only 400 to 700 **nanometres** (a millionth of a millimetre), yet this narrow band of visible light – or white light – is enough to give us full-colour vision. In Chapter 3 we saw how our eyes and brain allow us to 'see' colour (**6.1**), and a digital camera works in a similar way, creating a full-colour photograph from a combination of three primary colours – red, green and blue (**6.2**). These colours can be separated by passing white light through a 60° prism (**6.4**). The resultant image is called a spectrum.

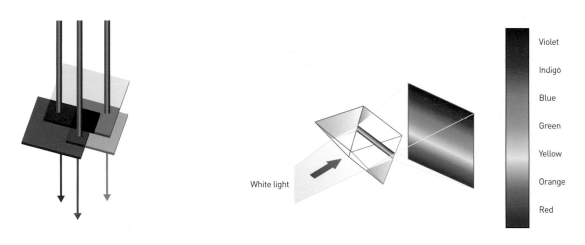

White light

Violet
Indigo
Blue
Green
Yellow
Orange
Red

6.3 A magenta filter absorbs green light; a yellow filter absorbs blue; and cyan absorbs red. Therefore, if a magenta and a yellow filter are placed together, they will absorb both green and blue, so that only red light can pass through. Similarly, a yellow and a cyan filter used together will absorb blue and red light, allowing green to pass. Finally, a magenta and a cyan filter will absorb green and red light, allowing blue to pass.

6.4 This image demonstrates white light being broken down into its constituent visible colours by being passed through a 60° prism. This is what occurs when rain and sunshine combine to produce a rainbow.

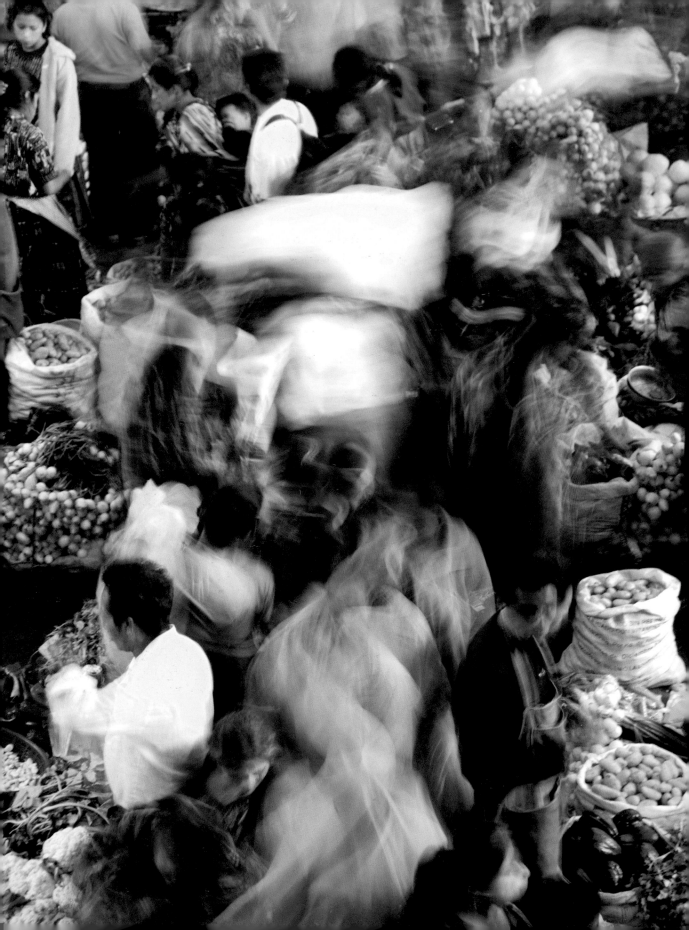

6.5 (opposite) It is hard to imagine how much work your eyes and brain must be doing in real time to allow you to see the mix of vibrant and subtle colours that Cayetano H. Rios captured in this busy market scene.

Colour Deficiency

Rather than use the term 'colour blindness', we prefer 'colour deficiency'. If you are in any doubt about the accuracy of your colour vision, a very useful book called *Ishihara's Tests for Colour Deficiency* (1998) can be found in many college and public libraries.

6.6 One of the Ishihara tests. You should clearly see the number 74.

Colour digital photography, like our eyes, separates the red, green and blue information in a picture into three distinct **channels** that are combined to view an image on screen, or as the first step in the process of creating a CMYK colour print (**6.5**). If you separate these channels and view them individually, as black-and-white images, it is easy to see how they differ (**6.7–6.10**): a red area of the subject will appear light in tone in the red channel, but much darker in the green and blue channels, for example.

Primary Colours

Remember that the primary colours used in physics (red, green and blue) differ from the primary colours used by artists (red, yellow and blue).

6.7 A full-colour image.

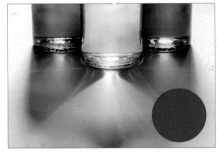

6.8 In the blue channel, blues appear lighter.

6.9 In the green channel, greens appear lighter.

6.10 In the red channel, reds appear lighter.

Digital Sensors and Colour

6.11 How a digital sensor sees colour.

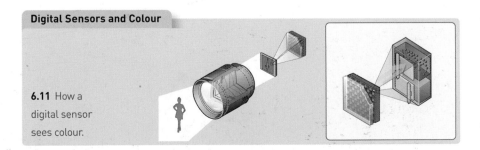

6.12 The original colour subject.

6.13 The tonal image through a pure red filter.

6.14 The tonal image through a pure green filter.

6.15 The tonal image through a pure blue filter.

6.16 The red tonal image coloured red.

6.17 The green tonal image coloured green.

6.18 The blue tonal image coloured blue.

6.19 The three coloured images are combined to produce a full-colour reproduction of the original.

RGB Channels on Screen

A good experiment is to shoot a full-colour subject three times using panchromatic black-and-white film that is equally sensitive to red, green and blue light. If you use a very pure red filter for your first exposure, a pure green filter for the second and a blue filter for the third, you will see clearly the differences between the 'channels' (**6.12–6.19**).

CMYK Output for Print

You can take this further, and use these three black-and-white images to create colour. First convert your negatives into positive images, then add a dye of the **secondary colours**: cyan to the red image, magenta to the green image and yellow to the blue image. If these three single-colour images are combined, they will create a full-colour image. This principle underpinned such historic processes as Technicolor in movie-making and dye-transfer prints in still photography, and what it tells us is that 'full colour' does not need to be recorded to create a colour photograph: the brightness of the red, green and blue wavelengths of light is all that we need.

6.20 (below) A one-shot digital sensor, the type used in most digital cameras.

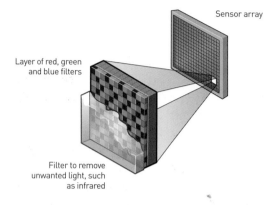

Sensor array

Layer of red, green and blue filters

Filter to remove unwanted light, such as infrared

Red channel Green channel Blue channel

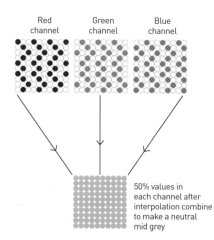

50% values in each channel after interpolation combine to make a neutral mid grey

6.21 (above) The make-up of the filter screen on a sensor. If there is an equal mix of red, green and blue in each of the channels, the combined colour will be a neutral grey.

Three-Dimensional Capture

Digital capture in three dimensions is a recent development in digital photography. It uses two lenses that are mounted approximately the same distance apart as human eyes, with the image viewed by 3D-enabled TV, a projector or digital viewer, or as prints made on a special paper with a lenticular surface (one on which the image appears differently according to the angle from which it is viewed).

6.22 (left) The manufacturers of the Foveon sensor have found a way of capturing full colour without the need for interpolation. It works by using three layers of sensors, each fully covered in either red, green or blue filters, to record full RGB data for each pixel.

The Digital Image

There are a number of methods of capturing a digital image, but the most common is the 'one-shot single-matrix' system used in most digital cameras (**6.20**). All digital-imaging **sensors** are colour-blind, in that the light-sensitive **photosites** or **photodiodes** that ultimately create **pixels** record only levels of brightness, rather than colours.

To enable the photosites to 'see' colour, a red, green or blue filter is placed over each of the sensors on the array, usually in what is known as a **Bayer pattern**, so that each light-sensitive point can then record the brightness of a single filtered colour (**6.21**).

A process known as **interpolation** is then used to convert the single colour from each photosite into a full colour image. This is a very sophisticated form of averaging that is employed to estimate the 'true' colour of a pixel by comparing it to its neighbours, whatever their colour. The accuracy of the interpolation determines the quality that can be achieved by the sensor, and the better the process, the fewer errors will occur and the more accurately the image will be recorded.

An alternative to the single-matrix sensor design is a 'direct-image sensor', where three layers of **pixels** are embedded in silicon. As the red, green and blue wavelengths of light penetrate the silicon to different depths, each pixel is capable of recording not only the brightness, but also the precise colour, creating a full colour image without the need for interpolation (**6.22**).

Sensor Types

Single-matrix sensors are found in the majority of digital cameras and are divided into two different types: **charge-coupled device** (**CCD**) and **complementary metal-oxide-semiconductor** (**CMOS**). Both convert light into an electric charge and process it into electronic signals. The signals are stored as pixels, with a pixel being the smallest element of a digital image.

In a CCD sensor, the electrical charge created by light shining on the sensor is transported across the chip and read at one corner of the array. An analogue-to-digital converter then turns each pixel's value into a digital value. In a CMOS sensor, there are transistors at each pixel that amplify and move the electrical charge by more traditional wires. This makes CMOS sensors more flexible, in that each pixel can be read individually, but each sensor type has its advantages and disadvantages.

CCD sensors create high-quality, low-**noise** images, and for many years this meant that they were considered a superior option to CMOS technology. CCDs can consume up to 100 times more power than an equivalent CMOS sensor, however. This has a serious impact on battery life, and CCDs are also considerably more expensive to manufacture. As a result, CMOS technology is the more widely used technology in today's digital cameras, featuring in everything from entry-level compacts through to high-resolution, professional **SLRs**.

The Pixel Array

The pixel array is the total number of individual receptors that make up the imaging sensor. This can be described in two ways:

Pixel Dimension: The total number of receptors making up the sensor array, measured horizontally and vertically (**6.23**); for example, 5616 × 3744 pixels. This also shows the proportions of the sensor array and therefore the shape of the image.

Megapixels: By multiplying the number of individual vertical and horizontal receptors, we can describe the pixel array in terms of **megapixels**, or millions of pixels. For example, a sensor with **pixel dimensions** of 5616 × 3744 pixels would be said to be a 21-megapixel sensor.

Grid References

The individual receptors on a sensor create an image that is made from square pixels. Because of this the image is called a 'bitmap'. This is how processing and manipulation can be accurately applied to an image: the software finds its way around by using grid references.

6.23 The pixel dimensions of a sensor.

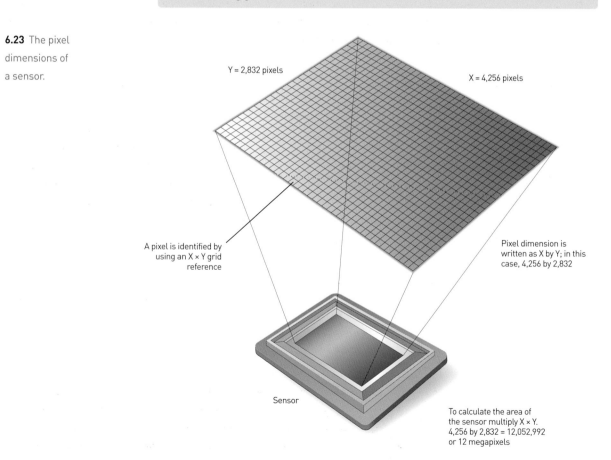

Y = 2,832 pixels

X = 4,256 pixels

A pixel is identified by using an X × Y grid reference

Pixel dimension is written as X by Y; in this case, 4,256 by 2,832

Sensor

To calculate the area of the sensor multiply X × Y. 4,256 by 2,832 = 12,052,992 or 12 megapixels

Resolution

There are two aspects to **resolution** with regard to a digital camera, and it is important to understand the difference between them:

Image Resolution: Image resolution is determined by both the size of the individual sensor and the resolving power of the lens. A 23.7 × 15.7 mm sensor containing 12.2MP is unlikely to resolve as much detail as a larger, 36 × 23.9 mm sensor with the same number of pixels, while a smaller sensor array will also require a higher-quality lens capable of resolving more detail.

Pixel Resolution: Pixel resolution is the number of pixels in a linear inch (or linear centimetre) of an image. There is a direct mathematical relationship between the pixel dimensions (see above), the document size and the pixel resolution.

For example, if an image has pixel dimensions of 4752 × 3168 pixels and you want to use it at a resolution of 300**ppi** (pixels per inch), the document size will be:

$$4752/300 \quad = \quad \textbf{15.84 in.} \text{ (40.23 cm)}$$
$$3168/300 \quad = \quad \textbf{10.56 in.} \text{ (26.82 cm)}$$

This would be the optimum document size that can come from this sensor at a pixel resolution of 300 pixels per inch, as it has not been scaled up or down in size. There are two accepted standards of resolution that are commonly used in digital photographic imaging:

72ppi For screen-based display on the Internet or via a projector. This is also suitable for e-mail attachments, as the low resolution allows small image files to be viewed, but not reproduced.

300ppi Good-quality **ink-jet** prints (for a portfolio or exhibition, for example) require a resolution of between 240ppi and 360ppi. Most photographers use 300ppi as their standard print-quality resolution, as this is also the recommended resolution for book and magazine reproduction (although this can vary depending on the quality of the printing). A resolution of 300ppi is also preferred by museums and galleries for archiving digital images of their artworks.

Imperial Measurements

The industry standard for pixel resolution is to measure it in imperial measurements (dots or pixels per inch). All software can allow a metric form (dots or pixels per centimetre), but this should be avoided as it can cause confusion, leading to huge file or image sizes if you use metric measurements by accident, instead of imperial.

ppi/dpi

There are two terms commonly used to describe resolution: pixels per inch (ppi) and dots per inch (dpi).

• **ppi** is the number of pixels making up a digital image in a linear inch, and most often refers to the display on a monitor.

• **dpi** is the measure of the number of dots of ink that can be placed on paper by a printer in a linear inch. In general, it can take between four and six dots of ink to make up one pixel in an image. Therefore, a good ink-jet printer will be capable of producing a high density of dots on paper, giving accurate colour and fine detail. Different dpi settings can be chosen on a printer to give fast, lower-quality 'draft' results or slower, higher-quality prints at a higher resolution.

Changing the Pixel Resolution

As you saw in the example on p. 183, the pixel dimensions and pixel resolution have a direct impact on the size of the image file in terms of its physical, print-ready measurements. If you take the minimum pixel resolution of 240ppi needed to make an ink-jet print, for example, and your sensor has pixel dimensions of 4256 × 2832 pixels, this will produce a printable image measuring 17.73 × 11.8 in. (4256 ÷ 240 and 2832 ÷ 240), equivalent to 45.03 × 29.97 cm. This is without scaling the image up or down in size, and therefore maintains the optimum quality as you have exactly the same number of pixels in the print-ready image as you started with (**6.24**).

If you wanted to output the same image to a screen resolution of 72ppi for web use, however, the size of the image changes dramatically, to 59.1 × 39.33 in. or 150.11 × 99.99 cm (4256 ÷ 72 and 2832 ÷ 72). The reason for this is that, although the image contains the same pixel dimensions from the sensor array, they are being distributed differently: 72 per linear inch instead of 240. This results in a huge document size, which would be impractical for display on most screens, so it would need to be scaled down.

Changing the Document Size

Changing the document size can have a significant effect on the image quality, depending on how dramatic the change is, and whether you wish to enlarge or reduce the size (**6.25**).

If you start with the same pixel dimensions used in the example above (4256 × 2832 pixels), this will produce a print size of 14.19 × 9.44 in. (36.04 × 23.98 cm) at a resolution of 300ppi. If you wanted to make a larger print – but still have a pixel resolution of 300ppi – then you would need to increase the size of the image: an A3-sized (42 × 29.7 cm) print will need a pixel dimension of 4961 × 3300, for example.

Enlarging the image to A3 means that the number of pixels needs to rise, but, as they were not in the original image, they have to be created by the computer. This process uses an interpolation algorithm, where the computer looks at the surrounding pixels and adds new ones that will match them in colour and tone, but it is not a perfect solution. If the image requires a large amount of new, interpolated pixels, quality will inevitably suffer, as the computer cannot invent extra detail in an image that was not recorded in the first place.

Reducing the print size is less problematic, and if you want to make an A4-sized (29.7 × 21 cm) print, 3508 × 2334 pixels are needed to maintain the 300ppi resolution. Reducing the image to A4 means that fewer pixels are needed, so the software discards some of them, throwing parts of your image away. While this is easier than creating new pixels, the data that is discarded is lost for ever, so you should be sure to save the higher-quality, original image separately: once pixels in an image are discarded, they cannot be reinvented without a loss of image quality.

Enlargement Programs

There are a number of programs available that use fractal mathematics or algorithms to enlarge images. All use interpolation to add pixels, and some work better than others. Some photographers claim that a better result comes from enlarging a file in two or three incremental steps, rather than making a huge expansion all in one go, where the software has to invent many pixels between existing ones, and artefacts (flaws) can arise.

6.24 All these images have the same file size, but the pixel dimensions are locked, giving different print or output sizes when the resolution (ppi) is altered.

Image Size

Pixel Dimensions: 10.3M

Width: 1800 pixels
Height: 2000 pixels

Document Size:

Width: 60.96 cm
Height: 67.73 cm
Resolution: 75 pixels/inch

☑ Scale Styles
☑ Constrain Proportions
☐ Resample Image:
Bicubic (best for smooth gradients)

OK
Cancel
Auto...

Image Size

Pixel Dimensions: 10.3M

Width: 1800 pixels
Height: 2000 pixels

Document Size:

Width: 30.48 cm
Height: 33.87 cm
Resolution: 150 pixels/inch

☑ Scale Styles
☑ Constrain Proportions
☐ Resample Image:
Bicubic (best for smooth gradients)

OK
Cancel
Auto...

Image Size

Pixel Dimensions: 10.3M

Width: 1800 pixels
Height: 2000 pixels

Document Size:

Width: 15.24 cm
Height: 16.93 cm
Resolution: 300 pixels/inch

☑ Scale Styles
☑ Constrain Proportions
☐ Resample Image:
Bicubic (best for smooth gradients)

OK
Cancel
Auto...

6.25 All these images have the same resolution (ppi). The output quality will be the same, but each image has a different output size, which alters file size as well as pixel dimensions.

6.26 All these images have the same print or output size. However, each image is set to a different resolution, giving differing prints with decreasing detail and overall quality. These settings also produce different file sizes.

Bit Depth

The amount of data captured by a pixel depends on the bit depth of the sensor. **Bit depth** – sometimes referred to as colour bit depth – is the range of tones from black to white that an individual photosite in a sensor can capture. As you have seen, a pixel can measure only the tonal brightness of light in one of the red, green or blue channels, and this brightness range is finite: it is determined by the manufacturer's design and sensor specification. The smallest unit of digital data is known as a **bit** and is a binary digit: that is, it can be recorded as either a 1 or a 0; white or black; or, on or off. This can be written mathematically as 2 to the power of 1 (2^1), and 8 bits make a unit known as a **byte** (2^8). Therefore, an 8-bit image contains 256 (2^8) tonal values between black and white (**6.27**).

Most output devices, such as monitors and printers, are 8-bit devices, which is largely due to the capabilities of the human eye and brain. When faced with a scale of tones ranging from black to white in 256 steps, we see it as a continuous half-tone, or a smooth and even flow from black to white. At bit depths below this, the appearance of a continuous tone breaks down, and distinct 'steps' begin to appear in the tonal range. It is important to remember, however, that a digital image is made up of three 8-bit colour channels – one each for red, green and blue. As a result, it can also be referred to as a 24-bit RGB image ($8 \times 3 = 24$), as there are 256 tones in the red channel, 256 tones in the green channel and 256 tones in the blue channel. It is possible to produce any combination of all three channels ($256 \times 256 \times 256$), which gives us the possibility of 16,777,216 colours in total. The bit depth of an image has a significant impact on the number of tonal steps and colours that can be rendered.

Bit depth	Steps from black to white	Maximum number of colours
8	256	16,777,216
10	1,024	1,073,741,824
12	4,092	68,518,346,688
14	16,384	4,398,046,511,104
16	65,536	281,474,976,710,656

In an 8-bit image, each pixel has a potential value of between 0 and 255 (256 steps of tone). It can therefore be plotted to create a bar chart that shows the distribution of tones in the image. In Chapter 5 we saw the **histogram** on the camera that can help you to judge the correct exposure. When you look at a histogram, you are looking at either a composite of the RGB channels (**6.28**), or each channel overlaid on the same chart (**6.29**).

6.27 Bit depths of 1, 5 and 8, and the range of tones that they produce.

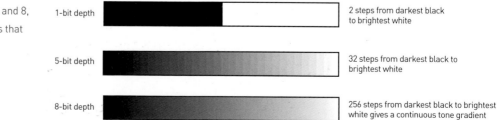

1-bit depth — 2 steps from darkest black to brightest white

5-bit depth — 32 steps from darkest black to brightest white

8-bit depth — 256 steps from darkest black to brightest white gives a continuous tone gradient

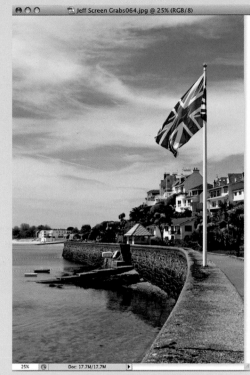

6.28 The Adobe Photoshop histogram shown as an RGB composite.

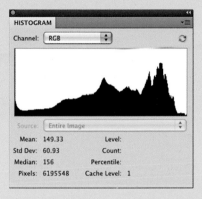

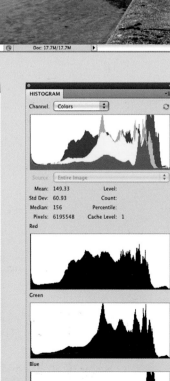

6.29 The Adobe Photoshop histogram shown as three separate channels.

Dynamic Range

No photographic process can capture all the tones that our eyes can see, although some are better than others. Photographers measure the range of tones that can be recorded – the **dynamic range** – in **f-stops**. There are two issues to consider: the dynamic range of the lighting of the subject, and the dynamic range of the medium that is recording it.

If you used an exposure meter to calculate the correct aperture (at a specific **ISO** and **shutter speed**) and the darkest shadow area in the scene gave $f/4$ and the brightest highlight $f/22$, the dynamic range would be 5 stops in total (the difference between $f/4$ and $f/22$).

6.30 If a histogram displays a tone map that is sitting between the shadow (0) and highlight (255) points, the image (**6.31**) contains no real black or white, and it will have a soft, flat appearance.

6.32 This histogram shows the same image with the highlight and shadow ends of the image (**6.33**) remapped to 255 and 0 respectively. This has put a minimum black and a maximum white into the image, giving it a full range of tones and a more natural appearance.

6.30

6.32

6.31

6.33

Minimizing Noise

If you control your exposure so that you keep the histogram slightly towards the highlight end, but without clipping the brightest parts of the image, it will help to minimize noise in the image.

6.34 An underexposed image will show detail missing from the shadow end of the histogram (**6.35**), resulting in many more tones reproducing as black.

6.36 An overexposed image will show detail missing from the highlight end of the histogram (**6.37**), resulting in many more tones reproducing as white. When printed, this means no ink will be placed on the paper, giving ugly clear patches in these parts of the image.

6.38 (overleaf) Helen Ritchie's photograph of a craftsman in his workshop has a vast dynamic range. It required some very difficult exposure estimation to keep as much detail as possible in the highlight and shadow areas.

This would be well within the capabilities of a digital camera, but if the range exceeded 7 stops, you would be likely to lose detail in either the highlights or shadows if recording **JPEG** files (**6.30–6.33**). **Raw** capture increases the dynamic range to 10 or 12 stops.

If the subject's dynamic range is greater than that of the resulting digital image, then the photograph will not reproduce all the tones in the original. Therefore, the photographer must decide where to position the exposure to give the best results (**6.34–6.38**).

6.34

6.36

6.35

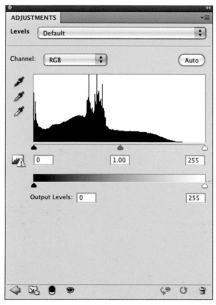

6.37

Choosing between JPEG and Raw Files

If a camera is set to capture JPEG files, then the data is automatically processed to produce an 8-bit file, with a dynamic range of around 7 stops. This can limit your options if you intend to perform any subsequent processing of the image, and could lead to a loss of quality, so selecting the Raw file format, if it is available, is advisable.

There are three main advantages to choosing Raw files over JPEGs. The first is that the dynamic range is extended to 10 stops or more (depending on the camera you are using), which reduces the risk of losing shadow and highlight detail in difficult subjects (**6.39, 6.40**). The greater dynamic range necessitates extensive and careful adjustment of the Raw file when you use your processing software, but it allows a higher degree of control over both the technical and creative aspects of an image (**6.41–6.43**).

The second advantage is the colour bit depth of a Raw file. This will again depend on the camera, but it can be a 10-, 12-, 14- or even 16-bit depth. The higher the colour bit depth, the greater the number of tones per pixel that can be recorded in each channel, giving more purity of colour and a wider tonal range. Most image-editing programs treat images that are higher than 8-bit as 16-bit, but this should not detract from the fact that having more data to start with will allow you to edit your images without risking a loss of quality. It is worth noting that most output devices work with an 8-bit colour depth, so a 16-bit image should be converted to 8-bit before output. This should be left as late in the file-preparation stage as is practical so that you get the benefit of the extra data for as long as possible.

A JPEG starts life as a Raw image that is capable of capturing a high dynamic range (as much as 11 f-stops). When processed to a JPEG by the camera's software, that is reduced to a range of around 7 stops. Any of the recorded pixel values that fall outside the processed JPEG range will be removed, thus setting a new highlight and shadow point for that image. The histogram can see only the 7 f-stop range, so the missing tones are said to be **clipped**.

Converting to 16-Bit

You will gain nothing if you convert an 8-bit file to 16-bit. All you will end up with is an 8-bit file in a 16-bit space: the computer will not 'create' any additional information.

Working with 16-Bit Images

When working with 16-bit image files you will need a powerful computer with plenty of memory. If you are unsure if your computer is powerful enough to deal with the larger files, then consider converting into 16-bit only those files that are going to require extensive manipulation or retouching.

6.39 (right) A subject with a dynamic range greater than 7 stops can display clipping at both ends of the histogram (**6.40**, below right) if you record it as a JPEG.

6.41 (above) The same subject shot as a Raw file shows the same histogram as the JPEG when first opened in Adobe's Raw processor.

6.42 (opposite, above) The clipping warning turned on by checking the boxes in the top corners of the histogram.

6.43 (opposite, below) By making adjustments in the Raw-file processing software, it is possible to reveal more detail at both ends of the histogram, as the file is capable of recording up to 12 stops of dynamic range.

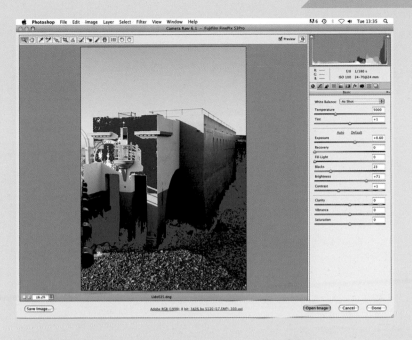

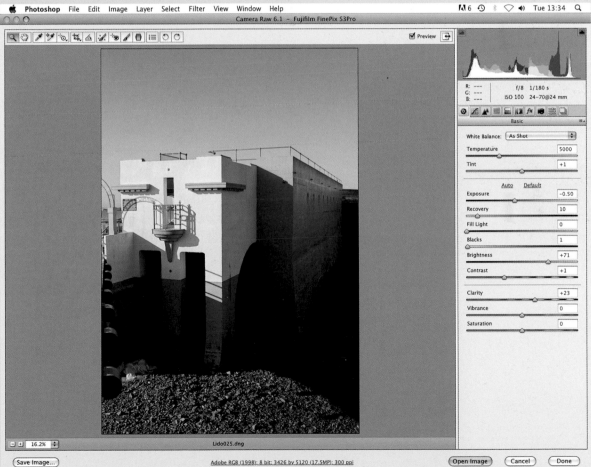

A successful photograph generally contains all the pixel values between 0 (black) and 255 (white). If a JPEG image has a dynamic range under 7 f-stops, when seen on a histogram, it will have fewer than 256 values – not enough data to make all the tones required. This can mean that there is no black or white in the image, making it look flat or soft. To correct this, you can use the Levels control in Photoshop to remap the image. The remapping process replaces missing pixel values by using interpolation to bring the image back up to 256 levels of tone. Smooth gradations in tone are replaced by sudden jumps; this can be seen as a combed effect (white lines) in the histogram (**6.44–6.46**). If the same adjustment were to be made to a 16-bit version of the same image, no interpolation would be needed, because the number of tones you started with is far greater than 256. Therefore, the additional data recorded in a 16-bit file gives a better quality to the image when it is processed (**6.47, 6.48**).

6.44 (far left) A badly lit 8-bit image.

6.45 (second from left) The remapped histogram before interpolation.

6.46 (centre) The remapped histogram after interpolation, showing the missing data.

6.47 (second from right) The same subject captured as a Raw file. All the tonal data that falls outside the histogram map will be removed when processing, as in the JPEG file.

6.48 (far right) After processing, this histogram shows no combing, as the volume of data is not 256 steps of tone, but 65,536, which does not require any interpolation. Adobe Photoshop displays all files – no matter what bit depth – as 8-bit, which can cause some confusion. The histogram of a 16-bit file really should show 0 to 65,535 pixel values along the histogram's base line, not 0 to 255.

The third advantage is that Raw files use non-destructive editing, and allow you to make a wide range of adjustments to the image, optimizing such elements as highlights, shadows, tone, brightness, contrast and **saturation**, as well as the **white balance** (**6.49**). This is discussed in much greater detail in the next chapter.

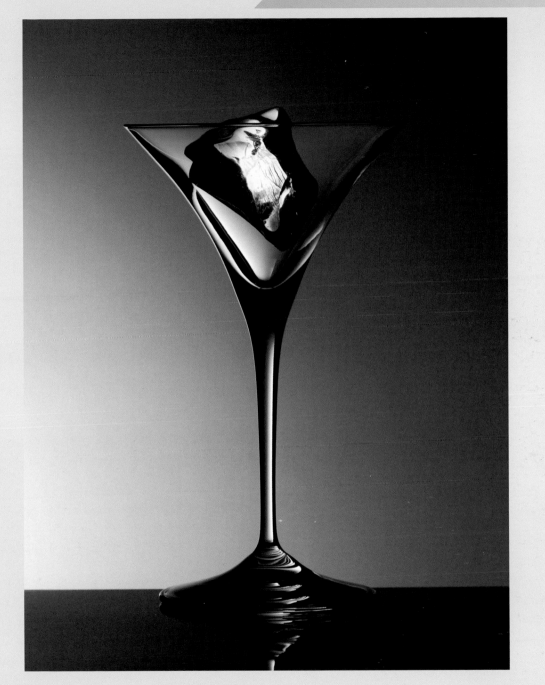

6.49 Although good studio lighting can give you more control over contrast, Jeff Robins still needed all his skills to process the Raw file of this still life successfully, as it has a very wide range of tones and tricky brightness and contrast issues.

Noise

Noise is most often seen as irregular speckles of colour in mid-to-dark-toned areas of a digital image (**6.50**), and because of this – by analogy with film-based photography – it is sometimes referred to as 'digital grain'. It is caused by the camera's sensor, which converts the incoming light to electrical signals that are then processed to form the image. Owing to impurities in the materials made to build the sensor, the electrical activity of the sensor itself will generate some signal, even when no image is being formed.

This is similar to the background hiss of audio equipment when it is switched on but is not playing anything: if a sound is quiet, the signal is weak, so you turn up the volume. Through this amplification, you enhance not only the sound that you want to hear, but also the background hiss.

Noise in a digital image works in a similar way. In low light conditions, you can increase the sensitivity of the sensor by raising the ISO, but this will increase the non-image-forming signal (noise) as well as the image itself. This noise will become increasingly worse the higher you push the ISO, as the noise generated by the sensor forms a larger proportion of the image data. In other words, the signal-to-noise ratio gets worse as the ISO increases.

Higher-quality, pro-spec cameras are often made with better components, which helps minimize noise to start with, and they tend also to have far more sophisticated processors and **firmware** that feature advanced noise-removal algorithms. As noise is also more prevalent at higher temperatures (and sensors produce heat as they operate), some medium-format backs have cooling fans built in to minimize the amount of heat generated, or use the camera's flash-synchronization system to turn the sensor on for just a brief period of time.

6.50 An image showing unpleasant digital noise.

Exercise

BACK TO THE FUTURE: DIGITAL IMAGE ARCHIVING

Resources

You will need:

- A digital photograph
- A computer with Adobe Photoshop software (CS2 or later)
- Access to a digital printer to test that your technique actually works

The Task and Extended Research

This exercise will reinforce your understanding of channels as well as questioning how digital images may be preserved in the distant future. The story is designed to take you on a voyage of discovery into complex areas of Adobe Photoshop, guiding you through these stages step by step, and giving you a greater insight into the potential of the program.

As with all the best stories, this exercise begins on a dark and stormy night, when you meet a strange, cloaked figure in the corner of a seedy downtown bar. He tells you that he is a time traveller who has been sent back 400 years from the future to find you. You think he is deluded, but are intrigued enough to sit down, accept his offer of a drink and listen to what he has to say. He whispers that a particular colour photograph that you will take ten years from now – when you will be at the height of your illustrious photographic career – could change the world for ever, for the good of all mankind. You try to find out more, but he is allowed to tell you neither the subject nor the location of the picture, as this could alter time itself. He does explain that because of this meeting, you will recognize the importance of this image as soon as you have taken it, and he will tell you exactly what you will have to do with it.

To 'save the world' your photograph needs to be held secretly in an archive in a world-famous museum 400 years from now, so the stranger can collect it and transmit it around the world to prevent a terrible disaster. 'But how can I get a digital colour photograph to last 400 years?' you ask. You know that archiving images in a digital file format would be hopeless given the speed of technological change, and a silver-based, C-type colour print might last 100 years at most. Even combinations of pigment inks and baryta acid-free paper would only have an archival life of around 250 years. Your mind is racing, but then you have another idea: surely the only possible way to archive any photograph for 400 years is as a black-and-white ink-jet print, dropping carbon atoms in the inks onto acid-free paper.

'That is very true', says the strange visitor, sounding rather pleased by your logic, 'except your picture must be seen in colour. We have worked out how to send your colour picture as three black-and-white prints, using your twenty-first-century technology, but you will have to follow our instructions very carefully indeed ...'

6.51 Photo by
Julian McLean.

6.52 (opposite)
Following the instructions
that the mysterious stranger
left behind.

Choose an image with strong shadow, mid-tone and highlight detail – the actual subject is unimportant. Once you have found a suitable image (**6.51**), the first part of the process is to disassemble it:

- Open your image in Adobe Photoshop.
- Modify the Canvas Size to leave a strip of white on one side – it does not matter which side.
- Reset the foreground colour to maximum black and the background colour to brightest white by clicking on the small symbol near the bottom of the main tool bar.
- Select the newly created white area, using either the Magic Wand or the Rectangular Marquee tool, and fill it with a gradient going from white (255) to black (0). The Gradient tool can be found in the main toolbar. In the tool settings at the top of the image window choose Foreground to Background as the Name, set the Gradient Type to Solid and the Smoothness to 100%. Ensure that you have the tool set to Linear Gradient. Click and hold the mouse, then drag the full length of your selected area.
- Open the Posterize tool (Image → Adjustments) and apply a setting of thirty-two steps to your selected gradient.
- Select the Eye Dropper. Open the Info window from the Window menu.
- Deselect the stepped gradient, and use the Eye Dropper to identify the R (red), G (green) and B (blue) pixel values for six evenly spaced steps on your gradient (not including black or white). Simply click on the step to see its values in the Info palette.
- Using the Type tool, label your steps with their RGB values.
- Flatten your image (Layers → Flatten Image) and save it as your 'control' or master image.
- Now, open the Channels palette using the Window menu and discard the red channel by dragging it onto the wastebasket at the bottom of the Channels window. The green channel will change to magenta and the blue channel to yellow. Discard the magenta channel and save the resulting black-and white image as a **TIFF** file, making sure you have the word 'yellow' in its file name.
- Reopen your master file and discard the green channel: the blue channel will change to yellow and the red channel to cyan. Discard the yellow channel, leaving cyan, and save the black-and-white image as a TIFF file once again, this time including 'cyan' in its file name.
- Repeat the process one final time, discarding the blue channel (the green channel will change to magenta and the red channel to cyan), followed by the cyan channel, so you are left with magenta. Again, save this as a TIFF, including 'magenta' in the file name. You will now have three multi-channel images representing the secondary colours (cyan, magenta and yellow) in your master file.
- For archival purposes, print these three images, ensuring they are all printed at the same size and with the same settings. For the greatest longevity, using carbon-based inks on acid-free paper would be ideal, but for the purpose of this exercise, any ink-jet printer will suffice. Label the prints 'cyan', 'yellow' and 'magenta' so you know which print relates to which file.

Note that when making prints from this type of file on an ink-jet printer, best results will be obtained if the files are converted from Multichannel to **Grayscale**, and then to RGB Color. You can do this by selecting Image → Mode from the main menu.

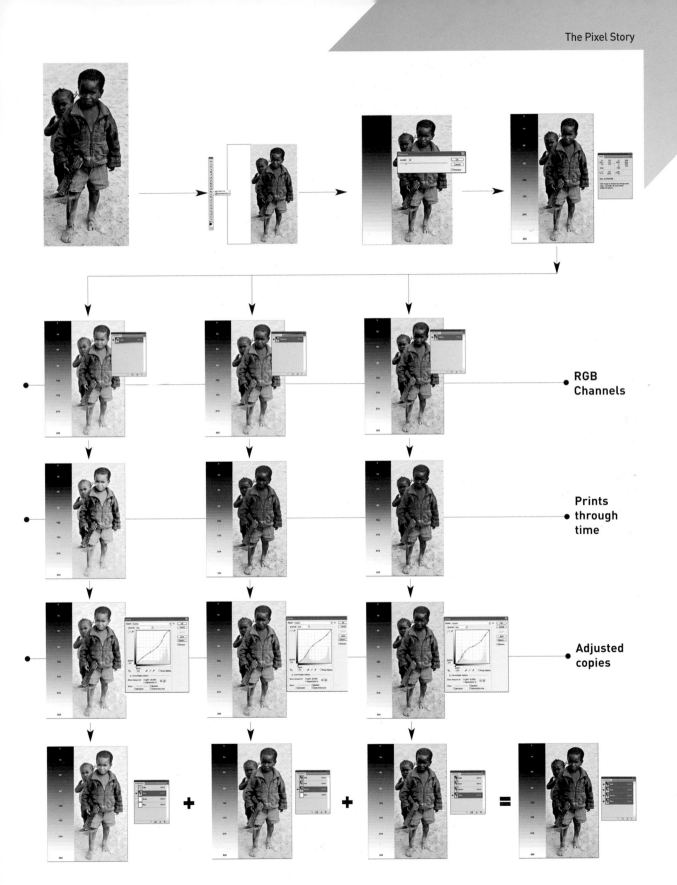

RGB
Channels

Prints
through
time

Adjusted
copies

You now need to make sure that your image can be restored into colour in 400 years' time, so the second part of the technique is to reassemble your picture:

- Take your three prints and scan or rephotograph them. If you photograph your prints, keep them the same size and ensure the lighting and exposure are as consistent as possible. The more care you take over this, the fewer problems you will have with the reconstructed image. Convert all three images to Grayscale, and save them with a different file name, including their colour (cyan, magenta or yellow) for easy identification.
- On each of the three images you now need to use Curves to match the pixel values that you placed on the gradient. Do this by loading one of your new greyscale images into Adobe Photoshop and choosing Image → Adjustments → Curves to open the Curves dialogue box. Click on the finger icon at the bottom left of the curve, then bring your cursor to the first of the bands of tone with known values that you placed on the gradient earlier. Click and hold the mouse, and then drag upwards (to raise the output pixel value) or downwards (to lower it) until the output value matches the pixel value you noted on the original image. Repeat this on each of the bands with the known pixel values.
- This process will need to be repeated on the other two images. At this stage it is advisable to resave your three adjusted images with yet another name, this time suggesting the colour and stage of the process.
- Starting with your adjusted cyan image, choose Select → All and then Copy, so as to copy the document's dimensions to the clipboard. Choose New → Document and use the clipboard as source. Ensure that the colour mode is set to RGB and the resolution to 300ppi.
- Open the Channels window and click on the red channel to make it active.
- Click back on your adjusted cyan image, Select All and then copy and paste it into your new blank image, ensuring that it is pasted into the red channel only.
- Now, go to the Channels palette in your new target image and click on the green channel to make it active. Open the adjusted magenta image, Select All and then copy and paste it into the green channel of your new file.
- Finally, activate the blue channel in your destination image and copy and paste your adjusted yellow image into it.
- Turn all of the channels back on in your destination file by clicking in the RGB composite and you should now have a full-colour image that matches your original file.

Feedback

Since you will never meet the cloaked stranger again, you will never know if your vital picture got there, but if you are looking at a good-quality colour image that was once three black-and-white images (**6.52**), and it is a fairly close match to your original, you will have succeeded in using this complex technique and learned about channels too. Can you think of other creative uses for this idea?

DIGITAL OUTPUT

In this chapter you will learn how to:

- Apply colour management to your digital photographs
- Prepare your images for screen-based and printed output
- Use non-destructive editing and simple image-manipulation techniques

Colour Management

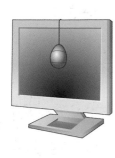

If you view a bank of televisions in a department store, it is unlikely that each screen will display the same colour or tonal range, despite their all being fed with the same signal. This is because the final output has not been corrected or standardized, and the same is true of digital photographs: between the image that you capture and its output – on a screen or as a print – you need to manage the colour at every step. If just one stage is not controlled, then colour accuracy is lost.

The colour and tonal values produced by a device are known as its **gamut** and it is unlikely that any device that handles colour – be it a camera, computer monitor, printer or scanner – will have the same gamut as another, even if they are made by the same manufacturer. This is despite each of them using the same digital data, which suggests that some means of 'matching' the colour between devices is required.

If you are only ever going to be using the same hardware and software – known as a 'closed-loop workflow' – then it is possible to achieve good, predictable results through trial and error. Yet while this can produce satisfactory results for images used within the closed loop, any picture that is exported into another workflow, such as a printer's or publisher's, may not be output in the same way.

In 1993, in an attempt to overcome this, eight leading manufacturers of the time (Adobe, Agfa, Apple, Kodak, Microsoft, Silicon Graphics, Sun Microsystems and Taligent) formed the International Colour Consortium, or ICC. Their aim was to produce a means of ensuring colour consistency across a wide variety of devices, from input to output, which they achieved through the use of a software colour engine and colour profiles that changed the gamut of a device to match an ICC standard. Consequently, images managed within an ICC colour workflow would behave in a predictable way, no matter where in the world they were handled. ICC profiling still underpins colour management in digital photography.

Calibration and Profiles

To make an **ICC profile** you need to map the gamut of the device (a monitor, printer, scanner or digital camera, for example) using either software- or hardware-based calibration. This is done by sending a set of known colours and tones to the device and then accurately measuring the resulting output (**7.1**). The differences between the input and the output image, in terms of colour, brightness and contrast, are then saved as a profile. When data is subsequently sent to that device, it is modified by the profile so that the result is corrected to an ICC standard (**7.2–7.4**).

7.0 (previous page) Helen Ritchie was first attracted by the heat coming from this workshop in Morocco. The white light is the hot steam from the dyeing process combined with the overhead light and yet more heat from an opening in the roof that exposes the sunlight.

7.1 (above) Your monitor and printer, and the paper you choose, require profiling for an accurate result.

7.2 (right) When an output has an ICC profile attached to it, a correction is made, compensating for the device's inherent gamut.

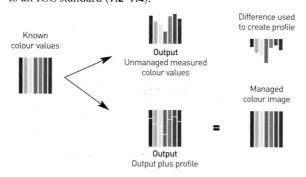

Known colour values

Output
Unmanaged measured colour values

Difference used to create profile

Output
Output plus profile

=

Managed colour image

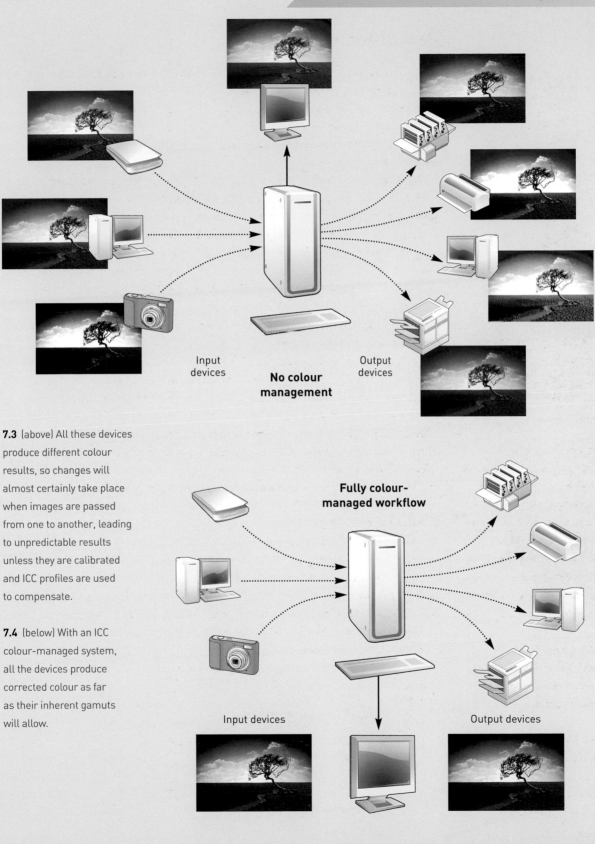

Input
devices

**No colour
management**

Output
devices

7.3 (above) All these devices
produce different colour
results, so changes will
almost certainly take place
when images are passed
from one to another, leading
to unpredictable results
unless they are calibrated
and ICC profiles are used
to compensate.

7.4 (below) With an ICC
colour-managed system,
all the devices produce
corrected colour as far
as their inherent gamuts
will allow.

**Fully colour-
managed workflow**

Input devices

Output devices

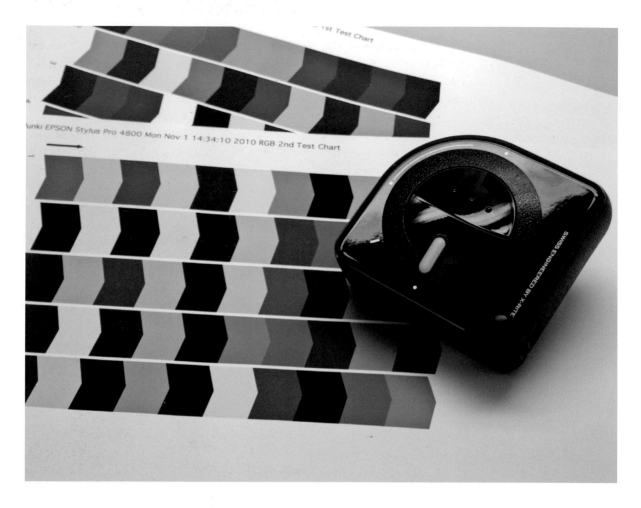

In the image: *1st Test Chart* ... *...unki EPSON Stylus Pro 4800 Mon Nov 1 14:34:10 2010 RGB 2nd Test Chart* ... *SWISS ENGINEERED BY X-RITE*

7.5 X-Rite's ColorMunki is a spectrophotometer, a piece of hardware that is designed to enable accurate colour calibration.

A device can only be calibrated to provide a profile as good as its inherent gamut can provide: an **ink-jet** print on a high-quality, glossy paper will be capable of producing a wider gamut than a laser printer using standard office paper, for example. The way in which a profile is created can also have an effect on its accuracy, with hardware-based calibration (**7.5**) a far more accurate and consistent option than software-based solutions that rely on the operator making visual comparisons and changes. The simple reason for this is that everyone sees colour slightly differently.

Calibrating your digital camera is now also possible at a relatively low cost. It can be done by shooting an image of a panel of colour patches (which can be carried in your camera bag), which is read by software to produce a profile for these unique conditions. This profile can then be applied to all images taken under those shooting conditions, using batch processing if necessary, to produce accurate and consistent colours. This system is very useful when using a digital **SLR** camera outdoors, as the **colour temperature** of daylight changes constantly.

Once a profile has been created, the colour management module (or CMM) passes the incoming data through the profile, making the corrections needed to display it accurately on screen. To make a print, this modified data is then passed through another profile that will make corrections for the printer.

7.6 (above) A simplified colour wheel.

7.7 (below) The elements of the LSH colour model.

7.8 (below right) The LSH colour model in 3D.

Luminance

Saturation

Hue (colour)

The colour wheel

The colour wheel with saturation

Colour Model

As we have already seen, digital photography relies on a set of **primary colours** (red, green and blue), and a set of **secondary colours** (cyan, magenta and yellow). In the diagram (**7.6**), colour displayed at the tip of a triangle can be made by mixing the two adjacent colours; magenta and yellow make red, for example. Any colour on the opposite side of the colour wheel will be its negative; for example, blue is the opposite of yellow.

The colour model used in digital photography also describes tone and brightness. This is described as 'LSH' (**7.7**), where L stands for **luminance** (brightness), S is **saturation** (the extent to which a particular red, for example, impresses the viewer by its *redness*), and H is **hue** (*which* colour – whether red, violet or orange, for example).

To understand how a colour model works, try to visualize a three-dimensional space (**7.8**) where hue is arranged as a circle or colour wheel; luminance is an axis that passes through the centre at ninety degrees and changes from black to white; and saturation is represented by moving outwards from the central axis (where there is no colour) to the outer edge (where there is full colour saturation).

Horizontal view of the colour wheel

Adding luminance as the vertical axis

Full 3D view, showing how so many colours are made

Working with Colour

The environment in which you view your monitor can have a significant effect on how you perceive colours. Viewing a screen in low levels of **ambient lighting** that are kept consistent throughout the day is far better than viewing while under bright office lighting or close to a window. The background colour of your screen can also affect perception, and bright desktop wallpaper is best replaced with a simple, mid-grey background for your monitor, which should not be cluttered with too many colours and icons. This may sound dull, but it does help to ensure a colour-neutral working space for checking and editing your digital photographs.

To help ensure that the images you view on screen are as accurate as possible, your monitor needs to be calibrated, and part of this process involves setting a standard white balance, usually known as D65 or 6500K (**degrees Kelvin**). For the best results, illuminate your prints with a bright, even light of the same colour temperature. The images will look warmer than the version on your monitor if you view a print by a standard desktop lamp, or cooler if taken outside and reviewed in indirect daylight. If you know that your images will be lit by a certain colour of lighting – in an exhibition, for example – you could allow for this and make adjustments to the colour of the print to compensate.

Daylight-Balanced Lightboxes

If you cannot afford a calibrated print-viewing system, you can use an old daylight-balanced lightbox to check your prints instead. Stand the lightbox upright and lay a sheet of grey card in front of it, with your print in the middle of the card. Although the print will be brighter nearer the lightbox, the large, daylight-balanced light provides an inexpensive way of checking the colour of your digital prints against the image on your monitor.

Colour Spaces in Detail

Initially, colour workspaces were device-dependent, which led to inconsistent results unless everyone in a workflow was using matching equipment with the same gamut. This, of course, was not practical, so four **RGB colour spaces** were devised that were not dependent on the device itself, and which had a fixed gamut. These colour workspaces are three-dimensional in nature and based on the LSH colour model outlined above, with each possessing a shape that is designed to suit a specific use.

Adobe RGB (1998): Provides a fairly large gamut of RGB colours (**7.9**) and is well suited for documents that will later be converted to **CMYK**. This space is most often used for such print-production work as book and magazine printing, which requires a broad range of colours. It is ideal for professional digital photography, so if your digital SLR camera offers a choice of **sRGB** (see below) and Adobe RGB, choose this wider workspace.

sRGB IEC61966-2.1: Abbreviated to sRGB, this colour space reflects the characteristics of the average computer monitor (**7.10**). This standard space is endorsed by many hardware and software manufacturers, and is becoming the default colour space for many scanners, low-end printers, mobile phones and compact cameras, as well as some software applications. It is the ideal colour space for images destined for online or screen display, but its limited colour gamut means that it is not recommended for pre-press work.

The two other workspaces, Colormatch and Apple RGB, are both used only in specialist workflows and are not available as in-camera options.

In addition to these four standardized colour spaces, there are many custom colour spaces available that are designed for individual and specific use, including ProPhoto, which is increasingly being used for handling **Raw** files. When an image has been converted into any one of these colour workspaces, it becomes tagged with that space, and all software can then correctly view that data, as long as it has been calibrated to ICC standards.

7.9 (right) The Adobe RGB 1998 workspace displayed on a Mac computer. You can find this program by navigating to Applications → Utilities → ColorSync Utility. Here you can view all the profiles and colour spaces stored on your computer.

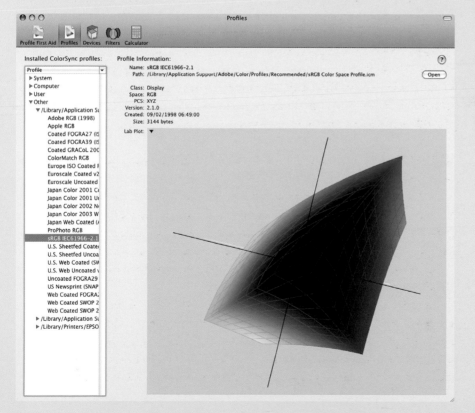

7.10 (left) The sRGB workspace. There is no equivalent viewing software built into the PC operating system.

Rendering Intent

As colour spaces all accommodate a specific range of colours, when you move an image between colour spaces, a set of rules called a 'rendering intent' is needed. This converts the colours from one colour space to another. While rendering intents are designed to address the problem of handling out-of-gamut colours during this migration, they can have an effect on the colours in an image. Out-of-gamut colours are simply the colours present in the source colour space that the destination colour space is incapable of reproducing. This is generally an issue when moving from a larger space into a smaller one. In digital photography there are two rendering intents that are used most often: Perceptual and Relative Colorimetric.

> **Perceptual**: All the colours in the larger space are compressed to fit the new, smaller space, which alters all the colours in an image, but maintains its overall look (**7.11**).

> **Relative Colorimetric**: All colours that are 'in-gamut' are migrated accurately, while out-of-gamut colours are 'clipped' to the nearest reproducible colour (**7.12**).

With the majority of modern scanners and digital cameras, the difference between Perceptual and Relative Colorimetric is very slight, but you may want to experiment and compare prints made using both. As a guide, Perceptual rendering works well for most scanned photographs and digital camera files, while Relative Colorimetric is often preferred for vector art, but this is still open to debate and is partly a matter of personal preference.

Colour Settings in Adobe Photoshop

Adobe Photoshop's Colour Settings are important, and the default may not be correct for your workflow or for those who output or archive your photographs (**7.13**). There are now accepted standard settings, but you should always consult your printer or publisher if at all possible, to ensure that they do not use an alternative.

Choosing Colour Settings from the Edit menu accesses the colour settings (**7.14, 7.15**). If you are in Europe, click on More Options at the right of the window and then select Europe Prepress 3 from the list. This makes all the necessary adjustments for you and is likely to be

7.11 (below left) Perceptual Rendering Intent.

7.12 (below right) Relative Colorimetric Rendering Intent.

7.13 (opposite) Getting the colour right is important even if you are working in monochrome. For this image, Adrian Multon wanted to simulate a darkroom sepia-and-gold-toner combination.

All colours could change when moving to a smaller colour space

All in-gamut colours would remain the same when moving to a smaller colour space. Out-of-gamut colours will alter

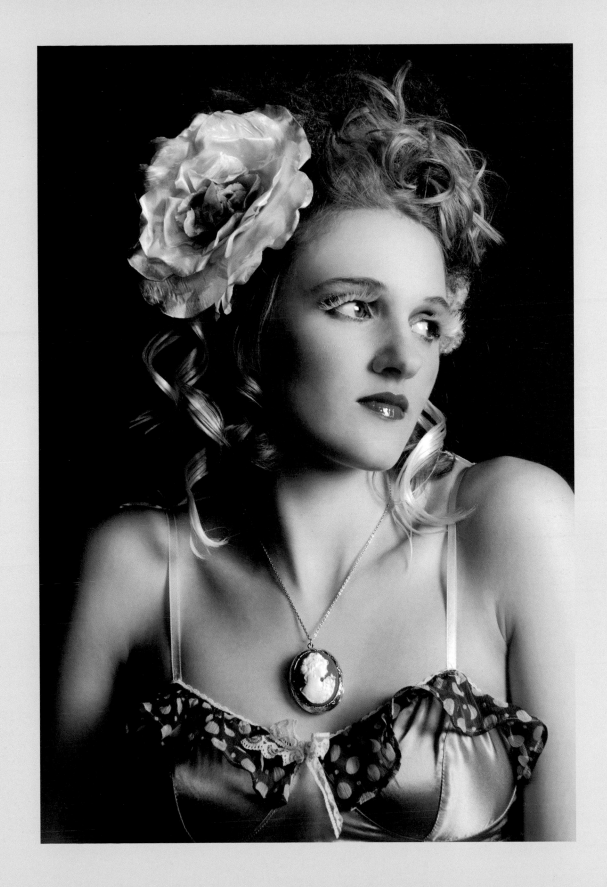

7.14 (right) Selecting Adobe Photoshop Colour Settings.

7.15 (far right) Colour Settings main dialogue window. To expand this panel, select More Options.

7.16 (right) Colour Settings pre-sets – selecting settings for Europe.

7.17 (far right) These are the correct Colour Settings for Europe. If you are working or having work printed or reproduced in another geographical location, you should investigate what standard settings are in use.

7.18 (right) Colour Settings pre-sets – selecting settings for North America.

7.19 (far right) These are the correct Colour Settings for North America. If you are working or having work printed or reproduced in another geographical location, you should investigate what standard settings are in use.

correct for working in Europe; other settings are available for pre-press work elsewhere (**7.16–7.19**). You can synchronize all your Adobe® Creative Suite® programs to use the same Colour Settings by opening and making this change in Adobe Bridge. If you are working with an earlier version of Photoshop, Europe Prepress 3 may not be an option, in which case you should choose either Europe Prepress 2 or Europe Prepress Defaults instead. Note that in all cases the Working Space for RGB is set to Adobe RGB (1998).

Colour-Management Policies and Workspaces

Once the Colour Settings are set up correctly, any file opened in Adobe Photoshop will be handled in one of three ways:

- If the file is tagged with the same colour space as the one that is being used by the program, then it will open with no warnings.
- If the image has a different colour space from the Photoshop workspace, then a 'Profile Mismatch Warning' will appear (**7.20**).
- If Photoshop finds no colour space attached to the image, it will produce a 'Missing Profile Warning'.

In the event of a Profile Mismatch, you are offered three options: Use Existing Profile; Convert to Working Colour Space; and Discard.

Use Existing Profile: The file will open in the current workspace, but no conversion will take place. You might use this if you are given work to do on someone else's file, as changing the colour space could alter the way the image looks when you hand it back to him or her.

Convert to Working Colour Space: Photoshop will change the colour space of the image (from sRGB to Adobe RGB, for example), and the file will be tagged with the new workspace for future users. It will look correct in your working colour space.

Discard: There is no advantage in discarding a colour profile, as it will alter the way an image looks, but on occasion this is requested. If you can, talk to the person printing your images and always prepare the file in the way that they request, even if they want you to discard its colour profile. Sometimes, a profiled image may not fit into their workflow or CMYK conversion process, so some print bureaux request images that have not been tagged.

A 'Missing Profile' file will usually be generated by images taken using an older digital camera or badly set-up **scanning** software. Again, three options are given: Leave; Assign; and Assign & Convert.

Leave: Opens the file and allows you to edit the untagged image. You will then be offered the option to convert the image to the default working colour space when you save the file.

Assign: Changes the appearance of the file, but the image will not be tagged with the new profile unless you choose to do so when saving the image.

Assign & Convert: Assigns the working colour space to the image and converts it at the same time, so the file is tagged with the working colour space.

It is possible for images in different workspaces to be opened at the same time in Adobe Photoshop. To view the workspace of an open image, click the small, right-facing arrow at the bottom of the main window and choose Document Profile from the drop-down options.

Checking the Colour Space

The default colour space when Adobe Photoshop is installed is sRGB, which you will need to change as soon as possible. In a college or any shared workstation environment, check that the RGB colour workspace is set to Adobe RGB (1998) every time you load Photoshop.

7.20 Adobe Photoshop's Profile Mismatch and Profile Missing dialogue boxes.

Using Different File Types in Adobe Photoshop

Although there is a long list of file formats in which you can choose to save your images, there are only four that you really need to concern yourself with: **JPEG**, **TIFF**, PSD (Photoshop Document) and Raw.

Raw files contain the pixel data captured by the **sensor**, so the only camera setting that alters the file is the **ISO** or sensor sensitivity. Aside from this, all the other settings can be adjusted in the Raw conversion software, which allows you to remaster the image. All the changes you make are recorded as a **sidecar** (**XMP**-format) **file** alongside the image itself, so the raw data remains unchanged. As long as the XMP file is kept with the associated Raw file, the changes made to the image will be displayed next time the Raw file is opened, and it can be further altered or totally remastered. The only change that can be made permanently to the Raw data is to delete it.

When you save a TIFF file in Adobe Photoshop, a dialogue box appears asking if you wish to save it in IBM PC or Macintosh **byte** order. If your image is to be opened in Photoshop on any platform you can ignore this setting, but if it will be opened in other software, it would be wise to save in the IBM PC byte order, as this can be read by the widest range of programs and computers. If in doubt, and it is paramount that the image can be opened, save two versions, one of each type, with the setting identified in each file name.

In earlier versions of Photoshop, only PSD files could be saved with **layers**. Layers are very useful while an image is still a work in progress, as they enable you to make changes more easily if a client comes back with last-minute alterations or you spot an error in some text. Recent versions of Photoshop now allow you to save TIFF files with layers as well, and there is no practical difference between using these and PSD files.

Priorities When Opening New Images

When opening a camera JPEG file, the first step should be to save it as a TIFF, changing the **resolution** from 72**ppi** to 300ppi (if necessary), but without resampling the image or changing the file size. This is also a good time to replace the camera's numeric file name with something more memorable. Image-import software allows some, or all, of this to be done automatically and in batches, and it means that your newly saved TIFF file now becomes a 'digital master' that you can archive and work from when needed, thus avoiding the damage caused by resaving JPEG files. For details on downloading your images, see p. 164.

Archiving TIFFs

If you are shooting JPEG files, convert your selected shots into TIFFs and archive these. If you need a JPEG to attach to an e-mail or use in a screen- or web-based presentation, make a new JPEG from your archived TIFF to suit your exact requirements.

Archiving Layered and Flattened Files

It is good practice to archive both the latest version of your file with layers and the final flattened TIFF file. A good trick is to save two files with exactly the same name, using the PSD format for your layered image and TIFF for the flattened file. In a professional environment, this can help prevent you sending layered files to a client, or accidentally deleting your layered file before the client's final approval. A flattened file will not be as easy for a third party to alter as a layered file, either, adding a level of protection to your chosen image when it is passed on to others.

Changing Default Software

On a Mac you can reset the default program used to open a specific file type by highlighting a file on your hard drive, clicking on File Info from the menu and selecting your image-editing program from the Open With option. It is also possible to do this on a Windows PC, but the process differs between operating systems. Once a file has been saved in an image-editing program, it will subsequently open correctly when you double-click on the file's icon.

7.21 Snow in central London is a rare occurrence, and Bella Falk was very careful to ensure that this unrepeatable image was saved at every stage of the image-processing.

Compression Types

When you save an image as a TIFF, a dialogue box gives you the option of applying four types of **compression**: JPEG, Zip, LZW (standing for Lempel-Ziv-Welch, its inventors) and None. The losses in JPEG have already been discussed, and Zip is rarely used in this way. While LZW can save space on your hard drive, there are many programs and older operating systems that will not open these files. Most of the world's museums do not support LZW because they do not expect it to be around in thirty to fifty years' time. The fourth option, None, is always safest when saving a TIFF.

Mean: 30.56
Std Dev: 18.84
Median: 27
Pixels: 206955

Level:
Count:
Percentile:
Cache Level: 1

7.22 A typical low-key image and its histogram.

7.23 A typical high-key image and its histogram.

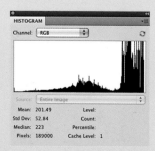

Mean: 201.49
Std Dev: 52.84
Median: 223
Pixels: 189000

Level:
Count:
Percentile:
Cache Level: 1

Once you have opened your file, you are ready to start editing it, and there is a specific order in which this process should be carried out: Levels to set highlight and shadow points in the image; Curves to remap the tonal values; and then Color Balance.

Levels

Although your camera should have done a fairly good job recording shadows and highlights when shooting JPEG images, it is possible that the exposure will have produced an image that contains neither white nor black. Using Levels to remap the highlights in your image to white, and the shadows to black, will improve the appearance of nearly all JPEG files.

In Photoshop, Levels is found in the Image > Adjustments menu. You should already be familiar with the **histogram** in your camera, and the Levels window presents a similar bar chart, with the tonal values making up the image marked on a baseline ranging from shadows (o) on the left to highlights (255) on the right. You will often read that a good, technically correct image should sit nicely between the two, with the darkest shadow being o and the brightest highlight 255, but this is not always true. A low-key image (**7.22**) will have a histogram that is naturally shifted towards the shadow end, while a high-key image (**7.23**) will have the bulk of its tones towards the highlight end. The height of the histogram is not important, as all it shows is the number of pixels in the image with the same tonal value. It will quite often be seen extending beyond the top of the window, but this is of no consequence.

To make sure that you have both black and white in your images, use the black and white sliders beneath the histogram to adjust the shadows and highlights respectively. Often, these do not need to be moved far, just inwards slightly until they touch the end of the histogram's bar chart.

Ideally, a histogram should not show any clipping at either end of the tonal range (**7.24, 7.25**), but this is especially important with the highlights. If you have values of 255, this means that no ink would be laid down onto the paper when you make a print. This can be acceptable with small, specular highlights, but is guaranteed to look unattractive over large areas.

In a newly exposed image, if the Levels histogram is clipped at the shadow end (**7.27**), you needed more exposure at the time of capture, while a histogram that reveals clipped

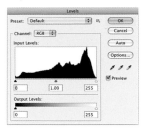

7.24 The position of this histogram shows a good exposure with no clipping. You can see the same information in both the Levels and Curves windows, with the curve superimposed over a histogram. It is also possible to adjust the highlight and shadow settings in the Curves dialogue box.

7.25 This image relates to the histogram in **7.24**, showing a good exposure. The photograph was taken by Jeff Robins while walking by the sea.

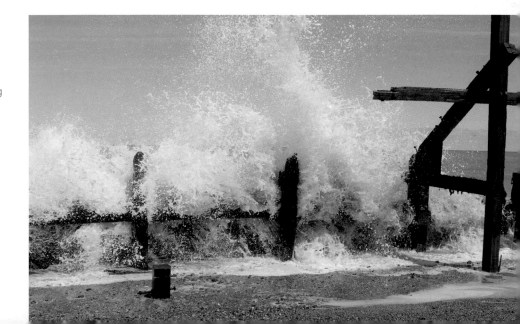

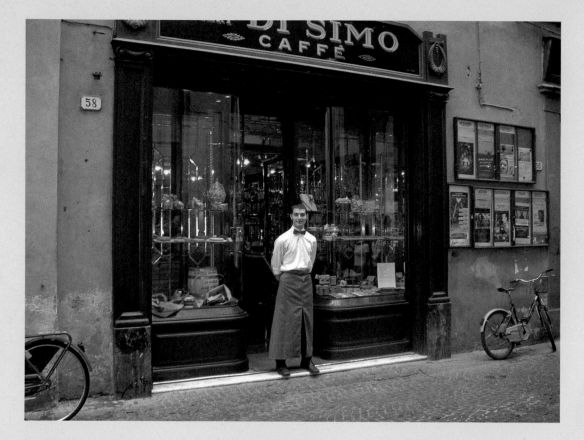

7.26 (above) A correctly exposed image, shot by Jeff Robins on a visit to Lucca in Italy.

7.27 (right) Using the Alt key to display clipping at the shadow end of the histogram.

7.28 (below right) Using the Alt key to display clipping at the highlight end of the histogram.

highlights (**7.28**) indicates that your picture may be overexposed. If either of these tonal areas is clipped, you would be advised to go back and shoot more images, adjusting the exposure as necessary, unless you are happy with the loss of detail.

The central grey slider on the baseline is the gamma slider, which can be thought of as an overall 'tone' control. If you slide it to the left, towards the shadow end of the histogram, it will open up the tones in the mid-tone to shadow areas, lightening the image; while sliding it to the right will darken your picture. Although this is useful, more subtle control can be achieved by using the Curves tool for this.

Other useful tools in the Levels dialogue window are the three Eyedropper icons towards the lower right of the window (**7.29–7.31**). The black and white Eyedroppers are used by clicking on the Eyedropper and then on the image to set the chosen pixel to black (value 0) or to white (value 255) to set the darkest and brightest areas in your picture.

The middle, grey, Eyedropper can be used to set the colour balance of the image to a neutral grey by clicking on a known neutral area in your picture. The selected point will be converted to grey, correcting any bias, as all the other colours will be adjusted by the same amount. You can try this in one or two different areas to see which gives the best results. While it may not always be accurate, it is likely to give you a good starting point for more detailed colour correction later on.

If you have a number of images that require the same (or similar) Levels adjustments, it is possible to open and adjust one image and save the adjustments. Your saved settings can then be loaded and applied to any other image, giving you the same result every time.

Preventing Clipping

To prevent clipping either the highlights or shadows when you adjust the levels, hold down the Alt key when clicking on and dragging either of the sliders. The image on the screen will go to white or black (depending on the slider you are adjusting) and, as you move the slider in, detail will begin to appear on the screen. This detail represents information that is now being clipped from the image.

7.29 (left and below) The tool panel and the Eyedropper settings in the options bar at the top of the desktop.

7.30 (above) The location of the Eyedropper tools in the Levels palette.

7.31 (left) The location of the Eyedropper tools in the Curves palette.

221

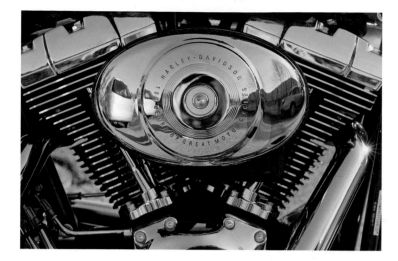

7.32 (left) An unaltered image of a Centenary Harley Davidson motorcycle, shot by Jeff Robins.

7.33 (below left) Moving the Gamma slider to the left will lighten the image.

7.34 (bottom left) Using Levels directly, rather than as an Adjustment Layer, does not allow for further adjustment: if you want to change the effect, you will have to reapply the Levels.

7.35 (below) Using an Adjustment Layer to change the Levels allows for further adjustments at any time.

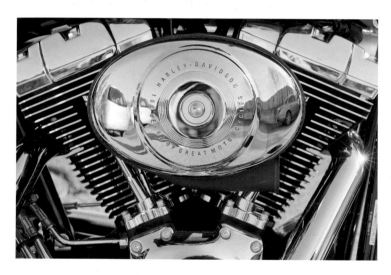

7.36 (below left) Moving the Gamma slider to the right will darken an image.

7.37 (below) Using an Adjustment Layer to change the Levels allows for further adjustments at any time.

7.38 (bottom left) The Levels panel, showing the Gamma slider moved to the right: using Levels in this way does not allow for further adjustment.

Curves

The Curves adjustment tool represents all the pixel values that can make up an image, from 0 to 255, displaying the output values against input values in a linear form (**7.40–7.43**). If the curve is a straight line from corner to corner, then the input values equal the output values and the image remains unchanged. It is possible, however, to change this relationship, and if the curve is raised, the output values will be higher than the input values, making the image lighter. Lowering the curve will result in a darker image. It is possible to place anchor points on the curve that allow you to make selective changes in tone within different tonal areas of the image.

The Curves window also displays a histogram with Levels controls, as well as the black, grey and white Eyedroppers noted previously. Curves can also be used in individual colour **channels**, allowing selective colour adjustment, and refinements may also be made to selected areas of an image.

Although the general principle of Curves is the same for all versions of Adobe Photoshop, you can access more options in Photoshop CS3, or later, if you click on the Curve Display Options button. Ensure that Histogram and Light (0–255) are selected so that when you pass your cursor over the image and click, you will see a dot appear on the curve. This represents the value of that selected pixel. If you click on the curve you will place a dot there (known as an anchor point), which can be moved by clicking and dragging in any direction. When this is done, you will see the Output Value alter relative to the direction of that move; a lower number will result in a darker image, and a higher number will result in a lighter image (**7.44–7.49**).

7.39 Sample image with no Curves adjustments, shot in California by Jeff Robins.

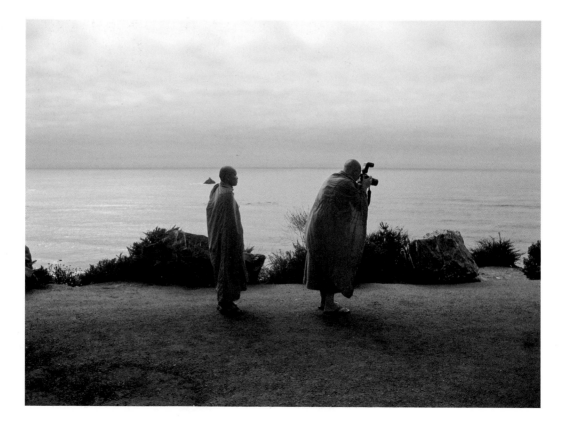

7.40 Destructive Curves adjustments can be made to an image by selecting Image → Adjustments → Curves from Photoshop's main menu.

7.41 Unless you use an Adjustment Layer to alter the curve, it changes the data in the file immediately.

7.42 (right) Non-destructive Curves adjustments can be made by creating an Adjustment Layer, either from the Adjustments panel or from the bottom of the Layers palette.

7.43 (far right) When a Curves Adjustment Layer is used, the data in the file is not altered until the layers are flattened and/or saved.

7.44 (right) A correctly exposed, unprocessed image of a fisherman's hut.

7.45 (centre) The same photograph, lightened using Curves.

7.46 (far right) The same photograph, darkened using Curves.

7.47 (right) The curve of **7.44**, showing no adjustment.

7.48 (centre) Raising the curve lightens the image.

7.49 (far right) Lowering the curve darkens the image.

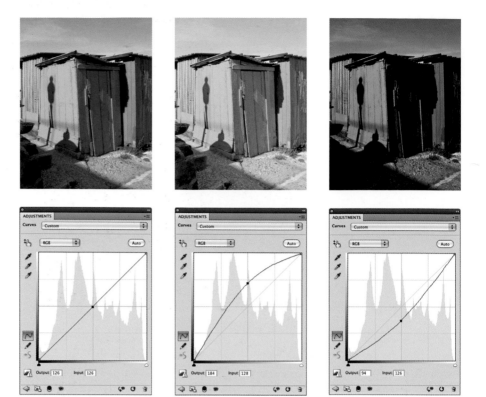

You are not, however, restricted to using a single anchor point on the curve: multiple anchor points can be used to adjust a smaller range of tones, or to lock an area so that it is not affected by other adjustments to the curve. Unwanted anchor points can be removed by clicking on them and dragging them off the curve.

As well as adjusting the curve yourself, you can load pre-set curves and apply them to your images, and it is also possible to save and then later reload curves that you have made for yourself.

The Curves tool in Adobe Photoshop CS3 and later versions of the program also displays a histogram, along with highlight and shadow adjustment sliders that work in much the same way as the sliders in Levels. If you check the 'show **clipping**' box, you will be shown a black or white screen when you click on one of the sliders and, as you move the slider inwards, detail will begin to be displayed on the screen. This represents detail that will be lost from the clipped part of the image (**7.50–7.54**).

Localizing Adjustments

Tonal adjustments made with Curves (and Levels) can be localized by first selecting part of the image, so the adjustment is applied only to the selected area.

Making Precise Adjustments

Using a mouse to move the curve can be rather crude. For greater precision, click on an anchor point and use the cursor keys on the keyboard to move it by one pixel tone value at a time.

7.50 (right) An unadjusted image.

7.51 (below left) The image has been lightened using the Levels/Histogram setting in the Curves Adjustment Layer.

7.52 (below right) A clipping warning can be activated in the Curves dialogue either by choosing this option from the menu at the top of the adjustment layer panel or by holding down the Alt key when applying the setting.

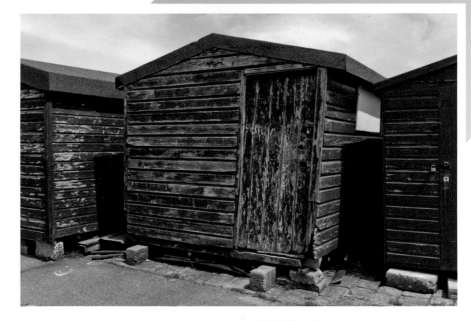

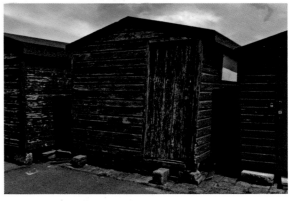

7.53 (above and above right) Using the Levels/Histogram setting in the Curves Adjustment Layer to darken the image.

7.54 (above and above right) The adjusted image and its histogram, showing the Curves adjustment with the clipping warning activated.

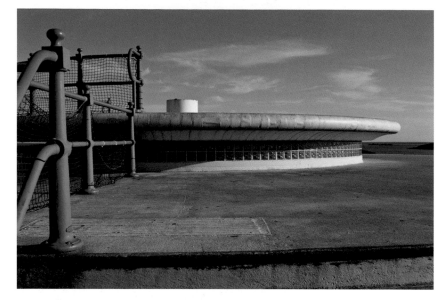

7.55 An image with a Curves adjustment applied and the Preview button checked to show the effect of the adjustment.

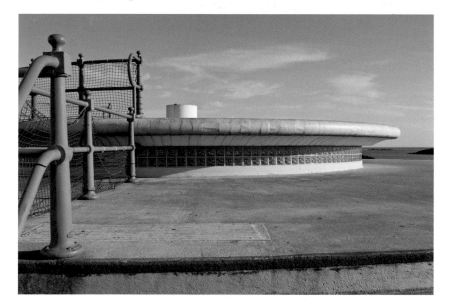

7.56 The same image without the Preview button checked, showing the image before the adjustment. Nearly all of Adobe Photoshop's tools have a Preview option.

7.57 (left) The image with a
Levels adjustment applied.

7.58 (below) Histogram with
Levels settings applied.

7.59 (above) Histogram with
the Levels setting undone.

7.60 (left) Resetting the
Levels adjustments.

7.61 (below) Histogram with
Levels reset, showing all
adjustments removed
without closing the window.

7.62 (right) The Color
Balance control panel.

7.63 (far right)
An image with the wrong
colour balance.

7.64 (below) The
corrected image.

7.65 (below right)
Colour balance
corrections.

Colour Correction

Most Photoshop experts have their own technique for colour correction, but there are three options that are quick and easy to learn. The first is to use Variations, which is accessed via Image > Adjustments from the main menu. Variations opens your image in a 'ring-around' window, which shows your Current Pick in the centre, with six colour options (red, green, blue, cyan, magenta and yellow) surrounding it (**7.66**). Moving the Coarse/Fine slider alters the intensity of the colour options. Clicking on one of those options will apply it to your preview image. Both the Current Pick and the colour options will be updated, allowing you to click on more than one colour to fine-tune your image. You can also adjust the overall lightness of the image using the Lighten and Darken buttons to the lower right of the main window.

A second, and more controllable, means of adjusting the colour in an image is to choose Image > Adjustments > Color Balance from the main menu. This brings up a simple dialogue box with three sliders that allow you to adjust the values in the red, green and blue channels. Remember that increasing red is the same as decreasing cyan in the image; increasing green will decrease magenta; and increasing blue decreases yellow. With a little practice, this offers greater control of the colour in the image, with Shadow, Midtone and Highlight buttons at the bottom allowing you to target the adjustments on a specific tonal range (**7.62–7.65**). As with Variations, Color Balance can be applied to just one layer in an image, or a selected area, as well as to the image as a whole.

The third option is to adjust the colour in an image by using Curves. The individual red, green and blue channels can be selected from the drop-down menu at the top of the Curves palettes, and making slight changes to each channel can provide you with very sophisticated and subtle control over the colour, although practice and experience are needed to get the best results.

7.66 The Variations window.

Grey Card

At the start of a shoot, many digital photographers take a picture of a standard grey card (**7.67**) that has a known 18% reflectance. They will then use a custom white balance setting in the camera to ensure accurately colour-balanced pictures, even in difficult or mixed lighting. Alternatively, this can be useful when using the Grey Picker in Curves and Levels to alter the white balance in **post-production**.

7.67 A standard grey card is expensive, but a similar card from an art shop will give a near match. You could also have a cool (bluish) grey card for a warmer colour bias, and a warm grey card to create a cooler mood in your shots.

Saving Your Image

When you need to save your images, especially for the first time, it is always best to choose your program's Save As option (**7.68–7.70**). This allows you to set a destination, a file name and a file type. This should help prevent you overwriting your original image, as if you choose Save, your file will be saved with the same name and into the same destination as the original. Unless you also have it backed up elsewhere, you could easily find that your original is lost.

This is also the time to think about adding **keywords** to your images. You should already have planned how you will archive them (see Chapter 5), but to aid you further when it comes to searching for specific pictures, you may want to add information by selecting File Info from the File menu. This offers you a number of predetermined fields that can be added to the file's existing **metadata** to make it easier to identify and locate the image in the future. If you do some research, you will find various keyword conventions commonly in use throughout the industry that will be acceptable if your image were to be taken into a stock

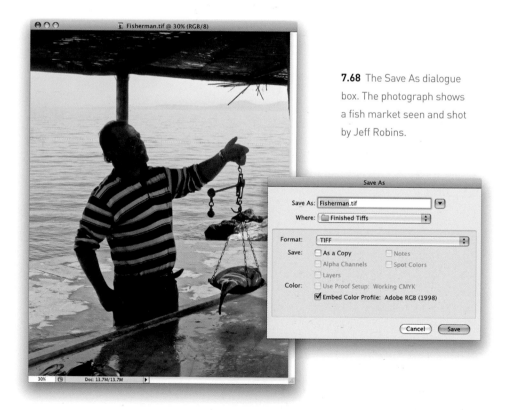

7.68 The Save As dialogue box. The photograph shows a fish market seen and shot by Jeff Robins.

7.69 The expanded Save As panel allows you to change the file name, as well as the file type and the save location.

7.70 If there is a danger of overwriting the original file, a warning will be shown.

library or put on a major database. Start to think about doing this from the outset, rather than leaving it until later: it is far easier to keyword a handful of images now, rather than trying to tag thousands of photographs later (**7.71–7.74**).

In recent years there has been a move towards archiving Raw files, as well as TIFFs, but it is important that any archived Raw file is stored along with its associated XMP sidecar file. As explained on p. 216, this contains the editing information associated with a Raw file, such as changes to the white balance, exposure or sharpening. Archiving the Raw image along with this file will mean that you are archiving any non-destructive editing (see p. 237) that has been carried out on the file. In such programs as Adobe® Lightroom®, edits made to a Raw file are stored, by default, in a catalogue (image database) set up by the program upon installation. It is possible to alter the preferences so that the edit information is incorporated into the metadata of JPEG, TIFF and PSD files, or, in the case of a Raw file, into an associated XMP file. As long as the original Raw file is kept with this editing data, it can be reopened in exactly the same state as the last time it was modified, allowing further editing and refinement if required. If you fail to do this, it will mean that you will have to re-edit the image, as it will open as if for the first time.

7.71 (below) File Info is accessed from Photoshop's main File menu.

7.72 (below right) The Info Description panel.

DNG Files

Many photographers now archive their Raw camera originals as **digital negative (DNG)** files, a 'universal' Raw-file format developed by Adobe. This format maintains all the properties of the original Raw file, but overcomes compatibility problems that can arise with different versions of Photoshop and the many different Raw-file formats in use by the industry. Most of the world's museums and galleries, however, still prefer to archive digital images as TIFF files with IBM byte order and no compression.

234

7.73 (above right) The Camera Data panel: this part of the metadata is not editable.

7.74 (right) The image and its metadata displayed together in Adobe Bridge. This data is the same as in Photoshop's Info window, and can be edited in the same way.

235

7.75 Bettina Strenske spotted these specialist window cleaners abseiling down the clockface of the Houses of Parliament in London; another unrepeatable picture to be archived very carefully.

For many photographers this may now be the best option for archiving their photographs, with the exception of images that have been heavily retouched or manipulated. In those cases, saving the image as a layered PSD or TIFF file, as well as a flattened TIFF, will prove a better option, although you should be sure that you can differentiate between the layered and flattened files.

Software for Importing and Sorting Photos

With digital capture it is always tempting to shoot many more images than you actually need, to ensure that you cover the subject. This inevitably results in the importing, and subsequent sorting, of a high number of image files. The further trend towards shooting and archiving Raw files has led to the development of a number of specialized pieces of software, such as Adobe Lightroom and Apple Aperture. These programs will open and process most generic file formats non-destructively (see opposite), although it will not be possible to recover clipped image data in the same way as you can with a Raw file. Because of the way the data is processed, however, it is often possible to recover a little more clipped data than if the file is opened directly into Photoshop.

Both these programs operate in much the same way, allowing you to import your files and view them on a digital lightbox, as well as to sort, label and rate them and add your keywords. You can also process Raw files, with most of these programs benefiting from extensive batch-processing and file-renaming functions. This software also makes limited retouching tools available for modification of your images, allowing non-destructive editing of all compatible file formats, including JPEG and TIFF, as well as Raw.

Destructive and Non-Destructive Editing

Destructive Editing

The conventional way of working on any file type, except Raw, in Adobe Photoshop changes the data in the image with each and every adjustment. Due to the nature and frequency of the mathematical calculations that are taking place, and the general rounding of numbers, each alteration moves the image further away from the original captured data. This is a one-way street, with no way back unless you save versions of the image at different stages.

Adobe made some progress in reducing these losses of data by introducing Adjustment Layers, which means that adjustments are made and stored on their own layer, and are not applied to the file data until the image is flattened. This reduces the number of calculations that are made.

In Photoshop CS2, Adobe took this a step further when it introduced Smart Objects. These also work by using layers, but expand the range of editing options to include filters and sharpening. Again, the results are visible, but are not actually applied to the file data until the image is flattened for output. If such images are saved with their layers intact, then it is possible to refine the adjustments at any time.

Non-Destructive Editing

Non-destructive editing has long been the aim of modern image-editing. It has been made more viable with the introduction of Raw files, where the image consists of its basic RGB channel data with the metadata holding the adjustments made on the camera. As these adjustments are held separately, either as an associated XMP sidecar file or in a catalogue area on the computer, non-destructive editing leaves the Raw file data unaltered.

This means that all changes are kept apart from the image and are applied only when it is exported to the required specification – as a JPEG or TIFF file, for example. As the image is changed only once, it maintains a greater degree of integrity and makes the resulting file as close as possible to the image as it was captured.

With this system of editing, it is possible to go back and remaster the output from the Raw file at any time without loss of quality. More recent developments now allow you to open TIFF, JPEG and PSD files in Raw-file processing software, allowing non-destructive editing of those file types as well.

Selecting and Sorting Images

When sorting through the images from a shoot, it is good practice to create folders for your selected photographs, including a 'reject' folder. You can then go through your images, make your choices, mark them up and use the program's 'sort' procedure to see only the chosen images. You can have as many different criteria as you like, and it is also possible to sort images based on such things as orientation, shoot date and file type. Used intelligently, all of these will help you to reduce the large number of images that are imported from your camera down to the important ones that will need processing to a higher level.

Trial Versions

You can try Adobe Photoshop and Lightroom, as well as Apple Aperture software, before you buy, by downloading a trial version. This is usually a 30-day time-limited trial, after which you will need a serial number; but that should be plenty of time to decide which program suits your type of photography and workflow, and seems easiest to use.

External Back-up

When editing is completed, move your good images into one of your newly created folders. Back them up to an external drive and also to media kept at another location – a **flash drive** or DVD, for example.

Raw-File Processing

The primary processing settings for your Raw files will be found in a 'Basic' menu (or similar) and will allow you to make fundamental changes to your images' exposure, density, tone, saturation and colour (**7.76–7.78**).

 7.76 Adobe Photoshop's Camera Raw processing window, with the clipping warning activated.

7.77 Some adjustments have been made to this Raw file, including correcting the horizon.

Many other adjustments can also be made here, including very good black-and-white conversions (**7.79–7.81**), along with lens corrections (using lens profiles), sharpening and **noise** reduction. Most programs also offer some retouching tools, such as dust removal, cloning, cropping, rotation and red-eye removal.

There is no technically correct setting for a Raw file, as this is where the photographer can adjust the image creatively to produce his or her own interpretation (**7.82**). A calibrated monitor and the correct profile are essential, as the image will otherwise be altered if it is moved onto another system or computer.

7.78 The Workflow Options panel allows you to set target specifications for the adjusted file.

Colour Depth

TIFF, JPEG and Photoshop PSD files all have an 8-**bit** colour depth unless the image has been converted from a Raw file as a 16-bit file. Do not be tempted to change any images that are shot as 8-bit to 16-bit (unless it is a Raw file), as you will gain nothing in terms of quality, but you will double the file size. The advantages of 16-bit imaging will only be available if the image is processed and output in 16-bit.

7.79 (right) A full-colour image in the Camera Raw window. Photo taken by Jeff Robins in Mariposa, California.

7.80 (below) The HSL/Grayscale panel in Camera Raw allows you to convert an image to black and white with a range of adjustments.

7.81 (below right) The HSL/Grayscale panel showing an altered relationship between yellow and blue.

7.82 (opposite) Palmer + Pawel used their Raw file image-processing skills and creativity to achieve this final result from their original image.

Black-and-White Conversion

A common method of converting a colour photograph into a black-and-white one is to choose **Grayscale** from the Image → Mode menu to produce a single-channel image that contains only greyscale data. This is suitable for output on a black-and-white laser printer, but it is not that much use for ink-jet printing, as colour ink-jet printers work best when they receive an image containing the three RGB channels.

Although you can do this by selecting Image → Adjustments → Desaturate (which leaves the file as an RGB file, but without colour), the best way to convert a photograph to black and white is at the processing stage, if you are working with Raw files, or by using dedicated black-and-white tools that allow you to choose the amount of colour that is taken from each channel of the RGB file. This is very similar to using plain coloured filters over the camera lens for black-and-white photography, to lighten or darken specific tones.

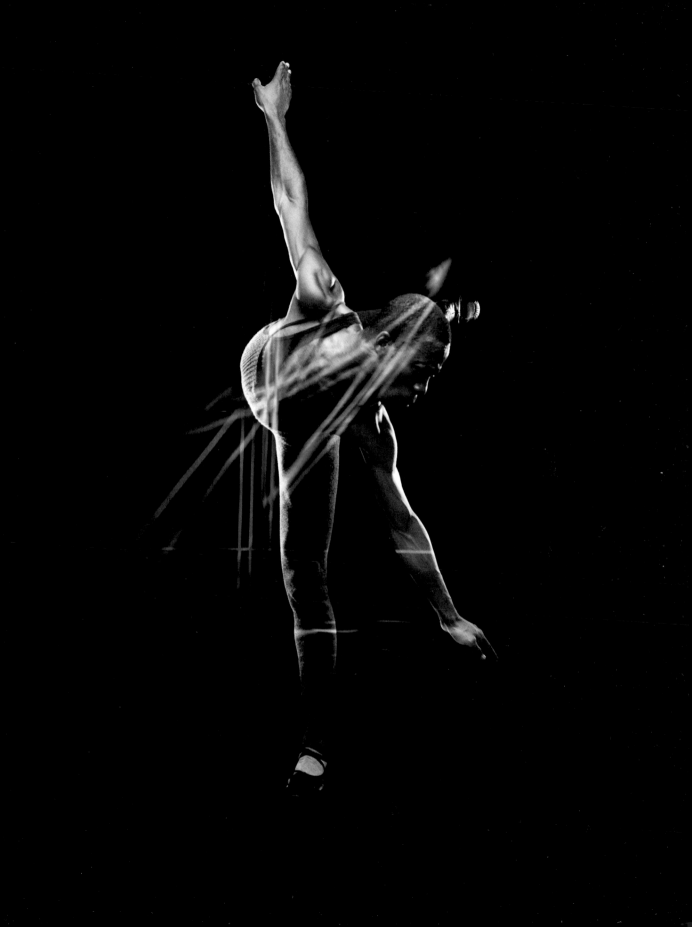

Image Output

In the past, the term 'output' mainly referred to output to print, whether for reproduction by a client or publisher, as a print for sale, or for display in a portfolio or exhibition. There are some fine art markets that still insist on silver-based C-type colour prints or Lambda-type prints that place digital images onto conventional photographic papers, but it is now broadly acknowledged that, if the correct combination of ink and paper is used, an ink-jet print can have a much longer life.

Today you must also consider electronic publication, such as general Internet use, screen-based presentations, iPad and similar tablet devices, and even mobile phones – all of which are now used extensively to publish images. Most of these require different size and resolution specifications, with colour-space and compression settings also needing to be considered. It is important to research fully the required specification and ensure that your images are correctly prepared if you do not want to be disappointed by the final result. Many of these specifications are now published in a document from the UpDig Coalition (UpDig standing for Universal Photographic Digital Imaging Guidelines), which can be downloaded for free from its website.

Output to an Ink-Jet Printer

Although an ink-jet printer is a common destination for digital photographs, getting the highest-quality output requires far more than simply pressing 'Print' (**7.83–7.86**). It is important that your file is tagged with the correct colour settings, and that you check the final image on a calibrated monitor. You also need to be aware that ink reacts differently to every make and type of ink-jet paper, and a printer profile is often needed to correct for this.

If you use the same manufacturer's printer, inks and paper, then you will find that the installation software for the printer includes generic profiles that can give satisfactory results. You should also check on the Internet to see if the manufacturer has updated its driver software, as it may offer better generic profiles for your use. Good paper manufacturers will also offer free profile downloads – again generic – for a range of ink-jet printers.

> **Uploading New Printer Profiles**
>
> If you upload a new profile, you will need to restart Photoshop before you can access it.

Generic profiles may prove adequate, but the best results will be obtained by getting a custom profile made for your specific printer-and-ink combination. There are a number of companies that are able to help, and most work in the same way. The first step is to download a file of coloured patches from the company's website; print these out using the correct settings for your printer, which should be loaded with the paper and ink that you wish to use. This test print is then posted to the profiling company, which will measure the coloured patches you have printed, compare them to the values that they should be, and create a profile that modifies the colour and contrast accordingly. Although this guarantees the best results, it does have one significant drawback: you will need a profile for each paper-and-ink combination that you wish to use. If you regularly switch papers, this can prove expensive.

CMYK Conversion

Prints destined for publication will be converted to CMYK before printing, but unless you understand this process in detail, it is far safer to leave any RGB-to-CMYK colour conversions to the printer: you could find yourself liable for expensive reprinting costs if you get this wrong.

Flatten before Output

Always flatten layered files before outputting them, especially if they are being printed elsewhere (at a digital print bureau, for example). Aside from the large file sizes that can take a long time to prepare, some software may omit some layers, resulting in a corrupt image.

7.83 (left) The settings
and options panel in the
Print dialogue.

7.84 (centre left)
Choosing Print Settings.

7.85 (below left) The main
Print Settings options.

7.86 (below) An image to
be output for print.

There are currently three main players when it comes to making photographic-quality ink-jet prints: Canon, Epson and Hewlett-Packard. All these companies make a range of domestic, semi-professional and professional printers, and while the information and screen shots used here relate to an Epson printer, the settings will be essentially the same, whichever make of printer is used.

All printers offer a choice of resolutions, often referred to as the 'print quality'. On some Epson models you may find a choice of 360**dpi**, 720dpi, 1440dpi and 2880dpi, or the resolution may be given in a more generic form: Economy, Fine, Photo, Best Photo and RPM (the highest resolution setting), for example. In most cases, using the highest resolution or the best quality setting is recommended for photographic prints. If your printer shows the resolution in a numeric form, it is important not to confuse the printer resolution (measured in dots per inch, or dpi) with the image resolution (pixels per inch, ppi).

Archival-Quality Prints

Domestic ink-jet printers use either pigment-based or dye-based inks, and it is important to appreciate the difference if you intend to produce archival-quality prints. Pigment inks tend to have a longer archival life than dye inks, although they can have other problems of colour shifts under different lighting. The paper can also play a part in the longevity of a print, with some acid-free papers giving a claimed archival life of more than 250 years for a colour image and up to 400 years for a black-and-white one when used in conjunction with pigment inks. By comparison, a traditional silver-based C-type print may start to fade after just 90 years. (Source: Wilhelm Imaging Research.)

Resolution

If the resolution of your image is different from that which is required for the intended output device, you need to change it. In Photoshop, selecting Image Size from the Image menu will bring the relevant options up on screen (**7.87**).

For archival purposes, **Pixel Dimensions** is the important item, as it tells you how many pixels were used in the capture of the image. To maintain the best possible quality from the capture, you need to keep as near as possible to the original figures, which is achieved by ensuring that the Resample Image check box at the bottom left is unchecked (**7.88**). You will notice that the Width, Height and Resolution boxes all become linked and Pixel Dimensions is locked. If you are changing the resolution so that your image is suitable for printing, change the ppi setting to 300ppi and click OK – the physical size of the document will change, but Pixel Dimensions remains unchanged.

When you make ink-jet prints, some experimentation will be needed to find out what the best resolution is for prints made on a given paper, but in general 300ppi is recommended for most paper-and-ink combinations. For images destined for output to the Internet, or another screen-based device, a resolution of 72ppi is the general standard, with sRGB as the colour space. Some electronic media will have to be researched to arrive at the required specifications, as not all devices are the same.

Backing Up

Remember to work from an archive image when resizing files, and save them with a different file name so you leave your original file intact. Make sure all your images and subsequent work on the outputting files are backed up, as data loss can be catastrophic.

7.87 (right) The Image Size window is accessed from Adobe Photoshop's main menu.

7.88 (centre) When Resample Image is unchecked, the Resolution and Size are linked, while the Pixel Dimensions are locked.

7.89 (below) Image Size panel with Resample Image checked. This shows that the link between Resolution and Size has been broken.

7.90 (right)
Unsharp Mask, Preview on.

7.91 (below)
Unsharp Mask, Preview off.

7.92 (below right)
Sharpened image.

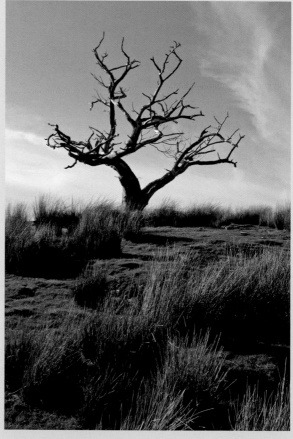

Sharpening

All digital photographs are made up of pixels. The process involved in generating them results in a slight loss of edge detail, or sharpness, in an image. To compensate, software is used to sharpen the image. Raw files have no sharpening applied in the camera, but you can sharpen them at the processing stage, which many photographers do to compensate for this loss of detail. The final and principal amount of sharpening required is determined by the image size and resolution, and should always be carried out just before the picture is output, either as a print or for use on screen.

Sharpening JPEGs

Generally, when you are shooting JPEG images you will have a lot more control over your final image if you turn the in-camera sharpening off and use your image-editing software to sharpen your pictures instead (**7.90–7.92**).

Enlarging Images

If you wish to increase significantly the size of an archived image, you will be creating new pixels, which can lead to a loss of detail and clarity. When cropping a digital photograph you cut away pixels, so if you then increase the size of the image to compensate, you may well have the same problem. In both cases, the general rule is to avoid enlarging an image by more than a fourfold increase in its pixel dimensions. If you have to enlarge it by a greater amount, either increase the image size by stages, checking the quality as you go, or use such specialist image-enlarging software as Perfect Resize (formerly known as Genuine Fractals).

Layers and Selections

Layers

Layers are an extremely useful function of most image-editing programs, as they allow you to manipulate the image with much greater finesse. The easiest way to think of layers is as sheets of clear acetate. Onto each of these 'sheets' (layers) you can place different parts of an image and, because the base is transparent, any layers below will show through. In this way you can have typography on one layer, illustrations and logos on others, and photographic images on yet more layers. Each layer can be activated and manipulated individually. To add something new to the image, you can simply add a new layer.

If you are using Adobe Photoshop, the Layers palette can be found under the Window menu, or you can use the F7 function key. In versions CS3 and later, you can also click on the Layers icon in the tools dock to the right of the screen. Whichever option you choose, it is useful to have the Layers palette open most of the time (**7.93**).

The tools at the bottom of the Layers palette, from right to left, are: Delete Layer, Create New Layer, Create New Group, Create New Fill or Adjustment Layer, Add a Layer Mask, Add a Layer Style and Link Layers. It is useful to familiarize yourself with each of these tools so that you can make the most of Layers. You should also understand how layers can be moved in relation to one another, by selecting a layer and dragging it into the desired position in the Layer palette 'stack'. For example, if something in your image has disappeared, it is likely that you have put another layer above it, covering it up; swapping the layer order may well rectify this.

When you open an image for the first time, it is made up of a single, locked layer called Background. If you attempt to work on this layer, some of Photoshop's tools will be greyed out and you will not be able to select them. Also, if a **selection** is made and then deleted from the image, it will be replaced with the background colour; so if you want to edit the image, you need to unlock the layer. As with most functions in Photoshop, there are numerous ways of doing this, the first being to double-click on the Background layer in the Layers palette. This calls up a dialogue box in which you can rename the layer. This can be useful, as it will help you to identify your layers and their content when you have many in use at once.

Alternatively, you can select Duplicate Layer from the Layers menu, or click on the small menu symbol to the top right of the Layers palette to bring up the same dialogue box. Finally, you can also copy the layer by dragging it to the Create New Layer symbol at the bottom right of the Layers palette, next to the trash can. This will produce an unlocked copy of the original, adding 'copy' to the layer name. You can also create a new, transparent layer by clicking on the Create New Layer icon: transparency is displayed in the form of a chequerboard of grey and white squares (**7.94**).

If you want to work on a specific layer, you first need to select it by clicking on it in the Layers palette: the layer bar with the name in it changes colour to denote that this is the active layer. You can then manipulate and edit whatever is on that particular layer without affecting any other layers. You can lock the active layer by clicking on the chain icon at the bottom of the layer palette. A locked layer cannot be moved or scaled (unless it is linked to another layer that is unlocked), which means that there is no risk of 'nudging' the layer accidentally.

Duplicate Layers

Using a duplicate layer will give you a way back if you do not like your changes. It is also a good way of seeing your adjustments before and after. Take care not to drag the layer into the trash can by mistake when copying, or it will be deleted without warning.

7.93 (below) An image and its Layers palette, showing the component layers.

7.94 (bottom) The chequerboard background represents transparency in a layer.

7.95 (top) All visible layers will display a small eye to the left of the layer icon.

7.96 (centre) The Exec Hand layer with its opacity set below 100%.

7.97 (bottom) The Merge, Merge Visible and Flatten Image options can be accessed via the menu at the top of the Layers palette or from the Layer option in the main menu. Depending on the layers, it may also be possible to Merge Down.

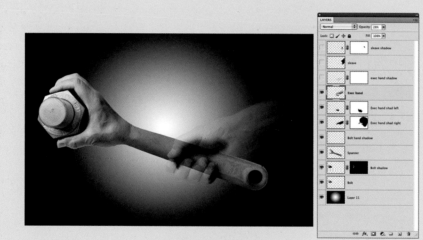

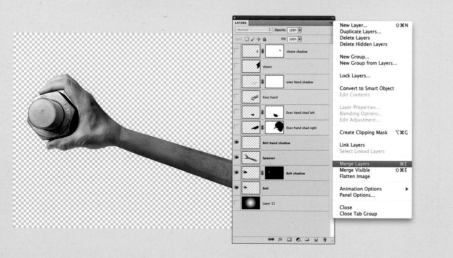

To link multiple layers, click on a layer in the Layers palette and then hold down the Cmd key (Apple Mac) or the Ctrl key (Windows PC) and click on the layer(s) that you would like to link it with. This will create a temporary link that will disappear as soon as you activate any other layer, but you can make the link more permanent by clicking the Link icon at the bottom of the Layers palette. If you move an image in a linked layer, all the layers that are linked to it will move likewise. This also applies when a linked layer is scaled. To unlink your layers, click on the layer you wish to 'free' and then click the Link icon.

To make it easier to see what is on the layer you are working on, layers can be hidden by clicking on the eye icon to the left of the layer's name (**7.95**), and you can also change the opacity (transparency) of the active layer using the slider at the top right (**7.96**). As the percentage is lowered, you will be able to see more of the layer(s) beneath the active layer.

All the layers in an image will remain editable at any time in the future, as long as the image is not flattened (or the layers merged) and you save the file in a suitable format, such as TIFF or PSD. There will come a time when you are satisfied with the way your image looks and want to start to combine some, or all, of the layers to reduce the file size and prepare the image for output. Best practice is to save two versions, one still with layers and the other flattened.

Choosing Merge Visible will combine all the layers in your image that are not hidden, so those with the eye icon showing will be combined. Alternatively, you can select individual layers in the Layers palette and choose Merge Layers to combine only these selected layers. If no layer collection is made, then Merge Down will combine the active layer with the layer(s) immediately beneath it in the Layers palette stack (**7.97**). The final option – Flatten – will combine all the layers into a single, locked Background layer that is ideal for outputting (**7.98**). Each of these options can be selected from the Layers menu option or from the drop-down menu activated from the top right of the Layers palette.

7.98 Final image created by Jeff Robins, using multiple layers.

Selections

A selection is a defined area of the image to which certain tools and functions can be applied. The selection boundaries are defined by moving black-and-white dotted lines that are often referred to as 'marching ants' (**7.99**). A selection can be turned off via the Select menu or by using keyboard shortcuts (Cmd+D for Mac and Ctrl+D for Windows). There are numerous selection tools in Photoshop, and you should be aware that no single selection tool is perfect for all images: they each have strengths and weaknesses. With practice you will begin to discover which tools work best for you, and there is no reason why you have to make selections with just one tool – selections can be added to, using different tools (**7.100–7.102**).

The Marquee tool makes rectangular and circular selections. If you hold down the Shift key while making the selection, it will be constrained to a circle or a square.

The Lasso tool allows you to make freehand selections, using either a 'free' Lasso or the Polygonal Lasso, which produces straight edges. The option to turn the Anti-Aliasing on or off (selected from the top tool menu; the default setting is 'on') can help smooth the edges of curves (see box on p. 254).

The Magic Wand tool makes selections by identifying all the pixels within a certain tolerance of a chosen pixel value. If the Contiguous box is checked in the tool menu, it will select only adjacent pixels of a similar value, but if it is unchecked, it will select all the pixels on the active layers that fall within that chosen tolerance. This can be useful for selecting areas of a similar colour, such as skies, for example.

7.99 (below) A selection displayed by a moving dotted line, or 'marching ants'.

7.100 (top) Refine Edge alters the transition between selected and unselected areas.

7.101 (centre) A selection used to contain a Hue and Saturation adjustment.

7.102 (bottom) Switching to Quick Mask Mode (by selecting the mask symbol at the base of the main tool box, or using the Select menu) makes it possible to edit a selection using the brush tools, applying black to protect an area of the image or white to remove the protection.

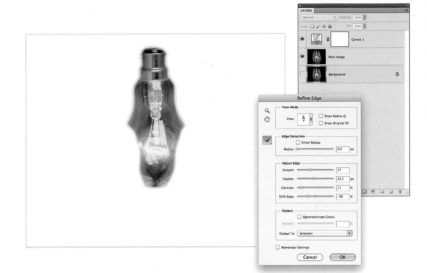

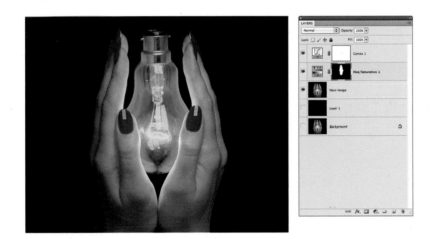

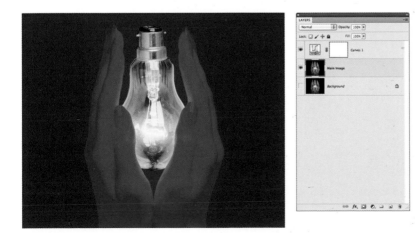

With all selection tools it is possible to soften the edges of a selection by setting a Feather (Select > Modify > Feather). The higher the feather radius, the softer the edge. This can be useful if you want to make a significant change to the selected area but do not want a hard, obvious transition between selected and unselected areas. A better option, however, is to leave feathering turned off, complete all your adjustments, and then use the Refine Edge tool. This will give you far more control over the edges of the selection, as well as allowing you to see how it affects the image.

7.103 The final, flattened image created by Jeff Robins.

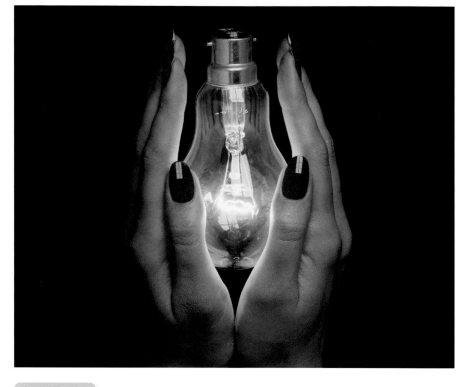

Anti-Aliasing

Anti-aliasing is used with any tool that involves the use of curves or diagonal lines, and is best left on when handling photographic images.

Graphics Tablets

If you have problems making accurate selections using a mouse, consider using a graphics tablet, which has a stylus shaped like a pen that allows far more intuitive control of the cursor.

Exercise 1

WORDS AS IMAGES

Resources

For this exercise you can work with the simplest of digital cameras or a high-end model, either on location or in a studio. You will also need access to a computer with Adobe Photoshop or similar image-manipulation software.

A layout pad or sheets of paper would be very useful for planning your image. When working on your exercises on a computer, take screen shots to include in your workbook and save some files at intermediate stages to go with your notes.

The Task and Extended Research

The aim of this exercise is to choose a word, phrase or line of poetry that you like and to create a photograph that illustrates – and incorporates – that text. You may choose something contemporary, something classic or even your favourite song lyrics, but the text must appear somewhere on the actual photograph in a suitable typeface, size and colour or tone, so that the text and image complement each other (**7.104**).

7.104 In this simulated project to promote healthy eating, Anya Campbell was careful to choose a suitable font, colour it to match the lettuce, and size and place it carefully to work in harmony with her image.

Getting Started

Choose your text carefully, or try out a number of possible ideas, logging those you reject in your sketchbook alongside those that look more promising. Research the basics of typography and look at magazines and posters to see how certain typefaces complement or add to the message created by the picture. Also, look at the scale of your type: too small and it may be unreadable, too large and it may detract from the image.

It is a good idea to look for typefaces in a library or online, photocopying or printing twenty to thirty that you think might be suitable, and writing down a single word that describes each of them. This will teach you how important your choice is going to be, as well as the different feelings that type can evoke.

The next step is to plan your photograph and the shoot. A good designer or photographer will work out where the type is going before making the picture, so the text reads easily against a plain, uncluttered part of the image.

Having taken your image and opened it in Adobe Photoshop, press F7 to display the Layers palette, and make a Duplicate Layer. Select the Type tool and click roughly in the part of your picture where you want your text to go. Choose your Font and Size from the drop-down list at the top of the screen. You can always make changes later.

Type in (or copy and paste) your text and see how it looks. A text layer has been created in the Layers palette, and you can double-click on the Layer icon to make changes to the size and style of your text at any time. You can also use the Move tool to reposition it if you want to.

If you select Layer → Layer Style, you can access a wide range of special effects that you can apply to your type, such as a drop shadow. Experiment with these by all means, but the general rule with type is that keeping it simple is often best. Once you think that you have a successful and balanced combination of type and image, save the layered file as a PSD or TIFF, as well as a flattened TIFF version for printing.

Feedback

You could make two or three different versions of your image, with changes to the font, and show them to your friends or tutors to see which they prefer and why. Do they think that your photograph works well with the text, or is there some obscure link that they do not understand?

If you get useful feedback, you can always go back to your layered file and make changes until you are really pleased with the final result and think you have the best layout for your portfolio. In some cases, you may find that you need to reshoot the image to make the photograph communicate or work better with your typography. This exercise is not as easy as it looks.

Using Bleed Space

When composing your picture in the camera, pull back a little to include more, rather than cropping precisely to your planned layout. This extra 'bleed' space can be very helpful when you are trying to balance and position your text.

Exercise 2

A SPLASH OF COLOUR

Resources

This exercise is about familiarizing yourself with Layers, so you can work with any camera, and it does not matter if you take your pictures in a studio or outdoors. You will need a computer with Adobe Photoshop or similar image-manipulation software that features Layers.

You will also need your workbook for making notes and adding examples of the images that you take, and screen shots of your progress.

The Task and Extended Research

The aim of this exercise is to create an image that works well in monochrome (either in black and white, or with a single tone, such as sepia), with the exception of one object that is in full colour (**7.105**). This could be anything from an old row of black-and-white shops, with one in bright colour, to a room interior in sepia with a full-colour view through the window – the subject is entirely up to you.

7.105 Helen Ritchie made a series of pictures using the layering techniques described in the exercise: this was a particularly successful example.

When you have decided on the image you would like to create, shoot the basic photograph in full colour. If shooting Raw files, process the image to get the best results for your intended use and open in Photoshop at the required resolution and output size. If working with JPEGs, open in Photoshop and make any adjustments that you feel are necessary. From this point on, the working method is the same, regardless of file type.

Locate the Layers palette, either on the Photoshop desktop or under the Window menu. The image currently consists of a single layer, called Background. You will not work on this layer but you should retain it, as it gives you a way back if you make any errors. Duplicate this layer twice and rename the new layers so that the top one has 'black and white' in the title and the one underneath has 'colour' in the title. Activate the black-and-white layer by clicking it once. Now choose the option Black and White under Create New Fill or Adjustment Layer at the bottom of the Adjustments palette, and use the colour sliders to adjust the tone until the image appears as you like it. You also need to restrict the adjustment work to the layer immediately below the Adjustment Layer in the stack, by clicking on the option Clip to Layer at the bottom of the Adjustments palette.

The adjustment layer that you create is now accompanied by a blank white square, representing a layer mask. Now click on the layer mask to make it active (denoted by a thin line appearing round the mask). The foreground and background colours will change to neutral when the mask is selected. If you now add black to the image mask, it will hide anything on that linked layer, allowing the colour layer below to be seen. This is probably best done using a brush, which can be set for soft or sharp edges and different levels of opacity, giving lots of control on how you paint the image. To get the best control you will need to set the foreground and background colours to Black (0) and White (255) – press the letter D on your keyboard. If you make any errors when painting the mask, just switch to white as the paint colour. To undo an error, press X on the keyboard.

As long as you leave this image unflattened (i.e. with layers), you can return to edit it again in future.

Feedback

If you manage to make a pleasing image that works both visually and technically, and your tutors and friends like the result, consider extending the theme to make a triptych of three images that look good with 'a splash of colour'. Alternatively, for a more significant challenge, how about creating a calendar containing twelve such images?

The Great Themes – Introduction

In the first seven chapters of this book you developed the technical knowledge and practical skills that will form the basis of your photographic imaging. In this section we will apply those skills to the various genres of photography that are often known as the 'Great Themes'. There will always be debate about how exactly these areas of photography are subdivided, and digital technology has blurred further the distinctions that photographers and teachers from twenty-five years ago would have recognized. At the start of each of the following chapters, we have therefore used only short definitions of the genres and sub-genres, but you must also realize that many contemporary artists and photographers now set out to redefine these boundaries and make us question what precisely is understood or meant by a documentary photograph or what constitutes a portrait, for example.

A good project is to find a local craftsperson and document their work or life. Bella Falk chose the difficult genre of 'still life on location' to develop a series of pictures for her portfolio.

The majority of photographers try to specialize in particular areas of image-making that they enjoy, hoping to become well known for a particular style or artistic voice. The reality, though, is that many will find themselves working outside their comfort zone in order to make a living. So, regardless of whether you aspire to being a fine art photographer who will question our preconceptions, or a commercial photographer trying to earn a living from your photography, the skills required to work across all the great themes are essential: skills developed by working in a variety of genres can help you to develop as a photographer.

Whether you are certain or totally unsure of your future direction in photography, this section aims to provide you with a broad set of skills that will help you to develop your photography and perhaps specialize in one distinct genre. The exercises at the end of each chapter should guide you and help you to identify where your talents – and passions – lie.

Photographers have always been inspired by the great masters of fine art. Laura Carew studied art history as well as photography, which helped inform her portrait of a young 'Merlin', photographed with the mood and lighting style of the Italian Renaissance painter Caravaggio.

259

In addition to practical skills, the ability to research effectively is vital for any photographer. It is particularly important to look at the historical development of a genre if you are to understand the issues that underpin contemporary photography in both a fine art and a commercial context. Each chapter in this section therefore includes a brief history with a number of highly relevant illustrations, as well as a much greater number of names of artists and photographers whose work may be useful in your research. The Internet will allow you to access a large body of both historical and contemporary work, which will (hopefully) influence your own development and ideas: there are very few artists who have not been affected by the work of others!

(above) Image-makers Pamela Ossola and Graham Diprose devised a hybrid technique that uses both darkroom printing and Adobe Photoshop to make coloured 'liquid-emulsion' images.

(above right) The Polish photojournalist Weronika Krawczyk was inspired by Walker Evans to visit the United States – in this case, Detroit – a couple of years after a recession had burst the bubble of its car industry.

By its very nature, any brief history has to leave out some photographers and artists, so use these chapters as a starting point for further exploration, rather than a definitive list. While Internet research will help you find their work – and that of others – do not forget that other resources, such as books and exhibitions, are just as relevant.

The practical sections that follow all begin with a discussion of planning, and the more carefully you plan any shoot, the less chance there is of something going wrong. To help you, we have tapped into the experience of a number of top contemporary photographers working in each of the following genres, with many of the suggestions and tips coming from these professional practitioners.

Most importantly, the chapters have been designed so that you do not necessarily need to have access to the latest high-resolution cameras, a professional studio and fancy equipment, or even have the ability to travel far from home. However, for those on an academic course, with access to high-end equipment, there is advice on how to make the most of this opportunity, with tips and examples that will help you to develop both your portfolio and your technical skills.

STILL LIFE IN THE STUDIO AND ON LOCATION

In this chapter you will learn how to:

• Plan still-life shots in the studio and on location

• Build your own inexpensive set

• Safely set up lighting in a studio to make exciting, creative images

Still Life Defined

Contemporary photography often pushes boundaries and questions definitions and values, so if we say that a still life is a work of art depicting mostly inanimate objects, someone will at once find an image that contains significant movement, or people, or something else that defies this definition.

All of these, however, simply add complexities to the basic skills of capturing found objects, or contriving an arrangement of them. On location, the subjects may need to be photographed at a certain time of day to make the lighting most effective; but in many ways, starting with the blank canvas of a background, a heap of objects and an array of studio lights can be far more challenging, and therefore rewarding as you start to master the genre.

Still Life: A Brief History

All areas of photography are influenced by what has come before, whether you generate your own style from appreciating and incorporating the manner of other artists' work, or reject their image-making. If you wish to understand still life, it is important to research how the genre developed, including its cultural and artistic contexts.

Still-life imagery can be traced back to Egyptian hieroglyphics, through Roman mosaics and wall frescoes and, more than a thousand years later, Italian Renaissance painting. In the seventeenth century, Dutch artists, such as Willem Kalf, often depicted shiny metal objects in which the reflections of other objects from the still life were visible in a very photographic manner (**8.1**). It was this type of 'photo-realistic' painting that provided inspiration for such early photographers as William Henry Fox Talbot (**8.2**). In his pioneering photographic book *The Pencil of Nature*, first published in six instalments between 1844 and 1846, Fox Talbot explored many genres and uses for his new invention, including still life. He also suggested that, in the event of loss or damage, photographic records of china, glassware and jewelry might be much more useful than a written inventory. In the 1930s, Edward Weston experimented with his famous series of pictures of peppers, often shot on large-format film for maximum detail and quality (**8.3**). It is also worth researching such post-war photographers as Irving Penn, Lester Bookbinder, Adrian Flowers and Ed White, and the Association of Photographers (AOP) website has many examples of contemporary still-life photography in its members' portfolios section.

The Second World War resulted in many advances in colour photography, and while aerial reconnaissance rather than art was the main aim, by the 1950s colour film was readily available in large-format sheets. Along with technical improvements in lenses and colour printing, this led to the golden age of still life in commercial advertising photography.

8.0 (previous page) All these items belonged to Helen Ritchie's great aunt, who was evacuated to the country as a child during the Second World War. The suitcase and contents were found after she passed away. Whatever these items meant to her, this image was Helen's way of telling the story for her.

8.1 (opposite, above) Willem Kalf was particularly interested in studying the way that light and colour bounce off reflective surfaces. He was instrumental in raising the genre of still life to the same level as portraiture in the eyes of seventeenth-century Dutch society.

8.2 (opposite, below) Kalf's realistic portrayal of the everyday appealed to very early photographers, such as William Henry Fox Talbot, when he was looking for suitable subjects to demonstrate uses of his invention of photography.

The genre covered everything from the humble 'pack shot' to complex food-and-drink photography, with lucrative imaging for cigarette promotion and a host of complex images made with double and triple exposures long before digital image manipulation was invented. While photographers' fees were very high compared to today, so were the skills required to become a recognized still-life photographer in the latter part of the twentieth century.

The need for high-**resolution** images meant that most commercial still-life photography remained film-based until only recently, when digital **SLRs** began to produce results comparable to scanned 5 × 4 in. sheet film. If you are using a smaller image size, the **depth of field** increases, leading to the need for less powerful lighting and an optimum aperture setting for the sharpest image of $f/11–f/16$ on a digital SLR, rather than the $f/22–f/32$ required for large-format photography. Yet whether you are photographing in a studio or on location, many of the lighting skills and tricks of the trade are just as relevant as they were twenty-five years ago.

Planning to Shoot a Still Life

Most still-life images begin with a blank canvas where you compose and light your objects to create an image. The starting point for this is what you are trying to say or want the viewer to understand. That is easy in advertising photography; you want the subject to look expensive, beautiful or delicious and, ultimately, desirable. But still-life images can also convey a much harsher message – about gun or knife crime, or drugs, for example – often in a more compelling way than if people or a real scene were involved.

Visual communication is a language and, like any other language that you learn, it is possible to make mistakes, where you mean one thing but your audience understands something different. This makes consideration of the target audience vital: for instance, a teenager may not interpret a certain type of image in the same way as someone of an older generation. Keeping your concepts simple, and being careful not to include lots of unnecessary props, often helps to focus a still life.

8.4 A spider diagram might help you to develop a concept for a still life. The idea is to relax and let ideas flow, no matter how crazy some of them seem when you first write them down.

Brainstorming

If you have difficulty getting started, the classic brainstorming technique using spider diagrams of words or phrases (**8.4**) can be a great help. Try word association: think of words or phrases with a similar meaning and use them to help you work up your concepts.

8.5 From the ideas generated by your spider diagram, you might gather your props and start to make a rough drawing of the composition.

8.6 This beautifully lit and original still life by Helen Ritchie needed careful planning from the initial idea, through to thinking about the lighting, exposure, image processing and final output for reproduction.

Rough Drawings

A good rough should give you a clue to your lighting – the hardness or softness, direction, and the mood you wish to create – and should also be useful in generating a detailed props list of all the items you will need to find and bring to your shoot.

Think about where a picture will be seen. If it is in a gallery, part of the viewer's enjoyment may come from studying it over many minutes or debating its meaning with others. If it is a poster in the street, or a page in a magazine, the viewer will experience it quickly, so its meaning needs to be grasped accurately in a few seconds. To help achieve this, draw rough sketches of your ideas before you shoot (**8.5**). This should include planning the foreground and background, selecting colours and considering where type might be placed on the image. It does not matter if your drawing skills are not great: it is still better to create 'roughs' and think visually than to generate images solely in your imagination or with words.

Most still-life images require the best possible technical quality, which will be admired by the audience almost as much as the concept and message (**8.6**). This may mean shooting on the highest-resolution camera possible, using the best-quality props (dust-free, well polished and so on), the most appropriate and attractive-looking lighting and, of course, the very best exposure and colour balance. Unlike pictures shot in the street, with a still life all the elements are under the complete control of the image-maker. Many good still-life photographers are proud of being known as control freaks, as there is no one else to blame if an image is not perfect. This is a genre that might appear easy, but is in fact one of the hardest to master.

Teamwork

Professional still-life photography often involves a team of people helping to produce an image. Many still-life photographers will themselves have gained their first experience in one of the following roles, whether helping a friend or assisting on a professional shoot.

Photographer's Assistant

The exact role of an assistant will be determined by the individuals involved, but in still-life photography it usually includes:

- Checking all the equipment is in the right place at the right time and making sure that everything is in full working order.
- Fetching and carrying props and equipment. Ensuring that packaging is kept for borrowed objects so that they can be returned.
- Moving objects carefully in an image while the photographer assesses the image from the camera position.
- Moving and operating lighting, and setting ratios through metering or viewing test shots.
- Keeping good records of all aspects of creating the image, logging both conceptual and technical issues.
- **Raw**-file processing, file naming to avoid mistakes and overwrites, and checking images for exposure, focus and colour balance (**8.7**).
- Making perfect cups of tea and coffee and looking after the client.

While a photographer may employ an assistant with specialist knowledge, there is little on the list above that a photographer could not do. But, by having an assistant carry out these duties, the photographer can concentrate on the conceptual side of the image and getting a perfect result.

8.7 Often an assistant will find him- or herself slaving into the night, checking and processing images to make them ready for the next day, long after the photographer, client and rest of the crew have gone home. Photo by Nico Avelardi.

Set Builder

Many interior photographs are not taken in real houses, but on purpose-built sets that allow the positioning of lighting and cameras where walls and ceilings would otherwise make this impossible. A set builder specializes in the fast and safe building of sets that a stylist will then dress.

Model Maker

Sometimes objects may be too small, or it may be too difficult or expensive to use the real thing. Chocolate bars in advertising photographs are often made as larger-than-life models with a perfect surface and coating, for example, while the ice in drinks is usually made of plastic or glass so that it will not melt during a shoot.

Stylist

A stylist is a specialist with a superb contact book who has the role of sourcing – buying, borrowing or hiring – the perfect props for the shoot.

Home Economist/ Food Stylist

A cook who prepares food especially for photography, whether beautifully cutting and displaying raw ingredients or cooking food to perfection. The food may look fabulous, but achieving this may involve tricks that render it totally inedible.

Still Life in Daylight

The simplest way to try still-life photography is to set some objects up in daylight in a back garden (**8.8, 8.9**). The way light falls on the objects will define their shape and form: if the sun is directly above, there will be no shadows except under the objects, while a cloudy, bright day will produce softer, less directional lighting that gives softer shadows. Be aware that strong, direct sunlight is likely to produce very bright highlights and deep shadows, possibly beyond the **exposure latitude** that the camera can record, and that different lighting will alter the form of the object and the mood of the picture.

Look at where you want to put the camera and at the direction of the light. There may be a particular time of day when the lighting on the objects is most attractive, or you may be able to move the camera to a different angle if the background is not so important. Look at the surface of the objects and opt for the lighting that gives the most attractive texture (**8.10–8.14**).

> **View from Lens Position**
>
> Trust your eyes and get used to looking at your still life from the lens position. With practice, this is a much better way to gauge lighting and composition than looking through a camera viewfinder.

8.8 A typical outdoor set-up, complete with a sheet as a diffuser.

8.9 This professional-looking result proves that you do not need an expensive studio to experiment with still life.

You can use **reflectors** or flags to remove or mask unwanted natural light. You can buy expensive equipment that folds up neatly or make your own, less pricey, equivalent.

If the light is coming from, say, the right side of your still life, it will cast a deep shadow on the left. You can then position your reflector to fill these shadows and put more detail into the dark side. Try leaning the reflector back at 45° to the ground and 45° to the camera as a starting point, and also move it closer to and further from the subject to see the changes this makes.

If the light is too strong and contrasty, or you need consistent lighting over a few hours to make a series of shots, consider building a light-tent. Alternatively, a white sheet can be tied above your still life to make a massive 'soft-box': this can give very attractive square reflections in shiny objects, which helps to show their shape and form.

There are many variations on this basic set-up: perhaps adding an additional light instead of a reflector, firing a flash into the still life or into a reflector to give more control and balance, and mixing artificial lighting with the **ambient** daylight.

8.10 Natural light with no reflector.

8.11 Natural light with a white reflector to fill the shadows in softly.

8.12 Natural light with a black flag to darken shadow areas.

8.13 Natural light with a mirror reflecting a hard light into the subject.

8.14 Natural light with a gold reflector to give a warm fill to the shadow areas. This is a good way to create 'late-afternoon' lighting at midday.

8.15 Using a shutter speed of $\frac{1}{250}$ sec., an aperture of $f/8$ and ISO 100 on a sunny day, an inexpensive garden studio achieved a very acceptable shot of sparkling wine being poured.

Still Life in a Studio

Set Construction

It does not matter if there are messy, rough-hewn pieces of wood outside the viewfinder selection, but any part of your set that appears in the frame needs to look perfect. Sets must be designed and built solidly so they can take the weight of any objects without any risk of the set bending or breaking.

Plan your lighting before starting to build the set. There is nothing worse than realizing that you want to add an extra light from below, or directly above, only to find that to do so, you have to redesign and rebuild the set from scratch. You also need to be able to get your hands into a set to move objects around and clean them, and you must therefore avoid access becoming too limited once the lighting is in place. Preparing for this in advance can ensure your shoot runs smoothly.

Avoiding Breakages

Always lock, tape up or firmly attach everything in your set, rather than propping or balancing items. If something can fall down, it will fall down, probably knocking over or breaking something else, and possibly requiring you to start over.

Lighting

While you may be able to use daylight coming through a window or skylight if you are shooting indoors, it is more likely that you will use some sort of artificial lighting (**8.16–8.18**), such as flash or continuous **fluorescent**, tungsten or flash lights. Your choice may be limited by availability, or could be based on certain technical criteria: if you want to record movement in a picture, for example, a continuous light source would be best, while flash is a better option if you want to freeze motion, such as when photographing splashing water.

If you are unable to block out all the ambient light falling on your set, flash has a major advantage in that it requires shorter **shutter speeds**, which can minimize or negate the effect of the ambient light. The brief, but bright, burst of light can also allow you to use smaller aperture settings for a greater depth of field.

Using Small Mirrors

The shiny side of aluminium foil or a mirror can be used as reflectors, but tend to produce an unnaturally bright **reflected light**. A smaller mirror can, however, be used to highlight an important area in a subject, such as the label on a bottle.

Homemade Reflectors

To make a reflector, buy a sheet of thick white card or board and stick aluminium foil to one side, with the matt side facing outwards. The white surface of your board will act as a soft reflector, while the matt silver will reflect a harder, more directional light. You may want to make a few of these in different sizes.

Daylight

Indirect daylight through a window or skylight will be blue, particularly if it falls from a blue sky or on a cloudy day; it may also pick up a green bias from the window glass itself. Since you cannot move the light, you need to plan the still-life set to be at the right angle to give the required lighting effect. Comparatively little light requires long exposures or wider apertures, giving a smaller depth of field. As with shooting still life outdoors, changes in weather can affect the consistency of your shoot. Daylight is continuously changing in colour temperature and quality, so care must be taken in its use.

Continuous Lighting: Fluorescent

Continuous fluorescent lights (**8.16**) run at a much cooler temperature than tungsten lights (see overleaf), and use less electricity too, making them both safer and cheaper to operate.

They were once a poor choice for photography, because of their **colour temperature**, but the ability to change a digital camera's **white balance** means that this is no longer the case. Like tungsten lights, fluorescent lights can be purchased with a wide range of reflectors and accessories, and while professional lighting of this type tends to be quite expensive, it is far better than 'bargain-basement' alternatives that tend to produce a variety of colour temperatures.

Maintaining Sharpness

If your studio is in a room close to a lift, busy road or railway line, beware of vibrations that may affect the sharpness of your pictures when you are using continuous lighting and long exposures.

8.16 Continuous fluorescent lighting.

Continuous Lighting: Tungsten

Tungsten lighting (**8.17**) was once a staple for studio-based still-life photography, with a choice of outputs from 150 watts all the way through to 2000 watts (2kW), and a range of reflectors and other accessories to modify the light. Today, however, numerous disadvantages have largely seen tungsten lighting replaced by flash or fluorescent lights in many professional studios. Tungsten lights get very hot and can melt or set fire to parts of the set, or any coloured gels or **diffusers** that are placed in front of them. The colour temperature of tungsten lights also alters with age or small changes in voltage, so they can be inconsistent. This is easier to correct with digital images than film-based ones, but you may want to consider shooting a grey card at the start of your shoot to provide you with a colour-balance reference. This form of continuous lighting also produces less light than flash, so photographs need to be taken with a wider aperture setting and/or longer shutter speed, which may limit your creativity.

In their favour, tungsten lights are cheaper to buy than electronic flash and, as they are a continuous light source, what you see through the viewfinder is generally what you will get in your image – there is no need to guess where the light will fall, as there can be with flash.

Dust Removal

Some digital SLR cameras use a vibrating sensor system to remove dust from the sensor. As the sensor 'floats', rather than being solidly attached to the camera body, you should always lock the mirror up for exposures that are longer than ⅛ sec. to avoid 'sensor shake'.

Tungsten Light Safety

Always use a thick glove to move a tungsten light's reflector or barn doors, as they get extremely hot and can cause serious burns to your hands and fingers. You should also allow a tungsten light to cool down fully before you try to move it, or you are very likely to break the bulb's filament.

Tungsten Bulb Safety

Avoid touching the glass of a tungsten halogen bulb, as perspiration from your fingers will damage the bulb and considerably shorten its life.

8.17 Continuous tungsten lighting.

Studio Flash

Electronic studio flash equipment (**8.18**) is expensive to buy and can cost even more to maintain. It also requires far greater health-and-safety considerations than other light sources. Despite this, it is a consistently popular choice with professional photographers. Part of the reason is that it gives absolutely consistent lighting, even if the voltage fluctuates, and it generates heat only for the very short flash, reducing the risk of overheating or studio fires.

Smaller studio flash units are normally either **monoblocs** (a complete flash unit where the flash head and generator are combined) or separate generator packs into which flash heads are plugged. A monobloc tends to be more portable, so it is a good option for taking on location, while a 'pack and head' system allows you to control multiple flash heads from a single generator. Regardless of the type, most flash systems offer a very wide range of accessories and light modifiers for added versatility, with a small tungsten modelling light giving a very good impression of the effect of the flash.

Working with electronic flash still involves risks, though, as capacitors in the unit are filled with electricity; this charge is then released to create a discharge spark between two terminals housed in a glass tube: the 'flash' of light. Since the amount of power created might be measured in thousands of joules (watts per second), you need to ensure you operate the unit correctly, as touching a charged flash tube or unplugging a charged flash head could result in an electric shock capable of causing serious injury, or even death.

It is important that you read the manual carefully or ensure you receive thorough training before operating a studio flash unit. A good habit is to fire the test button and then turn off the unit before changing or moving anything at all. If a still-life set involves water, or any other liquid, very careful additional planning is required, and you may need to consider waterproofing your lights to ensure that there can be no contact with the electronic flash units.

Positioning Flash Units

Move your flashes into position before turning them on, and always turn a flash unit off before moving it around. If there is any problem with a flash unit, turn the power off at the wall socket immediately, but leave the plug connected so that electricity in the capacitors can dissipate through the earth wire.

Flash Safety

If a flash unit starts falling over, get out of the way, rather than trying to catch it. Touching the flash tube while you are trying to save the light could cause serious injury: a much higher price to pay than replacing it.

Changing Bulbs

If a model bulb blows, fire the flash, turn it off and wait twenty seconds for any residual power to go to earth before changing the bulb.

8.18 Electronic studio flash lighting.

8.19 (left) A teddy shot from above, showing the top, but also the resulting distortion.

8.20 (above) No camera movements have been applied, resulting in the distorted image.

8.21 (left) Camera movements have been applied. The top is still visible, but now the distortion is gone.

8.22 (above) Using camera movements that keep the lens and sensor (or film) planes parallel removes the distortion.

Image Capture in Still-Life Photography

Whether you are working outdoors or in a studio with artificial lighting, there are a number of aspects of image capture to consider. Your choice of camera is the most obvious, and this should be concept driven: select the camera type according to the image you plan to produce. For most still-life photography, however, you will want to get the highest-quality image possible. If you own a small 6- to 10MP camera, you are unlikely to get as much detail as if you use a 5 × 4 in. plate model.

A large-format camera may also allow you to raise or lower the lens, rather than tilting the camera. This will avoid image distortion (**8.19–8.22**). If you tilt the lens towards the intended plane of focus, a camera with 'movements' can also give a much sharper image from front to back than a conventional SLR. This is because objects closer to the camera focus at a longer distance than objects that are further from the lens. By tilting the lens, you can bring both into focus in the same image (**8.23**). Tilting a plate camera back in the opposite direction can further enhance this effect.

This principle is called the Scheimpflug rule, after the Austrian army officer Theodor Scheimpflug (1865–1911), who devised it to correct distortions in very early aerial-reconnaissance photographs. The rule states: 'All objects lying in a plane can be perfectly focused when that plane, the lens and the film or sensor plane intersect at a common point.' Today, this technique is also used deliberately to distort the objects in photographs, as well as to allow photographers to set up the lens and film plane in the opposite direction so that only a tiny part of an image appears in focus (**8.24**).

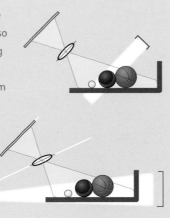

8.23 In a camera where the sensor (or film) and lens are fixed, the depth of field is also in a parallel plane. Following the Scheimpflug rule, if either the lens or sensor/film plane is tilted, then all three planes will intersect, producing an adjustable, wedge-shaped depth of field.

8.24 This effect – sometimes called anti-Scheimpflug – uses camera movements to give a minimum depth of field, as can be seen in this image of a tomato slice by Jeff Robins.

Perspective-control (PC) lenses designed for digital SLR cameras also allow you to apply the Scheimpflug technique and, while they are expensive, they do provide you with the potential to maximize or reduce the area that is in focus in your still-life images (**8.25, 8.26**). If you do not have access to a PC lens, then it is worth focusing about one-third of the way into your image to achieve the maximum depth of field for any given aperture (**8.27**).

A longer **focal-length** lens is usually better for still-life photography than a wide-angle one, as it will avoid the distortions inherent in wide-angle lenses. In a studio this will also place the camera at a greater distance from the still life, so you are less likely accidentally to shine a light into the lens and create flare. You should also use a lens hood or make a flag out of black card (**8.28**) to place between your lights and the lens to reduce the risk of lens flare further. Masking down the background of your still life immediately outside the intended image crop will cut down flare in the image itself, again improving quality.

8.25 (right) A perspective-control lens on a digital camera can achieve results similar to the effects offered by large-format plate cameras. Here the lens is shown zeroed, with no movements applied.

8.26 (far right) Achieving a drop-front effect with a perspective-control lens.

8.27 When a lens is set to its hyperfocal distance, everything in the photograph from half this distance to infinity will be sharp. As a rough guide, focus one-third of the way into a picture, rather than halfway into it.

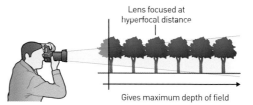

Lens focused at hyperfocal distance

Gives maximum depth of field

Camera and Aperture Settings for Still Life

If you want to minimize image **noise** in a still-life photograph, you will need to set a low **ISO** sensitivity, such as ISO 100. If nothing is moving in the picture, use a tripod so that you can close down the lens aperture for a greater depth of field and shoot at a slower shutter speed without the risk of camera shake. Beware of shutting your lens down to its smallest aperture setting, however, as diffraction – a change in the path of light rays – will result in an overall loss of sharpness as the light rays are bent around the edge of the tiny aperture hole (see p. 120). The best compromise for good depth of field, while avoiding diffraction, is to set the aperture to $f/11–f/16$.

8.28 The studio still-life set used to take a picture of
a Hasselblad camera, showing the overall lighting and
the use of black 'flags' to reduce flare and avoid unwanted
light shining directly into the camera lens.

Creating Your Still Life

Having chosen your camera, brought your still-life objects to the table, and sketched your proposed image, you now need to build and light your set (see p. 270). Your planning should have told you if you will need to light your subject from below, directly through the base of an object, or directly from above. The design of your set needs to take this into account, as well as avoiding any of its own structure casting unwanted shadows across the image, or getting in the way of the camera.

Place your objects and aim the main light from the planned angle. Turn down the ambient studio lights so that you can see only the effect of your lighting on the subject, and decide if you need a secondary light, whether another head, a reflector or a mirror. Take time to get the lighting for the still life absolutely right, and be aware that if you are using more than four lights from different positions, you will probably produce a poor result with confusing shadows.

Many photographers use a set of black L-shapes (normally used to check the cropping of prints) to view still lifes as they compose them. By changing the size of the hole and the distance that you hold the L-shapes from your eyes, you can also see the effect of using different focal lengths (**8.29**).

Only when you have your still life composed and lit to your liking should you move the camera into position, decide on the aperture you wish to use, turn the lighting up or down accordingly and set any camera movements (if available).

As a general rule, the longer you spend looking at your still life and checking it with test shots, the better the final image will be (**8.30**). In the commercial world, however, there may be a limited amount of time, so a photographer will have to decide if a problem is easier to remove through digital retouching or whether to spend extra time correcting it before the shot is taken.

8.29 Using a set of L-shapes to compose a still life. Holding them closer to your eyes gives you an idea of the image crop with a wide-angle focal length, while holding them at arm's length produces an effect equivalent to using a telephoto lens.

View from Camera Position

Always view your still life from the camera position: you will see far more detail (and problems) if you are looking directly at your subject than if you are looking through a viewfinder. If you can stay at the camera position while an assistant moves your objects or lighting, this will give you a much better idea of how any change will affect the image.

Take a Test Shot

Since the optimum image quality is imperative in most still-life photography, take a test photograph with the camera connected directly to a computer (tethered), or download your test shot via a card reader. Use the magnifier tool to zoom in and check every part of the image for technical quality and such problems as dust, parts of the set that are creeping into frame, or unwanted reflections in shiny objects. If you are shooting **Raw** files then check the **dynamic range** of the image, to make sure that the best result is possible without any loss of quality. If you are using any other file format then check for **clipped** highlights or shadows and, if they are found, adjust your lighting to correct this.

8.30 A well-planned, underlit shot by A. J. Heath. Remember that shots like this take much longer to set up than you expect, and getting everything aligned perfectly is vital. Patience is a huge virtue for all still-life work.

Tools of the Trade

Still-life photography requires an ever-growing kit containing often weird and wonderful items that will prove invaluable. Identify and collect any specialist tools you need for your particular style of working, and do not stick to standard photographic equipment. Car-boot sales can be a source of cheap and unusual items that are handy for still-life photography. Dentists' tools are particularly useful: tiny round mirrors, pointed hooks, small clamps and stands, and needle files should all be added to your toolbox. Other useful items include:

- A solid table with a lip that allows items to be clamped to it
- A glue gun for quick fixes to a set or to hold an object in place
- Laboratory stands and clamp arms with adjustable brackets
- Small bits of mirror or oddly shaped handbag mirrors
- Reflectors: white card, silver (matt or dimpled) and gold
- Stiff wire to support items, and also a wire that is easily bent (such as florist's wire)

- A range of tapes, including double-sided, clear, masking and gaffer tape
- Small weights to hold items in place
- Dust-off aerosol can
- Dulling spray to reduce reflections
- Atomizer spray for water (to create a morning-dew effect on fruit, for example)
- A range of solvents to clean items (before use, check that they will not damage the object you are trying to clean, and are not flammable, or toxic if inhaled in a confined studio space)

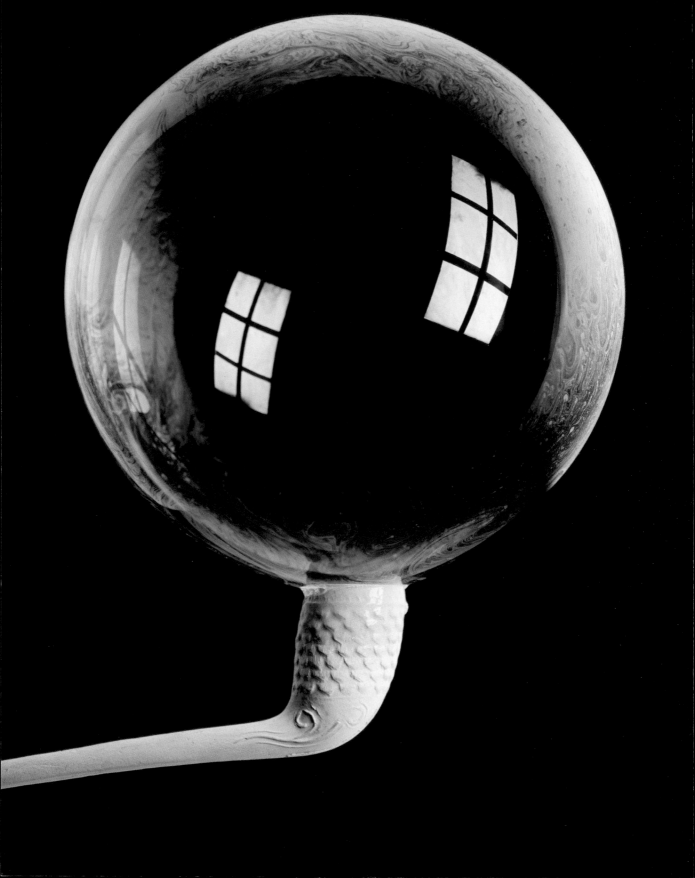

Logging Your Shots

You may find that many objects and projects require similar lighting; or a client who likes your portfolio may ask you to shoot his or her product in the same style as one of your existing pictures. Unlike most other areas of photography, studio still life offers the perfect opportunity to draw lighting diagrams and take careful notes about a set-up so that it can be repeated precisely (**8.31–8.33**). Many students and professionals maintain a scrapbook containing these details, along with a print of the final image, so that everything is to hand if matching shots are later required.

8.31 (opposite) A still life by Jeff Robins. The window effect in the reflection was achieved by running black tape across the softbox. The large soap bubble maintained a better shape when held upside-down, so the set was built upside-down.

8.32 (right) A three-quarter view of the lighting for the bubble shot.

8.33 (below right) A top view of the lighting for the bubble.

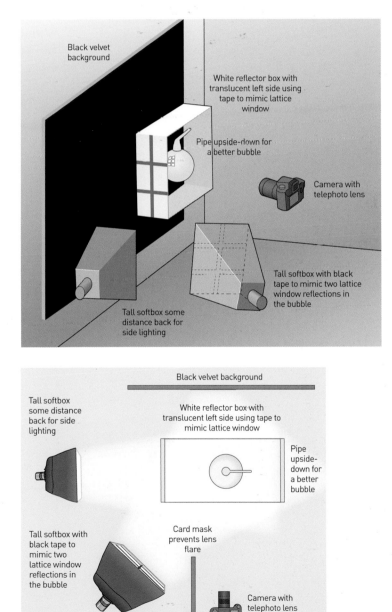

Black velvet background

White reflector box with translucent left side using tape to mimic lattice window

Pipe upside-down for a better bubble

Camera with telephoto lens

Tall softbox with black tape to mimic two lattice window reflections in the bubble

Tall softbox some distance back for side lighting

Black velvet background

Tall softbox some distance back for side lighting

White reflector box with translucent left side using tape to mimic lattice window

Pipe upside-down for a better bubble

Tall softbox with black tape to mimic two lattice window reflections in the bubble

Card mask prevents lens flare

Camera with telephoto lens

281

8.34

8.35

8.36

8.37

8.38

8.39

8.40

8.41

Still Life in Practice

Countless different subjects and treatments are covered by the term 'still life', many of which use a mixture of the techniques described below. These examples can be copied, modified and used for practice and, for this reason, we have stuck with props that are inexpensive and easy to obtain.

8.34 Set-building for the shoot of chopped mushrooms.

8.36 Setting the camera angle.

8.38 The final structure and lighting.

8.40 The camera showing the image to be captured. At this stage, a change to garlic was decided on.

8.42 (above) The final image.

8.35 All close light-reflective surfaces are covered in black to reduce unwanted light affecting the image.

8.37 Refining the lighting using small reflectors and black flags held in place using clamps and stands.

8.39 Refinement of the subject.

8.41 The working area showing the prepared garlic, ready for shooting.

8.43 Set-building using a light table to shoot a bottle and glass of beer.

8.44 Setting the side light to illuminate the label and add highlights to the glass. The camera was lined up and the background masked to cut out unwanted light.

8.45 Reviewing the image displayed on the camera's screen.

8.46 Refining the lighting using a small mirror attached to a clamp stand.

8.47 The work area and filling of the glass.

8.48 Shooting a series of images with different heads on the beer.

8.49 The finished image.

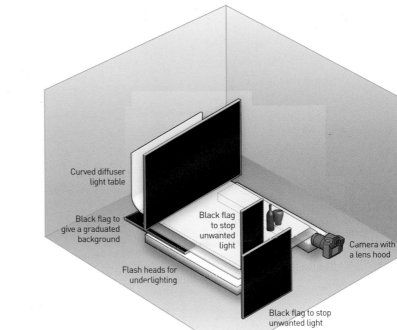

Curved diffuser
light table

Black flag to
give a graduated
background

Black flag
to stop
unwanted
light

Camera with
a lens hood

Flash heads for
underlighting

Black flag to stop
unwanted light

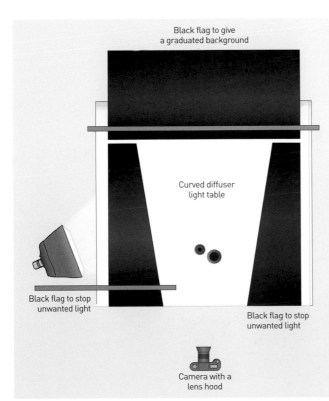

Black flag to give
a graduated background

Curved diffuser
light table

Black flag to stop
unwanted light

Black flag to stop
unwanted light

Camera with a
lens hood

8.50 (above) Three-quarter-
view lighting diagram.

8.51 (left) Top view of the
lighting showing extra
black flags placed on the
table to restrict the area
that the camera sees,
reducing the possibility
of flare in the lens.

How to Photograph a Mobile
Phone with Its Screen Illuminated

When shooting an illuminated object you will require one exposure for the phone (flash) and a much longer one for the screen (with all model lights turned off). When shooting digitally, you may be better off taking each shot separately and combining them in **post-production**, rather than trying to do the flash and a 10-sec. screen exposure all in one go. Both ways are possible.

8.52 The finished image.

8.53 The basic set-up, showing reflectors and flag protecting the lens.

8.54 Setting the camera up.

8.55 Reviewing the image on the camera's screen.

8.56 A different view of the set showing reflectors and flags.

Exercise 1
SWEET DAYS OF SUMMER

Resources

- This project is designed with a digital SLR in mind, but any camera with **Aperture Priority** and **Shutter Priority** (or Manual) mode can be used.
- Cook or buy an attractive-looking summer dessert, such as a cheesecake or lemon meringue pie.
- You will also need your sketchbook or workbook to make notes and add examples of the images you take.

The Task and Extended Research

For this exercise, you are going to produce a summer-inspired shot (even if it is the middle of winter) that could be used as a magazine or point-of-sale advertisement by a supermarket. Your research should involve looking at food photography in magazines, newspapers and books for ideas.

Getting Started

As the aim of this image is to evoke a feeling of summer, the styling is very important. Consider what props you will need in addition to your dessert: a picnic blanket or hamper, crockery and glasses, for example (**8.57**).

Next, choose a background. Shooting outdoors is the most obvious answer if you want to create a picnic scene, but you could also shoot in a studio if you prefer. If you choose to set your still life outdoors, pay attention to the lighting, and consider diffusing the light with a white sheet if it is a sunny day. You may also consider using reflectors. Try a few different arrangements and shoot images in both portrait and landscape formats to see which works best.

Feedback

One of the advantages of shooting this exercise on a digital camera is the facility for instant review. Use the magnifier in playback mode to check your images as you go and keep notes of everything you do, so that when you put your favourite shots in your workbook you can reach conclusions about the shutter-speed, aperture and **depth-of-focus** combinations that work best together.

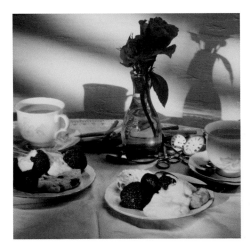

8.57 *Summer* by Graham Diprose was shot as one of four seasons to head chapters in a *Designer's Yearbook*, hence the props of designers' tools and the watches to denote the passing of time. In addition to the studio flash lighting, a long exposure using tungsten light gives the warm sunlit glow of early evening.

Exercise 2
AN ALLURING AROMA

A digital SLR is ideal for this exercise, but any camera that gives you full control over the aperture and shutter speed is suitable.

You will also need a bottle of perfume and, as before, your sketchbook or workbook is essential for making notes and including examples of your work.

The Task and Extended Research

In this exercise, the subject is a perfume bottle and the aim is to produce an advertising photograph that would be suitable for use as a full-page magazine article. It is entirely up to you what you choose for your background, but you may find you have more success if you can link it to the perfume in some way. Consider all the different connotations that a perfume might have. You could also shoot the perfume and background as two separate shots to be assembled on the computer, but be very careful that the lighting of the object and background match. Research the extensive range of advertising, magazine and point-of-sale material that already exists to see what images have been produced recently, and the techniques that are being used (**8.58**).

Getting Started

Every picture tells a story: your background might be a bedroom, or, to break away from a more conventional approach, something sophisticated yet abstract. You could try lighting the bottle using a window and a reflector, but if you have any artificial lighting, you should be able to be more creative.

Feedback

As with all the exercises, keep notes as you shoot and include these in your workbook along with a final image for reference. If you are on a formal photography course, show your tutors this exercise and your results. If you are pleased with your shots, consider making a series of images of different perfume bottles to add to your portfolio.

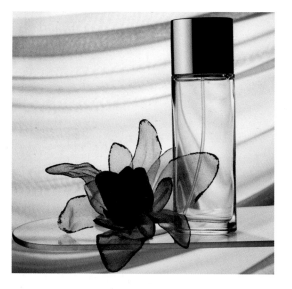

8.58 Given its coloured liquids, unusually shaped bottles and evocative names, perfume makes a great subject for a still life. This photograph is by Helen Ritchie.

LANDSCAPE AND CITYSCAPE PHOTOGRAPHY

In this chapter you will learn how to:

• Plan landscape and cityscape pictures, considering the time of day and the weather

• Shoot landscape images that require the least amount of post-production work

• Shoot powerful cityscape images, developing your own style of image-making

• Plan and shoot a series of images and stitch them into a high-resolution panorama

9.0 (previous page) A gritty cityscape of Munich's football stadium, pictured by Pamela Ossola. She changed her colour digital image into contrasty black and white to reflect the fact that whenever there is no game being played, the place looks monstrous, deserted and almost clinically disinfected.

9.1 (top) Alefiya Akbarally found a high vantage point to capture this cityscape of the traditional Dhobi Ghats (community washing pens) in Mumbai, India, which are under considerable threat of redevelopment into high-rise blocks of flats.

9.2 (centre) There are few feelings more exhilarating than finding a location, setting up your camera and waiting for that fleeting perfect moment to shoot. Photo by Robert Griffin.

9.3 (below) Duncan McNicol won the Association of Photographers' Gold Award for his monochrome series of landscape images featuring the work of a reed harvester in Norfolk.

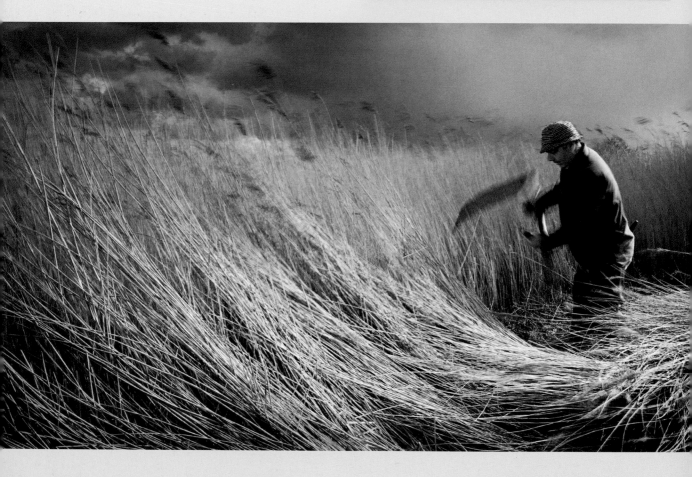

Landscape Defined

The environment has fascinated mankind ever since early humans began their migration out of Africa. While the availability of food, and changes in climate, may have been at the forefront of our ancestors' minds, the earliest settlers and farmers certainly chose locations that were visually attractive in which to build their communities. Indeed, it would seem that, as a species, we have always appreciated the natural beauty of the planet.

The desire to explore and appreciate the world is not lost on the current generation, despite the fact that most of the planet has been mapped from space and can be viewed via the Internet from the comfort of an armchair. Such views, however, give no indication of the constant changes in the seasons or weather that modify the appearance of the landscape so radically.

The desire of landscape artists is to capture the essence of their surroundings, and digital photography, with its ability to capture a moment in time that can subsequently be transmitted around the globe, is the ideal medium for recording and sharing the natural world.

Buildings in villages, towns and cities change the natural environment, enhancing or detracting from a view, or showing us how and where people from other cultures live (**9.1**). Artists have always recognized this, and cityscapes are as much a part of the landscape genre as the traditional idyllic pastoral scene. The images created by landscape artists will always have an underlying narrative, and the viewer can be as fascinated by a view that he or she has seen many times as by a scene from a part of the world he or she may never visit.

As always, there is the opportunity for genres to cross over, with a still life of locally farmed produce placed in front of a country landscape, for example, or the day-to-day activities of people in a far-off part of the world forming a strong part of a landscape's narrative. In advertising, an off-road vehicle might be intentionally placed against rolling hills to convey a message of its rugged traits and, while the extent to which we choose to buy into this illusion is a personal choice, such images allow some landscape photographers to survive commercially.

In both landscapes and cityscapes the light can change constantly, sometimes second by second as pools of sunlight appear through scudding clouds (**9.2**). There can be elusive moments when even the most mundane scene is transformed for a fleeting instant, and the landscape photographer's skill is to be in the right place at the right time. This is most often at dawn, when dew or mist can add to a scene, or at dusk, when a deep-blue sky forms a contrasting backdrop to the yellow and green city lights. With this in mind, landscape photography is certainly not a nine-to-five job: to succeed, you are often likely to be up before dawn and not get back from a distant location until well after the sun has set.

9.4 Despite making more than 150 particularly beautiful paintings, the Dutch artist Aert van der Neer died in abject poverty in Amsterdam in 1677 and the pictures he left behind were valued at next to nothing.

Landscape Art: A Brief History

Many of the cave paintings in Chauvet, France, depict animals in their natural landscape environment. They have been dated as approximately 30,000 years old, demonstrating early man's interest in depicting his environment.

Later, the Romans are known to have decorated their villas with landscape scenes. Similarly, Chinese and Japanese artists explored the landscape in work created throughout the Middle Ages.

Artists in medieval Europe rarely painted landscape subjects, however, and it was not until the Italian Renaissance that such paintings – albeit of idealized scenery – became popular. Seventeenth-century Dutch painters stand out for the near-photographic realism of their landscape painting. Jacob van Ruisdael was famous for his landscapes, sometimes devoting as much as three-quarters of a painting to the sky and clouds, with a small strip of the flat Dutch landscape at the bottom. The authors' favourite among these artists is Aert van der Neer, who specialized in moonlit river scenes (**9.4**).

Perhaps unsurprisingly, given its long-established history, the landscape was also one of the first genres to be explored in photography, with William Henry Fox Talbot producing rural pictures around Lacock Abbey, Wiltshire, and Louis Daguerre turning his camera on the boulevards of Paris. The bright light of a sunny day was initially necessary for all photography, but the exposure times required were still long: in Daguerre's image of the Boulevard du Temple (1838), the Parisian streets appear empty, save for a man who stopped for several minutes to have his shoes shined. With this simple act, he became probably the first human being ever to be photographed (**9.5**).

Other pioneering photographers expanded on the landscape tradition. Notable figures whose work is worth researching include David Octavius Hill, Robert Adamson, Frank Sutcliffe, Peter Emerson and the subject of a recent project by the authors, Henry Taunt, who used the wet collodion process for his studies of the River Thames, both coating and developing his plates in a dark tent on location (**9.6**).

9.5 This photograph by Louis Daguerre, taken in 1838, is believed to be the oldest in the world in which a human being appears.

9.6 In the 1870s, Henry Taunt would row down the River Thames with his assistants, camp overnight, set up a dark tent to coat his plates, take his pictures, develop them immediately, wash them in the river, dry them in the sun and then row home or on to his next location.

Two of the best-known landscape photographers are the Americans Edward Weston and Ansel Adams. Weston is known as much for his nudes and his still-life photography as for his outstanding black-and-white landscapes, but Adams's name is intrinsically linked to the natural world, especially his images taken in and around Yosemite National Park and his co-invention of the zone system for determining optimal exposure and development times.

If you are more interested in cityscapes (**9.7, 9.8**), then the work of Alfred Stieglitz is noteworthy for the atmosphere the photographer creates. Whether the subject is the streets of New York or Paris, or the canals of Venice, Stieglitz's work demonstrates that you can take a great photograph in rain or snow, not just on a sunny day. Alvin Langdon Coburn worked with Stieglitz before moving to London, where he used the **photogravure** technique to produce the cityscapes for which he is now famous.

The Hedrich Blessing Company, established in Chicago in 1929, is also worth researching. The company became famous for architectural images that elevated the photography of

9.7 It is not known why the Port of London Authority commissioned this panorama in 1937, but it has survived to give us a remarkable historical record of an area that was devastated during the Second World War.

9.8 In 2009, to celebrate the Port of London Authority's centenary, London's Riverscape Partnership – Mike Seaborne, Charles Craig and Graham Diprose – were sponsored to reshoot the 1937 panorama, using digital photography. Both panoramas are now archived in the Museum of London.

buildings from a simple record to a 'portrait' of the building, and it is still in existence today: its website includes some superb new photographers. Look also at the cityscapes of such artists as Paul Strand, André Kertész and the architect-turned-photographer Ezra Stoller.

Many of the early landscape and cityscape photographers approached their subject purely from a 'fine art' perspective, but since the 1950s an increasing number of photographers have specialized in commercial landscape photography, using the genre for advertising projects, as well as book and gallery output. Four figures to research are Duncan McNicol, Joe Cornish, Charlie Waite and Jem Southam.

In 1975, the groundbreaking exhibition *New Topographics: Photographs of a Man-Altered Landscape* had a considerable impact on the genre of landscape photography, and the influence of its eight contributing photographers can be seen to this day. Indeed, it is important to seek out the latest work by such contemporary figures as Sophy Rickett, Dan Holdsworth and Rut Blees Luxemburg (**9.9**).

9.9 Rut Blees Luxemburg is a German photographer who explores the urban landscape through night photography, long exposures and reflections.

Gallery Visits

The Internet is a helpful aid for your initial research, but it is a lazy way to look at the work of modern landscape and cityscape artists. It certainly cannot compete with a gallery visit, where you can experience the quality, scale and grouping of a body of work and gain a deeper understanding of precisely what the photographer is trying to explore or communicate.

Landscape Aesthetics

All our senses are needed to experience a landscape, but when you make a photographic record, only one of these is recorded: sight. While an image can remind a photographer of the smells or noises surrounding the moment of capture, the resulting image cannot re-create them for any other viewer. Although there is nothing wrong with taking pictures for your own pleasure, you must remember that what may have been a great landscape experience for you might be boring or confusing to others who were not there at the time. When people post their holiday pictures on a social networking site, for example, there is less of a connection for viewers who were not there at that particular moment.

Many of the most successful modern landscape or cityscape photographs contain an element of mystery. They do not attempt to tell the full story, but leave the viewer to add his or her own experiences, giving a sense of involvement with, or 'shared ownership' of, the image. Conversely, a 'picture-postcard' or 'chocolate-box' photograph requires little or no personal interpretation and so becomes simply a pretty record of a scene, without a deeper, more thought-provoking context.

Preparation

Your research should provide ideas about how you want to approach your landscape or cityscape photography. You need to define a provisional style or agenda as part of the planning for your work and try to imagine what your target audience will understand, enjoy or be mystified by. A key element in this must be how the light falls on the subject. With a landscape, this makes each picture the record of a 'decisive moment', documenting precise environmental conditions with the knowledge that they will never be repeated exactly again (**9.10**). Think about colour, too: sometimes the vivid colours of a landscape or building create emotion, while elements that are masked by rain, mist or fog may gain strength from a monochrome treatment.

Photographic 'Sketchbook'

Carry a compact digital camera or good mobile-phone camera with you at all times. Use this as a photographic 'sketchbook' to record scenes and locations that appeal to you. In this way, you can build up a list of places to revisit when the weather, season or time of day best suit your ideas.

9.10 Fast-moving clouds and bursts of sunshine can be perfect for landscape photography. Jeff Robins and Graham Diprose shot a series of images to stitch together for this final result.

Practical Planning

Maps or satellite images on the Internet are useful when it comes to searching for locations, but nothing beats walking around an environment, looking for an interesting angle or the way that light falls across the scene at different times of the day. Always note the time of day and direction of the light, and use a compass to identify east (for sunrises) and west (for sunsets). Note that the sun rarely rises and sets *exactly* in the east or west, though: the position changes depending on the season and your distance from the equator. You should gather as much other information as possible about your chosen location: the times and height of the tide if you intend to photograph a seascape or riverscape, or the time that a tall building casts an exciting, or unwanted, shadow across a cityscape. Plan how best to reach your chosen location, and where you can park or camp if you need to make an early start.

In addition to identifying the location, you may also need to determine whether there are any restrictions on photography. It is impossible to list when and where this might be an issue, so you need to find out on a case-by-case basis: some areas may be a problem, while others may not. If you have to cross a fence (or crawl through a hole in one) then it is fairly certain that you are entering someone's property. Not only could this mean you are trespassing on private property to take your images, but you could also face further legal issues if you subsequently publish a picture that was taken without permission.

When photographing in the city, the legalities become even more complex, with little or no consistency between different countries or regions. Wherever in the world you are photographing, though, it is important to remember a few basic rules. Using a tripod in the street may be seen as causing an obstruction, so should be done with caution if you do not have written permission from the authorities, while certain buildings may be deemed 'sensitive' or fall under anti-terrorism legislation. This decision may depend on a police officer on the spot, or it may be a citywide mandate, but either way it is not something you want to fall foul of. An e-mail or phone call to the local police, explaining who you are and what you intend to do, is well advised, especially if you intend to photograph in a foreign country. It may not only save wasting time, but also prevent you from triggering a security alert, and potentially having your equipment confiscated.

If you are commissioned to shoot a photograph, it is even more vital that you clear the relevant permissions, pay any fees that are required, obtain a receipt and agree to any restrictions that may be imposed: getting thrown out of a location in front of your client or models is at best embarrassing, and at worst could have long-term consequences for your professional reputation. Clearing permissions can differ vastly from one local authority to another. You may need to talk to the local authority's press office, who will give you permission over the phone, or you may have to contact an estates or leisure office, who will want an e-mail confirming your details. You may even be required to contact a dedicated filming unit that might want you to fill out a contract in advance of your shoot date.

Many landscape or cityscape images are taken in the early morning or at sunset (**9.11**), when temperatures are cooler than during the day; additionally, mountains and rolling plains are often more photogenic and dramatic as a weather front rolls in, so it is essential that you take the right clothes and footwear with you. They can include waterproof clothing, plastic bags to protect your kit from desert sandstorms, hiking boots or snowshoes rather

Sunrise/Sunset

If you want to be absolutely certain where the sun will rise or set on any given day, take a trip to your location a day or two in advance of your shoot.

Planning for the Best Lighting

To ensure you do not miss the ideal time of day for photographing your location, plan backwards from when you anticipate the lighting being at its best. Consider how long it will take you to travel to the location, set up your camera and make test shots, and leave in plenty of time so you have time to do all of this without being rushed.

ID and Permissions

If you are a college student or part of a photography club, ask your organization for a letter stating who you are and that your images are not for commercial profit, and always carry some sort of photographic ID with you. Where necessary, get permission in writing. An e-mail will often suffice, if it carries the name and contact details of the person granting you permission and you take it to the security or rangers' station before you start. You may even find that they will share some useful local knowledge.

9.11 Stunning architecture can be a great subject for a long exposure in twilight or at night. This photograph is by Bettina Strenske.

9.12 When a camera is pointed upwards at a tall building, vertical lines in the image converge at the top, producing distortion. When we view the picture, our perception is that the building is leaning backwards.

9.13 Using a perspective-control lens or a camera with movements, the lens can be raised to get a building in shot while keeping the camera and lens parallel to the front of the building. This corrects the perspective effect.

9.14 A perspective-control lens with no adjustment applied, looking up at the subject.

9.15 A perspective-control lens with the front raised will correct the distortion, as the lens is parallel to the subject.

than trainers, or wearing your oldest coat to blend in with the crowd in a dangerous part of the city. Make sure that someone knows where you are going and when you should get back. Be aware that mobile phones may not work in mountainous areas or far away from civilization, and if you are travelling to a particularly remote location, take a friend along for safety.

As well as planning for the location, you also need to prepare for the weather. You may want the atmosphere that rain provides, or frost on the ground, but you may not. Today's weather forecasts are generally accurate and will be able to tell you – to within an hour or two – when a change in the weather may occur.

Image Capture

You will normally want the best image quality available for your landscape photography. Traditionally, this meant using a medium- or large-format film camera, but digital **SLRs** are increasingly being used, now their quality has improved. Large-format cameras are still used occasionally – especially for architectural photography – with either film or a digital back, but this is simply because the camera movements can avoid problems of distortion. A specialist perspective control lens will achieve the same effect on a digital SLR, where the front part of the lens can be raised or tilted to correct for any distortions (**9.12–9.15**).

Special attention needs to be given to the exposure for both landscape and cityscape photography. The exposure measurement for landscapes can be difficult when the difference in brightness between the sky and the land is considerable. To counter this, many digital SLRs can be programmed so that they exclude the majority of the sky when an exposure reading is made, preventing the land from turning too dark.

For a cityscape, white or light-coloured buildings, concrete, or reflections from glass can mislead an exposure meter, and exposing accurately is made more difficult by very deep shadows. If you shoot **Raw** files, there are more options available when you process the image, but a simple alternative is to make two exposures at least two stops apart – one to retain the highlight detail and another for the shadow detail – and combine them using your image-manipulation software. In extreme cases, **high dynamic range (HDR) imaging** (see pp. 386–7) can also help to improve the dynamic range in an image, by blending together a sequence of different exposures.

If you are unsure precisely where to place your exposure, it is better to underexpose slightly, to hold the highlight detail and then open up the shadows using your image-editing software. This is because it is impossible to recover detail in highlight areas that have blown out to pure white, but shadow detail can often be lightened to produce a more acceptable-looking result.

Exposure Lock

A quick solution to metering when the sky is significantly brighter than the foreground is to use the camera's exposure-lock feature, which is most often activated by half pressing the shutter-release button and holding it down.

To do this, tilt the camera down so that the sky is not included in the viewfinder, take your exposure reading, apply the exposure lock and then recompose your image and shoot.

Preventing False Readings

If you are struggling to get an accurate exposure for a cityscape, set your camera to its **spot-metering** mode and take an exposure reading from a building that is mid-grey in colour. Lock the exposure or set it manually and this will prevent the sky, or reflections from water, from causing a false reading. In riverscapes where there is only a thin strip of buildings, this is vital.

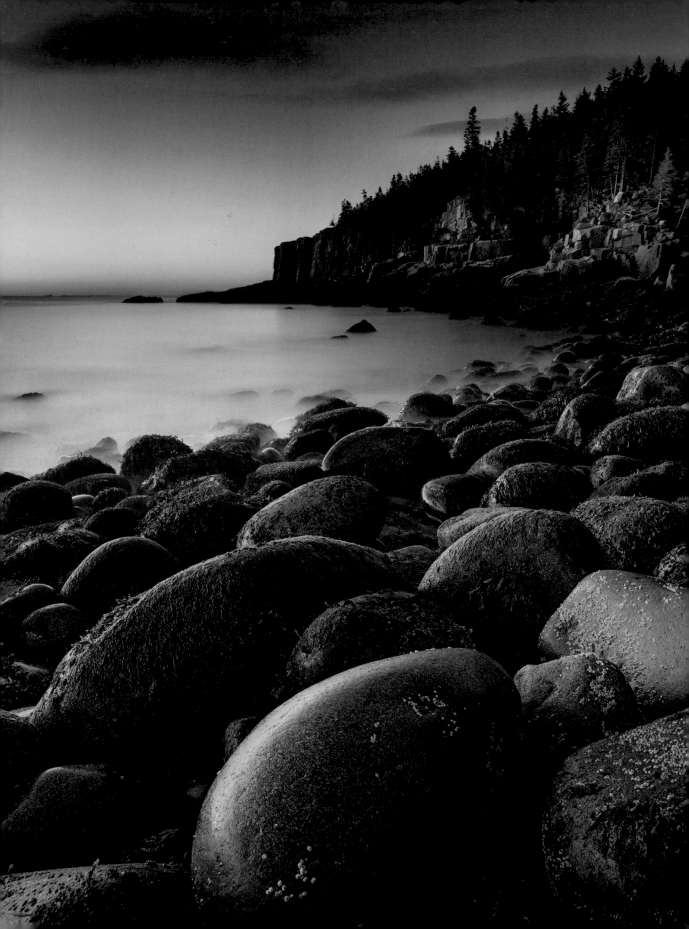

9.16 (opposite) The American landscape photographer Tom Mackie captured this stunning sunrise at Otter Cliffs in Acadia National Park, Maine. The combination of a small aperture and long shutter speed captured not only a fantastic depth of field, but also a very atmospheric effect in the movement of the waves.

9.17 (right) Ryan McNamara found this attractive early-morning cityscape scene and realized that he could make an even better narrative by including one of the joggers passing by, giving the photograph extra depth and interest.

Composition

Composition is a matter of taste, but here are a few ideas to consider for your landscape and cityscape photographs:

- Use 'leading lines' to lead the viewer's eye into or out of your picture (**9.16**): a kerb in a street or a riverbank in a landscape, for example. Having the line lead to a corner of the frame is particularly strong.

- Think about composing the picture in thirds, using the Golden Section (see p. 32). This might be two-thirds sky and one-third land or sea, or the other (more obvious) way round. In cityscapes the 'thirds' might be based on the positions of the buildings that appear in your picture. You can also subvert this rule and go for perfect symmetry.

- Place objects in the foreground to give pictures space and depth (**9.17**). This will add drama to any landscape or cityscape, as well as creating a greater connection to the more distant elements. You can then decide if you want to use a small **depth of field**, with only the foreground (or background) in focus, or a large depth of field where everything appears sharp.

- You can change the composition radically with a slight change of **focal length**. It is worth noting that many photographers prefer to use fixed focal-length lenses, rather than zooms, for landscapes and cityscapes, because of the optimized design of a **prime lens** (see p. 122).

303

9.18 While you might think that a dark or rainy evening is the worst time to go out and shoot pictures in a busy city, Bettina Strenske demonstrates how these conditions can produce great results, particularly when using a tripod and long exposure.

9.19 If there are heavy thunderclouds overhead, you might want to enhance them further. Jeff Robins and Graham Diprose used a grey graduated filter to make the sky darker still for this dramatic picture.

- Using a tripod and a long **shutter speed** enables you to record interesting movement, such as leaves blowing on trees. Reflections in ponds and rivers can also be enhanced or smoothed by a long exposure. In a cityscape, you can capture the frenetic pace of a busy street by recording cars and passers-by as a blur (**9.18**). With an exposure of around twenty seconds or more, cars and people can disappear altogether, but you may have to use a **neutral-density filter** to extend the exposure time in bright daylight.

- Graduated neutral-density filters that are clear at one edge, and gradually turn a pale or deep grey at the other (**9.19**), are useful for balancing a bright sky with a darker foreground.

- Graduated filters can be set at any angle, perhaps to darken the sky in one corner of a picture or to prevent the filter from affecting a tall building. A blue graduated filter is also useful for making an ordinary sky appear tropical, or a grey, overcast sky more appealing.

- Polarizing filters absorb light from reflections and can be useful for water in a landscape as well as windows in cityscapes. They can also be used to intensify a blue sky in a landscape, with the strongest effect achieved when the filter is at an angle of 90° to the sun.

- To warm an image or correct the slightly cool **colour temperature** of a cloudy day, you may need a selection of 81-series orange filters if you are shooting on film. You may also need to use a combination of filters to get the best result. With a digital camera, you can adjust the **white balance** to compensate.

- Above all, be patient. Look at the way the light is falling on your landscape (or cityscape) and be aware of anything that is moving within the picture that may enhance or detract from the image you want to create. Try to predict if the movement of the sun or clouds will improve your picture, and be prepared to wait hours, if necessary, to get the perfect shot.

Black-and-White Digital Landscapes

Many of the masters of landscape photography have worked in black and white, either because it was the only option available, or because it best suited their artistic endeavours. With care, you can achieve very similar results using a digital camera, and if you want to visualize your image in terms of tone and form, rather than colour, you can simply use the camera's black-and-white mode. As you have minimal control over the tonal content of the result, this is not the best way to create a 'finished' black-and-white image, but it is useful if you simply wish to visualize how a scene might appear in monochrome, while you are out in the field.

You will achieve better results if you shoot **Raw** files in colour and convert them to black and white using your Raw-processing software. This allows you to alter the tonal values of an image by lightening or darkening specific colours in the original, in a similar way to using filters over the lens for film-based black-and-white imaging. This type of conversion can also be done with **TIFF** and **JPEG** files in your image-editing program.

Once you have converted your image, make sure that it is in **RGB** rather than **greyscale** before trying to print it, as this will produce a better result if you are using an **ink-jet** printer. Having a monochrome image in RGB also allows you to increase the **saturation** for subtle, muted colours, or to adjust the curves in the individual **channels** to colour or tone your photograph.

Panoramas and Stitching

In 1937 the Port of London Authority commissioned Avery Illustrations to take what must have been the longest photographic panorama in the world: a study of both banks of the River Thames from London Bridge to Greenwich. The final image consisted of black-and-white prints stuck onto linen to produce a continuous panorama that measured 33 m (36 yards) and showed more than 5 miles of the river (see p. 294). Smaller, but no less interesting, panoramas have been taken across the world since, and even with the advantages of large-format film and plate-camera movements, they were extremely complex undertakings.

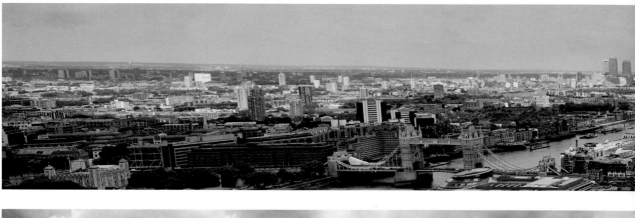

9.20 (top) Graham Diprose's rooftop panorama looking towards Docklands and the site of the 2012 Olympic Games in London.

9.21 (above) Using a tripod and ensuring that the camera is level in all directions saves time at the image-stitching stage, whether you are working manually or with specialist software. Palmer + Pawel took this attractive Docklands panorama.

A panoramic image can result in a spectacular landscape or cityscape, whether your aim is to produce a photograph that captures a dramatic vista without the distraction of a vast sky or expansive foreground, or to produce a striking record of a city's architecture. Digital imaging has made the procedure simpler than it ever was with film-based photography, and even if you own only a modest digital camera, it is possible to produce a detailed, **high-resolution** image. The simple premise for a panoramic image is to take a series of pictures that overlap, either by **panning** the camera from a fixed position, or by shooting while physically moving along the length of a road or river. In both cases, the sequence of images is then 'stitched' together on the computer to create a seamless panorama (**9.20–9.22**).

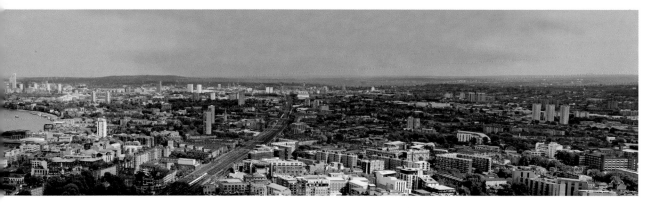

9.22 John Myers used an inexpensive digital camera to capture the elements in this image, but by carefully lining up two overlapping rows of six images he produced a result that could have been made with a high-end digital SLR.

Shooting a Panorama

Although shooting a panorama is relatively straightforward, there are certain rules that are best followed if you want to make it easier and less time-consuming to get the best results when stitching. Firstly, you should always use a solid tripod, ideally with a specialist panoramic head that allows for the correct positioning of the lens over its rotation point, although this is not essential. You should, however, ensure that the camera is level and that it remains level in all directions when it is **panned**. This avoids the risk that each successive frame is higher or lower than those preceding it, which can lead to a 'stepped' panoramic image or one that is very narrow when it is cropped.

While wide-angle lenses are great for single-shot landscapes and cityscapes, they should be avoided for panoramas, as the distortion towards the edge of the frame can create problems or distortions when it comes to stitching (**9.23**). A prime standard lens (50 mm equivalent) or a **zoom lens** set to this **focal length** is best, although a longer focal length can prove useful when you want to make a panorama over a greater distance, with the camera being moved to a number of shooting positions, instead of panning across a scene (**9.24**).

Regardless of whether you are panning or moving the camera between frames, it is important to make sure that your images overlap by a significant amount so that it is easy for your image-editing software (or you) to align one shot with the next – an overlap of one third of the frame is advised. Also, take into account anything that might be moving between two adjacent images and shoot extra frames if you have to, just to be sure. Similarly, try to avoid any vibration, as one image that is slightly softer than the rest will stand out in the final panorama: use a remote release to trigger the shutter and lock up the camera's mirror if possible.

Exposure Mode

Always set your camera to its Manual exposure mode so the exposure does not change when the camera is panned across the scene. If possible, shoot Raw files, as they can be processed identically to get the best result from the frames making up the final stitched image.

Making New Folders

If your camera allows you to create new folders to which your files are recorded, set one up for each panoramic sequence you shoot. This will make it easier for you to find and identify all the images making up one full 'stitch'.

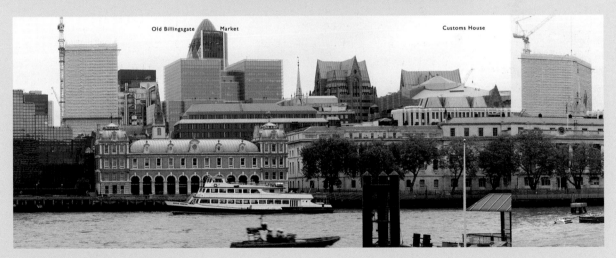

Old Billingsgate Market Customs House

9.23 (top) It can be tempting to think that a wide-angle lens will produce the best panorama, but as this test shot reveals, there can be problems with tall buildings appearing multiple times.

9.24 (above) By shooting smaller sections, with a longer focal-length lens, you very much reduce the problem of reappearing skyscrapers and get a more realistic picture.

9.25 In April 2006, Martin Langfield and Graham Diprose's 248MP image of Gas Street Basin in Birmingham was among the largest in the world. A few years on, however, many far bigger images have been captured.

Once you have started shooting your sequence of images, be careful not to change the focus between frames. You should plan the depth of field that you require before you start taking your pictures, and set the aperture accordingly. Focus manually, and consider taping up the focus and zoom controls to ensure they do not move inadvertently during the pan-and-shoot process.

If you are shooting large files, it is likely that you will need to have a number of **layers** open when it comes to stitching them together, and this may require a very fast, high-specification computer. For example, the panorama of Gas Street Basin shown here (**9.25**) was made by shooting fourteen separate images with a 33MP digital camera back, producing a panorama with an overall **resolution** of around 248 million **pixels**.

Exercise 1

THE EARLY BIRD

Resources

For this exercise, you will need:

- Your camera
- Tripod (if possible)
- Warm waterproof clothing (depending on the season)
- Drinks
- Compass
- Map
- Workbook for making notes
- Mobile phone, just in case

The Task and Extended Research

Many of the most effective landscape pictures are taken at sunrise, as an atmospheric mist from the chilly air can add greatly to the overall mood. The aim of this exercise is simple: to get up early and produce a landscape (or cityscape) at the very start of the day (**9.26**). You can find your location using any means you like: from a contour map; talking to locals for suggestions; or using the Internet. Try to avoid somewhere that you are already familiar with. You may have to climb a few hills or cross a few streams before you find that really special view, so it is important that you visit your prospective location before you shoot. Note the exact location and direction of travel of the sun and use this to determine where it will rise. When you return to shoot your picture, work out what time the sun will come up when you plan to return.

9.26 Although getting up at 4am may be unappealing, if it results in a fabulous dawn landscape – such as this image by Olin Brannigan – the sacrifice is worth while.

You can now plan your shoot – the equipment, how you will get to the location, and where you can stay cheaply overnight (if necessary) – and start listening carefully to weather forecasts. A mixture of sunshine and showers can produce exciting lighting conditions, but overcast skies and heavy rain rarely produce a good picture or a pleasant shooting experience, so pick a day for your shoot when the weather looks as though it will work in your favour.

You will need to be at your location at least half an hour before sunrise so that you have time to set up, and remember that you may need to use graduated neutral-density filters to balance a bright sky – this can be much easier than trying to correct the image in **post-production**, so ensure you pack your kit carefully. As the sun rises, you will probably have no more than five minutes when the conditions are perfect, but you should shoot some frames before and after this to be sure. Make sure that friends know where you are going, or take someone with you as an assistant. Finally, ensure that when you finish you leave no litter behind.

Feedback

Once you are back in the warm, download your digital pictures and review your work to choose the best images. Do not be surprised if some need a little post-production work.

As well as showing friends and tutors your results, consider contacting calendar companies (or the landowner, if you needed his or her permission first) to see if you can get a return on your investment.

While taking one good landscape picture means you have been successful, a series of themed images based on a particular location or topic (such as cliffs and sea, moorland or rivers) can give you a really strong portfolio of landscape photography.

Exercise 2
EVEN NEWER TOPOGRAPHICS

Resources

- This project will be shot in black and white, using either a digital camera or film. If you are shooting digitally, visualize the image in black and white, but shoot the image in colour for a better-quality output.

- You will also need your workbook to make notes and add examples of the images that you take.

9.27 It is important to understand the concepts behind the New Topographers' work if you want to make successful images in their style. John Schott took this black-and-white picture of the El Nido Motel in 1973.

The Task and Extended Research

The exhibition *New Topographics: Photographs of a Man-Altered Landscape*, curated by William Jenkins in 1975, challenged the existing view that landscapes and cityscapes have to be attractive (**9.27**). The images lacked artistic frills and replaced beauty, emotion and opinion with everyday views that were recorded and printed to an exceptionally high standard. Most of the photographers who were exhibited produced their images in black and white – despite colour technology being readily available – and this seemed to reflect a detached approach to the landscape.

Your task is to use your home town as the subject for a series of ten photographs (the same criteria for the photographers in the original exhibition), which are to be output in black and white and reflect the approach of the 'New Topographers'. Obviously, you will first need to research the New Topographics exhibition and the contributing photographers, looking at as many images as possible in order to understand the aesthetics and spirit of the movement.

Feedback

This is a great exercise to have in your portfolio if you are going for an interview for an academic photography course, where your ability to discuss an important artistic movement in relation to your own work is sure to impress.

Getting Started

You could approach this exercise by planning meticulously each and every location that you will photograph, or you might prefer a more spontaneous approach and simply walk around with your camera. Note that in the image shown here, by John Schott, the composition, precise camera angle and content have all been very carefully and thoughtfully constructed. You may find that you need to shoot twenty to thirty images, or more, before you are ready to edit them down to ten that work strongly together to produce your 'Even Newer Topographics' series.

Exercise 3
TAKING A WIDER VIEW

Feedback

A carefully shot panorama can result in a fantastic addition to your portfolio, and even a compact camera is capable of producing a great result. Panoramas also have the potential to sell well in a gallery or on a website. The technique is time-consuming, though, at both the capture and image-manipulation stages. It also requires patience and meticulous attention to detail, as everyone will be trying to 'spot the joins' in the final image (**9.28**).

The Task and Extended Research

The aim of this exercise is simple: to produce a panoramic image. The location of your panorama is entirely up to you: it could be a stunning view taken from the top of a hill; shot from ground level for a more intimate view; a riverscape; or a large public square or park in a city. In all cases, be sure to get permission to photograph if it is needed.

Getting Started

Your final image should consist of at least six stitched frames, but you can include more if you wish. There are two common methods to choose from when it comes to shooting:

1) Ensure the tripod and camera are precisely level and then take a series of pictures by panning the camera from a fixed position. Ensure that you overlap your frames and, if possible, make a number of complete passes to allow for errors and things that move between shots.

2) Point the camera in one direction, take your first frame, then move ten or twenty paces to one side and take a second frame. Repeat this until you have covered the view you want in shot. This approach works well if you walk along a river: the river frontage should give you a very accurate, continuous image, but skyscrapers or churches may make more than one appearance when you stitch them together.

When you have shot your sequence of images, load them into your panoramic stitching software (Adobe Photoshop's Photomerge feature is recommended) to create your panorama.

9.28 Jeff Robins planned, shot and stitched this high-resolution panoramic picture of Holy Isle, off the Isle of Arran in Scotland.

PORTRAIT, FASHION AND BEAUTY PHOTOGRAPHY

In this chapter you will learn how to:

- Plan a portrait, fashion or beauty shot, either on location or in the studio
- Shoot powerful portraits that require minimal post-production work
- Shoot eye-catching fashion and beauty photographs, developing your own style

Portraiture Defined

10.0 (previous page) Bella Falk explains, 'It was right at the end and model Evgeniya had been on her feet all day being flashed at by loads of different photographers. She hadn't had any lunch and she was pretty tired and fed up!' Bella captures all those feelings and more in this fabulous portrait.

10.1 (above) Many company annual reports include commercial portraits of the workforce, as well as the directors, highlighting their expertise and experience. Palmer + Pawel rightly thought that this would make a very useful portfolio image.

Our faces enable us to be recognized; they reflect the genes we have inherited from our ancestors; and they communicate personality, mood and character. By reproducing the human face, artists throughout history have attempted to capture the essence of their subjects. Besides traditional portraiture of this kind, the modern genre encompasses three more specialist areas:

Commercial Portraiture: Commercial portraits are often used in company reports or brochures (**10.1**). They are generally quite formal and designed to convey gravitas and responsibility. The sitter may be photographed performing some form of activity – such as meeting a client or sitting at a computer – or standing in front of a factory. Subjects will be concerned about how they are viewed, which means that pleasing a client can be difficult.

Social Portraiture: Social portraiture covers family portraits, weddings, school photographs and even pet photography. The style is sometimes referred to as 'high-street photography', as many practitioners work from shop premises with a built-in studio. Some companies work on a franchise model, training photographers in a specific style that is often aimed at providing funky and exciting portraits for a younger clientele. Another growth area is the portrait makeover, where a photographer teams up with a make-up artist to produce images where the client is transformed for the camera. New photographers often view social portraiture in a derisory light, but it is an area that can form the basis of a lucrative career (**10.2**).

Fashion and Beauty: The purpose of a fashion photograph (**10.3**) is to present an eye-catching look for commercial exploitation: while it has its basis in portraiture, capturing the personality or character of the model is often secondary and, in some instances, positively avoided. Beauty shots can be considered an extension of fashion photography, as clothes are often important in this type of work. This sub-genre consists of two distinct areas: one where the face, perhaps of a famous actress endorsing certain cosmetics, is very recognizable, and another where the model is unfamiliar but the lighting and make-up result in a look that others will aspire to.

While many new photographers aspire to work in these sub-genres of portraiture, there is no doubt that it is incredibly difficult – although not impossible – to make a living from them. This is not just because competition is fierce, but also because the fashion industry has, by its very nature, to refresh and reinvent itself on a regular basis.

10.2 (below) Even if wedding photography does not appeal to you, there is a growing market for bridal makeover portraits with more of a fashion and beauty style. Anya Campbell is developing a good business in this area. With thanks to Emma Hunt Bridalwear for permission to use this picture.

10.3 This image, by Xenia McBell, is a good reminder of the huge amounts of organization required to get all the components of a shoot – clothes, models, make-up artists, stylists, props and your kit – to work together in the production of a beautiful image.

Portraiture: A Brief History

Some of the earliest known human likenesses are found in the Cycladian art of Thera and early Minoan art of Crete; a number may be based on actual individuals. Rulers in the ancient world sometimes ensured that their likeness was recorded, using portraiture in mosaics, statues, wall friezes and coins as a means of communicating their power and status.

Western artists in the Middle Ages tended to depict the human figure – often saints or characters from biblical stories – in a stylized, two-dimensional form, and it is only in the work of Italian Renaissance artists that the realistic depiction of individuals in paintings becomes more widespread (**10.4**), with portraits of artistic patrons beginning to appear.

At this time, wealthy families would commission artists to paint their portraits, often with the aim of displaying their power and influence. The resemblance of the painting to the subject was paramount, with artists producing portraits that became near-photographic in quality. By the seventeenth century, the Dutch understanding of lighting and perspective in portraiture reached a peak with the work of Rembrandt, Vermeer and Frans Hals, among others. The period is also notable because, for the first time, there existed in Judith Leyster a female painter who appears not only to have been able to survive as a portrait artist, but also to have competed as an equal in this very male-dominated world.

In the eighteenth century, Thomas Gainsborough favoured the 'portrait in the landscape'. His great rival, Joshua Reynolds, broke away from that mode and used innovative poses. Modern photographers may particularly appreciate Reynolds's self-portrait, painted when he was aged about twenty-five, for both its lighting and the 'fleeting moment' that he ably captures (**10.5**). It is certainly a contrast to the more staid and formal style of his later years.

Commissioning these great artists was a costly exercise, and one that the middle classes at the start of the nineteenth century could rarely afford. Yet they too were keen to be recorded for posterity, and this led to the rise in popularity of the comparatively inexpensive silhouette (**10.6**). Once the silhouette had been drawn, another artist could cut copies from black card in minutes and these could be sent to friends and relatives – one example of the public's desire for multiple copies from the same original, many decades before the negative/positive photographic process was developed. With silhouettes so commonplace, the public was already used to the idea of portraits being in black and white when photography was invented.

One of the reasons that the new medium advanced so rapidly was the desire to reduce exposure times from minutes to seconds so that sharp portraits could be made. The first human portrait in the United States was taken in 1839, when the chemist and physician John William Draper made a remarkable **daguerreotype** portrait of his sister Dorothy, using an exposure time of 'only' sixty-five seconds (**10.7**).

10.4 This image of Dante Alighieri, painted by Giotto in the chapel of the Bargello palace in Florence, is an early example of Renaissance art breaking free from the stylized religious icon to allow more realistic depictions of human subjects.

10.5 Self-portrait by Sir Joshua Reynolds, *c.* 1750.

10.6 (left) Examples of silhouettes, *c.* 1800.

10.7 (right) It is believed that Dorothy Draper had her face covered in white flour while sitting for her brother, John William Draper. This reduced the exposure time, as daguerreotypes could 'see' only blue and ultraviolet light, not flesh tones.

10.8 (far right) Julia Margaret Cameron photographed many great Victorians, including Charles Darwin. Those striving for sharper pictures criticized her style at the time, but today we can appreciate Cameron's desire to record the character of her sitter, not just a likeness.

Within ten years, New York alone boasted more than seventy-five photographic galleries, and commercial portrait painting was virtually extinct. While the daguerreotype flourished in America, the negative/positive **calotype** was more popular in the United Kingdom, with such practitioners as David Octavius Hill and Robert Adamson elevating the photographic portrait into a true art form.

Scott Archer's invention of the **wet collodion** process in 1849 reduced the length of exposures even further, facilitating the greatest photographic mania of all: the carte-de-visite. Invented by a Frenchman, André Disdéri, in 1854, the carte-de-visite was a small, inexpensive photographic print that truly brought portraiture to the masses. By 1886 there were almost 300 studios in London offering the public the opportunity to have their portrait taken. Each produced between 20,000 and 80,000 cards per year, as well as huge profits for their owners. Cameras with multiple lenses were developed so that four or eight small images measuring roughly $4\frac{1}{2} \times 2\frac{1}{2}$ in. could be made at once for printing out in bulk, and pictures of famous figures became popular collectables. Almost every small town would have its own photographer, or a number of rival practitioners, each determined to cash in on the latest photographic trend.

The period also nurtured a number of photographers who were not seeking instant wealth, but who perceived portrait photography as a form of high art, no less valid than painting. Among the most remarkable was Julia Margaret Cameron, who did not take up photography until she was forty-eight. In the following eleven years she questioned and changed the genre of photographic portraiture through a combination of close cropping, a minimal **depth of field** and a return to longer exposures that showed the slight movement in her sitters (**10.8**). Contemporary portraiture still owes much to her work, which is made all the more fascinating by the circles she moved in and the people who sat for her. In some cases her portraits are the only record of their subjects' likeness that survives today. Cameron's friendship with Alfred Lord Tennyson was particularly fruitful, inspiring a painterly series of photographs based on his poem *Idylls of the King*.

There are numerous portrait photographers of the mid- to late nineteenth century whose work is worth researching. Notable examples include Charles Dodgson's

photographs of Alice Liddell (whom he later immortalized in *Alice's Adventures in Wonderland*); Frank Meadow Sutcliffe's portraits of fishermen and women; and Felix Nadar's superb portraits of many famous figures.

Up to this point, the need for bulky equipment, a studio background and considerable skill to shoot and develop images had meant that photography remained a professional pastime beyond the reach of all but the wealthiest of amateurs. This was all about to change. In 1888, the name Kodak was registered as a trademark and portable cameras and snapshot photography for the masses were launched, supported by the slogan 'You push the button, we do the rest.' After a roll of film was shot, the whole camera was sent back to Eastman Kodak of New York and the film was processed, printed and returned, with the camera reloaded. Now everyone could be a photographer, taking both formal and informal portraits with very little skill.

The early twentieth century saw the emergence of numerous art movements that questioned the prevailing ideas of previous generations, and photography did not escape this scrutiny. Among the groundbreaking figures of this time was Edward Steichen, who worked across many genres but is perhaps best known for his landmark portrait of Greta Garbo (**10.9**). Anyone interested in fashion photography will find Steichen's work from the 1920s and 1930s fascinating.

Some photographers moved away from a deferential approach to their subjects in favour of a more confrontational style; notable exponents of this approach include Paul Strand – best known for his portrait of a young boy from Gondeville, France, in 1945 – and August Sander, who practised it in his project 'People of the 20th Century' (**10.10**).

Among celebrity portraitists of the mid-twentieth century, Yousuf Karsh achieved particular renown for his portrait of Winston Churchill in 1941 and went on to photograph other famous figures, including many movie stars. Karsh's style owed much to the tradition of Hollywood cinema, and there is a great deal to be learned from analysing his classic lighting in particular.

10.9 Edward Steichen took this innovative portrait of Greta Garbo in 1928, when she was at the height of her silent-movie career and her on- and off-screen love affairs were the subject of intense public interest.

10.10 At first sight, August Sander's pictures of workers – such as this *Berlin Coalheaver*, 1929 – seem very simple: his sitters often stand straight on to camera, in the centre of the frame. But it is this lack of embellishment that makes superb documentary portraits.

Throughout the late twentieth century, Irving Penn and Richard Avedon were both defining new areas in commercial portraiture, taking fashion photography from its stylized haute-couture look to something that resembles far more closely the fashion images we see today. These photographers were in the right place at the right time, as popular fashion magazines began to be read by all, rather than just the wealthy and privileged. Both photographers were unafraid of risk-taking, and their experiments paid off – Avedon's pop art-style pictures of the Beatles for *Stern* magazine, for example, have become iconic (**12.1**).

The increased popularity and greater number of fashion magazines around this time meant that there were opportunities for numerous photographers, such as Norman Parkinson, John French, David Bailey, Terence Donovan and Brian Duffy, working in a range of styles. Between them these figures helped redefine British fashion photography and the concept of the celebrity photographer.

In the US, the most prominent fashion photographers of the late twentieth century often pushed boundaries: Robert Mapplethorpe gained notoriety for the blatant homosexual eroticism of his black-and-white portraits; Annie Leibovitz became famous through her challenging portraits of film stars, pop idols and politicians. Steven Meisel and Mario Testino are two of a number of fashion photographers who have successfully followed in the footsteps of Penn and Avedon in crossing over effortlessly into superb portraiture, although some of Meisel's work has courted controversy, most notably his images for Madonna's book *Sex* and his ad campaigns for Calvin Klein.

Contemporary practitioners continue to take fashion and portrait photography in new directions. Sam Taylor-Wood's self-portraits and images of famous faces are full of insight and make no attempt to flatter; her series *Crying Men* includes a fantastic picture of the actor Daniel Craig as few have seen him (**10.11**).

Among the most iconic current figures in fashion photography are Nick Knight, David LaChapelle, Miles Aldridge and Rankin. Aspiring portrait photographers, meanwhile, should study the work of Martin Schoeller, Platon and Jill Greenberg.

As well as investigating the big names, try to look at the work of students from photography courses worldwide: different countries favour different styles, and any of them might define what happens next in contemporary photography. There are also various national and international portraiture competitions that can provide an exciting source of inspiration, as well as offering opportunities for you to get noticed and published if you enter them.

10.11 (left) Sam Taylor-Wood's photograph of Daniel Craig from her series *Crying Men*. The artist commented, 'People can decide for themselves which they think are the authentic tears and which they think are fake. It's about the idea of taking these big, masculine men and showing a different side.'

Planning a Portrait Shoot

A successful portrait photographer must study people in order to capture the essence of his or her sitter, and will need an understanding of how people react to a camera and studio situation in order to make the sitter relaxed and comfortable. To do this, the photographer needs to appear to be competent, knowledgeable, organized and confident. Think in advance about what you are trying to achieve, as your concept will determine the lighting that is required, as will any **post-production** techniques, such as black-and-white conversion, that you plan to use.

The easiest way to have a relaxed shoot is to have researched your subject so that conversation can flow freely. Failure to talk to your sitter while hiding on the other side

of a large camera is certain to take your subject out of his or her comfort zone and make him or her feel nervous. When the session has been running for a while, the sitter usually starts to relax and to ignore the camera, concentrating instead on the photographer. This is when the best results tend to be achieved.

In the past, experienced portrait photographers would shoot the beginning of a session without film in the camera, just to get over this start-up period, but this is no longer necessary with digital imaging, as there is no cost implication. There is a downside to digital capture, though, as the technology can encourage the sitter to want to view the images instantly, which can disrupt the flow of the shoot. Usually, there is a natural moment to break after everyone has been concentrating for around ten minutes, and this is a chance to show the best images.

Some photographers find that shooting 'tethered', with the digital camera wired directly to a computer, is beneficial. If you do this, it is a good idea to position the computer's monitor out of sight of the sitter so he or she is not distracted, and you should also try to avoid looking at it too often yourself.

Instructing a sitter to bring a few favourite garments that will fit the style of your image will allow you to incorporate some natural breaks in your shoot, as well as trying out different looks. The more you plan ahead, the easier the shoot will be, so if you can set up the lighting and run some tests before your sitter arrives, or while a model is having make-up applied, you will have more time to shoot, and your subject will not be waiting for you to set up.

A good portrait should not lie, but physical detail can become secondary to revealing character: working on a balance between the two will often produce the required result. For fashion shots, your models should try on a garment before the shoot so that any minor adjustments can be made. If a make-up artist can meet a model (or be sent a few photographs of him or her) before the shoot, and be briefed by the photographer, it also gives the artist a much better chance of planning in advance and producing a great look.

Shooting in Daylight

Whenever daylight is used for your portrait, fashion or beauty shots, your planning must include the weather, the direction of light throughout the day, and your background (**10.12**). Bright sunlight is far from ideal, as it will cause your subject to squint if he or she is staring into the sun, or it may cast strong shadows across a face. Hazy sun with a thin layer of high cloud is much better for almost all shoots.

Shooting with a telephoto or **zoom lens** set to a **focal-length** equivalent of around 100 mm is ideal for head shots, as it will mean the camera is about 2 m away from your model – a comfortable distance that is similar to where you might stand for a regular conversation. A wide-angle lens will distort a face and give a very unflattering result, as well as requiring you to work much closer to your subject.

You can often get the most attractive pictures when the sun is almost behind your model and shining through his or her hair, with either a silver or gold **reflector** throwing light back onto the face. A white reflector may also help if you are shooting under harsh sunlight, and can also be placed under the model's chin to help lift deep shadows.

10.12 If you have the opportunity to travel overseas with the army, it must be very tempting to work only in the genre of photojournalism, but A. J. Heath took the time to get this fabulous portrait of a soldier in battle-dress.

10.13 Mastering fill-in flash can be tricky, whether in Manual or Auto mode. As this portrait by Seb Palmer illustrates, however, it is well worth learning the possibilities for your particular flash and camera combination.

Planning for Bad Weather

If you expect that the weather will change for the worse during an outdoor shoot, always photograph the most important portraits or fashion shots first.

Aperture Settings

Use an aperture of $f/8$ or $f/11$ for fill-in flash. A wider aperture is likely to lead to a shutter speed that is too fast to work with many camera and flash combinations, while a smaller aperture setting will need a higher flash output for every exposure, which will discharge your batteries quickly.

An alternative to reflectors is to use 'fill-in flash', either using the camera's built-in flash unit or a separate hotshoe-mounted unit (**10.13**). If you are working in Manual mode, this can be quite complex, as you want the flash exposure to be 1 or 2 stops less than the exposure for the **ambient light**. If you can, set the flash to manual and the lens aperture to, say, $f/8$. If you are using **ISO** 100, you should then 'lie' to your flash unit and set it to ISO 200 at $f/8$. The flash will be 1 stop darker than the ambient light, giving a bright **fill-in light**. Alternatively, set the flash to ISO 400 for a subtler, −2 stop fill.

Digital **SLR** cameras make the use of fill-in flash far simpler, as most models allow you to apply flash exposure compensation. If this is the case, set the flash to Automatic and set the camera's exposure compensation to $-\frac{1}{3}$ stop to ensure the background is not overexposed. Then set the flash's exposure compensation to $+\frac{1}{3}$ stop or more, experimenting until you get the effect you want.

Fill-in flash also has the advantage of adding a pleasant sparkle ('catchlights') to your sitter's eyes, although care is needed if your subject wears glasses. Similarly, fill-in flash can be useful indoors if your subject is back-lit by a window, but be careful of unwanted reflections in the glass.

In harsh sunlight, another technique is to use a larger flash unit on a tripod or light-stand, set at an angle to fill in any ugly shadows. Some photographers, particularly in outdoor fashion and beauty work, will backlight a subject with the sun, and then fire a flash into a white, silver or gold reflector to bounce the light onto the face and clothes. If the flash's sensor points towards the subject and does not pick up another flash, no additional exposure compensation should be necessary.

A spectacular effect for dynamic fashion shots and portraits involves underexposing the ambient background but giving the model, lit by flash, the correct exposure (**10.14**). This can best be done with the camera and flash set to Manual. To illustrate this, let us say that at ISO 100 the exposure required for an outdoor portrait is $f/11$ at $\frac{1}{60}$ sec. If you stop the aperture down to $f/22$, while maintaining a $\frac{1}{60}$ sec. **shutter speed**, you will underexpose the background by 2 stops. If you increase the power of the flash to give you the correct amount of light for $f/22$, however, your subject will be perfectly exposed, creating the impression of a shot taken at twilight, even if it is the middle of the day.

Exposure Settings

On a bright, sunny day, any camera set to Auto will shut down the lens aperture for the exposure, which will increase the depth of field and potentially bring an unwanted or busy background into sharp focus. Setting the aperture to $f/4$ or $f/5.6$ in Manual or **Aperture Priority** is often a better option if you want the subject to stand out against a defocused background. This is likely to result in a fast shutter speed, which is usually an advantage, especially if you are hand-holding the camera.

Indoor Shots

A technique similar to that described above, but suitable for indoor shots, involves using the camera on a tripod and measuring the light coming through a window (for example, ISO 100, $f/11$ and $\frac{1}{60}$ sec.). For the overall exposure, set the flash output to give the correct exposure for $f/11$. If your camera will synchronize at $\frac{1}{250}$ sec., then this will still give the correct exposure for the flash, but areas outside the window will appear 2 stops darker. Conversely, if you set a slower shutter speed ($\frac{1}{8}$ sec., for example), the flash exposure will still be correct, but the areas outdoors will be bright and overexposed. This provides you with absolute – and separate – control over the exposure for the background and foreground.

10.14 Helen Ritchie used the technique of 'lying' to the camera and flash, so she got the correct flash exposure for her subject while underexposing the background by a couple of stops in the middle of the day.

Shooting Indoors

If you do not have access to a photographic studio, it is still possible to take great shots of people indoors: portraits taken in a person's favourite room, surrounded by possessions that he or she cherishes, can be far more revealing than those against a plain backdrop (**10.35**). Fashion pictures taken in a bedroom or living room will also have a strong innate narrative, especially if the clothes and interior design relate to each other. This is very much the easiest way to start shooting indoors, as the blank canvas of a studio can be a daunting prospect, particularly if you are working with an inexperienced model.

If you want to keep things simple, then the daylight coming through a window will give a totally natural look, and can be controlled through the use of reflectors to lighten shadows and reduce the overall contrast. If the light levels are low, use a tripod and slow shutter speed, or increase the ISO to 400 or 800; the **noise** this introduces should still be acceptable on most current digital SLR cameras.

Indirect daylight coming through a window tends to be quite blue, potentially leading to cool-looking results. This can be corrected using your camera's Auto or Cloudy **white balance** setting, but it can also be interesting to turn on some tungsten lights to create warm pools of light around a room or on a model's face. Unfortunately this works less well with energy-saving bulbs, as these **fluorescent**-based lights will often create a sickly green glow.

If using tungsten photofloods, be aware that they can produce a harsh, direct light, with sharp shadows and strongly contrasting highlights. Bouncing the light off a white ceiling, wall or reflector produces a more natural-looking effect. It is often said that you should use soft light for women and harder light for men, but in contemporary portrait photography this is definitely a rule made to be broken: your lighting should reflect the style and mood of your image.

If you prefer to use flash for your indoor shots, then on-camera flash (either built in or hotshoe-mounted) is best avoided unless it is bounced or diffused in some way, but be careful not to reflect the light off a coloured ceiling that will throw a colour cast across the whole picture.

The positions of your camera and subject also need careful consideration, as both can alter how an image is perceived. A three-quarter view of a subject can give an informal, natural feel – particularly if the model's eyes are looking at the camera – while a full-frontal view is likely to produce an image that feels either more formal or more disquieting, bordering on confrontational, for the viewer. Turning the sitter side-on, so he or she is seen in profile (**10.15**), will emphasize the nose and chin (which may or may not flatter your model), but in a portrait this can suggest that the subject is a 'visionary', thinking great thoughts of far-away places. In a fashion shoot, however, it is more likely to symbolize the model's complete indifference to the camera or viewer.

Asking your sitter to lean forward slightly can make him or her appear more relaxed, producing an intimate picture with the suggestion that the subject might be about to confide a secret. On the other hand, if your subject is leaning back, away from the camera, he or she may appear rather aloof, although this can give useful extra body length and elegance to a fashion shot.

Slave Flash Units

For indoor portraits or fashion shots, small and inexpensive slave flash units (see p. 139) can be placed carefully around a room to give more exciting lighting. Many work with a photocell that synchronizes with the main flash.

Shooting Position

A full-length photograph of your subject taken from eye level can make him or her appear shorter in height than if you took the same shot from around knee level, so use a lower shooting position if you want to enhance your subject's height and make him or her appear taller.

10.15 If your model has a good
profile and you are working with
a great make-up artist, it opens
up all sorts of possibilities for more
original fashion and beauty shots.
This studio image is by Bettina Strenske.

Portraits, Fashion and Beauty in the Studio

Unless you are on a college course or have free access to studio facilities, hiring a studio will always be expensive. This makes your time in the studio precious, so meticulous planning is required beforehand and good people management is needed on the day of your shoot to ensure that any delays are minimal. Portrait sitters have to be made to relax in this alien environment, while models and make-up artists need to be directed and pampered to make them work hard and become involved in your concept.

While your subject is getting ready, aim to set up your background, camera and lights, and check the settings so that you are ready to shoot as soon as he or she is. If you are using a plain backdrop (a single-colour wall or a roll of background paper), you should position your camera as close to the opposite side of the studio as possible. If the model is standing, he or she must be far enough away from the camera to fit in the frame without your having to use a wide-angle focal length, but you also need to keep the model as far away as possible from the background to avoid unwanted shadows. Ideally, the positioning mark, stool or chair for your sitter should be about halfway between the camera and the background (**10.16**). The same rules apply for head-and-shoulders shots, although you will probably find this is much easier to achieve, even in a smaller studio.

Shooting with One Light

There is no reason why you have to use multiple lights to shoot a portrait, and when you are starting out, using a single light can actually help you learn about lighting more quickly (**10.17, 10.18**), with reflectors used to fill shadows (**10.19, 10.20**). A good starting point is to position your light at an angle of about 45° to the left or right of the camera. Set the height of your light so that it is about 2 ft above the sitter's head and angled down at 45°. This will provide you with a simple but effective one-light set-up that can be used directly for a hard light, or diffused by adding a softbox or **diffuser** for a softer result. The light can also be moved: if it is closer to 60° or 70° from the camera it will produce a more contrasty side-light, while bringing it closer to the camera position so that the light is more direct will reduce shadows for a lower contrast result. The light-to-subject distance can also be used to control contrast, as the further the light is from your subject, the softer it will become.

Model Height

If you want to take full-length shots but your studio space is small, avoid using a 6 ft tall model wearing 3 in. stiletto heels! Either take three-quarter-length shots if this is the only model you can use, or try to find someone more petite.

Lighting Check

Do not be afraid to ask a model who is not yet fully made up to come into the set for a lighting check. You can then sort out any problems while the make-up is finished.

10.16 A lighting diagram from the side.

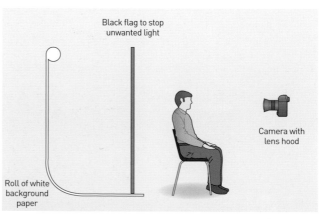

Black flag to stop unwanted light

Camera with lens hood

Roll of white background paper

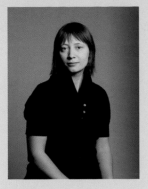

10.17 A portrait taken using a single light.

10.18 (right) The lighting diagram for this set-up from above.

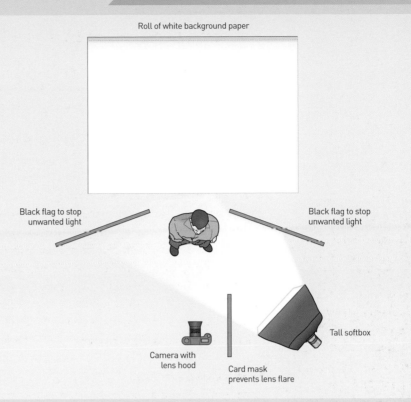

Roll of white background paper

Black flag to stop unwanted light

Black flag to stop unwanted light

Tall softbox

Camera with lens hood

Card mask prevents lens flare

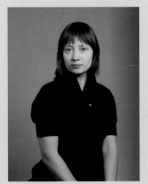

10.19 A portrait taken using a single light and a reflector.

10.20 (right) The lighting diagram for this set-up from above. Ideally, you need to map the exact position of your lights, models and the camera so that you can repeat a set-up again later if required.

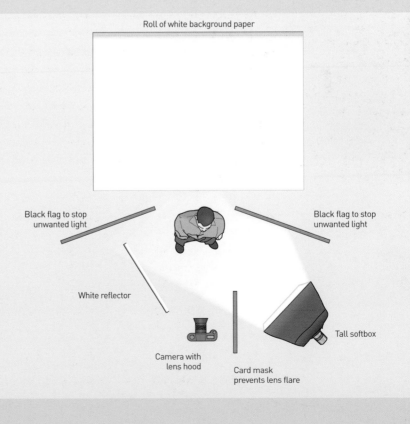

Roll of white background paper

Black flag to stop unwanted light

Black flag to stop unwanted light

White reflector

Tall softbox

Camera with lens hood

Card mask prevents lens flare

Shooting with Two Lights

When you add a second light to your set-up it is tempting to place it on the opposite side of the subject to the first light, but unless you are using very soft light sources, the conflicting shadows this can produce are likely to result in an unnatural-looking image. The highlights in the eyes can also look odd and may need retouching out. A better use for your second light would be to use it on the background (**10.21, 10.22**), possibly with a coloured gel or filter, but be sure that this light does not fall on your model, unless you want a coloured edge to the face or hair. If you are shooting a full-length fashion shot or portrait, you could also position your lights one above the other, and use a long piece of tracing paper or translucent Perspex so that your model's face and shoes are equally lit. Use black paper or card to ensure that light from this diffuser cannot bounce back into the camera lens and cause flare. It is important to mask off your main light if you want a black background, as any light that spills onto the backdrop may cause an appearance of dark grey, rather than pure black. Positioning your model well forward from the background will help. This also gives you the opportunity to use your second light as a hair-light will help a dark-haired subject stand out against a black background or prevent pale-brown or blond hair from looking dull and lifeless. A hair-light is positioned high and just to one side of the background, and aimed at the back of the model's head; take care not to let it shine into the camera lens (**10.23–10.27**). A spotlight lens or honeycomb lens can be useful in helping prevent unwanted light 'spills'.

10.21 A portrait taken using two lights: one on the model and one on the background to produce a 'counter-change' effect.

10.22 (right) The overhead lighting diagram for the previous image.

> ### Lighting the Background
>
> Light the background from the opposite side to your main light. The light side of the face will then be against the darker side of the background, and the shadow side of the face will stand out against the lighter background area. This can add definition to dark or blond hair, and is known as 'counter-change'.

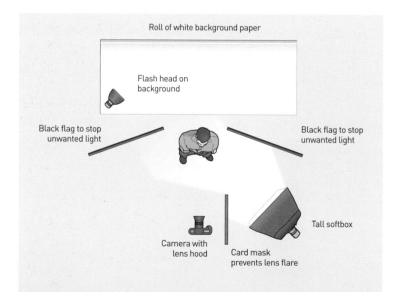

Roll of white background paper

Flash head on background

Black flag to stop unwanted light

Black flag to stop unwanted light

Tall softbox

Camera with lens hood

Card mask prevents lens flare

> ### Using a Hair-Light
>
> Using flash for your main light and a tungsten lamp for your hair-light can produce great results. If the camera is on a tripod, you can control the brightness of the hair-light by altering the shutter speed, perhaps to $1/15$ sec. or longer. Do not worry about the difference in colour temperature; the flash will freeze the model while the warm tungsten light can look very attractive on blond or dark hair.

10.23 A portrait using two lights and a reflector. One of the lights is flash and the other is a tungsten spotlight directed from behind onto the model's head. This was shot using a shutter speed of $^1/_{125}$ sec.

10.26 A portrait taken using two lights. The main light was directed on the model's face, with a second flash used as a hair light. Reflectors aimed at the face and from underneath the chin prevent harsh shadows.

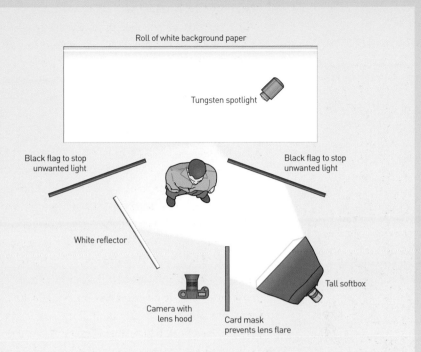

10.24 (left) The same set-up as **10.23**, with the shutter speed extended to $^1/_4$ sec., and the camera on a tripod. The main flash light freezes the model, while the longer exposure 'paints' warm tungsten light onto her hair. The amount is controlled by the shutter speed.

10.25 (above) The lighting diagram for the mixed lighting portrait.

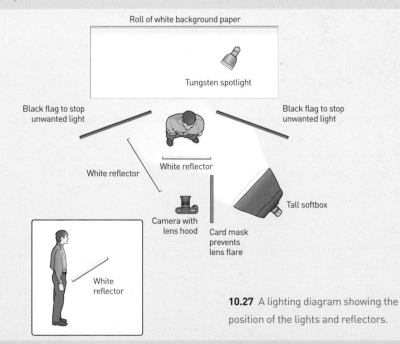

10.27 A lighting diagram showing the position of the lights and reflectors.

Shooting with Three or More Lights

Using three or more lights for your portrait and fashion photography gives you the opportunity to try new combinations (**10.28, 10.29**); you could, for example, use a hair-light in addition to two 'stacked' lights. If you are using flash, it is important to ensure that all your flash units are firing at once, so check that no one in the studio is standing in the way of the photocell of a distant flash unit.

An additional option if you are using a third light is to place it close to the ground, almost from the camera position, to ensure that a dress or person is evenly lit. This **fill-in light** does not need to be as powerful as your main light and is a more controllable alternative to using a reflector in the same position. While a fourth light may allow you to use all these options at once, it is safe to assume that if you are using four or more lights then you must either be doing something exceptionally complicated, or doing something wrong.

10.28 Using three lights and a reflector allows you to have a main light, a hair-light, and a third light either on the background or, if you are taking a full-length shot directed at the model, from ground level.

10.29 (right) The lighting diagram showing all these elements in position.

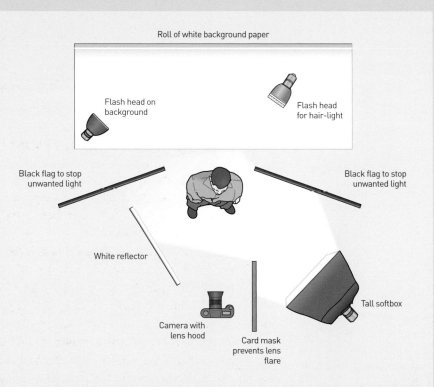

Roll of white background paper

Flash head on background

Flash head for hair-light

Black flag to stop unwanted light

Black flag to stop unwanted light

White reflector

Camera with lens hood

Card mask prevents lens flare

Tall softbox

Practise Lighting Set-Ups

If you have the opportunity, practise complex lighting set-ups with a friend first. Note the power of the flash units you use, as well as their exact position and the camera settings. A couple of shots of the set, taken using a compact camera or your mobile phone, can be a great reminder if you find a lighting set-up that you like. Measuring the height, distance and output of a lamp would be even better, and these figures are definitely worth adding to your workbook, along with a lighting diagram and a small print of the results.

10.30 In catwalk photography, the models move towards and away from the camera at relentless speed, the lighting changes constantly, and it may all be over in as little as ten minutes. Jasmine Nehme shows how to get the timing right.

Camera Settings for Studio Shots

Checking Test Shots

When you are making test shots to check your lighting and exposure settings, it is worth downloading your images onto a computer and checking them on a large, preferably calibrated, monitor, rather than using the camera's **LCD** screen.

While outdoor shots often look best when a fairly wide aperture setting is used to blur the background, in the studio you may prefer to stop the aperture down to ensure that your model appears sharp, particularly if he or she is moving around, or if you are cropping tightly in on the head for a beauty shot.

Many photographers set their lens to manual focus, put the camera on a tripod, sit the model on a chair or stool and check the sharpness at the start of a shoot – and then never touch the focus ring again. By closing the lens aperture down (increasing the depth of field) you can be sure that your subject will be sharp, which means you can come out from behind the camera, converse with your model and maintain a rapport as you shoot.

Similarly, in fashion catwalk photography many photographers will focus manually on a point on the catwalk, and wait for the models to reach the plane of focus before taking their shot. This saves waiting for the **auto-focus** to get a lock in what could be low light conditions, and guarantees consistently sharp results (**10.30**).

Talk to Your Model

Talking to and praising your model will help keep him or her relaxed and will help much more than playing loud music. Avoid taking pictures while your subject is talking back to you, though, as this will always distort the mouth and face.

Intentional Distortion

Large-format film cameras are becoming very expensive to use as film prices increase, but the camera movements that are used to avoid distortion in architecture or still-life photography can be used creatively for portraiture or fashion. The plane of focus can be adjusted by angling the front and rear standards of the camera, which can mean that a subject who is face-on to the camera will have just one eye or the mouth in focus, for example, with the rest of the face blurred. In digital imaging, perspective-control lenses give a very similar effect (**10.31**). You can also experiment with **selections** and blur filters in your image-editing software.

10.31 A perspective-control lens can be used to make subversive portraits where only a tiny element – one eye, for example – is in focus.

10.32 (opposite) The legend of William Tell provided Jeff Robins with the idea for this image. Needless to say, the arrow was already embedded in the wooden painted model of the apple before it was placed on the young boy's head.

Flipped Images

People normally see themselves in a mirror, so you may find that your model prefers a portrait that has been reversed, either by flipping it in your image-manipulation software or by reversing the negative in the enlarger.

Portraits of Children or Animals

W. C. Fields's famous recommendation, 'Never work with children or animals', holds true for photographers. Both have a much shorter attention span than adults, and if a young child or animal decides not to co-operate, there is little that you can do.

With children, getting down to their level and constructing the whole shoot as if it is some form of game will often keep them interested (**10.32**). It will also help if you mount the camera on a tripod, pre-focus the lens, and set a small aperture to ensure a good depth of field, as outlined above. Then you can involve yourself in a game with the child and use a remote release to trigger the shutter. Your subject will not anticipate when an exposure is going to be made, and may not even notice.

Strangely, you can fire a studio flash fairly close to a cat or dog and it will often pay no attention to it at all, so as long as the animal is happy to sit in front of the camera, you can take its picture. As with children, though, once animals have decided they have had enough, and walk off the set, getting them back in front of the camera can be impossible.

For professional advertising or marketing work, when there is a budget for models involved, you can increase your success rate by having two or three children who can be swapped in and out of the set. This can overcome the problem of a short attention span, although parents or chaperones can be a problem if they start pressurizing the child to perform, which often has the exact opposite of the desired effect.

Equally, most advertising photographers who have hired 'professional' animal models (and their handlers) have their own disaster stories to tell, so it is hardly surprising that there are a number of specialist taxidermy companies that will hire out stuffed animals for photographic use. This can be an effective solution in some circumstances, such as a college environment, although portraiture is largely replaced with still-life photography.

Exercise 1
HOW DID THEY DO THAT?

For this exercise you do not necessarily need a camera, just a magnifying glass and your workbook for making notes.

The Task and Extended Research

This project is an essential task for any aspiring portrait, fashion or beauty photographer. Buy or borrow a number of magazines with contemporary fashion or portrait pictures and select a range of images that you really like. The aim of the project is simple: study the images to try to determine how each shot was lit, and then produce lighting diagrams (from above and the side) for a selection of these images, illustrating where you think the lights were. Paste the diagrams into your workbook along with the picture from the magazine.

10.33 Xenia McBell was inspired by the work of American fashion photographer Steven Meisel to create images with a 1920s and 1930s feel.

Getting Started

By looking carefully at any image, it is possible to come to a fairly accurate conclusion about how it was lit. When you examine your selected images, ask yourself the following questions:

- Is the lighting hard (typified by dark, crisp-edged shadows), or soft (diffused, with less intense shadows)?
- From what angle is the light falling across the model's face and body: above, below or directly from the side? The direction of the shadows should give you a clue.
- Is the shot lit by one light, or do you think other lights have been used from other angles? What about lights on the background?
- Are any of the lights coloured? This could mean that more than one type of light has been used (flash and tungsten, for example), or that one or more lights has a gel over it.

Using your magnifying glass, look for reflections in the model's eyes. The number and shape of any reflections can tell you how many lights were in front of the model and whether they were coming from square softboxes, round photofloods, an umbrella or perhaps a large reflector. If there is a dark edge around the model's arms, legs or face, it is possible that a large black reflector was used to give body tone.

Although you will not know the power of each light, with multi-light set-ups, you will find that you can start to make judgements about the power of the main light in relation to a second, fill light: is the main light twice as bright, or more or less than this?

With outdoor portraits, look for signs that back-lighting, fill-in flash or reflectors have been used, again checking the model's eyes carefully. Unnaturally 'good' lighting may indicate that studio flash units have been used, or perhaps a car's headlights have become an impromptu light source.

Feedback

When you have drawn out the lighting diagrams to five images, show them to a friend or tutor and explain how and why you have reached your conclusions about the way in which a shot was lit. See if they agree or think there are any flaws in your analysis. If you are lucky enough to have access to a studio, you can take this project further by trying to use the image and lighting diagram to re-create the effect in your own pictures (**10.33**).

Exercise 2
GETTING YOUR TEAM TOGETHER

Resources

This exercise can be completed in a studio, outdoors on location, or in a house or flat. You will need your camera, some additional lighting (optional) and your workbook for notes and sample images.

The Task and Extended Research

This project is about learning to work with a team to create a final image. Planning meetings are vital so that the team can discuss ideas, plan clothes, props and styling, and make sure that everyone understands their role on the day. Drawing ideas and

bringing in tear-sheets always works better than using words alone. Try to keep a journal of your meetings and the ideas as your shoot develops. This can help you to learn project-management skills as you identify what went wrong and what was successful.

Getting Started

In most villages, towns and cities there are people learning hair styling, make-up techniques and even modelling. Like you, they have their hopes and dreams and could welcome someone offering to photograph their hair and make-up designs, or help them to build a good portfolio, so collaboration is what this project is all about.

If you have taken good photographs of your friends, you can approach a local college running hairdressing or beauty courses, and see if the tutors would like to work with you.

Once you have found yourself a model, make-up artist and hair stylist, arrange a meeting to discuss the resources available to you, ideas for the look you would like to create and where and when you could shoot. You will need to be willing to listen to others' ideas as well as trying to promote your own, as this is an opportunity for them as well as for you.

When you come to the shoot, try to execute a couple of ideas really well (**10.34**), rather than lots in a hurry and badly. Try not to rush the make-up artist or ask the model to do twenty changes in an hour, for example. Above all, do not expect everyone to be a perfect fit in the team from the start: some people may drop out after a shoot or two, while new people may want to join. Some you will work with only once, others for the next twenty years.

10.34 Build up a team of models, make-up artists and stylists. Everybody can benefit from making great portfolio pictures and the costs can be shared. Bettina Strenske took this picture.

Feedback

When you have a team that enjoys working with you and is learning from the experience, you are getting good prints for members' portfolios (possibly at your cost) and there are plenty of new ideas flowing from all of you, you will have completed this exercise. It is likely that you will also have a growing portfolio of professional-looking pictures. Keep your tutors and friends updated on what you are doing and let them make suggestions and help with ideas.

Exercise 3
A FAVOURITE ROOM

Resources

For this exercise you will need some sort of portable lighting (a hotshoe flash that you can use off-camera, for example) and a tripod. You will also need your workbook to make notes and add examples of the images that you take.

The Task and Extended Research

It is a good idea to start by using as your model a friend or relative you know well, and to photograph them in a room with which you are already familiar (**10.35**). This will help you to plan your image and decide whether to use ambient lighting, flash or mixed lighting, and what you wish the final image to say about your subject. Friends and relatives are also likely to be more patient if it takes you a while to set up and get the exposure correct.

Be sure to keep notes of your lighting and what you talked to your subject about during the shoot, for potential use in the future. This will help you when you have to work with people you have not met before and have only a short time to get your shot.

10.35 Most sitters feel more comfortable and relaxed in familiar surroundings. This can help you to achieve great portraits, such as this picture of a woman posing on her favourite chair for Nico Avelardi.

341

Getting Started

The brief is to take a portrait of someone in his or her favourite room, so that the room and its contents add to the final image as much as the mood and the lighting. Choosing a subject, visiting a home or office, and discussing the sitter's favourite room, and why it matters to him or her, is vital for this exercise.

Remember to find out what time of day the sunlight falls through the windows, and check to see if there is any other available and ambient light. If you have a tripod, think about how you can use mixed lighting, such as a warm tungsten lamp alongside your portable flash or daylight through the window.

Good planning may well involve sitting down with your subject and getting to know him or her one day, and photographing on another day. If you only meet your subject on the day of the shoot, it is still a very good idea to sit and talk for a while, before you take out your camera and set up your lights. Talk to your subject throughout the shoot, but, as noted above, be careful not to take pictures when he or she is talking back to you, as the mouth and face will be distorted.

Feedback

With a bit of practice and a few shoots with friends and relatives, this exercise can give you a workflow that you can use and develop over many years. Once you have had some successful results, try to arrange a sitting with a local, or maybe even national, celebrity.

Again, keep your tutors and friends updated on what you are doing and let them make suggestions and help with ideas. They may know someone interesting who would be willing to sit for you. Authors and businessmen and -women always need a good portrait, and sittings of family groups tend to sell well.

PHOTOJOURNALISM, REPORTAGE AND DOCUMENTARY PHOTOGRAPHY

In this chapter you will learn how to:

- Make successful photographs that grab the attention of a worldwide audience

- Develop your ideas into well-illustrated photo-stories

- Take photographs that document everyday life, and could interest future generations

11.0 (previous page) Ahmed Saleam was a sixty-three-year-old landmine-disposal worker from Western Sahara who had lost both his hands. As Robert Griffin photographed him, he explained, 'We removed the mines with no training. The only education we have in our work is our experience.'

11.1 (below) Good photojournalism tugs at our conscience and can sway public opinion. The award-winning film producer and photographer Fiona Lloyd-Davies took this poignant image of a mother feeding her malnourished child in Niamey Hospital in Niger.

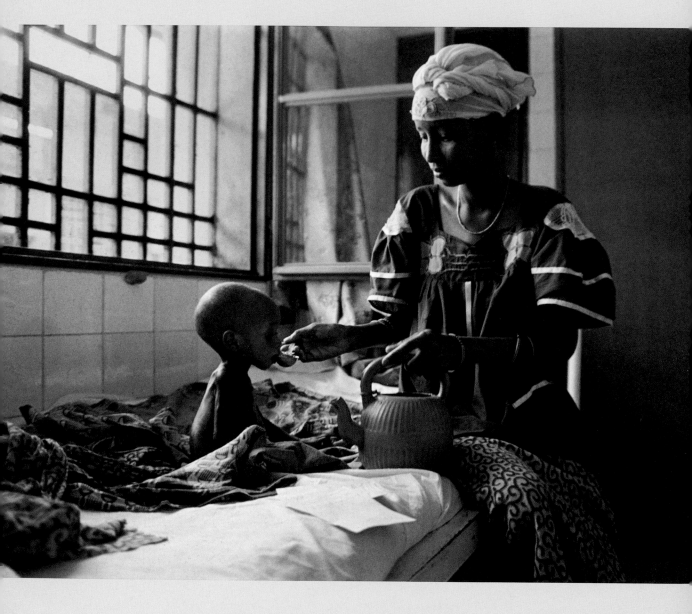

Photojournalism, Reportage and Documentary Photography Defined

There is considerable overlap between the terms photojournalism, reportage and documentary, so much so that the three are almost interchangeable. But while some people might want to debate complex and lengthy definitions, the following will suffice in outlining the fundamental distinctions between these sub-genres.

Photojournalism

Photojournalism is concerned primarily with recording current events through a single image or short series, destined for publication in newspapers, magazines, journals and the Internet. It has an innate immediacy that often means the photographer must travel to events around the world as they happen, to get pictures and stories out to the media (**11.1**).

In the past, the aim of the photojournalist was to record events objectively, but this is an area that has been strongly affected by changes in technology and in the way in which we receive our news. Objectivity still matters – images are rarely manipulated or retouched – but a photojournalist now has a far more complex role, and may well be expected to combine storytelling through still images with the skills of a journalist – researching and writing a story – and, increasingly, producing video.

This also raises one of the problems with being a photojournalist today: you cannot be everywhere at once. When any major news story occurs, it is very likely that within an hour, the worldwide media will be using amateur pictures and footage (at very little or no cost), while a photojournalist is still trying to buy a plane ticket.

Reportage Photography

While photojournalism is about communicating an event very succinctly, reportage is a more in-depth form of storytelling. The story covered may not necessarily be at the forefront of public interest, so reportage is less time-sensitive and more likely to concern an ongoing situation than a current newsworthy event. In the case of still images, reportage stories tend to appear as extended features in magazines and newspaper supplements.

11.2 Henry Taunt took this picture of Inglesham Roundhouse at the head of the River Thames in the 1860s. His motive was to promote his guidebooks and encourage the public to explore the river.

11.3 (opposite) Graham Diprose and Jeff Robins photographed from the same tripod spot some 140 years later, in the knowledge that their documentary image would be archived by English Heritage as a record for future generations.

As it is concerned with telling a more expansive story, reportage photography might involve a photographer spending much longer in a community to build relationships and understand the subject's point of view. If he or she is lucky, the photographer will have been commissioned to cover the story, although there is an increasing trend towards freelance photographers covering a story that interests them – often at their own expense – and then attempting to sell it once it is complete.

Reportage is also distinct from photojournalism in that the personal viewpoint of the photographer or commissioning editor may be more evident. The photographer's brief and target audience can change the style and content of the images, and this puts a responsibility on the photographer to exercise integrity when planning and shooting a story. It is relatively easy to mislead a viewer, or for the photographer to promote his or her own beliefs or agenda. Certainly, two photographers from different countries and cultures would be likely to take different images and produce distinctly different versions of the same story.

Documentary Photography

As the name implies, this sub-genre is about documenting a location, situation, event or scene. All photographs that record the events of today will, in time, become documentary photographs, in much the same way as we perceive photographs from the past (**11.2, 11.3**). A photograph of a family outside their home at the end of the nineteenth century may not necessarily have been taken with the future in mind – it might simply be a family snapshot, for example – but as they cease to be part of our present view of the world they become an important record of a frozen moment from history, giving us an insight into the past. Such photographs prompt a debate on what we choose to record and, most importantly, archive, as well as our motives for doing so: the very process of selection will 'edit' the history of our society that future audiences will see.

Photojournalism, Reportage and Documentary Photography: A Brief History

The gathering and presentation of news can be traced back to the messengers of ancient Greece and Rome, who used the spoken word to share details about such current events as battles, famine or disaster. Although the written word allowed for a long-term record to be produced, this was a lengthy process, so it is unsurprising that the tradition of news being delivered verbally – presumably with frequent omissions or embellishments – continued to the mid-fifteenth century and the advent of the printing press. The ability to reproduce many copies of printed documents at great speed led to the appearance of the first newspapers in the seventeenth century in central Europe. They spread across the continent, and then the globe, at a similar pace to the printing presses needed to produce them.

One item these early newspapers did not contain, however, was good-quality illustrations. This started to change when the *Illustrated London News*, published from 1842, became the first weekly paper to include pictures (up to thirty-two etchings from artists' sketches) in every issue (**11.4**). Part of the promotion for this venture was a large (6 × 3 ft) panoramic image of West London taken from a **daguerreotype** by M. Claudet and made in sections by eighteen engravers. Some of those engravers may also have played their part in one of the first true acts of photojournalism, when copies of Roger Fenton's pictures of the Crimean War were reproduced in the *Illustrated London News*. The ill-fated Charge of the Light Brigade in 1854 had led to increased public interest in the war and so, with the backing of the British government, Fenton visited the Crimea in 1855 to become, in effect, one of the earliest photojournalists. On the opposite side of the lines, Carol Szathmari – a Romanian painter and photographer – recorded events from the Russian point of view, though little of his work now survives and he remains less well known than Fenton.

Although the photographic technology of the time did not allow action photographs of battles in progress, Fenton's sensitive and bleak images were the first to document war as an 'event', with his *Valley of the Shadow of Death* (1855), littered with spent cannonballs, being a fine example (**11.5**).

Today, Fenton can be accused of posing, and possibly even constructing, his images of war, but no one should forget the impact these images had when they were exhibited in London and Paris upon his return. It was the fact that the *Illustrated London News* etchings were made from real photographs that marks these images as the beginnings of the genre, with the audience ready to accept that, unlike an artist, the camera could 'never lie'.

Yet while Fenton had been careful, given his patronage, to avoid corpses and mutilated bodies appearing in his photographs, Mathew Brady and his one-time assistant Timothy H. O'Sullivan were not so constrained when they photographed the American Civil War. Brady started as a portrait photographer, opening a gallery in New York in 1844, and another in Washington, D.C. in 1849, where he produced photographs of many army officers (George Custer among them) as war loomed.

11.4 From its first issue on 14 May 1842, the *Illustrated London News* was published weekly until 1971, and it only ceased publication in 2003. It is a remarkable historical document of the nineteenth and twentieth centuries.

11.5 Littered with cannonballs, *Valley of the Shadow of Death* was just one of more than 300 images of encampments, battle sites and soldiers of all ranks that Roger Fenton took during his assignment in the Crimea. With this undertaking, Fenton became the first photographer to document any war.

11.6 Timothy H. O'Sullivan was not the first photographer to portray death, but his images, such as *A Harvest of Death, The Field of Gettysburg, July 5th, 1863*, were among the first to reach and shock a general public largely used to more sanitized pictures of conflict.

11.7 'I don't know their names ... but I did hear someone call him "Pincus" ... so here they are right across the street from their burning tenement ... it looks like Pincus had time to grab a woman's dress ... his best coat ... but minus the pants.' Photo by Weegee.

11.8 (overleaf) Bert Hardy's *The Gorbals Boys* was taken in Glasgow around 1948. George Davis and his friend Leslie Mason were walking up Clelland Street on their way to the shops. The picture, syndicated worldwide, did much to highlight the plight of the children living in post-war slums.

In July 1861, Brady was invited to visit the front line and witness the Battle of Bull Run, where the Union army was heavily defeated (and Brady nearly captured). Following that event, Brady sent his assistant, O'Sullivan, and a group of photographers to photograph many of the major battles in the Civil War. Brady's team shot more than 10,000 plates during the war, and many of the resulting photographs were exhibited in his New York gallery rather than being published in newspapers. Brady fully expected the US government to reimburse the $100,000 he spent capturing the vivid pictures of death, but they only offered him a quarter of that figure. While Brady died penniless, many of the images from this period survive, providing us with a photographic record of key contemporary events. O'Sullivan's *A Harvest of Death, The Field of Gettysburg, July 5th, 1863* is among the most poignant (**11.6**).

War continued to provide a fertile subject for the photojournalist, but it is interesting that while there were photojournalists working in the trenches during the First World War, most images involving corpses and mutilation were censored at the time. A jingoistic 'comrades-in-arms' angle was far more likely to be welcomed at home, while the army chiefs were more comfortable with commissioning painters to depict the front line than with having photographers record the reality.

Technological advances had by this time also changed the nature of capturing and distributing images. The invention of dry plates in 1871 considerably increased the sensitivity of the emulsion, while flash powder (1887) allowed many more good pictures to be taken in low **ambient light**. By the end of the nineteenth century, printing technology had advanced to allow half-tone images to be printed on a high-speed newspaper-printing press, while research into the transmission of photographs by telegraph or telephone culminated in the launch of Associated Press's Wirephoto service in 1935.

Until these changes, photojournalists were expected to make pictures that were of exhibition quality, but would get to a picture desk in time for the next edition, so quality and speed were both paramount. The arrival of the first 35 mm Leica camera and flashbulbs in the mid-1920s started to allow photographers to capture successful images in adverse lighting conditions, but newsprint continued to reproduce black-and-white images poorly. This soon changed, however, as such magazines as *Life* (from 1936) began to print using fine screens on coated paper, giving superb reproduction.

Not all photojournalists adopted the small, portable and light Leica, though. Arthur Fellig, better known as Weegee, always used a large-format 5 × 4 in. camera and flashbulbs to record his images of crime, car crashes, injury and death in and around New York's Lower East Side during the 1930s and 1940s. Weegee often arrived on the scene before the authorities, and had a complete darkroom in the boot of his car that enabled him to sell his pictures to New York newspapers and picture agencies as soon as the print was fixed (**11.7**).

Although it was the dawn of photojournalism's golden age, the 1930s was also the era of the Great Depression and the rise in Europe of Hitler and Mussolini. Against this backdrop, Franklin D. Roosevelt set up the Farm Security Administration (FSA), an organization tasked with reducing America's rural poverty. Within the FSA was a small information division, led by a visionary director, Roy Stryker, who was charged with providing educational, press and public-relations material. To achieve this, a team of documentary photographers was hired, including Walker Evans, Dorothea Lange and Gordon Parks, whose work is today recognized as having redefined documentary photography and rediscovered a 'lost tribe' of Americans who never had any part of the American Dream.

11.9 Homer Sykes chose black and white for his book *Hunting with Hounds*. This seemed to bring an equality to the society huntsman and the more humble rat-catcher, in this study of the essence of rural life.

Although Kodachrome colour film (invented in 1935) would have been available to these FSA photographers, many of them – and those who followed after the Second World War – recognized the power and impact of black-and-white imaging. At the time, early colour film was also known to have a poor archival quality, so black and white was again the preferred choice for documentary images that needed to stand the test of time.

This view was endorsed after the Second World War by four seminal documentary photographers: Robert Capa, Henri Cartier-Bresson, George Rodger and David 'Chim' Seymour. Together, this quartet created the Magnum Picture Agency in 1947, and their philosophy of combining sharp visual reporting with creative artistry has survived to the present-day organization. Capa was the initial leader and was a photographer of extremely high standing. His photographs of the D-Day landings in Normandy in 1944 rank as some of the finest battle images ever taken, even though all but eleven of the negatives were accidentally melted by a technician at *Life* magazine.

The lives and work of all four of Magnum's founding fathers are well worth further research, as are others who later joined their ranks and worked for the magazines of the era, such as *Time* (1923–), *Life* (1936–2007), *Look* (1937–71), *Picture Post* (1938–57) and *Paris Match* (1949–).

In February 1962, the *Sunday Times* launched its first free colour supplement; it was soon followed by many competitors. Among the fashion and lifestyle features, many leading photojournalists of the second half of the twentieth century used these supplements to reach a wide audience.

Recent decades have not been short of violent conflict across the globe. It is hard to pick out the work of one or two photographers among so many who have risked (and sometimes lost) their lives to bring us images from the front line, but Don McCullin stands out for having produced images so powerful that the British government refused to allow him to cover the Falkland Islands conflict in 1982. McCullin's contemporary, Larry Burrows, took some of the most poignant images of the Vietnam War until his helicopter was shot down over Laos; more recently, Simon Norfolk's work in Afghanistan has combined the photojournalist's staple subject – war – with a classic documentary style.

War is not the only subject, however, and such photographers as Bert Hardy, Homer Sykes, Martin Parr and Daniel Meadows are also excellent sources of inspiration (**11.8, 11.9**).

The contemporary media – television, the Internet, newspapers and magazines – have an insatiable appetite for images. Yet at the same time, it is becoming more difficult to earn a living as a photojournalist or a reportage or documentary photographer. Unless you are willing to visit war zones or the poorest parts of the world, there is always someone on the scene before you when a story breaks, with a mobile phone ready to capture low-**resolution** stills or video of an event as it happens, often for no payment or indeed acknowledgment. Nevertheless, if you can write well, talk to camera, and shoot movies as well as stills, there remains a space for the professional photojournalist, although this is one area of photography where digital technology has, in many ways, made things harder rather than more straightforward.

Planning Your Assignment

There is an interesting contradiction in the fact that having an organized plan will give you greater freedom when shooting your photojournalism, reportage or documentary project. This planning should extend from the logistics of travel through to meeting the people involved, as well as ensuring that you are aware of and sensitive to any cultural or political issues surrounding the story. Make sure that you are properly equipped, and have backup camera options in case of equipment failure, especially if your project will be taking you to a remote region for an extended period of time.

Planning Your Assignment: Photojournalism

If you have never tried working in this genre, you should start with something simple, such as a local parade, carnival or sports event where there is nothing confrontational to worry about. You will still need to plan where to position yourself in relation to the light to get the best shots, and also decide what you want to say about the event, perhaps turning it into a narrative by covering the preparations and clearing-up as well as the event itself.

If you get some good shots, contact the local media straight away – even if they have their own photographer covering an event, they may be interested to see your images as well. Note the names of anyone who poses for you, and be sure to spell them correctly. Laws vary from country to country, but asking someone for his or her name, and mentioning that the picture might be published, will often count as obtaining permission to use the image. While the local media may not pay much for photographs they use, it is still good experience.

Very early on, you will find that you need a simple camera workflow so you can concentrate solely on your shots without having to stop and adjust the controls. This may involve returning to the Auto settings, but make sure that everything is set up and working properly before you start, with fresh batteries in the camera if necessary.

As you gain experience, set yourself increasingly challenging assignments, but always remember to research your subject carefully and write a brief that will help you clarify your intentions. Remember that you are telling a story in pictures, and list the sort of images that you will need; you may want some broad, scene-setting shots, as well as close-up pictures from the thick of the action. You need to decide where your sympathies lie: if you are photographing a demonstration, for example, do you agree more with the protesters or the authorities confronting them? You should also consider the target audience for your images, as this could well alter your perspective on the story.

Sometimes the best shots of street confrontations come from behind the police lines, and introducing yourself to one of the officers in authority beforehand can help to keep you

Official Photographer

With any local event, find out who is organizing it and contact him or her beforehand. The organizers may be happy to make you their official photographer, allowing you backstage access or a better vantage point in return for pictures or coverage in a local paper.

Personal Safety

On any photojournalism assignment you should always consider your personal safety, especially in a potentially confrontational situation. In a demonstration, for example, protesters may believe that you are on the side of the police and photographing them to single them out for later arrest, while the authorities may assume that you are looking for an 'anti-establishment' angle and try to suppress your pictures.

Paparazzi Style

A surprisingly challenging exercise for budding photojournalists is to wait at the stage door of a theatre to try and get some paparazzi-style shots of famous actors, sports people, politicians or bands. Have your camera set up beforehand and call your celebrity by his or her first name – most people will usually turn round and look at you when their name is called. Tell the celebrity how great he or she looks and ask him or her to stop for a couple of shots. You'll be surprised how often people can be swayed by vanity and you'll get a great VIP picture.

11.10 Starving in sight of plenty. There is no need to travel to foreign lands to shoot such scenes as this one by Olin Brannigan. By stopping and talking to people on the streets, and offering a few coins, you may well get a very strong picture.

out of trouble with them. You should also be sure to e-mail or call the police if you intend to photograph a parade that includes prominent political or religious figures, especially if you plan to use a long lens from a balcony or roof.

In addition to photographs, make plenty of notes, using a dictaphone or your mobile phone to record details about the event so that you can write up your story accurately, while it is still fresh in your mind. In the same way that you study the work of a photojournalist in a newspaper, it is worth looking at the style of written coverage that accompanies the image because, increasingly, the photographer will be expected to supply words as well as pictures. Even if your early projects are only for your own practice, think of the pictures and text as two parts of the same final product, and show them to others for their comments.

Whether you are hoping to enrol on a college course or get some freelance work published, you should try to put together a varied portfolio that contains a mix of feel-good stories and harder-hitting events (**11.10**).

Planning Your Assignment: Reportage

Reportage assignments involve covering a story in great depth, often over a long period of time, so while much of the planning advice mentioned above is relevant, the research and arrangements can take significantly longer and will be far more complex. Whether you intend to work with a local campaigning group or try to break into a more closed organization or society, gaining people's confidence and trust will be vital (**11.11**). This can take time, and you may need to go to many meetings and listen and talk to people before you can bring along your camera and start work. This will also help you to develop the story through a deeper understanding of your subjects' views, concerns or agenda. Setting up a contact person at your intended location can be very important. Preferably this will be someone who has access to the organization or people that you wish to cover. This is essential if there are differences between you and your intended subject in terms of language, culture and customs, or you think there may be problems with transport, security or accommodation. A good contact can be just as important in parts of your own country as abroad.

If you are planning to travel or take a gap year, then you may be able to combine pleasure with the business of setting yourself reportage briefs in the countries that you are visiting. As always, detailed planning is vital, and in some places you may need to be careful about shooting 'in-depth' projects while travelling on a tourist visa. You should also make sure that you have all relevant permissions, try not to work and travel alone, and let people know where you are going and what time you will report back that you are finished and safe. Obviously, if you travel in a war zone, or areas of any country that has security issues, you will be putting yourself at much greater risk (**11.12**). Most media companies now ensure that their reporters are sent on a 'hostile environment' course as a precaution, although such courses are very expensive and beyond the budget of most freelance photojournalists. Even in countries that are generally regarded as safe, journalists and photographers are considered as targets by some extreme organizations.

In preparing any story, whether at home or abroad, a reportage photographer will face moral dilemmas. The most obvious is that the images he or she takes or selects during editing can be used to lend strength to a particular argument or cause. This may be part of an editor's brief, or the photographer's own agenda, but it could just as easily weaken what is intended as an unbiased story. In the event of your witnessing a road accident or seeing a child injured in a war zone, the greatest dilemma is whether you take your pictures first, or help immediately.

Making Contact with Editors

Contemporary reportage photography is unlikely to be commissioned, no matter how good the idea. However, it is still worth while contacting the feature editors of suitable newspapers and magazines before you start. They will often agree to take a look at your project when it is completed, or they may provide suggestions that would make it more marketable to them and give you an idea of what they might pay.

Using Compact Cameras

A high-end compact camera that is capable of shooting high-resolution stills and high-definition digital video will be light enough to slip into a backpack or pocket, and is unlikely to attract the interest of authorities and criminals. It can be used as a backup to your digital **SLR**, or in situations where carrying a large camera kit could cause problems.

Press Pass

In many parts of the world, some form of press pass can be vital, although having 'journalist' or 'photographer' listed as your profession can also work against you. Having a stamp from certain countries in your passport will ensure that you are excluded from, or even arrested in, others; sometimes you can ask for a stamp or visa on a separate sheet.

11.11 (right) Nuclear power stations tend to be a little sceptical of photographers asking if they can come round and take pictures, but with a good outline of his idea and how it might be used, Steve Franck was able to gain access and assistance from the management of Dungeness Power Station, Kent.

11.12 (below) A child's toy gun or a real one? Photojournalist Tolga Akmen faced this question in a dangerous town in eastern Turkey when he was greeted by this small boy. Luckily, it turned out to be a toy.

Planning Your Assignment: Documentary

Documentary photography covers a wide range of topics, as the camera is the ideal medium for recording any event, whether in your own life, your community or on a national or international scale. Your personal choice over the moments in history you record, the image content and the context of how you and your audience relate to your chosen topic are all points to consider, but the key element of all documentary photography is a strong idea. In many areas of documentary photography you will work across the boundaries of pre-defined genres: Walker Evans's photographs, for example, are often seen as beautiful portraits, yet their stronger context is as a document of the human condition in the American 'dust bowl' of the 1930s.

All documentary photography needs an audience, which might be for an exhibition, a book or a website. A local museum may want to have modern aspects of town or city life archived for future generations, and a context that may appear mundane and everyday to you could have a totally different meaning for viewers in fifty years' time.

'Then-and-now' images are always popular, and many local libraries, museums and websites have collections of such photographs that can be a good starting point. All you have to do is try to identify the exact spot in your town or city where a photograph was taken, match the **focal length**, and produce a contemporary version of the historic scene. This may well involve people at work as well as architecture and, if a near-empty street from a hundred years ago is now choked with cars and buses, that should be what you record (**11.13, 11.14**).

Museums and local councils may agree to support your project, possibly even helping you put on an exhibition of your 'then-and-now' images in a gallery, town hall or library. What they are very unlikely to do is to offer you any money for all your hard work, but if you have a strong idea that is well planned, a larger local company may be willing to provide sponsorship, particularly if it knows there is going to be an exhibition and publicity.

Photographic companies are also unlikely to provide you with monetary funding for documentary projects, but they may be willing to lend you camera kit or supply printing materials in return for their logo appearing on all the publicity material and an invitation to any opening event. Building long-term relationships with your suppliers can be invaluable for future projects, and cash sponsors are always impressed if an international photographic company is involved.

Exposure Times

Many of the early documentary photographers shot with long exposures: people and horses move only very slowly, while reflections in water are smoothed out and enhanced. If you shoot with an exposure of one second, you can match this technique and also create a better sense of the pace of movement in today's streets.

Approaching Sponsors

If you are approaching a sponsor, always ask for a sum that you consider represents the value of the sponsor's name being attached to your project, rather than costing out your materials, time and fee. If your project is likely to attract a lot of publicity and interest, it is worth more money, regardless of the actual costs involved. Once you have determined your figure, produce a proposal that clearly outlines the benefits of sponsoring your project, as well as any publicity and promotion that is already in place.

High-Resolution Images

A century ago, photographers shot on large-format negatives, so you may want to borrow a high-resolution digital camera to avoid the possibility of their old pictures being sharper and more detailed than your contemporary images.

11.13 Oxford High Street may well have appeared bustling to Henry Taunt in 1896, but even with an exposure time of around half a second, the horse-drawn tram is pin-sharp. To take this view, Taunt simply walked out of the front of his shop at number 34 and set up his camera.

11.14 The same view in summer 2000, showing how the speed of life has changed. Jeff Robins and Graham Diprose decided to use a similar shutter speed to Taunt's to capture the movement in this busy city-centre scene.

Self-Publishing

There are a number of websites that will enable you to design and self-publish a book of your project (**11.15**). This is a professional-looking way to show a big project as part of your portfolio, or to encourage a gallery to exhibit your work or a sponsor to fund it.

Whether you are looking to entice sponsors or simply clarify the aims of your project, it can help to write a rationale. This does not have to be an extensive document – just 500–1000 words – but it will set out the background and context of the project, the idea itself, the method you plan to employ, a timeline (if applicable), your intended audience, and your proposed output, be it a book, exhibition or website. Some of this will be nothing more than a wish list, with time and/or money possibly limiting some of your intentions, but a well-written rationale can draw publishers, galleries and potential sponsors into taking an interest in your work.

Practical Skills

Anyone thinking of pursuing a career in photojournalism or reportage photography so he or she does not have to learn about studio equipment and lighting needs to think again. While a still-life photographer can always reshoot a picture, and a portrait or fashion shoot is likely to involve dozens of very similar images being taken with a view to the best one being chosen, photojournalism and reportage involve just one moment in time, so you need to be completely familiar with how your equipment works so that you can react instantly to any situation. Such techniques as fill-in flash need to be practised until they are instinctive, and it is essential that you understand when to use **auto-focus** and when setting the focus manually will be quicker. In addition, a photojournalist needs to have total control over such basics as the **ISO** and focal length for any given situation, as well as knowledge of **depth of field** and the best lens aperture. You will also need to be ready for unusual lighting conditions – not just **fluorescent**, but also the mercury vapour and sodium types that are often found in sports halls and other venues – and knowing how to set a custom **white balance**, both quickly and accurately, is essential.

Being fully conversant with flash is yet another skill that you will need to master as a photojournalist, so that you understand how to use bounce and diffused flash to take good portraits in awkward 'press conference' situations. The techniques may have been described elsewhere, but a photojournalist or reportage photographer must have instinctive control of all of them, which means you need to practise over and over until you feel confident enough to face any situation (**11.16**). Whenever you feel that you have struggled to get a good shot, try to work out what you could have done differently or better.

11.15 (opposite) New digital printing technology makes it possible to self-publish beautiful hardback books, either singly or as a short run of ten or fifty copies, which opens up new opportunities for photographers. Graham Goldwater used an online company to make this professional-looking book.

11.16 (below) Tolga Akmen needed permission from the Turkish Ministry of Justice to gain access to this prison. He also needed all his technical skills to take this great image of a sad-eyed old prisoner in a very difficult mixture of lighting.

Black Velvet

Always carry a piece of black velvet in your kit. This can be thrown over a busy backdrop (such as unwanted sponsor logos if you are photographing sports personalities after a match or contest) to make a simple portrait shot that does not require retouching.

11.17 In 1942, the Japanese army used small birds to carry anthrax into Zhejiang province, China. Fiona Lloyd-Davies met Tang (and her brother-in-law), who was seven when she was infected and woke up bleeding from her mouth. Doctors cut the skin off her face to save her life. Research is vital to help you understand the lives of people in different cultures.

The main reason that you need to master all of the techniques noted previously is that, at the same time as setting up all your kit, you will also need to be communicating with people around you and be aware of any changing situation that might be about to make your job much easier or considerably more difficult and confrontational. Put simply, operating the camera should be secondary to being aware of your surroundings and ready to take a shot, no matter what the circumstances.

In addition, the days when a photojournalist took the pictures and a fellow journalist wrote down the names and conducted interviews are disappearing fast. You will now either need to be a journalist who also takes pictures, or a photographer who writes the captions and stories; and, in many cases, you will also need to be confident enough to shoot video footage – and to do all this in situations where a reshoot is highly unlikely.

As a result, photojournalism and reportage photography require the most complex set of skills in contemporary professional practice. But they can also offer the most rewarding opportunities, allowing you to communicate across cultures and continents and to create images that can help shape public awareness and opinion (**11.17**).

Exercise 1

A GRAND DAY OUT

Resources

This is a very simple 'getting started' exercise, so all you need is your camera, a flash (if available) for **fill-in lighting**, and a range of focal lengths (either a **zoom lens** or a selection of **prime lenses**). You will also need your workbook to make notes and add examples.

The Task and Extended Research

Research a local parade, fun day, fair or similar event. Find out who the organizers are and contact them, offering to let them have some pictures of the day. They are unlikely to say no, and even if they already have an 'official' photographer, they will probably be willing to help you with your exercise.

Depending on the event, plan the type of shots that could tell the story: the stalls, the characters, people laughing and having fun, and so on (**11.18**). Your task is to shoot ten or twelve pictures that capture the atmosphere of the event and are backed up with captions, the names of the people in your pictures and anything about them that you were able to find out. This is the hardest part, because if you are self-conscious and try to sneak pictures from a distance, you will not get the information you need; but if you talk to people and get them posing for you for fun, you can have a great shoot.

11.18 A low camera angle and enthusiastic subjects in this picture by Nico Avelardi give you some idea of how a small-scale local event can produce some great images for your portfolio.

Getting Started

This exercise requires you to approach strangers, ask them to pose and collect their names, e-mail addresses and even a few details about them that you can use to write a brief caption. If you go into this project with a positive mindset, it will be easy, but if you feel shy or negative, it may be nearly impossible.

Think of a few good opening lines to engage people, and do not be disheartened if some ignore you or are rude. If you are taking some attractive pictures with a digital camera, you can always show them to your subjects to get their names and e-mail addresses so you can send the images on. Some people will probably tell you a bit more about themselves and you can use this information to write your caption. Do not forget to send them any pictures you have promised to share with them, and also to ask if they mind the pictures being used in your portfolio or published anywhere.

Feedback

Arrange your best pictures in a sequence that helps to tell the overall story of the event, with a very strong image at the beginning and a fun one at the end, and show them to your friends or tutors to see how well they think you have told the story. If you did not spot any local press photographers at the event, it may also be worth while going to your local newspaper office and showing them your pictures and captions. They may not pay you much, but this could become your first published work.

Exercise 2

THE LOCAL PROTESTERS

Resources

This is a more in-depth project, where getting to know your subjects and earning their trust is more important (**11.19**). You will need camera equipment that allows you to shoot in difficult lighting conditions, often where flash is not allowed or would be disruptive. A tripod might be useful, but may also look overly formal.

The Task and Extended Research

Research local newspapers and council meetings to find out who is objecting to what in your local area, and when you find an interesting story, get in touch with the protagonists. You may well find that you can get a better idea of their story by researching these people or organizations online and, while you do not have to sympathize with their cause, it will generally help if you do. You will then need to get yourself fully briefed on the campaign, the people involved and their roles, and also the other side of the argument.

You are looking for a series of pictures that will tell the story of the protesters' campaign and will hopefully help them to make their case. At every stage you should keep notes or make recordings and write them up so you have all the information to hand when

you come to put the final story together. If you have to join an organization and let them use your photographs, so be it, but be careful not to get drawn in if you discover any dark and worrying secrets.

The campaign may last for weeks or even months, so be aware that this exercise might remain a work in progress for some time. Because of this, the size and design of your final output is not something you can plan while the story is still ongoing.

Getting Started

This exercise is about telling a story through both images and words. To be successful, you will need to be able to write about the campaign as well as take the pictures. You must ensure that you have everyone's name and role recorded correctly and spelt accurately, whether for a caption or a longer article. You may also have to decide how far to side with one group and to consider what you would have done if you had been commissioned to cover the story from the opposition's viewpoint.

There is a mistaken view that photojournalism means waiting for something to happen in front of your lens. While there will, of course, be spontaneous events, much of the time you should plan a 'shooting script' of images that would be useful to take to cover the story and make the argument.

In this way you avoid allowing yourself to be distracted and ending up with a lot of disjointed images that do not work well together. If you do find something unexpected, shoot that by all means, but make sure you finish the story you started before covering any new one.

Feedback

This is a very good project to discuss with friends and tutors, both in terms of the protest and any difficult issues that it throws up, and also with regard to how well you are recording and communicating the event through your camera and words. Very occasionally, the regional or national media will pick up a local issue and, if that happens to you, be sure that you are ready with your pictures and story.

11.19 It is quite remarkable that Henrietta Williams was able to gain the confidence of the men of this Belfast Orange Order Lodge and take a series of intimate pictures of their activities.

Exercise 3

THE LOST WORLD

The Task and Extended Research

Wherever you live, it is likely that a short distance from your home there is a 'lost world', whether it is an old railway line or quarry, for instance, or an abandoned military base. Your project is to document everything that remains of your chosen site for posterity, in case there is a move either to preserve what remains, or to remove it (**11.20**).

Be sure to obtain any necessary permissions to visit the site and to take pictures, as it is better to befriend the owners and knowledgeable locals than to be caught trespassing. An ability to engage with older generations and take the time to listen to them reminiscing about the site could prove invaluable in your research, and if they are willing, you could record your interviews as supplementary oral histories.

Getting Started

Visit local libraries and museums to see if they hold any useful information or old photographs of your site. If they will let you make copies of any images they hold in their archives, and you can work out the camera angle and lens used, then you have the opportunity to produce some fascinating 'then-and-now' photographs. You might even find that the local museum would be willing to include your pictures in their archive. This may not necessarily be for a payment, but it is a good start. Document and keep a diary of the project, and get a friend to take pictures of you as you work.

11.20 Graham Diprose documented a number of sites where the Wey and Arun Canal, in Surrey and Sussex, was being restored. These images provide 'before and after' views of the works.

ALTERED IMAGES

In this chapter you will learn how to:

- Apply the theoretical and practical advice in this book to your own experiments in image-making, inspired by some of the ideas in this chapter
- Recognize that many of the great masters of photography would allow themselves time away from their regular work to experiment
- Control the technical side of a new approach, however outlandish, so that it is repeatable and can be honed to perfection

Experimental Photography

No matter which genre they were working in, many of the great masters of photography had a playful side, and they would often experiment with new techniques. Occasionally, as in the case of Richard Avedon's 1967 solarized portraits of the Beatles (**12.1**), these images have subsequently become some of the photographer's best-known works.

'Playtime' is a word that is often frowned on in an academic or professional environment, but this book should give you the confidence to experiment with original ideas, possibly outside your usual genre or style, and not only learn from your inevitable mistakes and failures, but also enjoy your exciting successes.

This final chapter contains a number of ideas for altering photographic images using silver-based and digital techniques, or a combination of the two – many of which have been developed by the authors and their alumni. This is not a definitive list of techniques, but a broad range of ideas that you might like to try out for yourself. Hopefully they will inspire you to be playful in your own image-making and devise some new methods of your own.

12.0 (p. 369) The head shot began as a film colour slide from a fashion show. This was then scanned, manipulated and superimposed onto a photo of a drawing that Pamela Ossola had made in her sketchbook. The image was then pitched as an illustration for a rock band's CD cover.

12.1 (opposite) The Beatles, London, 11 August 1967. Photos by Richard Avedon.

Silver-Based Techniques

Photograms 1

Photograms are normally made by placing objects onto a sheet of photographic paper on the enlarger baseboard (see p. 101). For a series of book illustrations entitled *Intangibility of Time*, Pamela Ossola found some old sheets of 25 × 20 cm (10 × 8 in.) black-and-white film that she could use under a brown or red safelight. She made copies of old photographs and her own images onto the film to produce a positive image, sometimes printing the positive image onto another piece of film to reverse it once again. She then used this mix of positive and negative film images to create her photograms, printing them onto photographic paper or art paper coated with **liquid emulsion**. To add an extra dimension, the film was not always laid flat on the paper, so parts of the picture would drift out of focus (**12.2–12.5**).

12.2–12.5 Four photograms made using images on film (both in and out of focus) printed onto art paper coated in liquid emulsion. These form part of Pamela Ossola's series *Intangibility of Time*.

Photograms 2

The ideal exposure time for a photogram made in the darkroom is around 10 seconds or longer, but when Devin Louttit wanted to make a photogram of his goldfish in a bowl, the immediate problem was that the fish would not remain still long enough. So he replaced the enlarger with a small flash unit, placing the goldfish bowl on top of the photographic paper and waiting until the fish were fairly close to the bottom. The safelight allowed him to choose the best arrangement of the fish before firing off the flash, which he held about two feet above the bowl (**12.6**).

Having established that he did not need an enlarger to make a photogram, Devin stuck four sheets of 10 × 8 in. printing paper to his (darkened) bedroom wall and waited for his cat to sit in front of them. He then fired his flash from the opposite side of the room to create a life-sized photogram (**12.7**).

12.6 (right) Devin Louttit's photogram of his goldfish bowl.

12.7 (left) Devin Louttit's photogram of his cat.

Peppercams

12.8 (below) One of Scarlett Pimlott Brown's 'Peppercam' pictures.

12.9 (below right) A 'Veggicam' picture by Scarlett Pimlott Brown, made using a pinhole pumpkin.

Pinhole cameras are nothing new: they range from beautiful mahogany-and-brass examples to simple devices made at home from a shoebox or biscuit tin. Scarlett Pimlott Brown decided to go down a very unconventional route with her camera, and cut a small slit in the back of a hollowed-out pumpkin so she could slip in a sheet of photographic paper, with a pinhole lens opposite. The results were interesting, particularly as the slightly acidic pumpkin juice soaked into the paper in places, which tended to retard the alkali developer.

From pumpkins, Scarlett moved on to peppers, and the 'Peppercam' was born (**12.8, 12.9**). Some light leaks through the skin of the pepper to introduce strange patterns and textures to the image. Other 'Veggicams' are currently in production, including living ones that will take pictures while they are still attached to the plant, recording a pinhole image over time.

12.10 (opposite, above) Lomographer Julija Svetlova's double exposure of pigeons on a pavement and floral wallpaper.

12.11 (opposite, below) Julija Svetlova's Coloursplash exposure technique.

Lomo Coloursplash Double Exposures

The 'Lomographer' Julija Svetlova has perfected the technique of reloading a 35 mm film to make double exposures that produce beautiful 'happy accidents', and has also found a way of using her Lomo Coloursplash camera to create a double-exposure look for an image that is shot in one go.

The key to this is the Coloursplash's Day and Night settings. The Night setting forces the camera to use a long **shutter speed**, which can be controlled by keeping your finger on the shutter-release button. Julija will find a suitable night subject, such as an illuminated building, and press the shutter to make the exposure for this scene. She then places her hand over the lens and finds a friend or another suitable subject and releases the shutter-release button. A colourful flash goes off, effectively creating a second exposure on the same frame.

Hybrid Techniques

Silicon to Silver

A popular workflow is to shoot on film, scan the slides or negatives into the computer and then manipulate them in Adobe Photoshop before printing them digitally. Pamela Ossola and Graham Diprose experimented with reversing that process.

This simple idea started with a digitally captured portrait of a graphic designer, whose typographic work had been projected (again digitally) onto her face (**12.12**). The digital file was prepared with slightly lower contrast than normal, and printed onto A3 paper using an **ink-jet** printer. The print was then copied onto 5 × 4 in. black-and-white sheet film (although any smaller format would have produced a good result), which was printed in the darkroom onto heavyweight art paper that had been coated with **liquid emulsion** (**12.13**).

12.12 (right) Graham Diprose and Pamela Ossola began by making a portrait with some of the model's design work projected onto her face. This was shot digitally, in colour, but it also worked well in black and white.

12.13 (centre) A colour print was made from the digital file and copied onto large-format black-and-white sheet film, without any filters. This negative was then printed onto fine art paper coated with liquid emulsion to make this version of the portrait.

12.14 (far right) Working from the original digital colour print, they used a hybrid technique using a mixture of the darkroom and Adobe Photoshop to make a full-colour 'liquid-emulsion' image.

> **Drying and Washing Times**
>
> Liquid emulsion needs at least four hours to dry between coating and use. After development and fixing, a very thorough wash of about one hour is required, as the thick art paper soaks up a lot of chemicals. Since the brush effect will be different on every print, it can be a good idea to make a few prints so that you can choose the best as your final image.

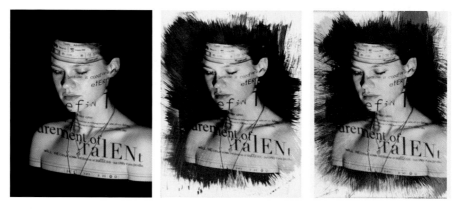

The next stage of this project grew from someone commenting that it was a shame that liquid-emulsion images could not be made in colour. This led to a number of darkroom-based and digital experiments (**12.14**), with the most successful results achieved using a set of Kodak Wratten 'colour-separation filters' that consisted of a narrow-cut (very pure) red tricolour filter (no. 25), a blue tricolour filter (no. 47B) and a green tricolour filter (no. 58).

The first step is to make a colour ink-jet print from a digital photograph, preferably on matt paper and with slightly reduced contrast to retain highlight and shadow detail. This print is copied three times onto black-and-white **panchromatic** film, first through the red tricolour filter, then through the green filter and finally through the blue filter. It is important that the camera remains the same distance from the print for each shot.

Each of these filtered images is then printed onto a sheet of A3 art paper coated with liquid emulsion; mark up each sheet with an R, G or B in pencil so that you know which filter was used in the creation of the negative (**12.16–12.18**). Once your three liquid-emulsion prints have dried, they need to be held down so they are as flat as possible, and then copied using a digital camera. It helps if you write three labels – red, green and blue – to place beside each print so that they are clearly identified at the next stage. The alignment of each print is not important, but you should not change the print-to-camera distance between frames.

The final stage is to take your digital files and combine them in Photoshop, 'colourizing' each filtered image with its opposite colour: the red-filtered image is colourized cyan; the green image colourized magenta; and the blue image yellow. These three images – cyan, magenta and yellow – can then be layered on top of each other, aligned, and the blending mode set to Multiply to create a full-colour, liquid-emulsion image (**12.19**). Any minor colour adjustments can be made at this point.

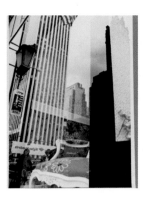

12.15 (above) Reflections in a shop window that Pamela Ossola photographed in New York.

12.16 (right) A liquid-emulsion print from a black-and-white negative shot through a no. 25 red filter.

12.17 (centre) A liquid-emulsion print made from a negative shot through a no. 58 green filter.

12.18 (below right) The final liquid-emulsion print, this time from a black-and-white negative shot through a no. 47B blue filter.

12.19 (far right) After Pamela had copied each liquid-emulsion print digitally, the new images were colourized and layered, resulting in this full-colour 'liquid emulsion' image of the shop window.

Exposure Settings

If your film camera has a built-in exposure meter, it should take account of the different density of the three colour-separation filters. On cameras without a built-in exposure meter, increase the exposure by $1\frac{1}{2}$ stops for the 25 red filter, $2\frac{1}{2}$ stops for the 58 green and 3 stops for the 47B blue.

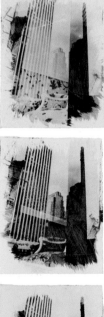

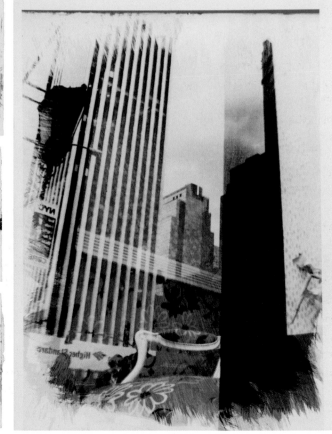

An Alternative Technique

Experiments were also made to see if we could produce a traditional, darkroom-based liquid-emulsion colour print using the Kodachrome processing principle of making colour dyes in each layer in turn. This involved printing a 'red' negative onto a sheet of art paper coated in liquid emulsion, and then using cyan dye-couplers and a colour developer to process the image. When this had been processed and dried, the same sheet of paper was coated with another layer of liquid emulsion and printed from the 'green' negative, this time using magenta colour couplers in another colour-developer bath. The process was then repeated a third time using the 'blue negative' and a yellow colour developer. Although this resulted in what could nominally be described as a colour image (**12.20**), there was no control over the accuracy of the colour, which led to the idea being abandoned.

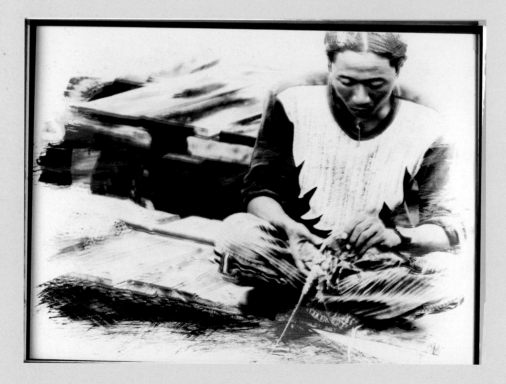

12.20 A purely darkroom-based approach to creating 'coloured' liquid emulsion did not produce colours that were in any way close to the original, or controllable, but it still makes for an interesting image in its own right.

Rainbow Clouds, Seascapes or Dancers

The following technique is not new, but it makes use of the tricolour filters and colour separation described above to produce a very attractive result for minimum effort. If you are using a film camera, place it on a sturdy tripod and shoot a 'triple exposure' using the red, green and blue filters respectively. Anything that does not move between your frames being recorded should be the correct colour (as the three **channels** are reassembled), but anything that moves position between exposures – such as clouds in the sky, choppy water in a lake, waves at the seaside, and so on – will come out as bright yellow, magenta or cyan, depending on the filter being used. The precise nature of the result is determined by how far things move in your picture and the time you allow to elapse between each exposure (**12.21**).

If your film camera cannot shoot **multiple exposures**, you can instead shoot three separate frames (ideally on slide film), one through each filter, then scan and layer them in a single Photoshop file, setting the blending mode of each **layer** to Multiply. The same technique of shooting three separate exposures and assembling them in Photoshop can also be used for digital cameras, and will allow you to make minor colour adjustments to fine-tune the 'full-colour' areas of the image.

In the example shown here (**12.22**), a dancer in a white leotard was photographed against a black background, with red, green and blue filters used to produce three exposures on a single frame. Areas of the model's leotard that have been exposed onto the film through all three filters appear white, while any areas that have moved between shots appear blue, green or red when exposed through a single filter, or yellow, magenta or cyan when they have been recorded by two filtered exposures.

12.21 People walking on a jetty gave Graham Diprose a great opportunity to try out this technique of triple exposure through tricolour filters. The rainbow rippling waves were an added bonus.

12.22 The studio environment helped Graham Diprose deal with the added complexity of shooting the tricolour-filter technique as a multiple exposure, directly onto transparency film.

High-Resolution 3D Images

The idea of shooting two images from slightly different angles to replicate human vision and create a 'three-dimensional' image is not new: such photographs, known as stereograms, were popular in the late nineteenth century, and had a resurgence in the 1950s. The images from the latter period were different, though, as one image was photographed through a red filter and the other through a green or cyan filter, and they were not viewed side by side in the same way as earlier stereograms. Instead, the image pairs were viewed through 3D glasses with lenses that were the same colour as the filters, resulting in an image that 'leapt' from the page and became popular for everything from B-movies to children's books and comics (**12.23**).

Having two high-**resolution** Leaf Aptus cameras to hand, and the red and green separation filters from the previous exercises to place over the lens of each, Pamela Ossola and Graham Diprose decided to see what effect resolution would have on digital 3D images. The cameras were placed roughly five inches apart to simulate human eyes, using lenses with identical **focal lengths**, and were set up to shoot a colour image at the same time.

One camera was fitted with a red filter, and the other had a green filter over the lens, and for every ten portraits that were taken by the paired cameras, a blank frame was shot to ensure that the pairs of red- and green-filtered images would be easier to identify. After the shoot, the image pairs were assembled in Adobe Photoshop, aligned around a central point and with the Layer blending mode set to Multiply.

Our conclusion was that the higher the resolution of the digital files, the more readily the brain is fooled into seeing a 3D image, whether it is seen as a print, viewed on a computer screen or displayed using a digital projector.

We later experimented with red and cyan anaglyph imaging – the kind that requires 3D glasses when viewed – using a strong cyan gel instead of a green filter, and it was noticeable that, being 'opposite' colours, red and cyan gave a stronger 3D impression, although the flesh tones were a little cool (**12.24**).

It is possible to use special software to combine these images in the form of a print and then overlay a lenticular screen (one with a specially moulded surface that gives the illusion of depth) to produce a full-colour image that does not require glasses to be viewed in 3D.

12.23 If you can find a couple of pieces of red and green filter, you should be able to see this portrait in 3D.

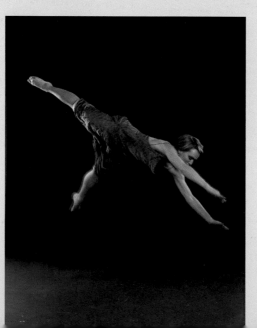

12.24 This 3D action shot of dancer Martina Langmann was not easy for Graham Diprose to shoot. The shutter on one camera was opened as she began to jump, and at the peak of the jump, the second camera (synched to the flash was fired), exposing both images at once. You can view the 3D result using red and cyan filters held over your eyes.

12.25 Using a redundant scanning camera back and moving the model during the 20-second exposure, Jeff Robins and Graham Diprose achieved this homage to Dalí with no post-capture image manipulation.

A New Life for Old Kit

It is amazing how expensive digital equipment from as little as ten years ago is consigned to the scrap heap. This section is designed to inspire you to look out for shops or studios that are having a clearout, or to keep an eye open for old digital cameras in car-boot sales and charity shops.

In the mid-1990s, digital cameras were in their infancy, but several companies began to make digital scanning backs that would fit onto a medium- or large-format camera and allow an electronic image to be recorded. In these very early stages, these backs allowed files of around 60Mb to be captured using the photographer's existing equipment, while saving the cost and time of film and processing. The downside was the 10- to 15-minute exposure time needed to perform a 'scan' with the digital back (acceptable for still life, but not much else), and the very high price. Less than a decade later, single-shot digital sensors had become good enough to consign this expensive kit to the back of the studio cupboard, and today we have digital **SLRs** that achieve similar results for a fraction of the price. Recently, however, the authors decided to get an old digital back out to see if it still worked, not with the 20-minute scan, but with the 20-second pre-scan. Because the pre-scan image is made up of either horizontal or vertical scan lines, it is possible to shoot images that show interesting distortions if the subject moves during the exposure. If a model moves during a scan, for example, you will see elongated or distorted limbs, rather like a Salvador Dalí painting (**12.25**).

12.26 (opposite, above) Graham Diprose shot this portrait using a Wratten 25 red filter. The result, from a Leaf 6 digital back, is not retouched.

12.27 (opposite, below left) A 'black' Wratten 87 filter will expose the sensor only to pure infrared. This portrait, by Graham Diprose, used a 10-sec. exposure, although the 'film grain' effect of the sensor noise owes more to luck than judgment.

12.28 (opposite, below right) This image from an early digital camera back gives the appearance of light 'dripping' down the sensor: it is unlikely that a similar effect could be achieved using modern equipment.

12.29 (below right) Jeff Robins used Adobe Photoshop layers to combine a range of images shot from different angles to create this powerful image of HMS Belfast.

The effects that can be achieved with older cameras are not just limited to the distortions recorded using a scanning camera back. All digital-imaging **sensors** are sensitive to **ultraviolet** and **infrared** light, but early cameras used an expensive filter over the lens, rather than a filter in front of the sensor, and without this filter in place, these cameras can take stunning infrared photographs with no manipulation (**12.26, 12.27**).

Similar results can be achieved if you can obtain an old digital camera that has little or no value and remove the cyan-coloured infrared filter in front of the sensor. Although this will modify the camera irreversibly, some very interesting images can be produced. Leaves on trees make very successful subjects, and on a sunny day you may be able to work at **ISO** 400 with the aperture wide open, as it is the invisible infrared wavelengths of light that you are recording. The image may be recorded as a deep magenta colour, but this can be transformed into a black-and-white image by using any of the conversion techniques already described.

Early digital cameras may also behave in very unusual ways if an image is grossly overexposed, as in the example here. We believe that photons of light have filled each **photosite** on this early sensor (in a Leaf 6 digital back) and are overflowing into the next one, creating the impression of light 'dripping' down the digital chip (**12.28**).

It may also be worth experimenting with a flatbed scanner as an image-capture device. If the scanner has a transparency-lighting lid, very attractive digital photograms can be made by placing objects on the glass scanning 'bed'. You may need to try a few different software settings to get a good effect (or even to make the scanner work at all), and if the lid has to be half-open, place a dark cloth over the scanner to prevent the **ambient light** from creeping in.

Joiners

We explored panoramic images in Chapter 9, but you do not have to create a seamless image: making a mosaic of lots of images shot from different angles can create an interesting representation of the original subject. David Hockney called his versions of these photomontages 'joiners', and explained that they were a reaction, influenced by Cubist art, against ordinary photographs. Here you can see an image created by Jeff Robins using a similar technique (**12.29**).

Cross-Processing Using Curves

The individual curves in an **RGB** image can be used to produce some fascinating effects. After loading your image in Adobe Photoshop and opening the Curves tool, choose one of the individual colour channels and make adjustments to the curve. You will find that it will not only alter the tone of that channel, but will also affect the colour of the overall result and, by altering the three channels as shown here, it is possible to produce results similar to cross-processed film (**12.30–12.38**).

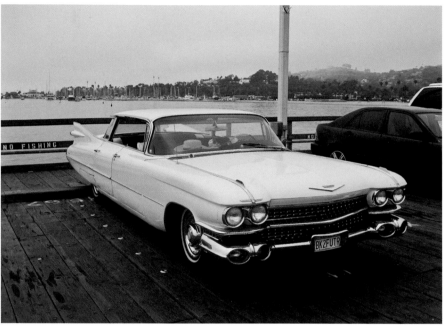

Saving Curves

Remember to save your Curves adjustments, so you can create a whole library of effects that can be applied to other images.

12.30 An image of an American car shot in California by Jeff Robins.

12.31 The red channel was selected from the Curves adjustment layer, and the contrast increased by raising the highlight end and lowering the shadow end of the curve.

12.32 The same Curves adjustment layer with a similar adjustment applied to the green channel.

12.33 Finally, the blue channel is selected and the contrast decreased by lowering the highlight end and raising the shadow end of the curve.

12.34 A second Curves adjustment layer is set to composite RGB and the overall contrast increased by raising the highlight end and lowering the shadow end of the curve.

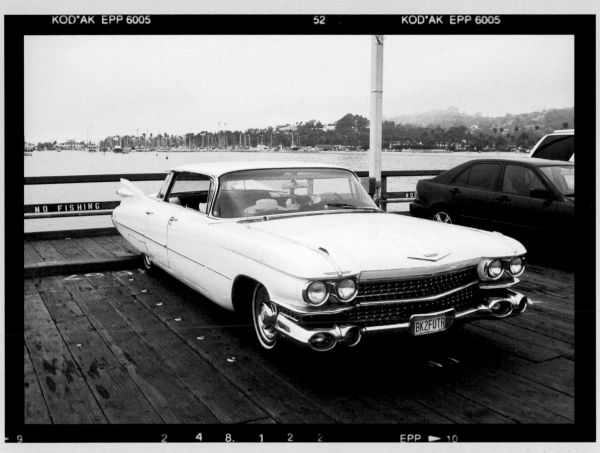

12.38 The finished result, set into a film frame that was scanned in to add to the film-based feel.

12.35, 12.36 (above and above centre) In the layers palette, add a Solid Colour from the adjustment layer menu. In this case, lime green was chosen, and the layer positioned at the top of the layer stack.

12.37 (above right) Adjust the opacity of this new layer to around 10%, to add a slight colour cast across the whole image.

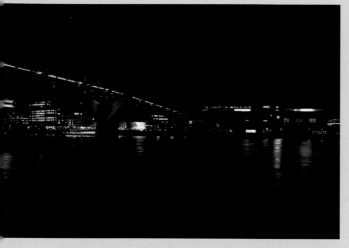

12.39 2.5 seconds, *f*/16, ISO 400.

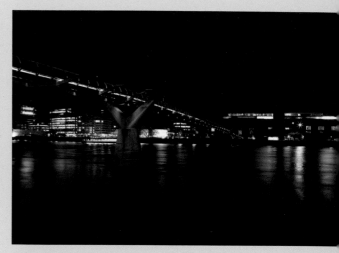

12.40 6 seconds, *f*/16, ISO 400.

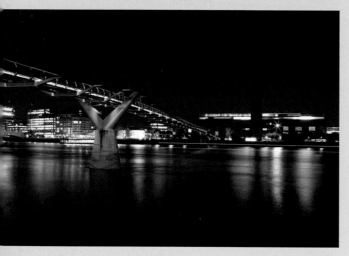

12.41 13 seconds, *f*/16, ISO 400.

12.42 113 seconds, *f*/16, ISO 400.

High Dynamic Range Imaging

High dynamic range (HDR) imaging is a technique that is often used when a subject's **dynamic range** exceeds the capabilities of the camera. Using a tripod, you need first to shoot a sequence of images at different exposure settings (**12.39–12.42**), so you have one shot that contains the highlight detail, another that covers the shadows, and a number of shots in between. This is often done in 1-stop increments, and the exposure adjustments must be applied to the shutter speed rather than the aperture, otherwise the **depth of field** will change between images.

Once you have your exposure sequence, the images are opened and combined using a dedicated HDR program, such as HDRsoft's Photomatix Pro, or an HDR tool in an image-editing program. In Adobe Photoshop you can use the Merge to HDR feature, which converts and combines the images into a 32-**bit** file. This is beyond the range of our own eyes, so the image needs to be 'tone-mapped' to display the HDR image successfully (**12.43**).

In Photoshop's HDR Conversion window, turning on Toning Curve and **Histogram**, and selecting Local Adaptation as the method, will give you the greatest number of options and the most control. Apart from trying to display the very wide dynamic range of an image, with lots of shadow and highlight detail, you could also experiment with the relationship of colours and tone to produce some surreal effects during the tone-mapping process.

12.39–12.42 (opposite) There were more images shot in the sequence than shown here, but it is important that you always alter the shutter speed, rather than the aperture, so that you maintain the same depth of field across the sequence.

12.43 The final HDR image, created by Jerry Nielsen, who has exploited the wide dynamic range using Photomatix Pro software.

12.44 (main image) Another effect that can be applied using Photoshop is posterization, which can be found in the Image → Adjustments menu. Here is a photo of a box of lemons with the Posterize adjustment set to a level of 4.

12.45 (bottom left) The source image of a box of lemons.

12.46 (bottom right) The same image with Photoshop's Solarize filter applied (Filter → Stylize → Solarize).

Negative/Positive Inversion

If you want a quick way to make a pop art-style image, your image-editing program's Invert command will prove useful, as it will allow you to change an image from positive to negative. In Adobe Photoshop, Invert is found under the Image > Adjustments menu and, as well as applying it to the whole image, you could experiment with inverting just part of an image. You might also want to try discarding one or more of the colour channels and replacing them with a modified version of a different channel. The only limit is your imagination (**12.44–12.46**).

Digital Distortion

Changing an image's proportions can be a fun way of highlighting a specific feature in an image or simply changing the way it looks. This can be done in specialist software or in Adobe Photoshop by heading to the Edit > Transform menu and then selecting one of the tools, such as Scale, Rotate, Distort, Perspective or Warp.

Photoshop's Liquify tool can also be useful if you want to distort a chosen area of an image, rather than the whole picture. This is found under the Filter menu and can be used to 'push' areas of an image by using the Warp, Twirl, Pucker and Bloat tools, each of which has its own unique effect.

It is also possible to lock parts of an image by placing a mask over an area that you do not want to distort. Using selections, this mask can be applied to any part of an image, or just an individual channel or specific layers, which provides you with very precise control over what appears in your image and how the layers are managed (**12.47**).

Using Distortion Tools

When using distortion tools in an experimental way, copy the layer you wish to work on so that the distortion can be undone by discarding that layer, rather than starting again with a new version of the image. Also, be sure to save various stages of your image with slightly different file names in case you get a new idea and want to go back to a particular point.

12.47 The gold bar was created by Keith Neale using a rendering program (so it is really a drawing), and was distorted in Adobe Photoshop. The result was combined with the cut-out images of chains and then placed on a background generated in Photoshop. Concept and production by Jeff Robins.

12.48 The photographer Keith Neale began to experiment with 'altered images' using quite early versions of Adobe Photoshop and is now a master of the art form. All you need is plenty of patience and years of practice.

Changing Reality

The outmoded notion that 'the camera never lies' is disproven by the fact that an image can be built from several components to give a photographically realistic look to a bizarre or impossible subject (**12.48**). This is best done in your image-editing software using layers and layer masks, and will work best when everything is planned from the outset. Draw your idea on paper to start with, and list all the components that you need to shoot, along with their size, the appropriate camera angle and the type of lighting. If you take time to plan this precisely, you will have far less reconstruction and repair work to do when it comes to combining your elements.

With some images, photography may not be necessary, as 3D rendering software allows you to create quite realistic artificial landscapes – either in their own right or as a background for a portrait or still life – from 'wire frame' models drawn on computer. Alternatively, the background may be real and the foreground object could be rendered.

Index

Picture Credits

Unless stated otherwise in the list below, all images © Graham Diprose and Jeff Robins.

Adobe product screenshots reprinted with permission from Adobe Systems Incorporated 5.4–5.6, 5.32, 5.33, 6.30, 6.32, 6.35, 6.37, 6.40, 7.14–7.20, 7.24, 7.29–7.31, 7.34, 7.35, 7.37, 7.38, 7.40–7.43, 7.47–7.49, 7.58, 7.59, 7.61, 7.62, 7.65, 7.66, 7.71–7.74, 7.76–7.78, 12.31–12.37; © **Alefiya Akbarally** 9.1; © **Tolga Akmen** 11.12, 11.16; © **Thomas Alexander** 3.48; © **The Richard Avedon Foundation** 12.1; © **Nico Avelardi** 8.7, 10.35, 11.18; **Bayerisches Nationalmuseum, Munich** Louis-Jacques-Mandé Daguerre, Boulevard du Temple, Paris, *c*. 1838, 9.5; © **Olin Brannigan** 9.26, 11.10; © **Scarlett Pimlott Brown** 12.8, 12.9; © **Anya Campbell** 2.9, 5.15, 7.104, 10.2; © **Laura Carew** p. 259 below; **Chandler Chemical Museum, Columbia University, New York** 10.7; © **Tamara Craiu** 5.1; © **Graham Diprose** 2.0, 2.2, 2.24, 3.53, 4.11, 5.0, 8.57, 9.10, 9.20, 11.20, 12.21, 12.22, 12.24, 12.26, 12.27; © **Graham Diprose and Martin Langfield** 9.25; © **Graham Diprose and Pamela Ossola** p. 260 left, 12.12–12.14; **Courtesy of Graham Diprose and Jeff Robins** 9.6, 11.2, 11.14; © **Huw Diprose** 2.15; © **Nadya Elpis** 0.2, 1.19, 1.23–1.26, 3.51, 4.13; © **Bella Falk** 1.0, 1.20, 2.26, 7.21, p. 259 above, 10.0; © **Kit Fordham** 3.31; © **Steve Franck** 2.16, 11.11; © **Graham Goldwater** 11.15; © **Luana Gomes** 0.1; © **Robert Griffin** 1.18, 9.2, 11.0; © **A. J. Heath** 2.17, 5.22, 8.30, 10.12; © **Adrienne Hoetzeneder** 5.7; **International Center of Photography/© Getty Images** 11.7; © **Tom Jenkins** 4.12; **Kodak Collection/National Media Museum/Science & Society Picture Library** 1.1; © **Weronika Krawczyk** 0.3, p. 260 right; **Library of Congress Prints and Photographs Division, Washington, D.C.** 10.8, 11.5, 11.6; © **Fiona Lloyd-Davies** 11.1, 11.17; © **Devin Louttit** 12.6, 12.7; © **Rut Blees Luxemburg** *Cockfosters*, from the series *Piccadilly's Peccadilloes*, 2007, 9.9; © **Xenia McBell** 10.3, 10.33; © **Tom Mackie** 9.16; © **Julian McLean** 6.51–6.52; © **Ryan McNamara** 9.17; © **Duncan McNicol** 9.3; **Duane Michals**, *Alice's Mirror*, 1974. © Duane Michals. Courtesy Pace/MacGill Gallery, New York 4.37; Used with permission from **Microsoft**: 5.27–5.30; © **Henrietta Molinaro** 12.49; © **Adrian Multon** 7.13; **National Gallery, London** 8.1; **National Media Museum/Science & Society Picture Library** 1.2; **Museum of London** Port of London Authority, Thames Riverscapes, Wapping, 1937, 9.7; **Museo Nazionale del Bargello, Florence/ Alinari/Bridgeman Art Library** 10.4; © **John Myers** 9.22; **National Portrait Gallery, London** 10.5; © **Keith Neale** 12.47, 12.48; © **Jasmine Nehme** 10.30; © **Jerry Nielsen** 12.39–12.43; © **Pamela Ossola** 2.25, 3.41, 6.0, 9.0, 12.0, 12.2–12.5, 12.15–12.19; © **Sebastian Palmer** 10.13; © **Palmer + Pawel** 3.19, 4.0, 7.82, 9.21, 10.1; © **Die Photographische Sammlung/SK Stiftung Kultur – August Sander Archiv, Köln/VG Bild-Kunst, Bonn and DACS, London 2012** 1.21, 10.10; *Picture Post*/© **Getty Images** 11.8; **Private collection, Montreal** Aert van der Neer, *Moonlit View on a River*, 1647, 9.4; © **Man Ray Trust/ADAGP, Paris and DACS, London 2012** 3.52; © **Cayetano H. Rios** 6.5; © **Helen Ritchie** 6.38, 7.0, 7.105, 8.0, 8.5, 8.6, 8.58, 10.14; © **Jeff Robins** 2.13, 2.14, 2.19, 2.21, 2.23, 3.2, 3.3, 3.32, 3.33, 4.1, 5.31, 6.49, 7.25, 7.26, 7.32–7.33, 7.36, 7.39, 7.98, 7.103, 8.24, 8.31, 9.28, 10.32, 12.29, 12.30, 12.38; © **Sebastião Salgado/Amazonas/nbpictures** 3.50;© **John Schott** 9.27 © **Mike Seaborne, Charles Craig and Graham Diprose** 9.8; **Photo by Cindy Sherman** Courtesy of the Artist and Metro Pictures 4.36; © **Christian Sinibaldi** 1.15, 1.17; **Edward Steichen**/*Vanity Fair*/© **Condé Nast Publications** 10.9; © **Bettina Strenske** 1.29, 2.3, 7.75, 9.11, 9.18, 10.15, 10.34, 12.50; © **Julija Svetlova** 1.14, 1.27, 1.28, 3.0, 3.4, 12.10, 12.11; © **Homer Sykes** (www.homersykes.com) 11.9; © **Sam Taylor-Wood.** Courtesy White Cube 10.11; **Drazen Tomic** 1.3, 1.4, 1.5, 1.7, 1.13, 2.4, 2.6, 2.11, 2.22, 3.11, 3.21, 3.22, 3.30, 3.43–3.47, 4.10, 4.14–4.22, 4.25, 4.29, 4.33, 5.2, 5.8–5.11, 6.1–6.4, 6.11, 6.20–6.23, 7.1–7.4, 7.6–7.8, 7.11–7.12, 8.23, 8.27, 8.32, 8.33, 8.50, 8.51, 10.16, 10.18, 10.20, 10.22, 10.25, 10.27, 10.29; © **Martin Usborne** 1.22; **Edward Weston**, *Pepper, No. 30*, 1930, 8.3. Collection Center for Creative Photography © 1981 Arizona Board of Regents; © **Henrietta Williams** 11.19; © **Davinia Young** frontispiece, 5.20

401

Further Reading

General Reading

Ingledew, John, *Photography*, London, 2005

Branston, Gill and Stafford, Roy, *The Media Student's Book*, London and New York, 2010 (5th edn)

Digital Photography

Ang, Tom, *Digital Photographer's Handbook*, London, 2008 (4th edn)

Eismann, Katrin with Palmer, Wayne, *Photoshop Restoration and Retouching*, Berkeley, 2006 (3rd edn)

Evening, Martin, and Schewe, Jeff, *Adobe Photoshop CS4 for Photographers*, Oxford and Boston, 2009

Evening, Martin, and Schewe, Jeff, *Adobe Photoshop CS5 for Photographers*, Oxford and Boston, 2011

Fraser, Bruce and Schewe, Jeff, *Real World Image Sharpening with Adobe Photoshop, Camera Raw and Lightroom*, Berkeley, 2010 (2nd edn)

Kelby, Scott, *Professional Portrait Retouching Techniques for Photographers Using Photoshop*, Berkeley, 2011

Critical Theory

Barthes, Roland, trans. Howard, Richard, *Camera Lucida: Reflections on Photography*, New York and London, 1982

Cotton, Charlotte, *The Photograph as Contemporary Art*, London, 2004

Sontag, Susan, *On Photography*, London and New York, 1977

Wells, Liz (ed.), *Photography: A Critical Introduction*, London and New York, 2009 (4th edn)

Still-Life Photography

Manna, Lou, *Digital Food Photography*, Boston, 2005

Martineau, Paul, *Still Life in Photography*, Los Angeles, 2010

Landscape and Cityscape Photography

Adams, Ansel, *Ansel Adams: 400 Photographs*, London and New York, 2007

Cornish, Joe and Ephrams, Eddie, *Joe Cornish: A Photographer at Work*, London, 2010

Gerlach, John and Barbara, *Digital Landscape Photography*, 2009

Salvesen, Britt, *New Topographics*, London, 2009

Portrait, Fashion and Beauty Photography

Angeletti, Norberto and Oliva, Alberto, *In Vogue: The Illustrated History of the World's Most Famous Fashion Magazine*, New York, 2006

Bright, Susan, *Auto Focus: The Self-Portrait in Contemporary Photography*, London, 2010

Ewing, William A., *Face: The New Photographic Portrait*, London, 2006

Ewing, William A. and Brandow, Todd, *Edward Steichen: In High Fashion*, London, 2008

Ford, Colin, *Julia Margaret Cameron: A Critical Biography*, Los Angeles, 2003

Von Hartz, John, *August Sander*, New York, 1997

Photojournalism and Documentary Photography

Fellig, Arthur ('Weegee'), *Naked City*, Cambridge, MA and London, 2003 (originally 1945)

Meltzer, Milton, *Dorothea Lange: A Photographer's Life*, New York, 1978

McCullin, Don, *Don McCullin*, London, 2003

Parr, Martin, *The Last Resort*, Stockport, 2009 (originally 1986)

Williams, Val, *Anna Fox: Photographs 1983–2007*, Brighton, 2007

Shutter priority
The photographer chooses the *shutter speed* (most often to control movement within the image, or avoid camera shake) and the camera uses its exposure meter to select the appropriate lens aperture.

Shutter speed
The length of time that a mechanical or electronic shutter allows light to fall onto the camera's film or digital *sensor*.

Sidecar file
In digital imaging, a sidecar file may be saved alongside a *Raw* image, containing *metadata* relating to changes made to that image file. If the sidecar file is separated from the image file then the changes made to the Raw file during the conversion process will be lost. See also *XMP*.

SLR (single-lens reflex)
Describes a camera that allows you to view the image directly through the lens by means of a moving mirror and pentaprism (a five-sided prism that turns a beam of light by 90°).

Spot metering
A specialized light meter, or function of an in-camera light meter, that measures the exposure from a very narrow angle of view, often less than 10°.

sRGB
A *colour space* designed by Hewlett Packard and Microsoft, primarily for use in the production of images for electronic (on-screen) reproduction, although it is also the only colour space for some compact digital cameras. Has a smaller *gamut* than *Adobe RGB* (1998).

Subtractive colours
See *Secondary colours*.

T

Terabyte
1,000,000,000,000 *bytes*, or 1,000 *gigabytes*.

TIFF (Tagged Image File Format)
An industry-standard file format for image storage and output. It is supported by nearly all image-handling software and hardware, and its lossless format means that opening and resaving a TIFF file does not alter the original image data. Now the most widely used file format for high-quality digital images.

TTL (through the lens)
Most often used to describe metering systems that use the light passing through the lens to gauge the exposure.

U

Ultraviolet (UV)
A type of electromagnetic radiation that is beyond violet in the visible spectrum. Film is inherently sensitive to ultraviolet light, which can cause unwanted changes to an image. These effects can be greatly reduced by the use of an ultraviolet or skylight filter.

V

Vector graphics
Vector graphics files store the lines, shapes and colours that make up an image as a mathematical formula. These formulae can produce an image that may be scaled to any size and will not pixellate with enlargement in the same way as a bitmap (*pixel*-based) image will. All vector-based images have to be 'rasterized' (converted to bitmap) to be viewed or printed.

W

Wet collodion
An early photographic process that involved coating a sheet of glass with a collodion (a viscous solution of pyroxylin) containing light-sensitive chemicals. This coating had to be done immediately before exposure, as its sensitivity would fade as it dried out; and the image had to be processed immediately too. This gave rise to the use of a dark tent when working on location for both coating and processing.

White balance
The adjustment of light sources or camera settings, or subsequent image processing, to produce a neutral or desired colour balance.

Wi-Fi
A collective term describing any device, such as wireless networks and mobile phones, which can communicate with another using radio waves. Many peripheral devices – a keyboard and mouse, for example – are now linked to the computer using Wi-Fi technology.

X

XMP (extensible metadata platform)
An associate or *sidecar* file format directly linked to a *Raw* file, where any changes made to that image using the Adobe Camera Raw file-processor are stored. This XMP file is accessed and edited whenever the Raw file is opened and changes are made; the original Raw file is not altered in any way. This is known as non-destructive editing. If the XMP file is removed or separated from its Raw file, all changes will be lost, forcing the automatic creation of a new XMP file.

Z

Zone system
A photographic technique devised by Ansel Adams and Fred Archer in the 1940s based on careful visualization (before shooting), exposure control (at the time of capture) and contrast control (during processing) to produce the optimum result using black-and-white film.

Zoom lens
A lens containing a range of continuously variable *focal lengths*. Not all of these focal lengths function equally well, and some photographers claim that *prime lenses* give higher-quality results.

Photodiode

A light-sensitive receiver (either a *CCD* or a *CMOS*) on a digital imaging chip. Used in an array that forms the sensor, with each photodiode collecting the light that is subsequently converted into one *pixel* in the image.

Photogravure

A fine art printing process dating from the 1830s, in which an image is transferred to a flat copper plate, which is etched and used to make ink-based prints.

Photosite

Another name for a *photodiode*.

Pixel

Derived from 'picture element'. The smallest amount of tonal data making up a digital image.

Pixel dimension

The number of *pixels* found in the linear horizontal and vertical planes making up an image; for example, 4256 × 3832 pixels.

Post-production

Work that is done after an image has been transferred to a computer. It can be used to describe anything from *Raw*-file processing to the full manipulation of an image.

Primary colours

The additive colours (red, green and blue) commonly used in monitors and image-editing programs. Primaries combine to give us other colours: red + green = yellow; red + blue = magenta; blue + green = cyan, and so on.

Prime lens

A lens with a single, fixed *focal length*. Prime lenses tend to produce a lighter and better-quality result than a *zoom lens*.

Profile

A profile is used to ensure that the colours recorded or seen by one device are translated accurately when seen by another device; so that an image on a monitor looks the same when printed, for example. A profile is generated by calibration of a device and is used to correct for any discrepancies as an image moves through the workflow towards a common target.

ppi (pixels per inch)

The number of *pixels* in a linear inch, in either a vertical or horizontal direction.

R

**RAM
(Random Access Memory)**

Integrated circuitry where a computer temporarily stores data that is being used by the *operating system* and running software. It is most commonly used in a 'volatile form', which means it will empty its contents when turned off.

Raw

A file format that contains the unprocessed but *interpolated RGB* data from a camera's *sensor*, along with full *metadata*. Considered by many as a 'digital negative'.

Reciprocity Law

A law in physics that produces the fundamental formula for

exposure: $E = I \times T$, where E = exposure, I = intensity of light (controlled by the aperture) and T = time (controlled by the *shutter speed*).

Reciprocity Law failure

In film-based imaging, the *Reciprocity Law* fails when there is a very low intensity of light, requiring a much longer exposure than the law would expect. It also fails when the light intensity is exceptionally high, requiring considerably shorter exposures, although this is rarely encountered.

Red-eye

An effect produced when a camera flash passes through the subject's pupil and illuminates the blood vessels at the rear of the eye. Most often happens when the flash is situated very close to the lens, so it is particularly common when a built-in flash is used.

Reflected light

Light reflecting off a subject, rather than falling on it. See also *Incident light*.

Reflectors

Light-coloured surfaces (usually white, silver or gold) that are used to bounce light back into a subject, usually to lighten the shadow areas.

Resolution

The measurement of the amount of detail in an image. In digital imaging, it is dependent on the optical resolution of a lens and the number of *pixels*, usually given as pixels per inch (*ppi*).

RGB

Red, green and blue; collectively known as the *primary* or *additive colours* of light.

S

Saturation

The measurement of the purity of a *hue*, ranging from grey (minimum colour) to maximum colour. Together with hue and *luminance*, it makes up the three-dimensional LSH colour model used in digital imaging.

Scanning

A collective term for using hardware and software to convert an analogue image into a digital one. This can be from either transparency or negative film, or from printed media.

Secondary colours

Cyan, magenta and yellow. Most often found as inks or dyes in the printing process as they subtract light from white paper – hence their alternative name, 'subtractive colours'.

Selections

Used in image-editing programs to isolate areas, allowing changes to be made to the image while protecting unselected areas from the work being done. When used in conjunction with *layers*, selections are a very powerful creative tool.

Sensor

A light-sensitive digital-imaging chip that captures an image.

Live view

A feature that is available on nearly all compact digital cameras and a number of digital *SLRs*, and that displays a live image on the camera's rear *LCD* screen. In the case of digital SLRs, this avoids using the mirror or pentaprism of the camera and makes *HD video* recording possible.

Lossy compression

Any form of image compression that discards some information during the compression process, considerably reducing the file size, but also reducing the quality of the original image.

Low key

A lighting style that produces an image that is dark overall. Often only one light is used, possibly controlled with a weak fill light or simple reflector.

Luminance

The lightness or brightness of any particular colour. Together with *hue* and *saturation*, makes up the three-dimensional LSH colour model that is widely used in digital imaging.

LZW compression

A lossless data-compression algorithm developed by three mathematicians – Lempel, Ziv and Welch – in 1984. It can be used to save *TIFF* files and also forms the basis of the GIF file format used in the production of web pages. It should be noted that when used with TIFF files, it is not compatible with some image-handling software.

M

Megabyte

1,000,000 *bytes*.

Megahertz (MHz)

1,000,000 hertz, where hertz is used to measure the number of electrical changes per second. Often used to describe the refresh rate of a computer monitor.

Megapixels

1,000,000 *pixels*. Often used to describe the total number of pixels making up a digital image, which is found by multiplying the number of vertical pixels by the number of horizontal pixels: for example, an image measuring 4256 × 3832 pixels = 16,308,992 pixels, or 16.3 megapixels (MP).

Memory card

Portable, solid-state storage device for data captured in a digital camera.

Metadata

Part of the *EXIF* data that contains such information as date, time and camera settings. This data is part of the image file and can be read either on your camera or in any good image-handling software.

Microlens

A lens covering each individual *photosite* on a *sensor*.

Monobloc

An 'all-in-one' studio flash design that has the flash tube, capacitor and all relevant controls built into the flash head.

Multiple exposure

A setting that allows more than one exposure to be captured in the same frame.

Multi-zone metering

Also known as matrix (Nikon) and evaluative (Canon) metering. The camera's light meter measures the exposure from across the whole image.

N

Nanometres

A unit of length equal to one billionth of a metre. Primarily used when measuring the wavelength of light and the rest of the electromagnetic spectrum.

Narrow-cut filter

Specially made filters that separate the red, green and blue components of an image when exposed onto *panchromatic* film. These filters are very accurately made: they admit only a very narrow band of wavelengths of light through them, and stop all others.

Neutral-density (ND) filter

ND filters reduce the amount of light passing through them, without affecting its colour. They are very useful when shooting in bright conditions, as they will give you more control over your choice of aperture and *shutter speed*. ND filters are available in a variety of strengths, usually measured in *f-stops*.

Noise

Pixel values that are produced randomly and are non-image-forming. Noise is typically generated by high *ISO* settings or long exposure durations, although many digital cameras now have in-camera processing to combat this.

O

Ordinary film

A black-and-white film that is sensitive only to blue light. Unexposed film can be handled under an amber or yellow safelight.

Orthochromatic

A black-and-white film that is sensitive to green and blue wavelengths of light, but not red. Can be used with a red safelight in a darkroom.

Operating system (OS)

The software that is usually pre-installed on any computer when sold. It contains many programs for use on a day-to-day basis, as well as controlling the access to the data and programs stored on it.

P

Panchromatic

A black-and-white film that is sensitive to red, green and blue wavelengths of light. Can be handled safely only in total darkness.

Panning

The deliberate movement of the camera to follow a moving subject during an exposure. Depending on the *shutter speed* used, the subject will typically appear (relatively) sharp against a blurred background.

High key
A lighting style that reduces the amount of shadow and mid-tone areas in a scene to produce a very light image, often by using multiple light sources that result in very little modelling in the subject.

Histogram
A graphic representation as a bar chart of the tonal values in an image, from 0 (black) to 255 (white). Can be viewed in-camera to assess exposure, or in an image-editing program, where it is likely to be used to optimize or correct an exposure.

Hyperfocal distance
The point of focus at which everything from half that distance to infinity will appear acceptably sharp at a given aperture setting and *focal length*.

Hue
Describes all the colours in the visible spectrum, and together with *luminance* and *saturation* makes up the LSH colour model, widely used in digital imaging.

I

ICC profile
See *Profile*

Image stabilization
Lens-based or *sensor*-based system that reduces the effect of unwanted camera movement, minimizing camera shake. Lens-based stabilization uses a system of gyroscopes in the lens, while in-camera stabilization attempts to cancel out camera shake by moving the sensor.

Incandescent
A form of light produced by passing an electric current through a wire and raising its temperature until it glows. This hot filament is protected by a glass envelope (the bulb), which contains an inert gas to increase the life of the wire filament. This is the most common form of domestic lighting and can be made to produce light at different *colour temperatures*. Commonly known as tungsten light.

Incident light
Refers to the light that is falling onto a subject, rather than the light that is reflected off it.

Infrared (IR)
An electromagnetic radiation that is beyond the red end of the visible spectrum. Can be recorded using specialist film or a digital *sensor*, although most sensors have an IR-blocking filter that may need to be removed first.

Infrared (IR) filter
A filter designed to block *infrared* wavelengths. An IR filter is placed in front of most digital camera *sensors*, as these are inherently sensitive to infrared light, which would have a negative effect on the recorded image.

Ink-jet
A printing process where small quantities of ink are placed onto paper through a fine nozzle. This ink is forced out of the nozzle by using either heat or a material that changes shape when a voltage is applied, squeezing the ink out. Ink-jet printers use dye or pigment-based inks based on the *CMYK* colours, with other colours sometimes added for improved colour reproduction.

Interpolation
A mathematical algorithm used in a digital camera to produce a full-colour *RGB* image based on the data recorded by a single red-, green- or blue-filtered *photosite*. In-camera processing uses the values of neighbouring photosites to determine the actual colour and interpolate the missing data.

ISO (International Standards Organization)
Recognized worldwide as the standard measurement of the sensitivity of film and digital *sensors* to light.

J

JPEG (Joint Photographic Experts Group)
A digital-image file format that compresses data to reduce the size of the file. Uses *lossy compression*, so some data is permanently lost.

K

Keywords
Words – such as the location or subject – that are added to an image's *metadata* and are often used to locate and identify the image at a later date. Many image libraries use standardized keywords to make it easier to search for stock photographs.

Kilobyte
1,000 *bytes* or 1,024 bytes, depending on the context.

L

Layers
The majority of image-editing programs allow individual image elements to be placed on layers that can be edited independently of each other. A layer can be thought of as a sheet of film allowing layers below to be concealed or revealed.

LCD (liquid crystal display)
A visual display technology that is used to display data on a screen in a digital camera, mobile phone, flatscreen monitor and television, among other devices.

Lens aberrations
A collective term that covers inherent faults in the way a lens produces an image, including barrel or pincushion distortion, *chromatic aberration* and vignetting.

Liquid emulsion
A solution containing a light-sensitive emulsion suspended in gelatine that can be painted onto such surfaces as paper, fabric, wood or metal, then exposed to light and printed in a similar way to a conventional black-and-white print.

it can take between 4 and 6 dots of ink to make up 1 *pixel* in an image.

Dry plates
Invented by Richard Maddox in 1871, these greatly contributed towards bringing photography to the masses. A glass plate was coated with a light-sensitive emulsion suspended in gelatine, which made it possible to buy and store pre-prepared photographic plates, rather than coating, exposing and developing them on location.

DVD-R/DVD-RW
Write-once (DVD-R) and rewritable (DVD-RW) optical discs that are similar in appearance to CDs, but with a higher storage capacity: a single-sided, single-layer disc is capable of holding 4.7Gb of data, while other versions can hold 8.5Gb, 9.4Gb and 17.8Gb. As with CDs, DVD-R discs generally have greater archival stability than DVD-RW discs.

Dynamic range
The range of tones between black, the darkest shadow, and white, the lightest highlight in a subject. In photography, it is most commonly given as the number of *f-stops* between those two tonal extremes.

E

EXIF data (exchangeable image file)
EXIF data contains *metadata*, which is made up of information found on your camera, such as the date and time, and camera settings. This information is stored in the file and you can add other details, such as copyright notices and *keywords*.

Exposure latitude
The amount by which an image can be over- or underexposed while still delivering an acceptable-looking result.

F

f-stop
The term given to the aperture setting on a lens. It is dependent on the actual diameter of the aperture in relation to the *focal length* of the lens.

Fill-in light
The name given to a secondary light that is placed to lighten shadows cast by the main light. Also used in 'fill-in flash', when using a flash to lighten dark shadows in ambient lighting conditions, such as direct sunlight.

Firmware
The software built into a device that tells it how to run. A digital camera uses an onboard computer that is programmed to control how it works, allowing manufacturers to introduce updates to the firmware to make improvements.

Flag
A collective name given to any item (although usually a black card or board) that stops unwanted light from falling on the subject or the lens when taking a picture.

Flash drives
A solid-state storage device, with no moving parts, for computer data. The term encompasses the *memory cards* used in cameras and portable music players. They all work in much the same way, but vary in terms of the read-and-write speed when handling data.

Fluorescent
In photography, fluorescent refers to a form of lighting that is produced by passing electricity through a gas, causing it to glow and produce visible light. This form of light is often greenish-yellow in colour, producing unpredictable and sometimes unpleasant results unless it is filtered or the *white balance* is set carefully.

Focal length
When a lens focuses light from infinity onto the smallest possible point on a screen, its focal length is the distance from the centre (nodal point) of the lens to the screen.

Font
In digital typography, a font is defined as a style or design of a particular typeface. Care must be taken to ensure that a font used on one computer will be available for use on another computer, if necessary.

G

Gamut
A particular defined range (subset) of colours that is specific to a device or process. When an image is passed to another device or process that cannot reproduce the same gamut, some colours will be 'out of gamut'.

Gigabyte
One gigabyte (Gb) is equal to 1000 *megabytes* (Mb), or 1,000,000,000 bytes.

Gigahertz (GHz)
A measurement of frequency: 1GHz is equal to 1 thousand million hertz. Hertz are used to measure the number of electrical changes per second, with GHz used to describe the speed of the main processor in today's computer.

Greyscale
A single-*channel* image made up of tones of grey, rather than *RGB* colour channels.

H

HDRI (high dynamic range imaging)
Often referred to as HDR. This technique combines a range of different exposures of the same scene to record the full tonal range, either to compensate for a scene with a high *dynamic range* or for creative effect. Images are typically created with a 32-*bit depth*, and then remapped to 8-bit using a process known as tone mapping.

High-definition (HD) video
High-definition video format available on many digital cameras, including *SLRs*. Most commonly refers to *resolutions* of 1280 × 720 *pixels* (720p) or 1,920 × 1,080 pixels (1080i/1080p).

CD-RW

A rewritable CD format (hence 'RW') that allows the data on the disc to be erased and the disc reused. This format is not recommended for long-term image storage, as this type of disc often has poor archival qualities.

CCD (charge-coupled device)

A type of imaging *sensor* where the light received by each *photodiode* for a single exposure is transported across the sensor and read at one corner of the array. An analogue-to-digital converter then turns each *pixel*'s value into a digital value.

Centre-weighted metering

The camera's exposure meter bases its reading on the average of the light in and around the centre of the frame image, often indicated by a visible circle in the viewfinder or a group of small highlighted areas.

Channels

In digital imaging, a *pixel* records tonal data based on the amount of light that falls on it. This light passes through either a red, green or blue filter, with the data stored in a channel reserved for that colour. These channels can then be accessed in software and edited, altering the pixel's colour, brightness and *saturation*.

Chromatic aberration

A lens defect caused by different wavelengths of light focusing at slightly different points, resulting in coloured fringing effects, particularly towards the edges of a picture.

Circle of confusion

A point in an image that no longer appears as a dot, but is sufficiently out of focus that it appears as a circle.

Clipping

When data runs off one end (or both ends) of the *histogram,* it indicates that the shadows and/or highlights have been 'clipped'.

CMOS (complementary metal-oxide-semiconductor)

An imaging *sensor* in which transistors at each *photosite* amplify and move the electrical charge, so that each *pixel* is read individually. An alternative to *CCD* sensors, and increasingly common in digital *SLR* cameras, partly because of lower production costs.

CMYK

Cyan, magenta, yellow, key: the colours widely used in printing, where 'key' is black.

Colour space

A mathematical model or map of a device or process that describes its *gamut*. A colour space can be either *RGB* or *CMYK*, and is often displayed as a three-dimensional space. Device-independent colour spaces are also used as industry-standard targets: examples include *Adobe RGB* (1998) and *sRGB*.

Colour temperature

In the context of photography, refers to the colour of white light, which can be warm or cold. Colour temperature is measured in *degrees Kelvin* (K), where the higher the value, the cooler (bluer) the light.

Compression

Used to reduce the size of an image file for ease and economy of storage or speed of transmission. Such formats as *JPEG* use *lossy compression*, which permanently affects the image, while *LZW compression* (used for *TIFF* files) is lossless, but cannot be read by all image-handling devices and software.

CPU (Central Processing Unit)

The primary element in a computer, where the user's instructions are carried out. It could be thought of as the computer's brain.

D

Daguerreotype

An early photographic process, announced in 1839 and named after its inventor, Louis-Jacques-Mandé Daguerre. Polished silver plates were made sensitive to light by placing them in an iodine vapour to produce silver iodide. After an exposure lasting many minutes, a latent image could be seen following 'development' with the fumes of heated mercury; a solution of hot common salt was used to fix it.

Degrees Kelvin

A scale used to measure the *colour temperature* of a light source: the higher the temperatures, the cooler the colour, with the temperature of 'average daylight' (and flash) commonly given as 5,500K.

Depth of field

The area of a scene either side of the focal point that is acceptably in focus. The smaller the aperture setting, the greater the depth of field.

Depth of focus

The distance between two points in an image that will give satisfactory focus. It is dependent on the aperture and *focal length* of the lens, and the distance from the subject.

Diffuser

A material placed over a direct light source to scatter the light and produce a softer lighting effect that is less directional and contrasty.

Digital zoom

A means of enlarging a selected part of a digital image in-camera by cropping into the picture, thus reducing overall quality.

DNG (digital negative)

A universal *Raw*-file format developed by Adobe, designed to overcome the problems caused by having numerous proprietary Raw-file formats. Adobe DNG conversion software converts all recognized Raw files into a standard DNG format.

dpi

The measure of the number of dots of ink that can be placed on paper by a printer in a linear inch. In general,

Glossary

A

A sizes (A5, A4, A3 and so on)
European standard for
manufactured paper sizes,
ranging from A0 to A10. The
largest size, A0, is 84.1 cm ×
118.9 cm, with each successive
smaller size made by taking
the length of the shorter side
and making it the new longer
side, thus retaining the same
proportions. The most
commonly used size for
documents is A4, which is
21.0cm × 29.7 cm.

Additive colour
See *Primary colours*

Adobe® RGB
A *colour space*, also known
as Adobe RGB (1998), widely
used in digital photography.
It describes a wider *gamut*
of colours than *sRGB*. This
space is designed to suit
photography that is likely to
end up being output to print.

AEL (automatic exposure lock)
A camera control that locks the
exposure, forcing it to remain
the same even if the camera
is then directed towards
a different area of the subject.

Ambient light
The available light falling on
a subject. The term tends to
be used to describe available
natural light, or artificial lights
other than those put in place
by the photographer.

Aperture priority
The photographer chooses
the lens aperture (*f-stop*),
usually with consideration
to the *depth of field*, and the
camera selects the appropriate
shutter speed to give the
correct exposure.

Auto-focus (AF)
Auto-focus systems use either
infrared or ultrasonic sensors
to identify a particular area
(or areas) of the scene and
bring it into focus. It is
possible to switch between
continuous focus, where the
sensors follow any subject
movement, and single focus,
where the camera will hold
the focus as long as the shutter
release is partially depressed.

B

Bayer pattern
A specific pattern of red,
green and blue filters covering
the *photosites* on a digital
camera's imaging *sensor*.
There are twice as many green
filters as there are red and blue
filters (to emulate human
vision). The Bayer pattern was
first used by Kodak and has
now been adopted by most
sensor manufacturers.

Bit
Short for 'binary digit'.
The fundamental element
underlying all computer
functions, with two states:
on (1), and off (0). Binary
code is based on this concept.

Bit depth
The number of tones, ranging
from black to white, that can
be captured by a *pixel* in
a *sensor*. An 8-bit pixel can
record 256 steps of tone, but
because an image needs all
three colours (red, green and
blue), the image will have a bit
depth of 8 × 3 = 24, which can
produce 256 × 256 × 256 =
16,777,216 colours.

Bluetooth
A radio-based technology
for transferring data from
virtually any input device –
such as a keyboard, mouse or
mobile phone – to a computer,
as long as they are Bluetooth-
enabled. The distance across
which this data can be
transmitted may be limited.

Blu-Ray
An optical disc-based system
for storing data. Blu-Ray is
similar to CDs and DVDs in
appearance, but is capable of
holding considerably more
data than either: 25Gb on
a single-layer disc, or 50Gb on
a dual-layer disc. Originally
introduced to allow high-
quality distribution of movies
to the domestic market, Blu-
Ray has now been adopted by
computer users who want to
store large quantities of data,
such as images.

Buffer
The buffer in a digital *SLR*
camera controls the flow of
data to the *memory card*,
allowing data to flow at
a specific rate to ensure that
the card is not overloaded.
A camera will stop working if
the specified size of the buffer
is exceeded, and will not
continue to function until at
least one of the images held
has been downloaded, or has
'cleared' the buffer.

Burn
'Burn to disc' usually refers to
CDs and DVDs, where data is
burnt into a metal layer within
the disc, using a laser beam.
The term is also often used
(incorrectly) to refer to the
process of copying images
or data onto a hard drive.

Byte
A unit of digital data made up
of 8 *bits*.

C

Calotype
An early photographic process
developed and named by
William Henry Fox Talbot
and announced in 1840; also
called the Talbotype. The
process involved soaking fine-
quality writing paper first in
a silver nitrate solution and
then potassium iodide, which
impregnated the paper fibres
with light-sensitive silver
iodide. The latent image was
made visible by immersion in
a silver nitrate and gallic acid
solution and then fixed by
removing the unused
chemicals with sodium
thiosulphate. After washing
and drying, the negative
image was waxed to make
it translucent and prepare it
for printing.

CD-R
A 'write-once' CD format,
most often with a 700Mb
capacity. Data can be written
to disc using a CD-writer, or
burner, but once written it
cannot be erased or rewritten.
CD-R discs can be read by
the built-in drives in most
computers, and the long-term
stability of some discs makes
them a useful medium for
archival storage.

Exercise 2

A WELL-KNOWN PHRASE

12.50 We all know how it feels to be in a dense crowd, and Bettina Strenske has generated an image that sums this up visually. When working with this type of constructed image, work backwards from your final visualization and make sure that all the elements will fit together.

Resources

For this exercise you will need your digital camera and access to a computer running Adobe Photoshop. You will also need your workbook to document your ideas, and it is a good idea to record all the stages of your image production, from pictures of the set through to screenshots of the image-manipulation stages.

The Task and Extended Research

Your task is to illustrate a well-known phrase or saying, such as 'Out of the frying pan, into the fire', 'Burning the midnight oil', 'Skeleton in the closet', 'Sledgehammer to crack a nut', and so on (**12.50**). It can be very interesting to research the meaning or origin of your phrase and, as there are thousands to choose from, there is the potential to make a series of images, rather than just one.

Getting Started

This exercise is firstly about planning. How are you going to illustrate your phrase, and how will you combine photography with computer-based image-editing? You will need to draw a series of rough sketches that will help you visualize the final image, and work out how you need to shoot the various elements to make the digital editing as easy as possible. Be careful to avoid lighting coming from one direction in one element and from another for a different part of the picture, and think also about scale, rather than hoping you can fix things later on the computer. Perspective, lens choice and camera angles also need to be planned carefully, as do focus and depth of field.

When you have photographed all your elements, you can start to assemble them, but be sure to save your work very regularly, make screenshots as you go, and be patient so you do not 'paint yourself into a corner' and find that you need to go back several stages and change direction.

Feedback

Once you have achieved a result that you are happy with, you will have attained most of the skills and ideas that this book can give you. This is a wonderful exercise to return to from time to time, as it is important to practise and revitalize your existing skills. With luck, you will find your 'phrases' get better with each image that you make.

Exercise 1

A BLANK CANVAS

Resources

For this exercise you will need access to a darkroom, an enlarger and some well-exposed 35 mm negatives. You will also need a pot of liquid emulsion, protective gloves and overalls (and possibly goggles) and three atomizers of the kind used to spray plants with water.

The Task and Extended Research

This exercise asks the question 'is there anything onto which you cannot print a photograph using liquid emulsion?' Experiment with making prints on a range of less conventional surfaces: if you want to try to print an image onto a brick, or a tennis ball, or a mirror, or an old child's doll, then why not? If you think that a loaf of bread might go soggy in the developer, try giving it a couple of thick coats of matt varnish to seal it before coating it with liquid emulsion. Above all, be creative (**12.49**).

Getting Started

Trying to print onto irregularly shaped surfaces means that you are more likely to splash chemicals around than if you were processing conventional paper, so wear protective aprons, overalls, gloves and, if necessary, goggles, and make sure that anyone in a communal darkroom is fully aware of your intentions. Do not try to make pictures on your (or your friend's) skin, as the long immersion in processing chemicals is dangerous.

In some cases, such as with prints made on larger objects, it may be necessary to use plant atomizers filled with developer, fixer and water to process your object, but ensure that there is something, such as a larger dish or plastic dustbin, to catch the chemicals that drip off. Ideally, you will need a final wash of at least 30 minutes before leaving your objects to dry naturally. Do not worry if they look slightly dark under the safelight: they could look great when they are out of the darkroom.

Feedback

With luck (and a little practice), you should end up with some creative images made on all sorts of objects and surfaces. Your images may be prone to rapid deterioration, so it is a good idea to get, at the earliest opportunity, some high-quality pictures of them to keep for your records.

12.49 The designer Henrietta Molinaro coated the lower half of sheets of heavyweight art paper with cement. When it was dry, she coated the whole sheet with liquid emulsion. Her negatives were photograms of plants laid onto high-contrast lith film. The result is that the plant roots appear to be in heavily textured 'earth' while the delicate leaves appear 'above ground' on the smooth art paper.